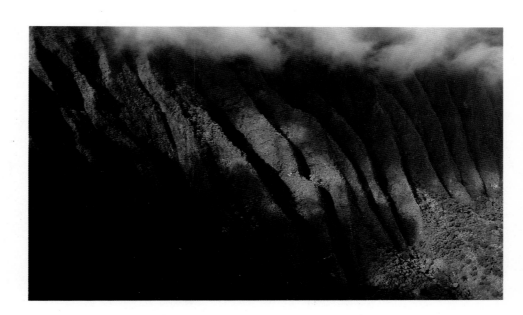

OVER
HAWAI'I

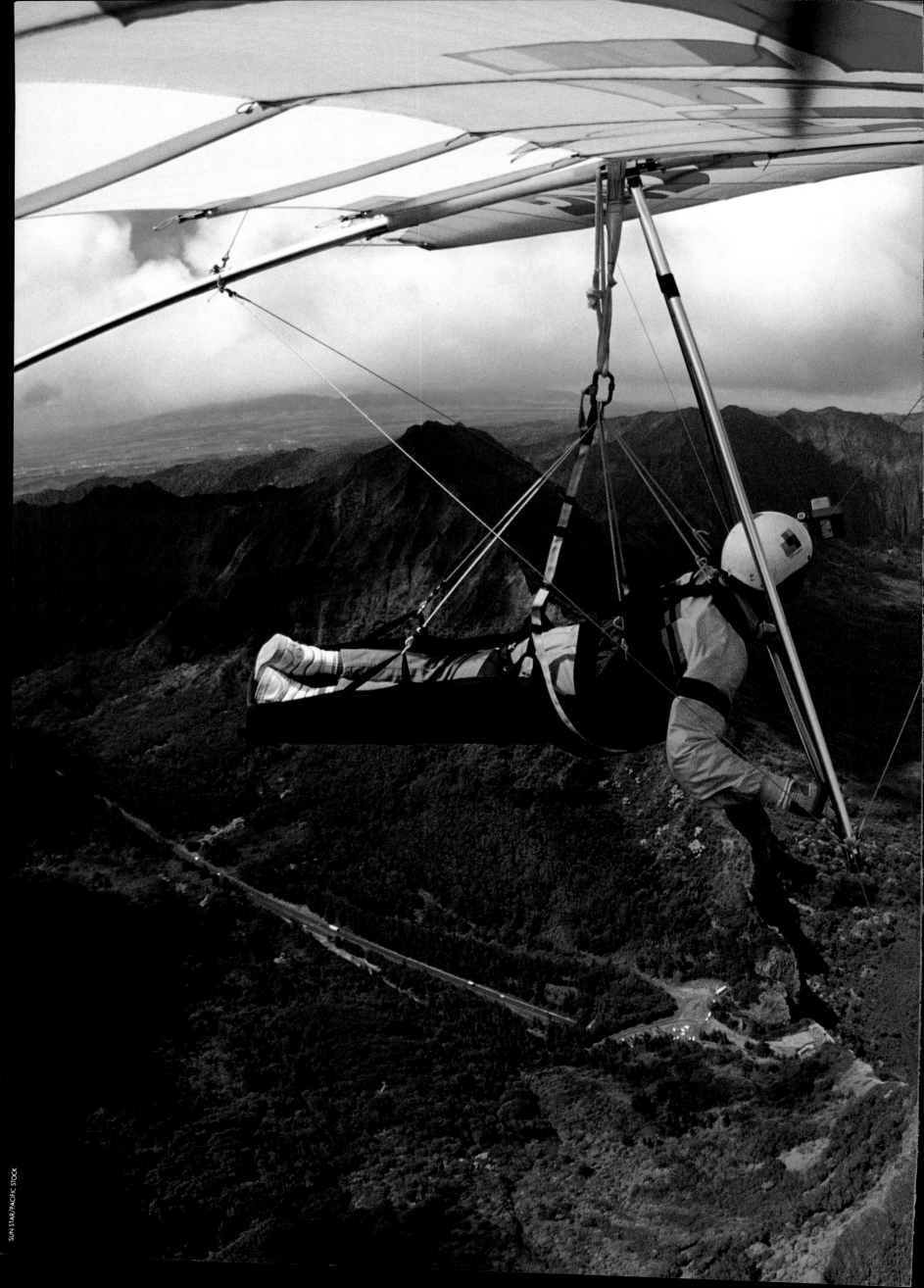

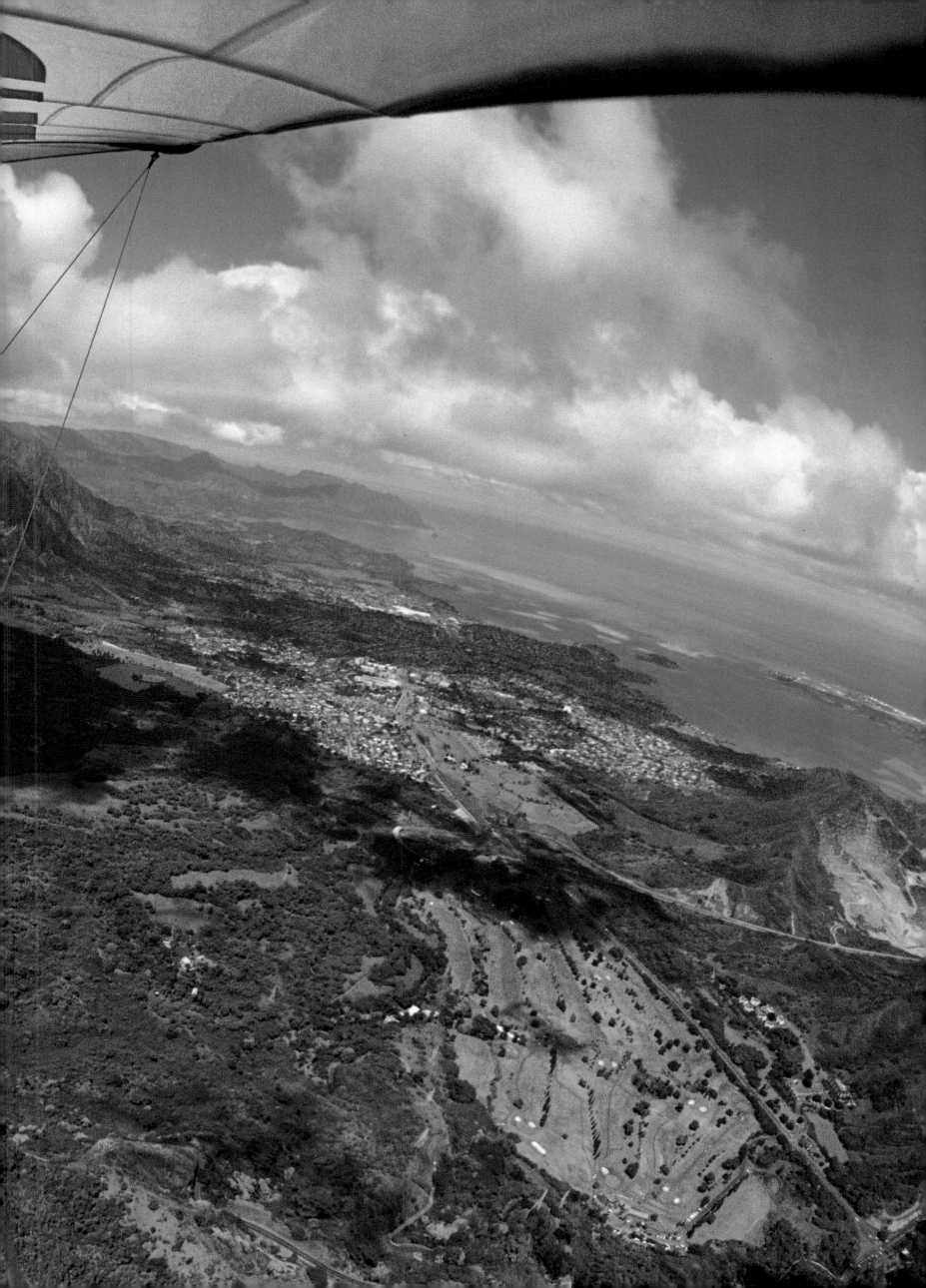

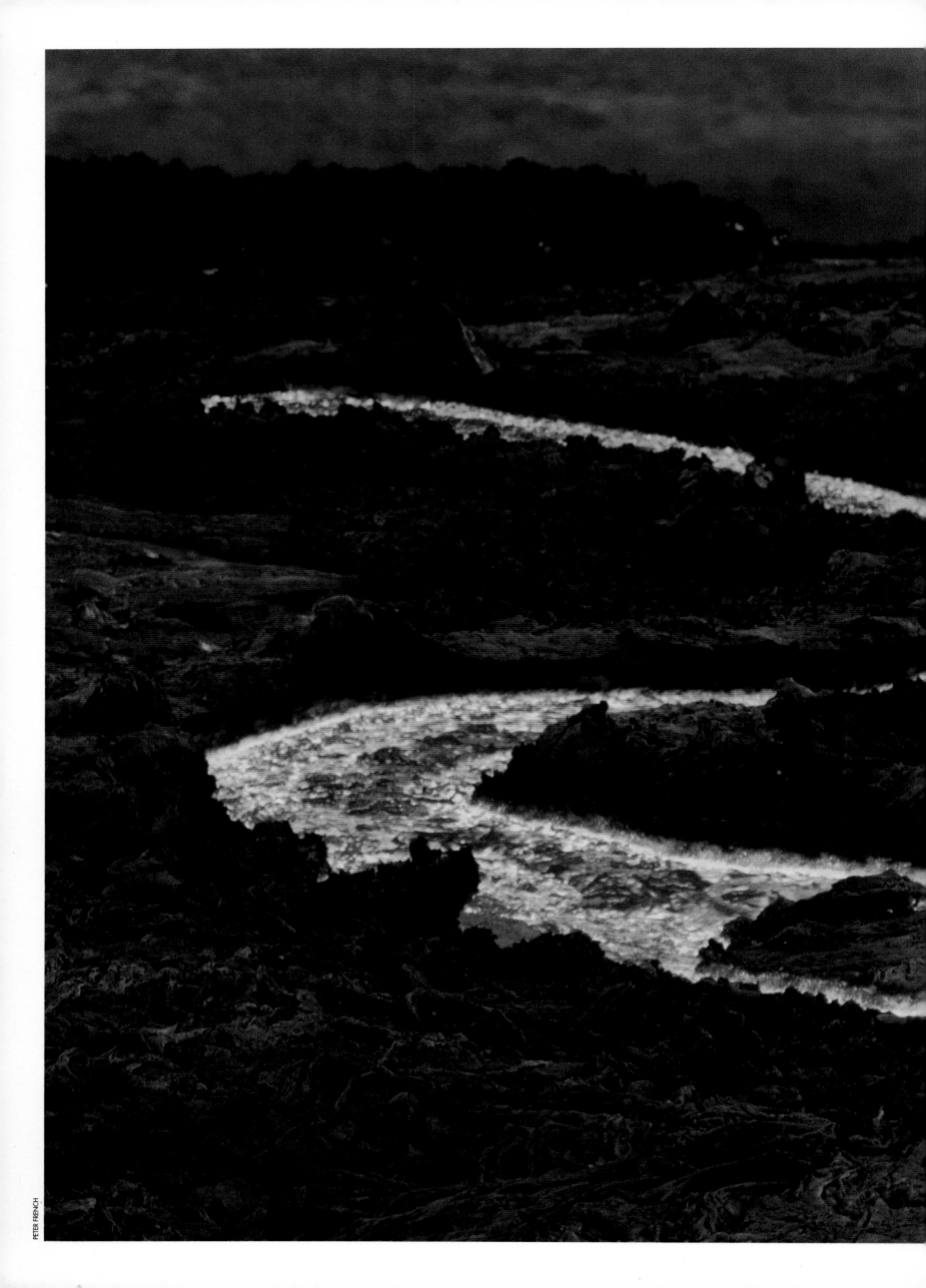

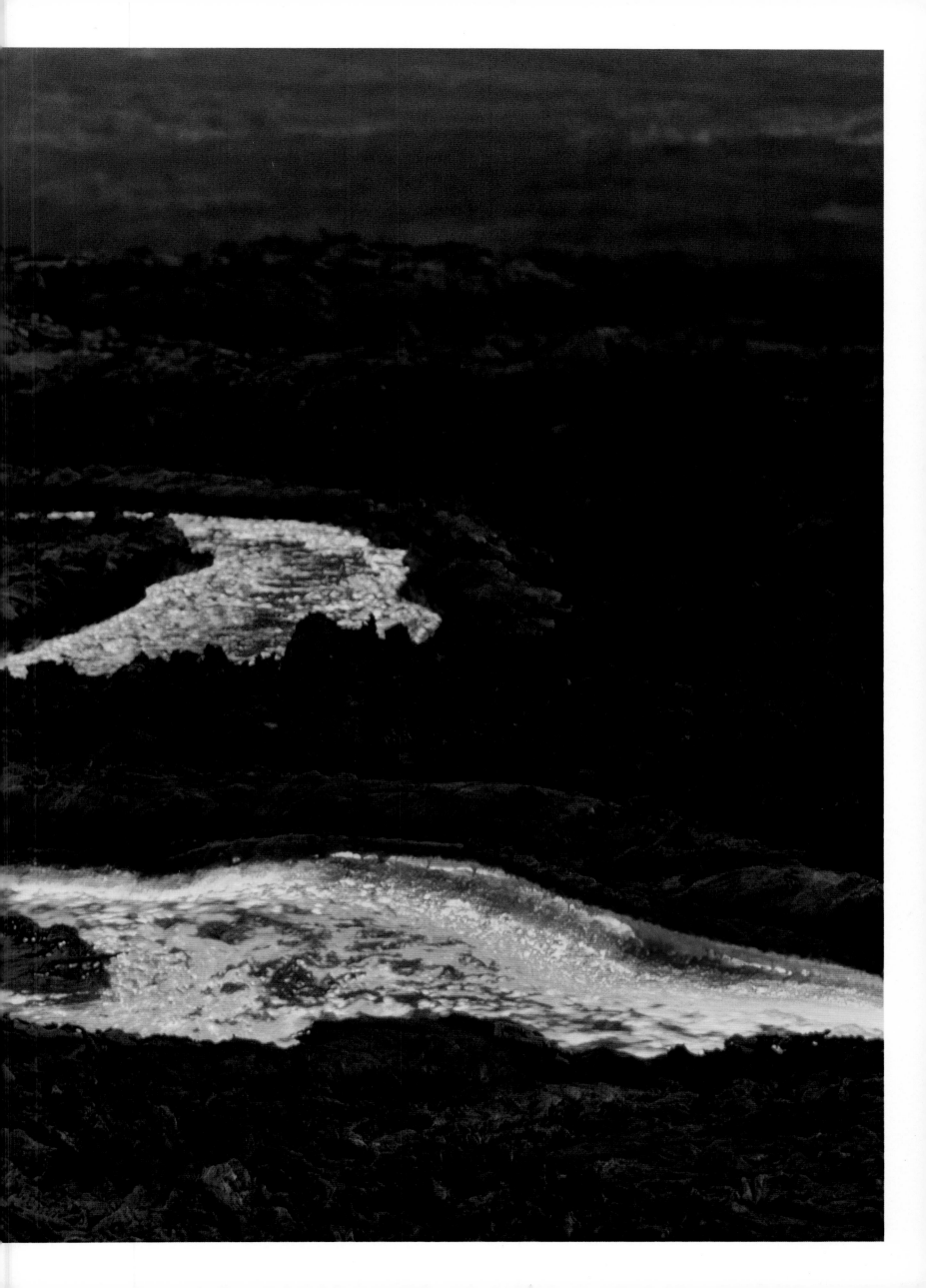

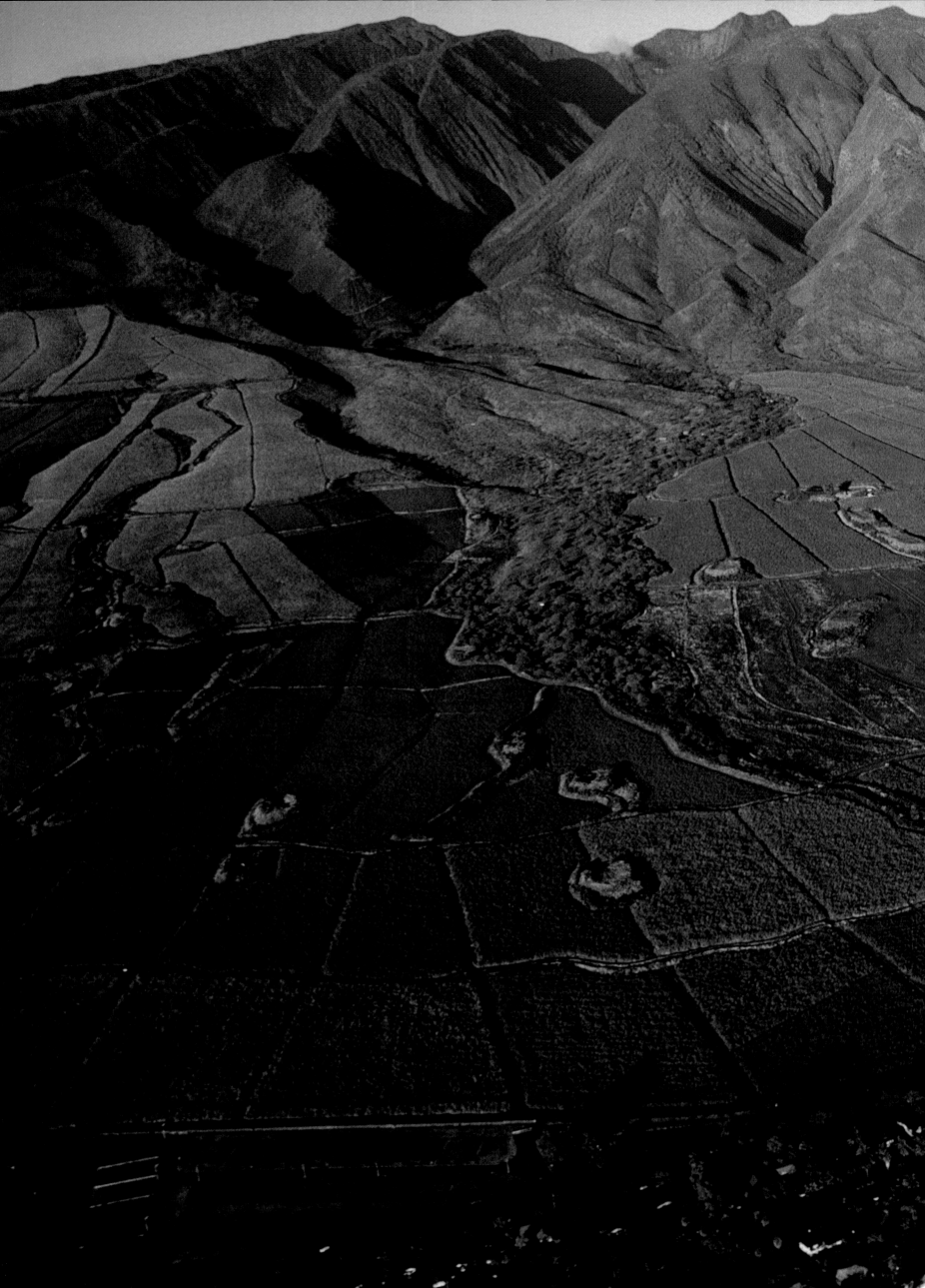

OVER HAWAI'I

FOREWORD BY
JAMES A. MICHENER

TEXT BY STEVEN GOLDSBERRY
PHOTOGRAPHY BY REG MORRISON

WELDON
OWEN

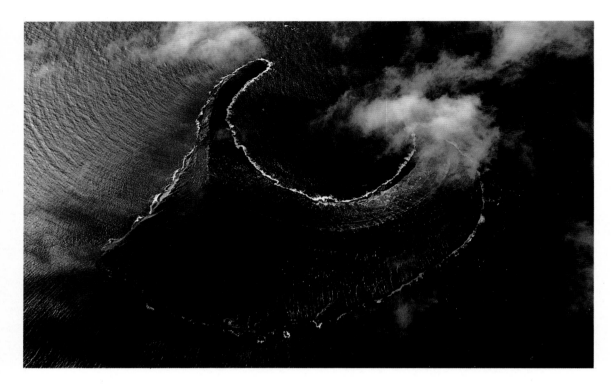

A WINGS OVER AMERICA® PROJECT

This edition published in the United States of America in 1995 by
Weldon Owen Reference, Inc.; 820 Montgomery Street,
San Francisco, CA 94133. Phone (415) 291-0100, Fax (415) 274-7383

ISBN 1-887451-03-X

WINGS OVER AMERICA® Series
Chairman: Kevin Weldon
President: John Owen
Associate Editor: Laurie Wertz
Copy Editor: Virginia Rich
Researcher/On-Site Location Coordinator: Barbara Roether
Design: Tom Morgan, Blue Design (from an original concept
 by John Bull, The Book Design Company)
Map: Mike Gorman
Production Director: Stephanie Sherman

OVER® HAWAI'I text and captions by Steven Goldsberry
Principal photography by Reg Morrison
Pilots: Fixed wing: Dale Bringelson, Kevin V. Britt, Bobby L. Norris
Rotary: Francis Akana, Irwin C. Malzman

Printed by Toppan Printing Co., China
Production by Mandarin Offset, Hong Kong

Printed in China

Above: In legend the sea-breached crater of Lehua Island, north of
Ni'ihau, was said to be a giant crab claw that once held Hōkū pa'a, the
North Star.

Opposite: The surf report for Waikīkī this day was "flat to a foot."

Page 1: The Pu'u o Kona cliffs on windward O'ahu. During rainstorms
each of the folds is lined with a waterfall.

Pages 2–3: A hang glider launched from Makapu'u cliffs on windward
O'ahu has sailed north eight miles and positioned himself above the
Pali Lookout.

Pages 4–5: A bit of lava crust has broken off and rides like a boat over
this winding lava river in Hawai'i Volcanoes National Park on the Big
Island.

Pages 6–7: In various stages of maturity, the sugarcane fields of leeward
Maui run from the coast to the West Maui Mountains.

Pages 10–11: Called the Pink Palace because of its unique color and
architecture, the Royal Hawaiian remains one of the most elegant hotels
on Waikīkī Beach.

Pages 12–13: The cloak of Poli'ahu, the snow goddess, covers this cinder
cone on the peak of Mauna Kea (white mountain).

Page 14: The southeastern spur of the Ko'olau Range above Waimānalo,
on O'ahu.

Pages 16–17: A lava-kindled fire razes a forest of 'ōhi'a trees near the
Pu'u 'Ō'ō vent, Kīlauea, Hawai'i.

Pages 18–19: The glow of a summer sunset recedes behind the Wai'anae
Range, and the lights of Honolulu blanket O'ahu's south shore with
sparkling, mesmerizing color.

Page 20: The Nā Pali cliffs of Kaua'i stand like the feet of the huge,
mythical dragon-lizards the Hawaiians called mo'o.

A NOTE ON HAWAIIAN SPELLING

The orthography of Hawaiian words has been a problem since the first
Westerners began writing down what they heard the islanders saying.
Over the years the language, as it converted from strictly oral to written
communication, became simplified (r's and t's, for example, were
dropped). Linguists added the ' mark (hamzah, or 'okina) to indicate
the glottal stop, and the ō mark (macron, or kahakō) to lengthen a
vowel. The editors of Over Hawai'i have endeavored to print Hawaiian
words accurately, according to current scholarly practice.

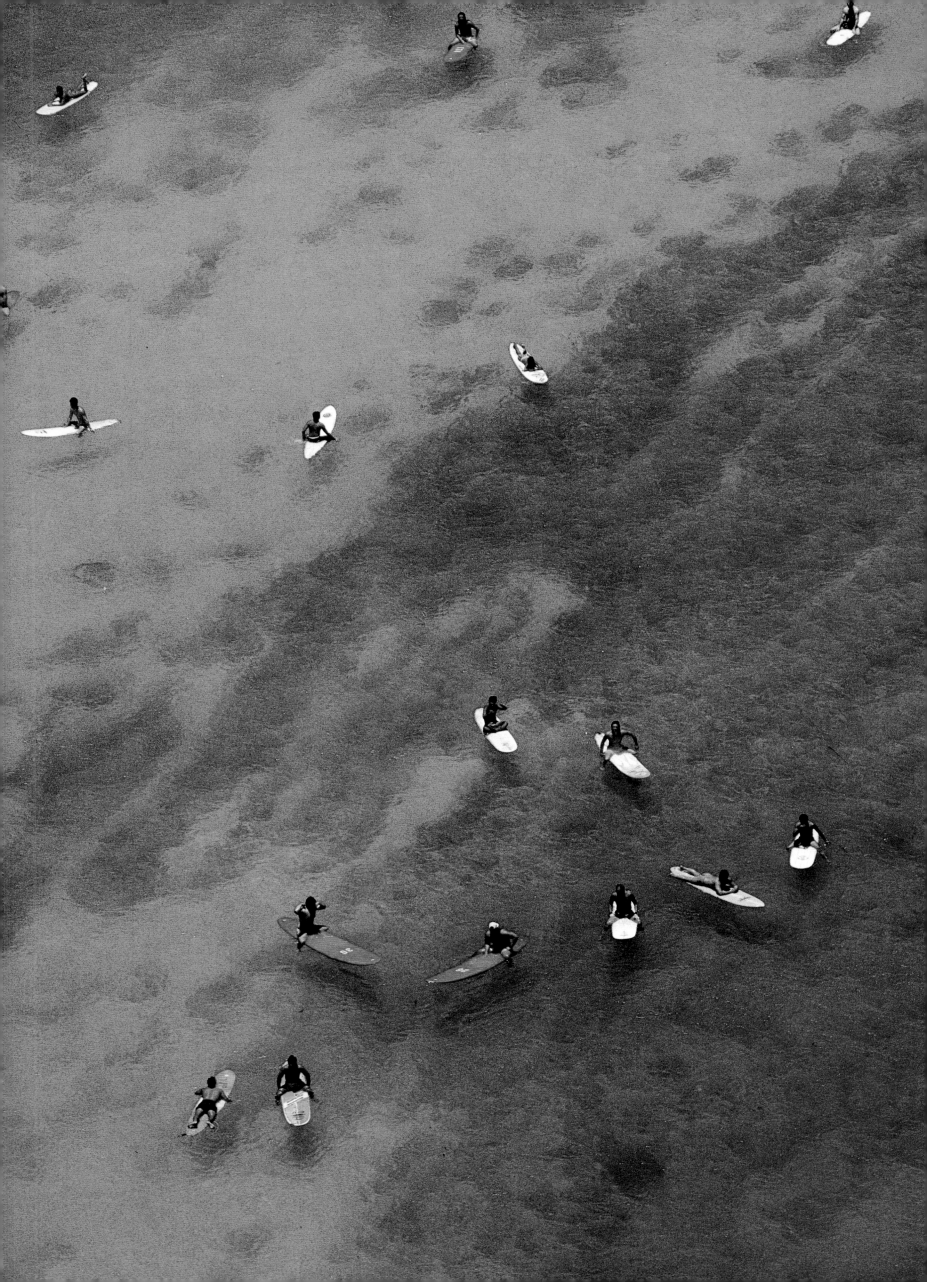

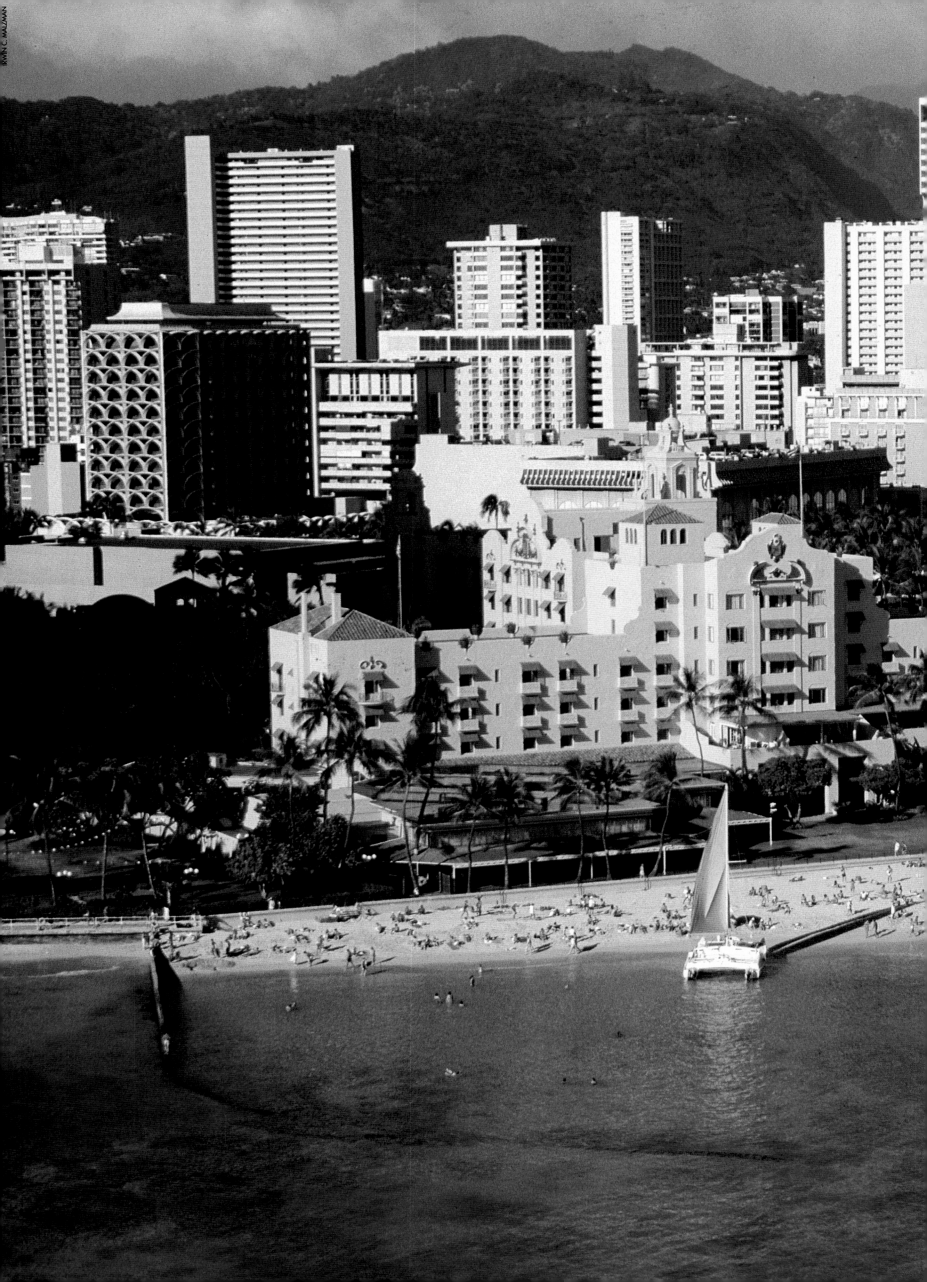

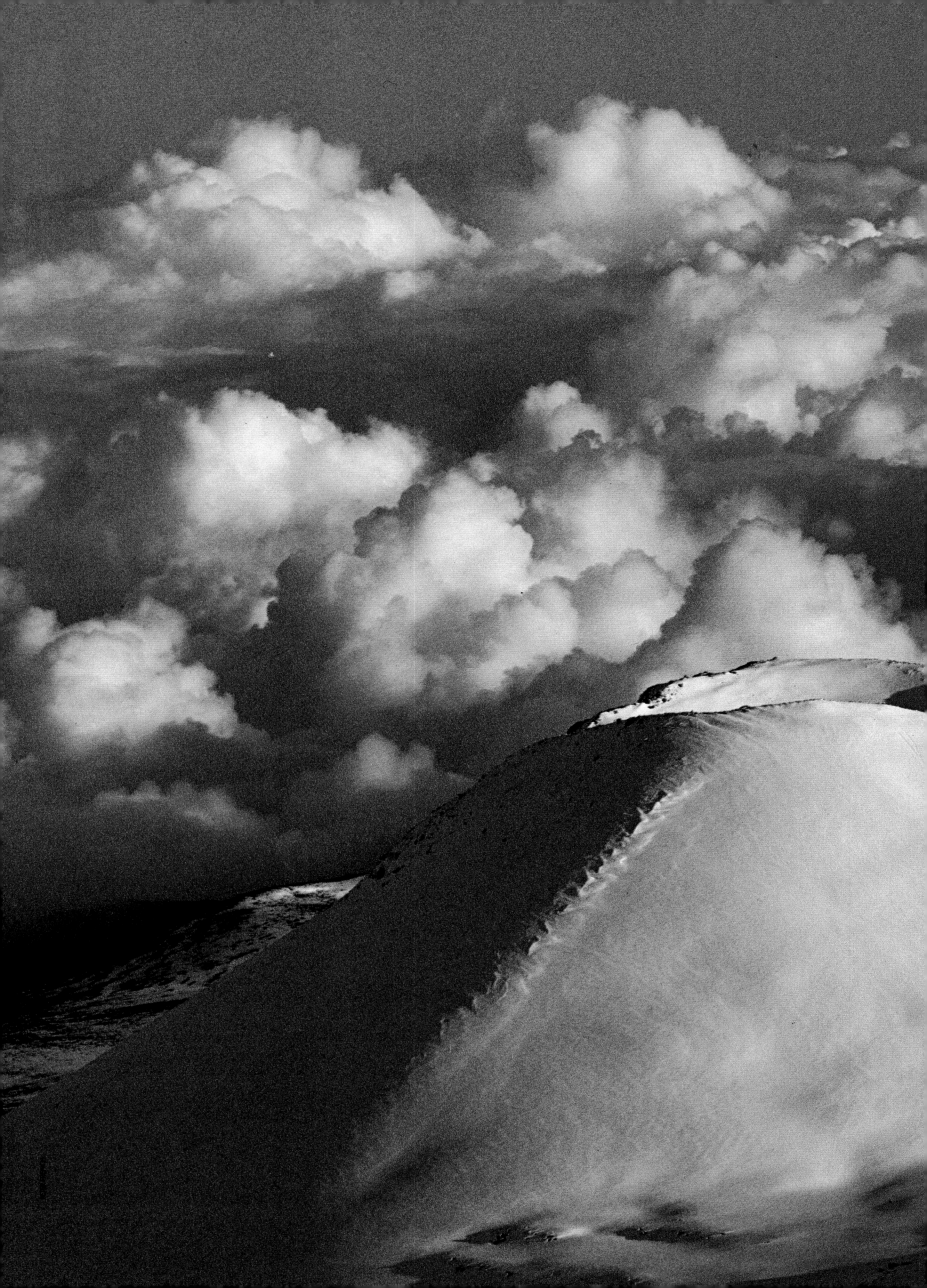

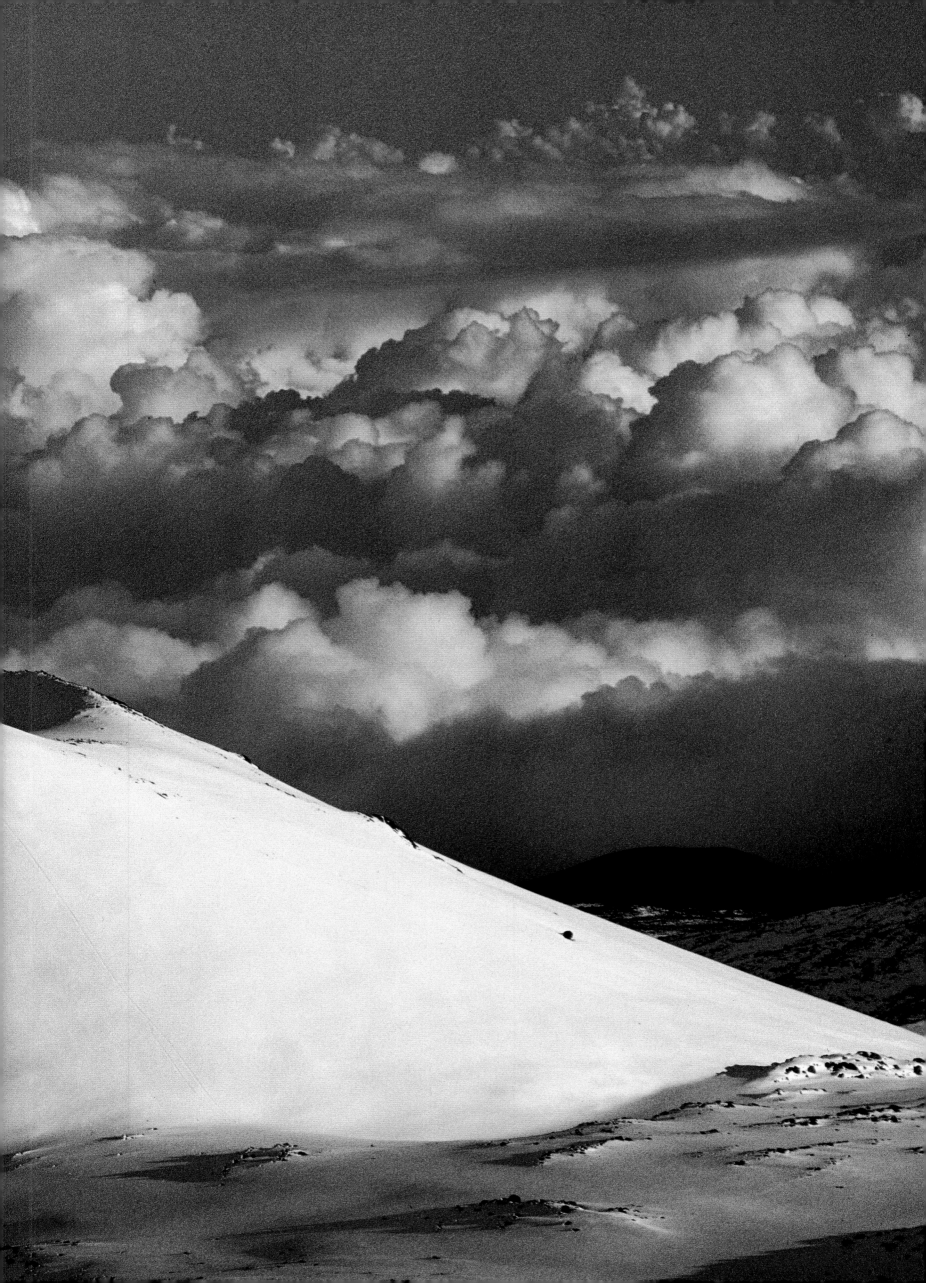

Mad About Hawai'i

BY JAMES A. MICHENER

Years ago I described myself as a "nesomaniac," an invented term constructed from two Greek words meaning "island" and "mad about." I have spent a fair portion of my life exploring islands and writing about them, and in those years of study and exploration I concluded that whereas there are some stunning islands in the world like Capri, Bora Bora and Jamaica, no group can compare with that cluster of enchanting ones we call Hawai'i. Here magnificent scenery, incomparable vegetation, delightful people of many races, a wealth of flowers and a rare collection of songs unite to make the islands a unique paradise. I am mad about Hawai'i and attempted to explain why in my novel of that name.

During two long tours of duty in World War II, first as an officer who tried to keep Navy planes flying over enemy-held islands, and later as the officer in charge of writing the histories of the various islands, I had a rare opportunity of seeing from the air an enormous span of the Pacific Ocean from Easter Island to Australia, from Hawai'i to Okinawa, and during these travels I learned how majestic, mysterious and inviting islands can be when seen from aloft. At first the sea is empty in all directions, not a cloud in the sky ahead, not even a bird flying, and then slowly, on the distant horizon, a towering cloud begins to form, marking the spot beneath which an island hides. How exciting it is to come upon such an island from the air, and how elegantly *Over Hawai'i* presents an aerial view of Hawai'i's islands with their abundance of compelling views: the rain forests, the great cliffs, the sweeping beaches, and soaring above them all, the towering volcanoes. To be appreciated, islands should sometimes be seen from the air, for then their relationship to the ocean stands out more clearly.

When I worked in Hawai'i, over a period of some twelve years, 1950–62, my wife and I lived part of the time in a cliffside house atop a rise in Pūpūkea overlooking O'ahu's north shore, and there in the evenings after quitting the typewriter, I would sit on the lānai and study the ocean waves as they thundered on the beach. I saw storms bend the palm trees and tides sweep inland to engulf the roads, but I also saw times when the ocean was as calm as the surface of a mirror with stars and a rising moon dancing on the waters. In those quiet times I often speculated on what the future of these heavenly islands might be. Seventy years from then, in the middle of a new century, would Hawai'i still represent the acme of what can be accomplished when men and women who love beauty and know how to protect it, and how to discipline themselves and their society? Or would it deteriorate to a bruised land, overcrowded, scarred with junk and devoid of beauty? I saw then that its future could develop in either direction, depending on the will of the people to protect the wonders they had inherited, and I could not decide what the chances were for beauty to prevail.

Now when I return to Hawai'i I see that whereas there are more people than there used to be, far more cars on the road, and condominiums rising in lovely coves that used to be open to the sea, I also see that out beyond the cities and towns little damage has been done. On my last visit to Kaua'i and

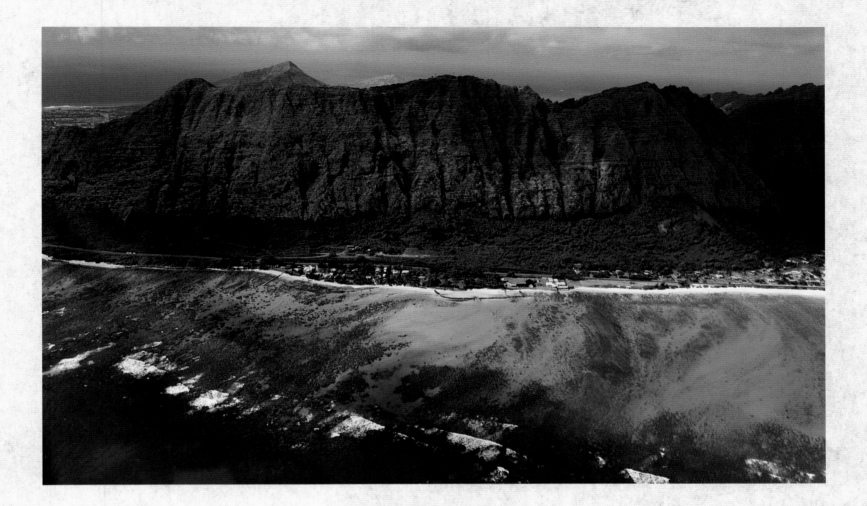

the Big Island I saw so much open land resting in the sunlight as it had for thousands of years that I cried to my partner: "These islands can remain unspoiled for another hundred years!"

It was a heartening conclusion. To maintain the glories of Hawai'i, open space is needed for trees, the growth of flowers, the play of wind and storm on the landscape, the freedom of people to move about and to have picnics along the shore. For the ultimate happiness people require contact with nature, and in Hawai'i that contact should include the ability to watch the great volcanoes erupting and pushing their red-hot lava into the Pacific to build new land. They should be able to see taro growing, and palm trees swaying, orchids hiding in strange places and pineapples ripening in the sun. Quite clearly men, women and children can live in concrete jungles where food and water are brought to them, but prudent ones also escape now and then to the countryside to remind themselves of how human life is really sustained: from the land.

The great continental mass of the United States and Canada is blessed by having off its shores, and relatively accessible, two clusters of islands, Hawai'i's closely knit islands in the Pacific, and the Caribbean's widely scattered islands in the Atlantic. It's as if God had said: "On the mainland you'll work and worry, build and barter, but offshore I'll give these islands for rest and recuperation." What a marvelous arrangement! No wonder I'm mad about Hawai'i.

James A. Michener

James A. Michener

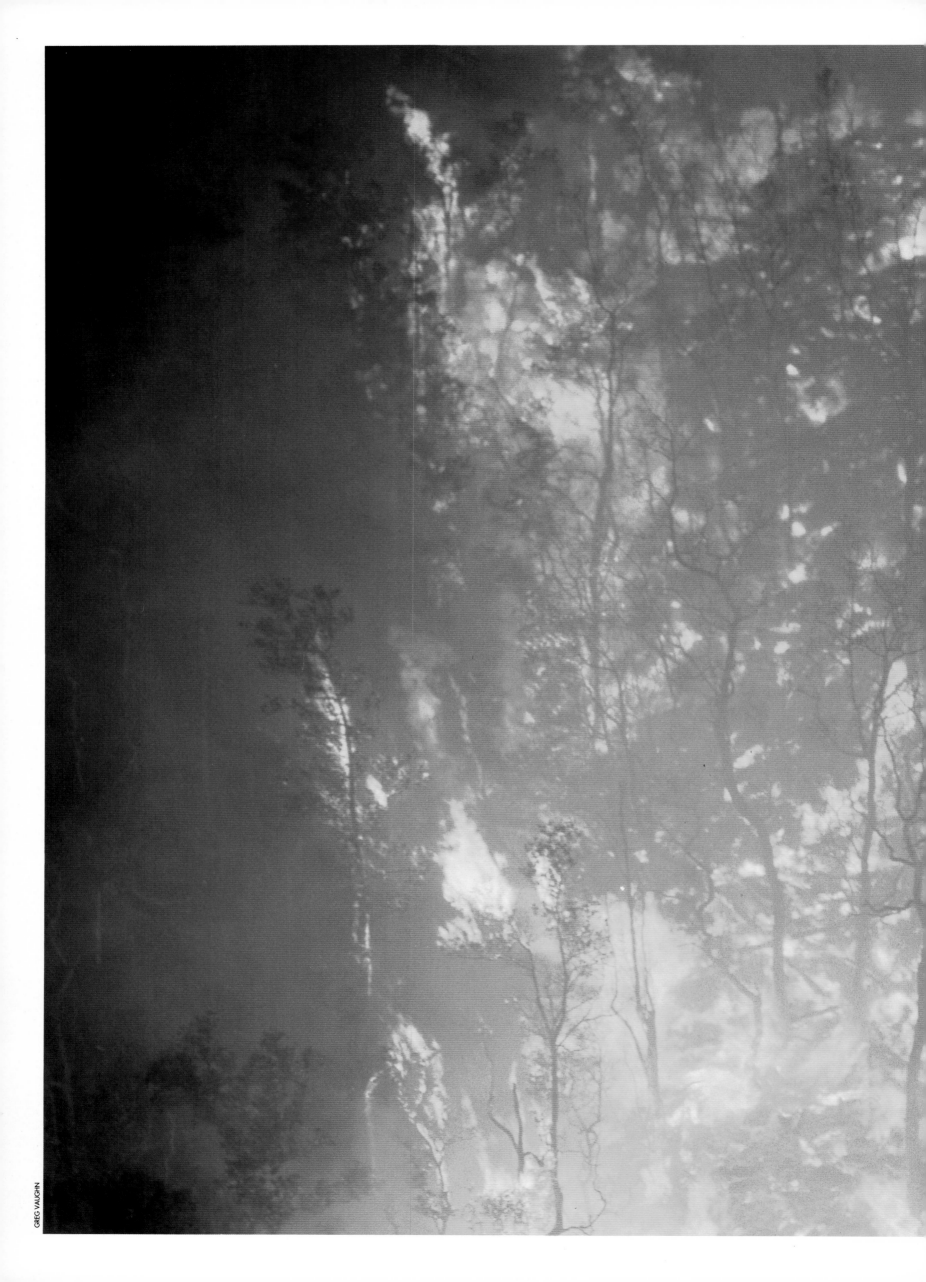

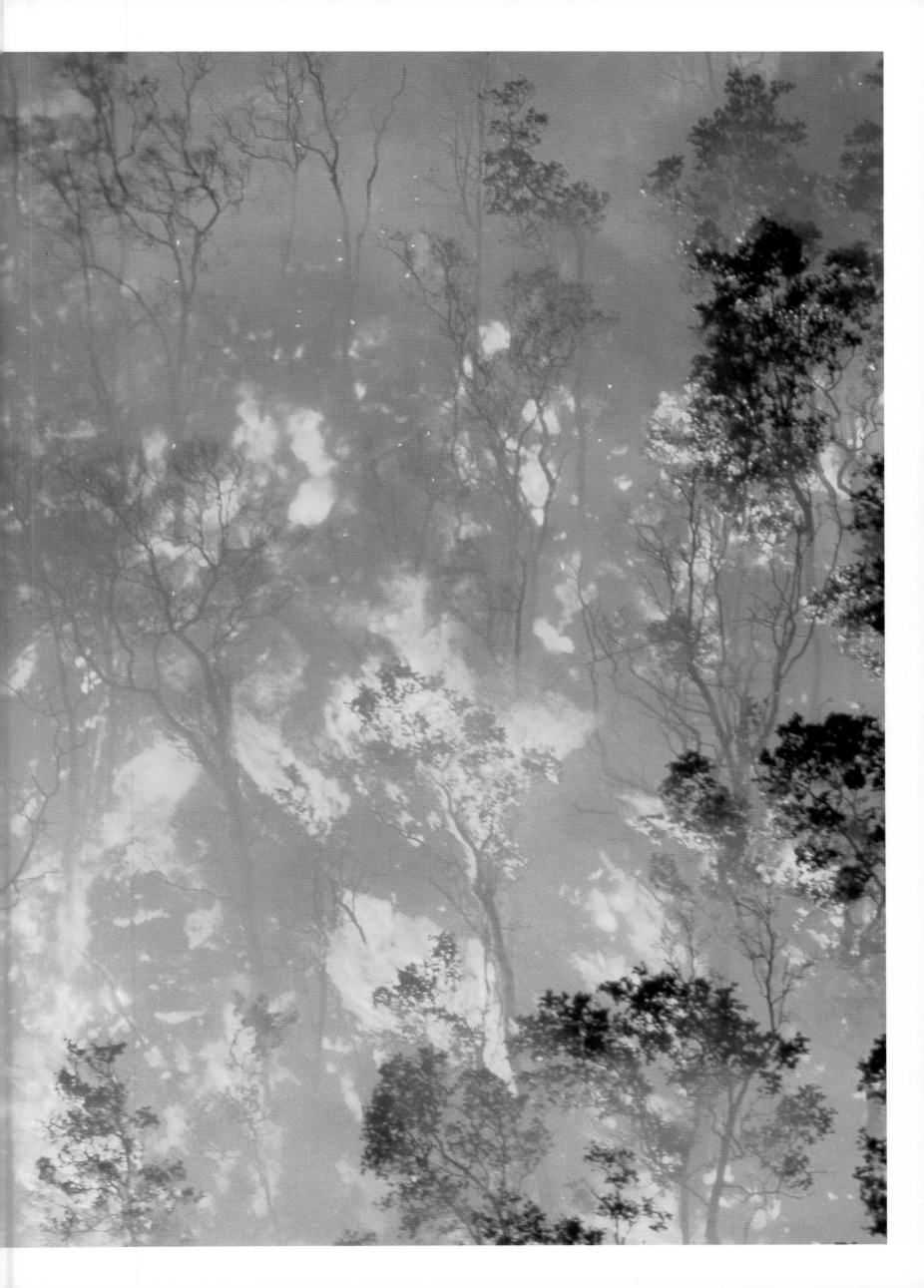

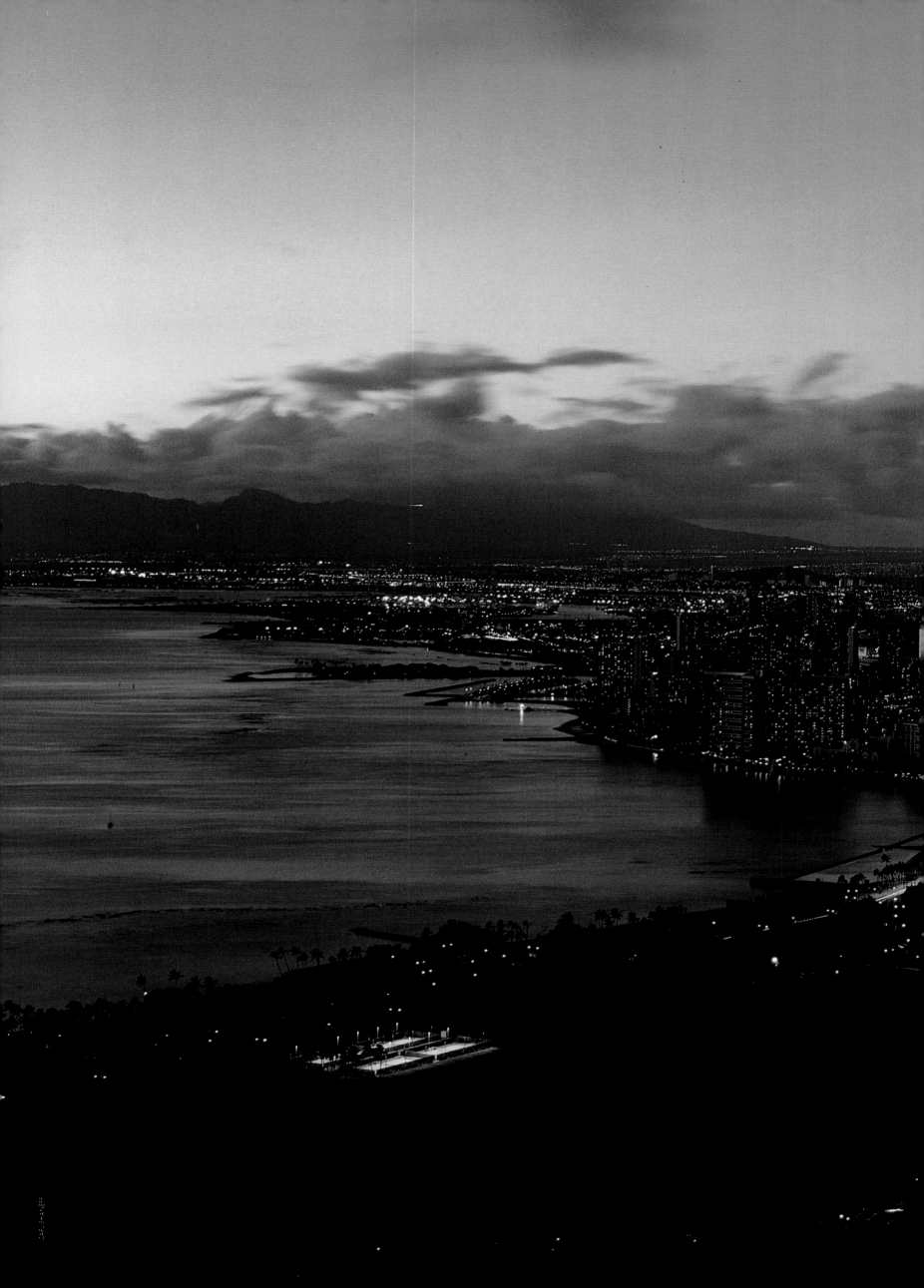

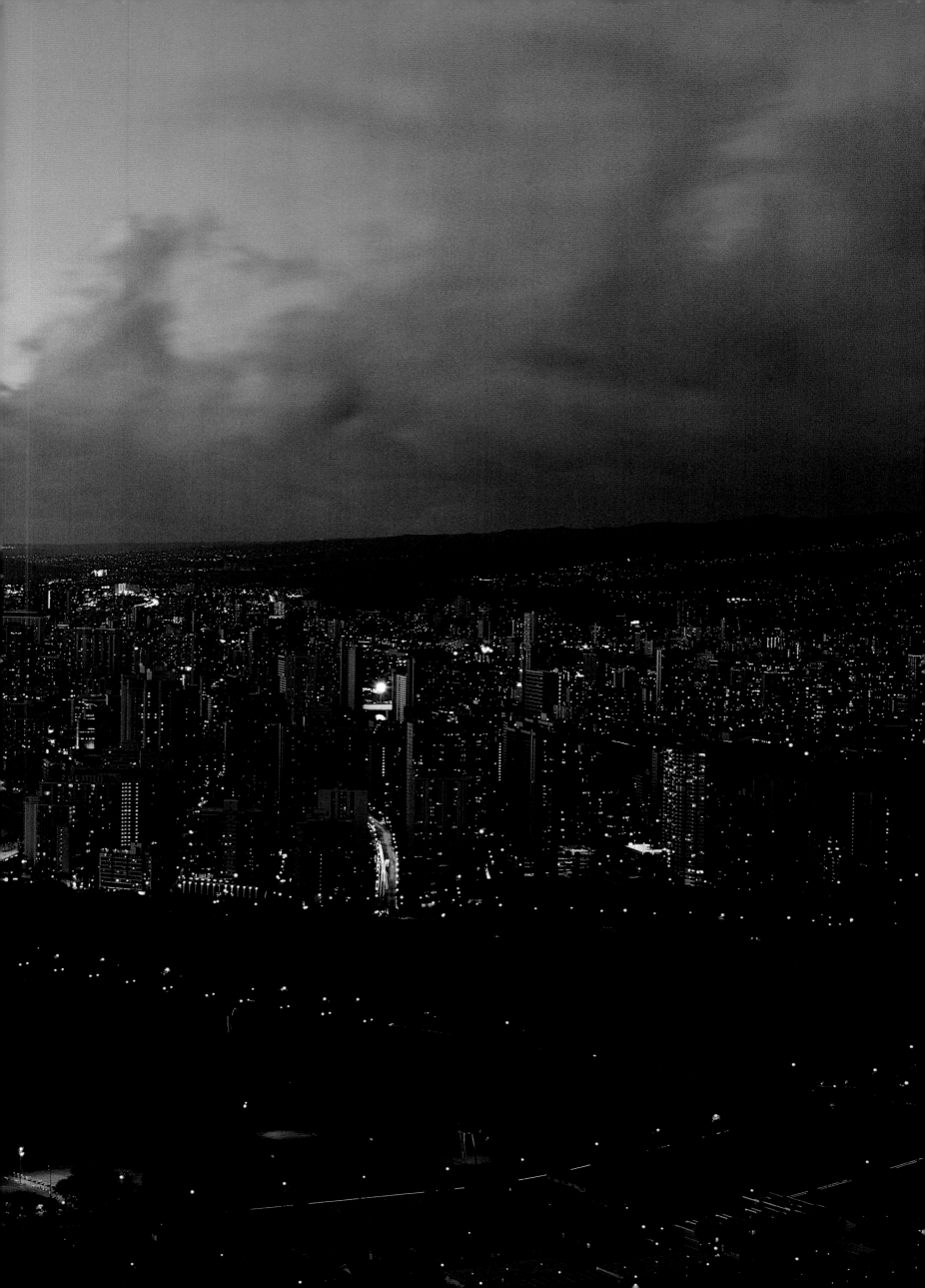

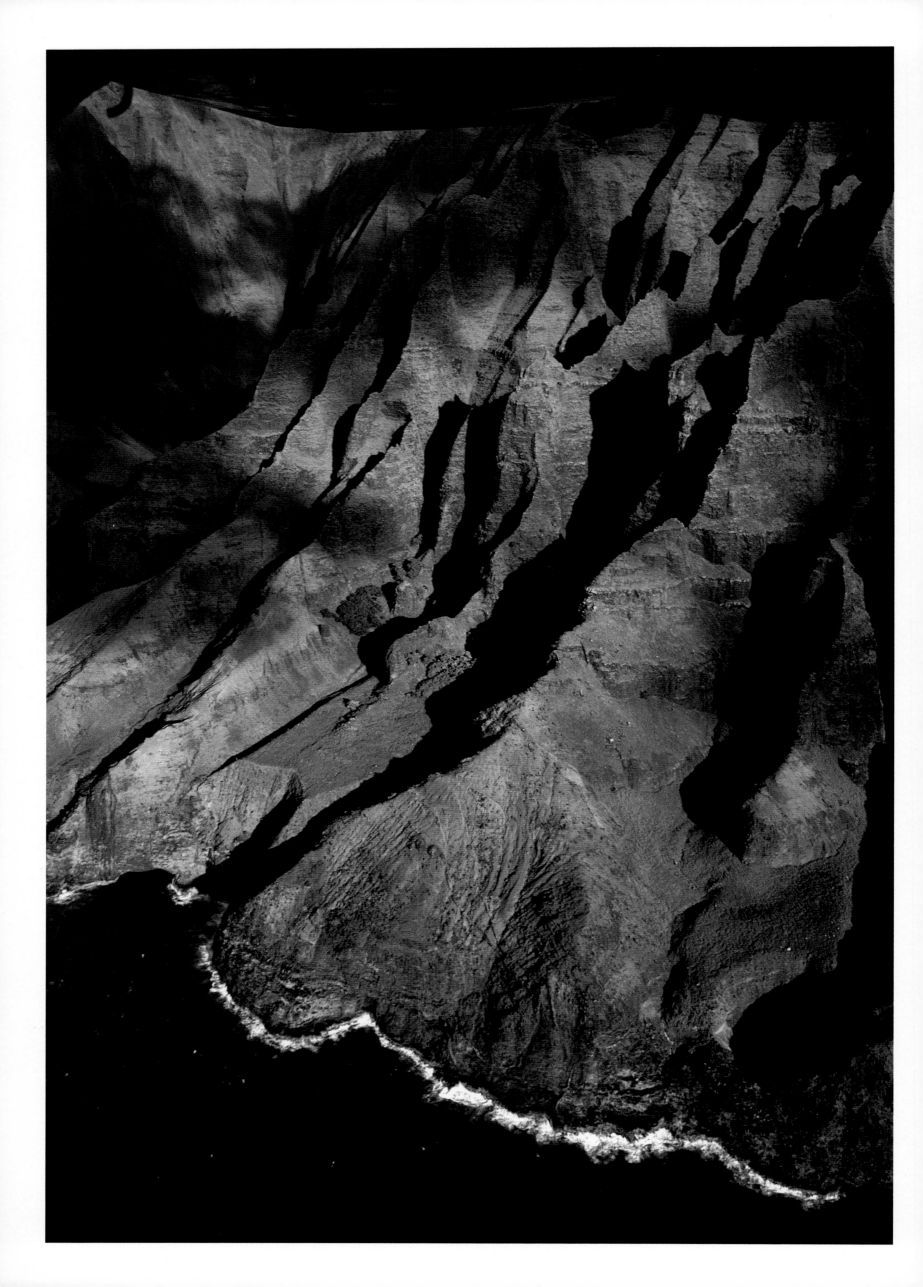

CONTENTS

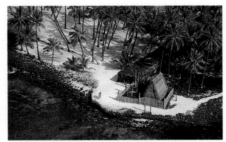
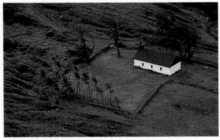

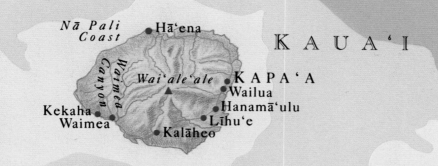

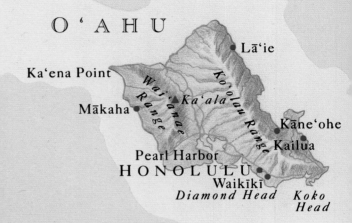

Nā maka o ka makani

THE EYES OF THE WIND

On a map the islands of Hawai'i look like a giant green comet shooting across the blue Pacific. The Big Island, with its crown of fiery volcanoes, is the head of the comet. The tiny atolls far to the northwest are the thin tail.

Washed by storms and rarified through free-ranging weather patterns crossing the vast Pacific, the air in Hawai'i is miraculously clear. To photographers the island atmosphere is a consummate lens. Color and focus remain sharp even at great distances. No wonder Hawai'i—the most photographed place on earth—is so frequently shot from above.

Beyond purely technical considerations, it has been suggested, the aerial perspective here bestows a kind of atavistic and divine wisdom; it shows nothing new, but it offers such dramatic angles through the clear Hawaiian air that the beauty of the islands shines with profound impact.

According to ancient legend, the air was the element of those who possessed the greatest magic: gods who could become clouds, sorcerers who released spirits to the ethers, and bird people who glided over the islands like the 'iwa, the bird most resembling the form of a flying human. Their knowledge came from the sky. Their flights were pathways to a supreme consciousness. When they looked down they saw through the eyes of Uli, goddess of the heavens.

Today we ride along the same high pathways in planes, gliders, helicopters. The islands are different now. But images of the past remain in the present. So much so that it's possible to tell Hawai'i's history through a series of contemporary photographs, taken from the aerial vantage points of those original, mysterious sky travelers of ancient times.

For millennia the eyes of the wind have witnessed remarkable change. *Over Hawai'i* chronicles that change, from the first red gleam of surfacing magma to the blinking beacon on a radio tower.

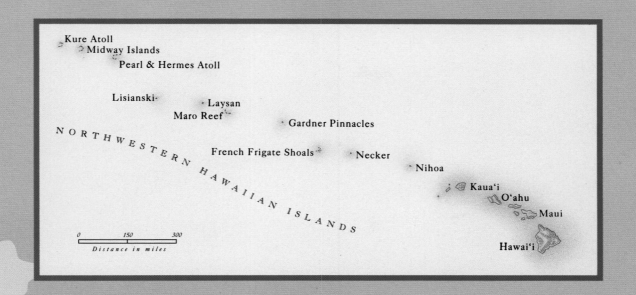

Kure Atoll
Midway Islands
Pearl & Hermes Atoll

Lisianski
Laysan
Maro Reef
Gardner Pinnacles
French Frigate Shoals
Necker
Nihoa

N O R T H W E S T E R N H A W A I I A N I S L A N D S

Kaua‘i
O‘ahu
Maui

Hawai‘i

0 150 300
Distance in miles

*Kalaupapa
Peninsula*

M O L O K A ‘ I

P a c i f i c

O c e a n

Kaunakakai

*West
Maui
Mtns.*
WAILUKU
KAHULUI

Lahaina
Pukalani
M A U I

Lāna‘i City

Kīhei
Hāna

*Haleakalā
National
Park*
○ *Haleakalā Crater*

L Ā N A ‘ I

K A H O ‘ O L A W E

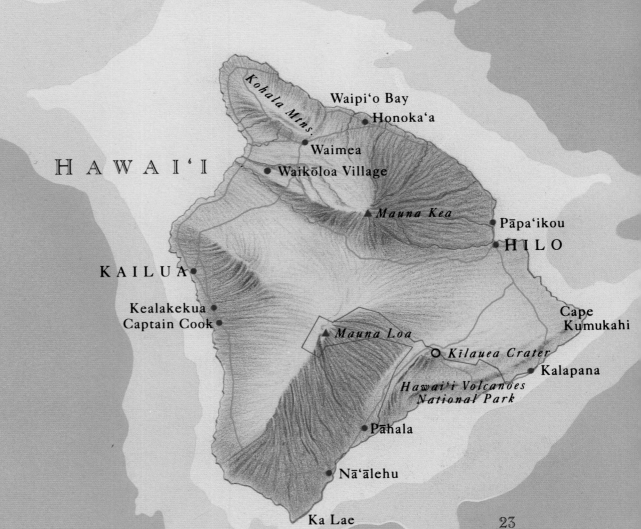

Kohala Mtns.
Waipi‘o Bay
Honoka‘a

Waimea
Waikōloa Village

H A W A I ‘ I

▲ *Mauna Kea*

Pāpa‘ikou
H I L O

K A I L U A

Kealakekua
Captain Cook

Cape
Kumukahi

▲ *Mauna Loa*
○ *Kīlauea Crater*
Kalapana

*Hawai‘i Volcanoes
National Park*

Pāhala

N

Nā‘ālehu

0 10 20 30
Distance in miles

Ka Lae

23

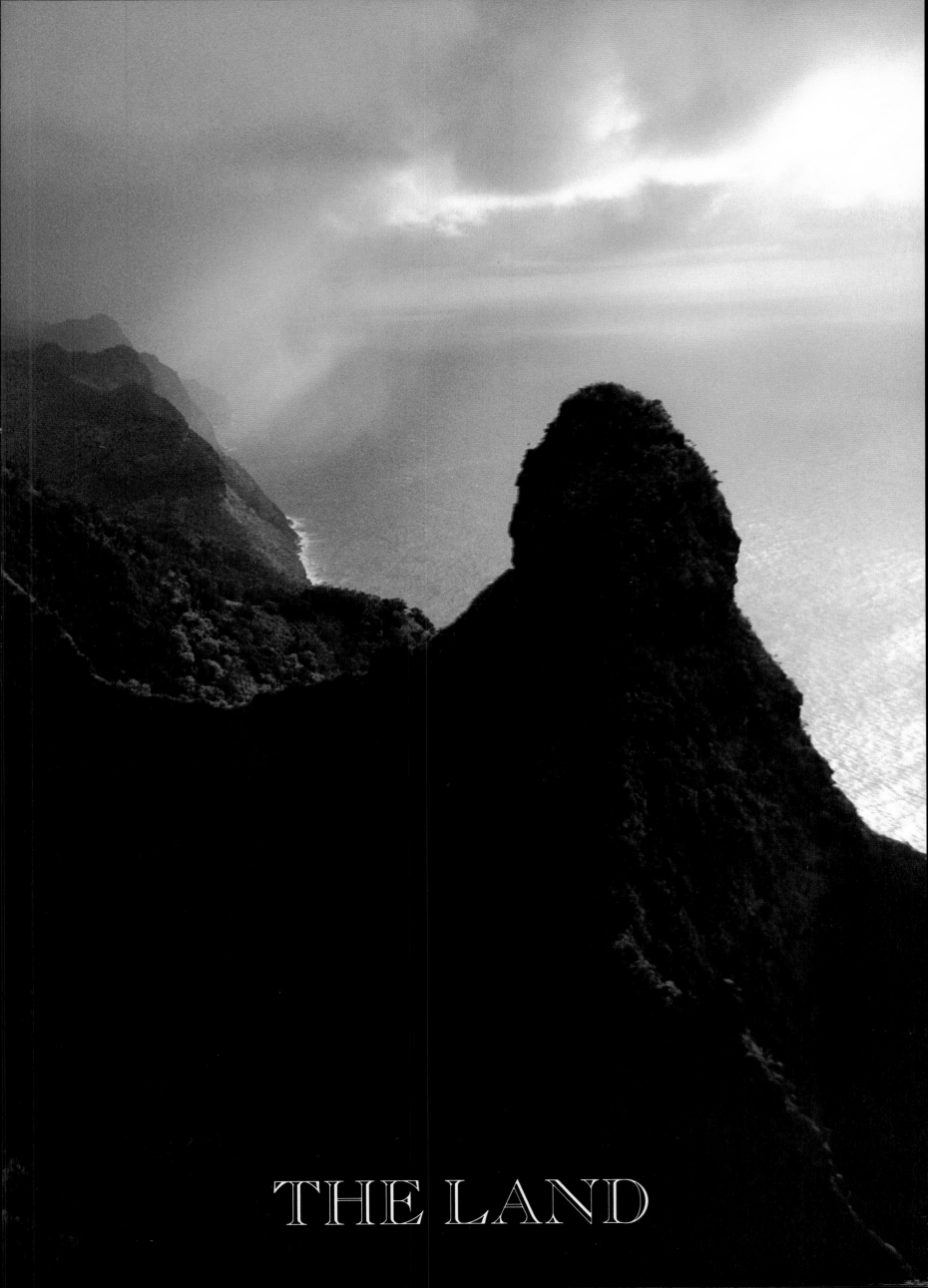

THE LAND

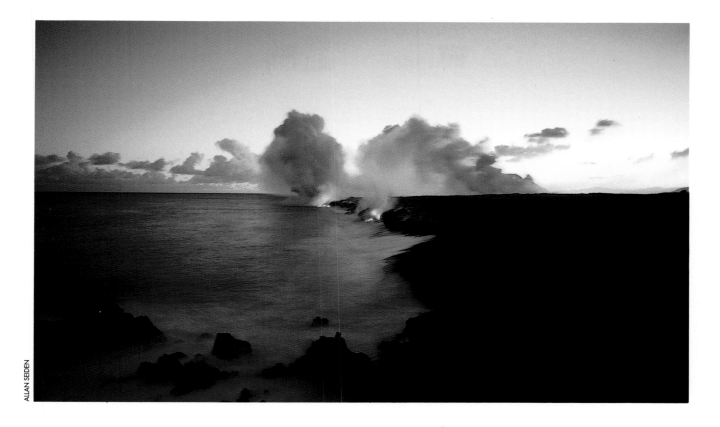

THE LAND

The islands of Hawai'i were born in the darkness of Pō, the primeval night. Here a crack of light opened. The first lava bubbled out. This was over 42 million years ago, according to geologists. Where the crack opened, it has been determined, is where it is open still, at a "hot spot" on the ocean floor located 19° to 20° above the equator at a longitude of approximately 155°20'. The erupting vents at Kīlauea volcano and at Lō'ihi, the seamount destined to be the next Hawaiian island, are over the hot spot now. But they are moving, along with the entire archipelago, sliding northwest on the back of a lithospheric plate that moves four inches per year.

The Hawaiian Islands form a chain extending 1,523 miles southeast to northwest, near its midpoint crossing the Tropic of Cancer. There are 132 islands. Of these, 124 are minor, virtually uninhabited fragments, the rims and coral crusts of ancient volcanoes. The eight main islands—Ni'ihau, Kaua'i, O'ahu, Moloka'i, Lāna'i, Kaho'olawe, Maui and Hawai'i (the "Big Island")—feature an amazing variety of terrains for such a small area. From leeward deserts and snow-mantled mountains to sand dunes, savannahs, swamps, river valleys, rain forests, palm-lined beaches and active volcanoes, Hawai'i is a phenomenon of diversity.

The islands comprise one of our youngest land forms, having arrived within the last $^1/_{110}$th of the earth's life span of 4.6 billion (4,600 million) years; that's within the last thirteen minutes on a 24-hour clock. The process that creates and destroys the chain is a slow one. An island rises out of the sea, and as it builds high into mountains, it moves. When it drifts away from the hot spot, it cools, its volcanoes die, and it is shaped by rain, wind and surf, and the plants and animals that cling to its surface.

Eventually, the island erodes away, the ocean covers it again, and it becomes a seamount. A series of such seamounts, called the Emperor Seamounts, extends northward from the top of the Hawaiian archipelago. Seventy million years ago these were islands themselves, in the same location as today's Hawai'i. Colahan Seamount, thought by geologists to be the first "Hawaiian" island, lies beneath the ocean to the northwest of Kure Atoll, which is the last visible peak at the northwest end of Hawai'i's

Previous pages: Twin pinnacles jut into the clouds above Nā Pali (the cliffs) on Kaua'i. *Left:* A cooling lava lake near Kīlauea cracks to reveal its molten core. *Above:* A Kīlauea lava flow spills into the sea near Kalapana, Hawai'i. Twenty miles south of this point lies the seamount Lō'ihi, which will eventually become the next Hawaiian island.

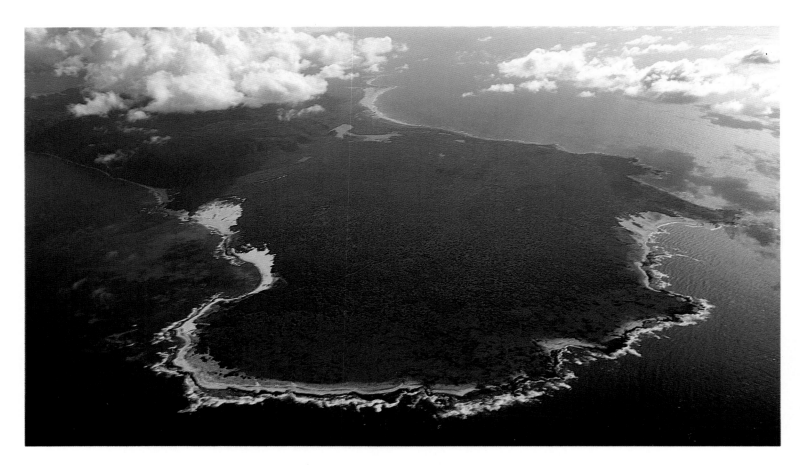

Above: The northern plain of Ni'ihau island was formed by a series of low-rise cinder cones and lava streams that erupted after the formation of the island's shield volcano. Lying beneath the clouds to the left is Mount Pāni'au, part of the original shield. *Right:* Honokōhau Falls plunges toward the green heart of Honokōhau Stream, deep in the West Maui Mountains. Aerial access to mountain fastnesses on the main islands is limited by cloud and wind conditions, and views like this are rare.

undersea mountain range. The first visible peak is Mauna Kea, the highest point on the Big Island and the tallest mountain in the world if measured from its base six miles down in the Hawaiian Deep.

The string of islets stretching away from the main islands covers nearly 1,200 miles. Those farthest away, including Kure Atoll, the Midways, Pearl and Hermes Atoll, Lisianski, Laysan, and Maro Reef, are limestone caps resting on deeply submerged volcanic pedestals. The rest—Gardner Pinnacles, French Frigate Shoals, Necker, Nihoa and Ka'ula—are the severely eroded remains of volcanic craters, none larger than a few hundred square yards. Today these windswept, nearly barren bits of land—the Northwestern Hawaiian Islands, often called the Leeward Islands—shelter fewer than a hundred human inhabitants, stationed at military installations on Kure, Midway and French Frigate. The other residents are seabirds, a few native land birds, the Hawaiian monk seal and the green sea turtle, all protected by the Hawaiian Islands National Wildlife Refuge.

The oldest main island, Ni'ihau, lies 23 miles northeast of Ka'ula and nineteen miles west of Kaua'i. The terrain of Ni'ihau is dominated by 1,281-foot Mount Pāni'au, the remnant of a shield volcano. The most common mountain type in the Hawaiian chain, a shield volcano is a broadly rounded peak built up by innumerable thin lava flows. Most of the Ni'ihau shield has eroded away, and all that is left is the cliff-truncated southwestern flank. A later series of eruptions—all low and short-lived cones— poured lava out to form the plains to the north, west and south of the original shield. In many areas this new land blanketed Pleistocene-epoch reefs that had formed 2.5 million years ago when the sea was 300 feet lower than current levels.

The geologic activity that shaped Ni'ihau repeated itself on the younger islands. Typically a shield builds itself thousands of feet above the sea. Rainwater runoff wears away the peak and cuts the slopes

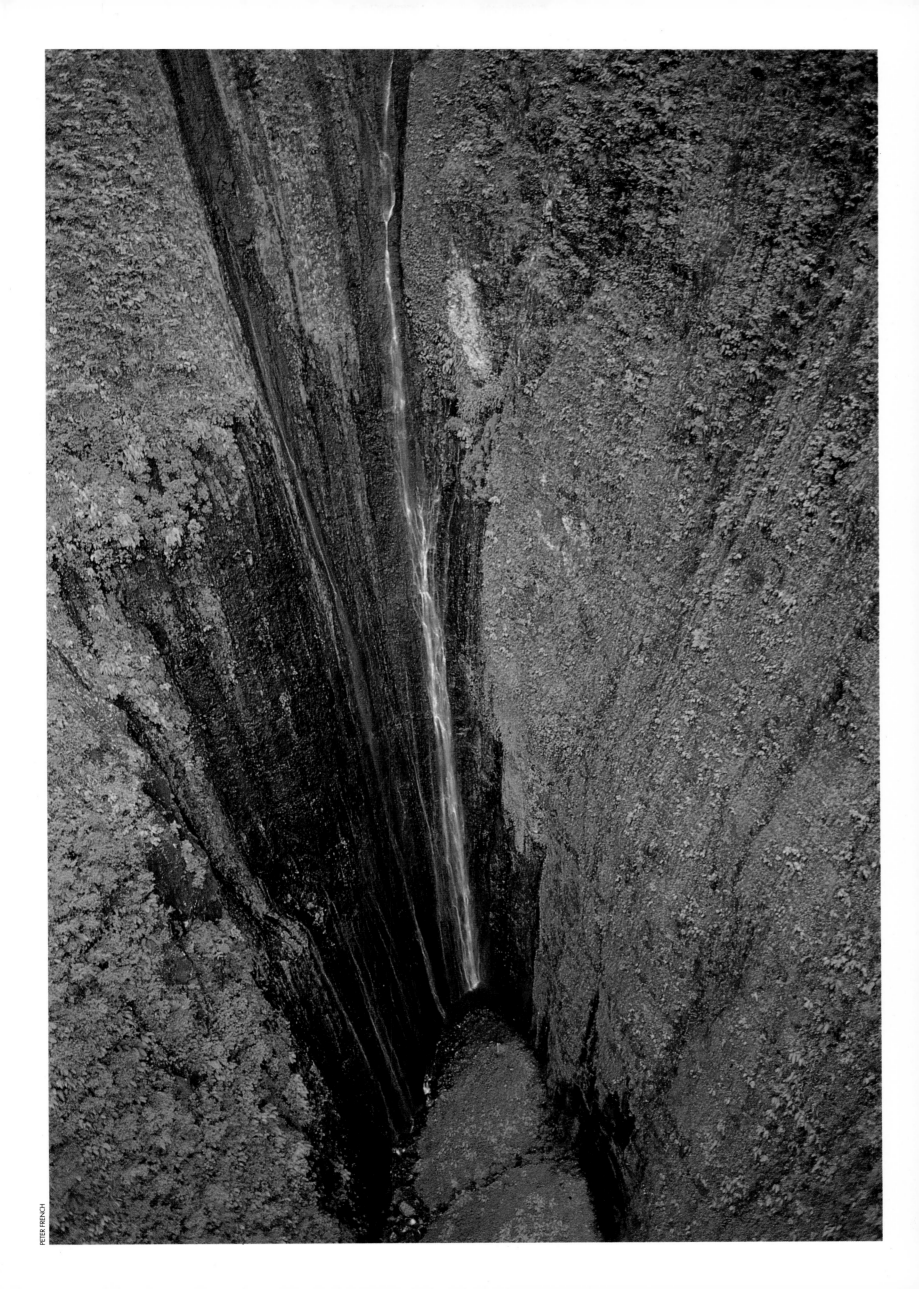

Right: With widths from 30 to 100 feet and speeds up to 60 miles per hour, a Mauna Loa lava river roars downslope "with a sound like a thousand jet engines."

Opposite: Surrounded by the Kōloa Basin, the Hoary Head Range of Kauaʻi ends at a sun-flaring Nāwiliwili Bay.

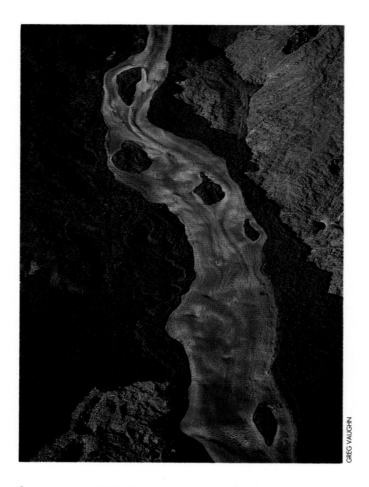

GREG VAUGHN

into canyons and valleys. The surf carves sea cliffs. When enough soil has appeared, the first wind- and waterborne seeds sprout. Coral polyps take hold in the shallows and begin to fringe the island with reef. With sea level changes, the ocean intermittently exposes or inundates the reefs. Then, in the final stages of the island's growth, a late volcanic series contributes primarily lowland cones that spread their lavas out in plains and capes. Alluvium from the eroding mountain washes over these flows and provides more soil for complex forests.

About six million years ago—after much of the original shield of Niʻihau had eroded but long before its plains fanned out—a single, massive shield volcano emerged to the east. The lava mountain featured a huge caldera, ten to twelve miles across, the largest in evidence in Hawaiʻi, and it pumped out 1,000 cubic miles of molten rock. Eventually the southern slope of the shield collapsed, and two flank calderas opened on the east to create coastal lowlands. Such was the beginning of Kauaʻi.

The giant caldera at the top of the Kauaʻi shield has eroded away. The island's peak, Waiʻaleʻale, was once along the eastern slopes of the caldera, but is now a wide plateau flattened by eons of rainwater. The most striking geological features on Kauaʻi, the Nā Pali Coast and Waimea Canyon ("The Grand Canyon of the Pacific"), were created by erosion, the Nā Pali by a combination of streams and surf, and Waimea by Waiʻaleʻale's runoff. As millennia passed and Kauaʻi took its lithospheric journey away from the hot spot, the rain-fed streams expanded into rivers, the longest rivers in Hawaiʻi. Alluvium covered valley floors and plains, canyons deepened dramatically, and sand dunes, coral benches, deserts, swamps and estuaries took shape.

By now another volcano had appeared 100 miles south. Again it was a shield, which in time became the Waiʻanae Range of the island of Oʻahu. Geologic evidence indicates that the Waiʻanae shield and the later Koʻolau shield were built upon the eroded stub of a still older volcano, perhaps as old as the truncated domes underlying the Leeward Islands. The Koʻolau volcano erupted after much of the Waiʻanae land had eroded, and the lava flows from the new windward caldera pushed back the sea between the two mountains, forming a median plateau and banking against the Waiʻanae slope. This volcanic doublet origin of Oʻahu would be repeated on younger islands in the chain.

With the formation of the two shields, a period of volcanic calm ensued in which the ocean and its reefs, over millions of years, rose 300 feet above and later dropped 60 feet below present levels. Further erosion hollowed spectacular canyons into the shields, and then a new flurry of eruptions—the Honolulu Volcanic Series, which occurred over hundreds of thousands of years—scattered cinder and tuff cones, like Diamond Head, around the southeastern corner of O'ahu.

The two calderas atop the main shields were approximately the same size, eight to ten miles long and four or five miles across. Both have since eroded into shoreline valleys. The Wai'anae caldera was centered at the back of what is now the Wai'anae Valley, and the rains here sheared off a level plateau called Mount Ka'ala, the highest point on O'ahu. The Ko'olau caldera was centered between Kailua and Kāne'ohe, two major land divisions on the windward coast.

As the ocean receded it turned O'ahu's fringing reef into plains of coral pavement. Three Ko'olau mountain streams draining centrally and south converged in a single main stream that cut through the pavement and created a narrow canyon. In the softer, sedimentary land upstream of the coral, each of the three streams scooped out a broad, shallow valley. When the current epoch began and the sea level rose 60 feet, the canyon and the three valleys submerged. As the ocean filled in, it formed a three-armed harbor with a deep, narrow channel: Pearl Harbor.

On the leeward and windward coasts, more streams bit into the shields, producing deep, amphitheater-headed valleys with vertical walls. Plunge-pool action of waterfalls eroded the valley walls into the typical grooved or corrugated shape, none more beautifully than along the Ko'olau Range, where the trade winds annually dump hundreds of inches of rain. Several valley heads receded to a common point, the ridges between them gradually disappeared, and the result is a long, curving cliff face like the windward Pali.

Two new twin volcanoes erupted to the southeast to create the island of Moloka'i. Again the western shield appeared first, but without a caldera rose only a few hundred feet. The eastern shield climbed much higher and later went through a secondary eruptive phase (like O'ahu's Honolulu Volcanic Series) with its attendant smaller cones. One such cone formed the flat basaltic shield of Kalaupapa (Makanalua) Peninsula; another, Moku Ho'oniki island off the eastern point. On the higher shield, a

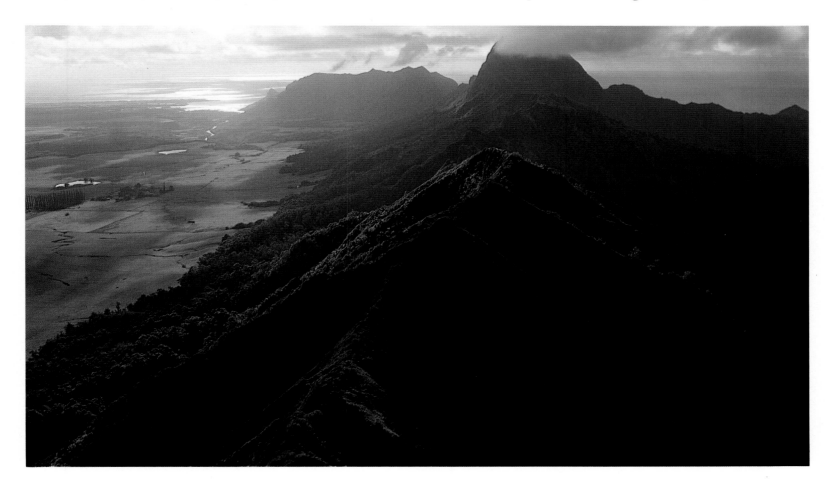

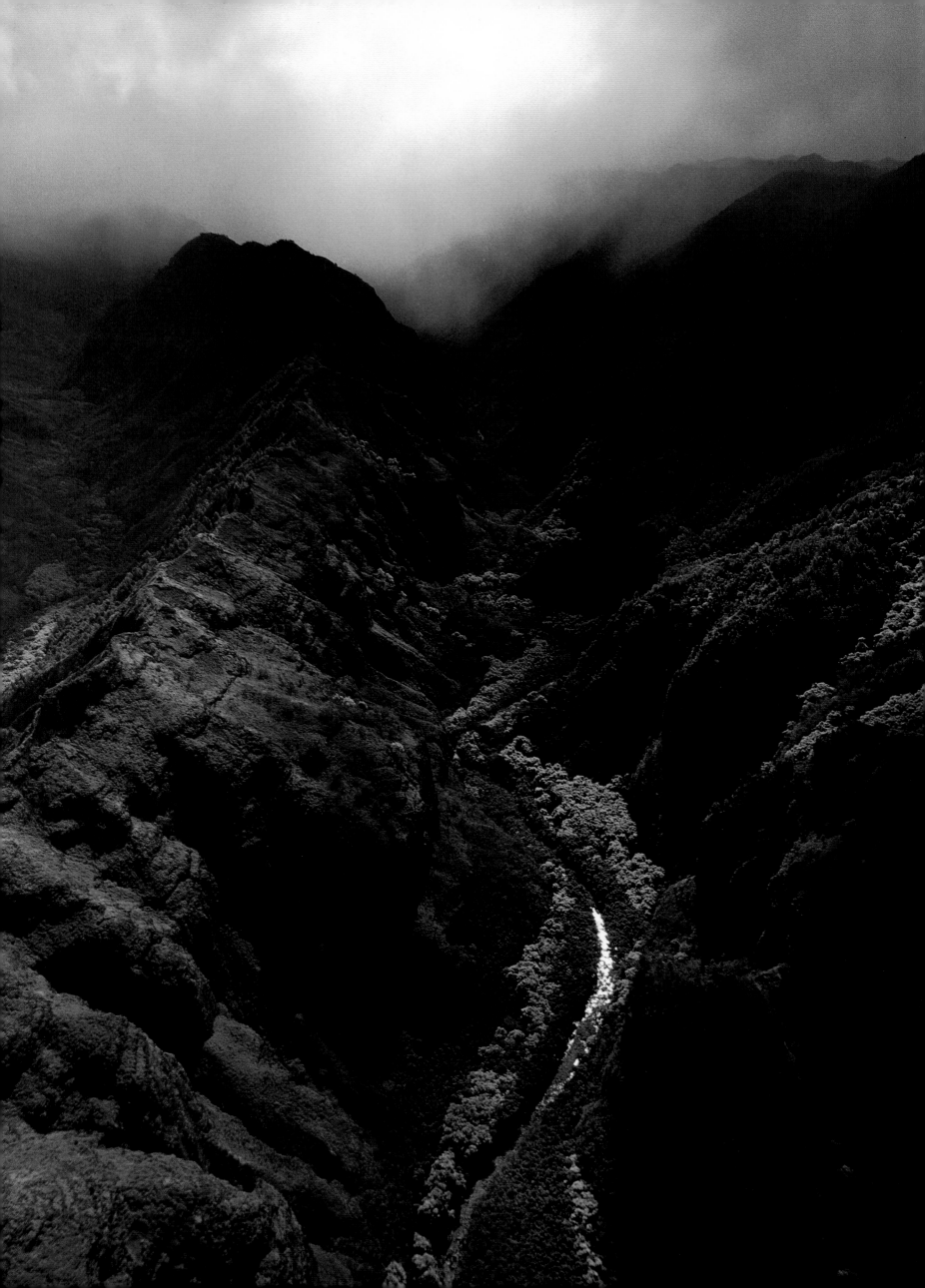

massive slump may have dropped half of the East Moloka'i mountain into the ocean, resulting in the cliffs of the north coast. Most geologists believe this did not happen, however, and that it was receding valleys that caused Hawai'i's most precipitous sea cliffs, the highest of which rise 2,000 to 3,600 feet.

Directly south of Moloka'i, the Lāna'i cone roared out of the sea. Its shield erupted along northeast and southwest rift zones, following the same pattern as the first Moloka'i volcano. The next two islands, Kaho'olawe and Maui, built themselves along the same pattern. There was a time with the lower sea level when these sister volcanoes were all part of the same island. Geologists named it Maui Nui, Great Maui, and its area at 2,000 square miles was roughly half the present size of the Big Island. Today both Lāna'i and Kaho'olawe languish in the arid shadow of Maui. Because its highest point is at 3,370 feet, Lāna'i pulls in some rain, but only enough to cut one stream valley comparable to those on the northern islands. Kaho'olawe is brown, barren and windswept now, but in earlier times its low surface supported an extensive ecosystem.

The island of Maui grew in generally the same way as O'ahu and Moloka'i, with twin volcanoes and a connecting isthmus, and a rash of secondary eruptions that scattered cones across the older lava. Erosion scoured the west Maui caldera, leaving deep, pinnacled valleys like 'Īao. On the eastern shield, Haleakalā, streams cut so far in that two north-and-south-heading valleys met at the center of the mountain, reducing the summit by 3,000 feet to its present height and leaving a huge depression that ran in a single jagged line from coast to coast. Volcanic activity resumed, and these two valleys filled with lava and cinder cones to become Haleakalā Crater.

While Haleakalā refined its shape and drifted away from the hot spot, the earth's magma began pumping through seven new volcanoes. The Kohala shield was the first to appear, nearly a million years ago, followed quickly by another vent, called Nīnole, opening in the ocean 70 miles south of Kohala. These two separated shields were the beginning of the island of Hawai'i. Mauna Kea, destined to be the chain's tallest peak, rose between the two, pushing its lavas over the southern flank of Kohala and possibly touching Nīnole. Certainly Hualālai—the next volcano—abutted the others, and a single island half as big as today's Hawai'i emerged.

Most of the bulk of the southern half came from Mauna Loa, the Long Mountain, which erupted as Nīnole became extinct. Mauna Loa contains 10,000 cubic miles of rock, making it the largest volcanic mountain on earth. It was joined to the east by the sixth shield in the cluster, Kūlani. Both Kūlani and Nīnole have virtually disappeared under continuing flows from Mauna Loa, whose lava has capped all but a few ridges of Nīnole's old stream valleys.

The Big Island's seventh volcano, Kīlauea, rises on Mauna Loa's southern flank. Kīlauea is pumping lava as these words are being printed. The current eruptive phase began in January 1983, and by the summer of 1990 the lava flows had destroyed much of the coastal town of Kalapana and the famous black sand beach of Kaimū.

As the erupting volcanoes added girth to Hawai'i, the erosive forces of rain, wind and ocean trimmed it away. Deep valleys typical of windward ranges appeared along the oldest portion of the island to the northwest. The Ice Age also shaped the face of Hawai'i, not only by changing the sea level but by creating on Mauna Kea a series of small glaciers that scoured the peak, leaving miniature moraines.

The glaciers and snow-capped summits of Hawai'i are an indication of the variety of land forms found here. In these subtropical latitudes, over 2,000 miles from the closest continent, the islands contain nearly every kind of geological region and provide an array of welcoming habitats. Only the heartiest and luckiest could make the serendipitous journey on their own: a few plants and animals, a seed, a nut, small fry, an occasional exhausted bird. These were the first strains in the symphony of life that would make this place one of the most unusual and fragile ecospheres known.

Rain-fed Waimea River on Kaua'i bends in quiet sunlit arcs beneath the familiar pale green leaves of kukui (candlenut) trees. Hawaiians planted kukui by simply dropping the nuts wherever they wanted trees. Sometimes they hiked along ridges and tossed the nuts into ravines below.

Above: The pilot makes a hard-banking turn for this view of the Big Island's leeward corals.

Opposite: To the casual observer, this forest canopy on the northern slope of Haleakalā on Maui has the appearance of an age-old, pristine wilderness. But the recently introduced mango trees (the red leaves) and hala (the light green bursts) show that people have been here.

Hawaiʻi stood as an impossible goal for most organisms, cushioned as it was by billions of cubic miles of turbulent water and air. Snakes never would reach its shores, nor any other reptiles (except sea turtles), nor amphibians. Land-based mammals had virtually no chance. And the odds that a nonmigratory bird could land here were one in several million. But given Hawaiʻi's 42-million-year history it did happen (probably only once, ornithologists say) that a single gravid female finch, knocked by a storm out of her flight path and propelled into the unknown by powerful gusts, found herself in a strange new land. By then floating seeds had sprouted along Hawaiʻi's beaches. Fern spores had ridden in like dust on the winds. Hooked, barbed and sticky seeds arrived in the feathers of migrating ducks and petrels and sandpipers, plovers, tropic birds, terns and shearwaters. The birds' digestive tracts had carried in seeds of brightly colored fruits, which also sprouted. From the mud on the birds' feet had come the eggs or larvae of snails and other mollusks, and these too found amenable Hawaiian breeding grounds. Clouds nursed the plants into forests, tall, rioting, epoch-enduring rain forests that covered the old volcanoes in cloaks of green. The streams bristled with shrimps, goby fish and snails whose marine larvae had climbed the cascades and grown into adults in the upland pools. Insects had also come, sailing through the atmosphere and alighting on the leaves. And then more birds, repeating the scenario of the finch.

The basic law of life is descent with change, and the millions of years the natural colonizers had to themselves to evolve produced startling change. From about 250 insect immigrants over 4,000 different species emerged. A single ancient pomace fly was ancestor to about 900 ornate species; one kind *(Drosophila heteroneura)* developed mallet-headed males that fight for territory like butting rams. Dragonflies, spiders, butterflies and moths became extremely complex and colorful. No mosquitoes. Twenty mollusk colonizations yielded a thousand species; 250 kinds of flowering plants evolved to

1,800; 135 ferns to 168. By the time the first Polynesians guided their canoes to Hawai'i's shores, there lived here some of the most unusual flora and fauna anyone would ever see.

The birds changed too. The owl (pueo), crow ('alalā), goose (nēnē) and hawk ('io) took on slightly different features from their continental ancestors, but the little finch mama proliferated at least twenty species of very distinctive honeycreepers and honeyeaters. Some, like the 'apapane and 'i'iwi, developed bright red feathers that the Hawaiians used to make ornaments and capes. Other finch relatives were green and yellow: the 'akialoa, with a long, downward-curving beak like a tendril, and the 'akihi-po'o-lā'au, which sang a soft, elaborate melody through the rain forest understory. The earliest Polynesian settlers found twice as many bird types here as the Europeans would. In the ancient days a man-sized flightless goose walked the land, and a flightless rail not big enough to eat, and other flightless birds. There was a flightless owl three feet high that ran down its prey with long legs like a barn owl's. Legends tell of fierce owls that flew in flocks of thousands, and of the people gathering owl eggs for food.

The only terrestrial mammal to establish itself successfully in Hawai'i was the hoary bat, a migratory native of North America. Now a unique reddish color (its mainland brothers are brown) the Hawaiian bat still lays in a reserve of body fat in late summer to prepare itself for long-distance flights. Its migratory instinct has been suppressed, however, and the fat bat sits at home.

For much of Hawai'i's endemic bird population the first canoes scudding the beaches meant death. Recent discoveries of fossil bones and other remains indicate that over 50 percent of the islands' avian species disappeared after humans arrived. To make the land suitable for agriculture and aquaculture the Polynesian settlers burned off much of the lowland forests, diverted streams for irrigation, and altered the shorelines to create artificial fish ponds.

In defense of the Polynesians, it must be remembered that although their communities initially shattered the delicate sphere of natural life here, the settlers, through generations of accumulated wisdom, had become predisposed to maintaining balance in the ecosystem. Families identified themselves with plant and animal totems. Signs in nature guided their handiwork. They labored hard for sustenance in their new home, and after more than a thousand years of practice it came easy. What they took from the islands they learned to give back. But their harmonious existence would be challenged by future settlers. And the land, which had been born as a crack of light in the dark ocean, and had been transformed by so many forces, would continue its inexorable change.

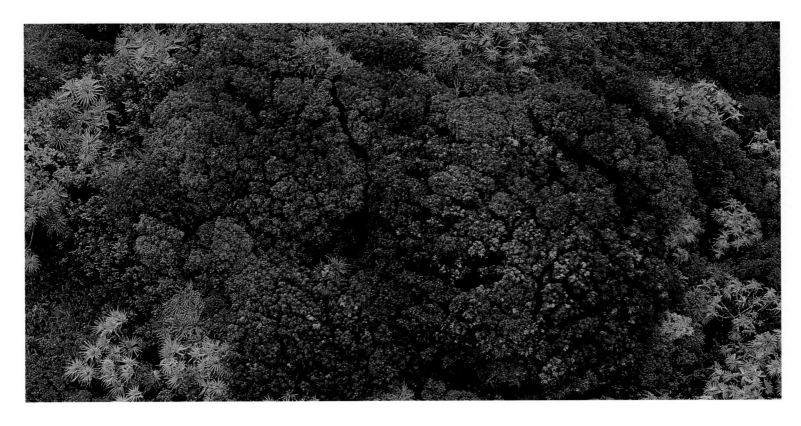

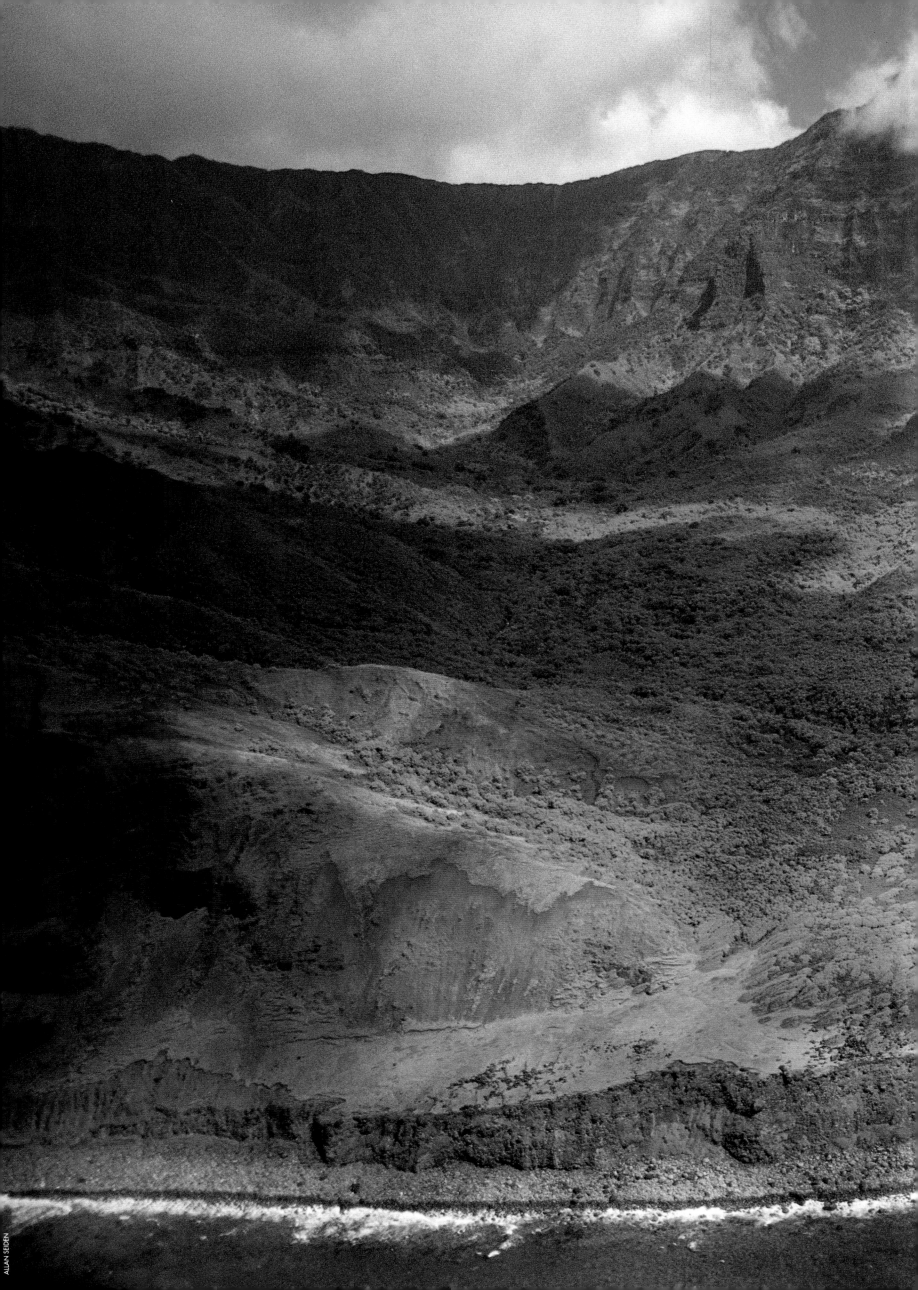

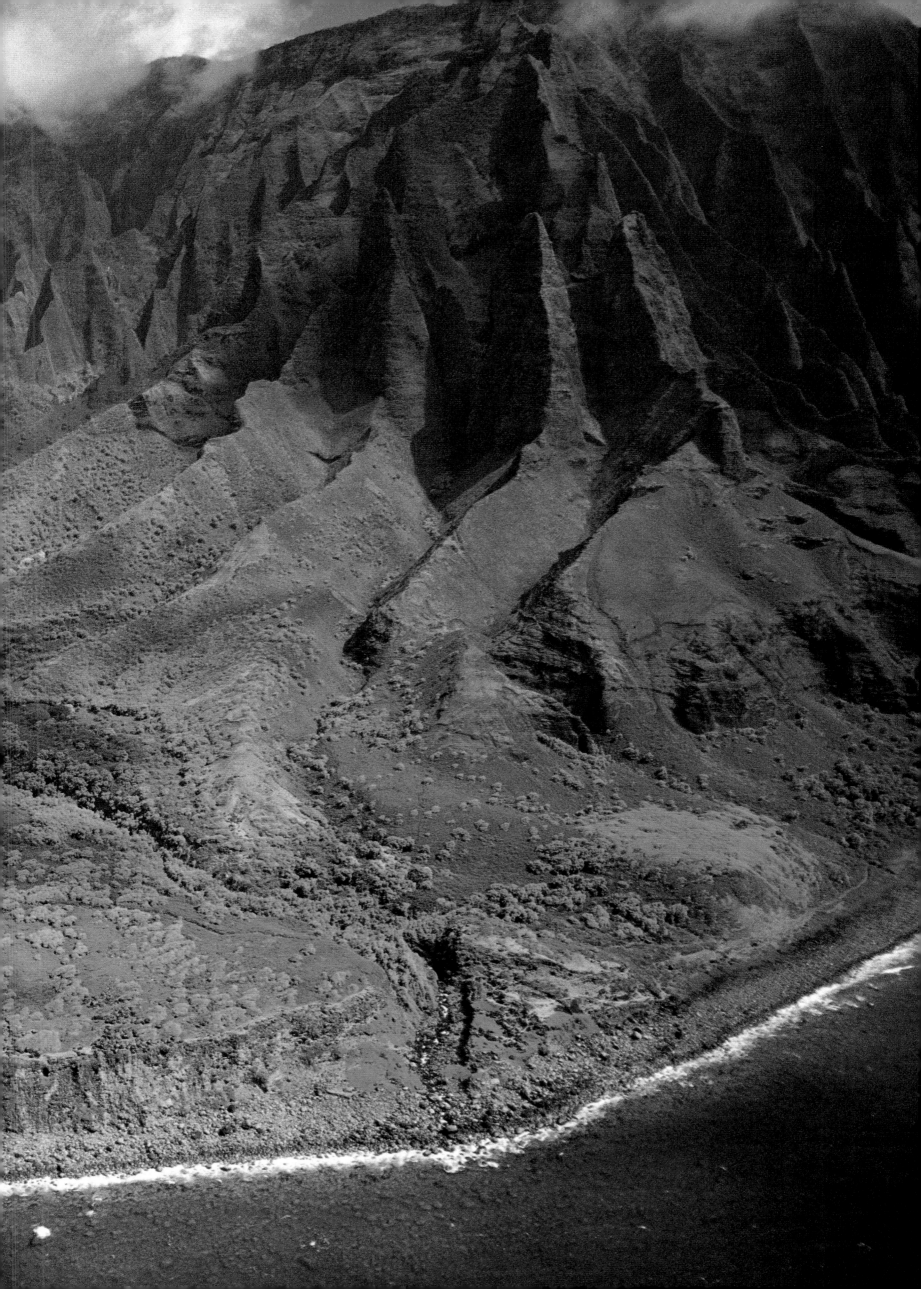

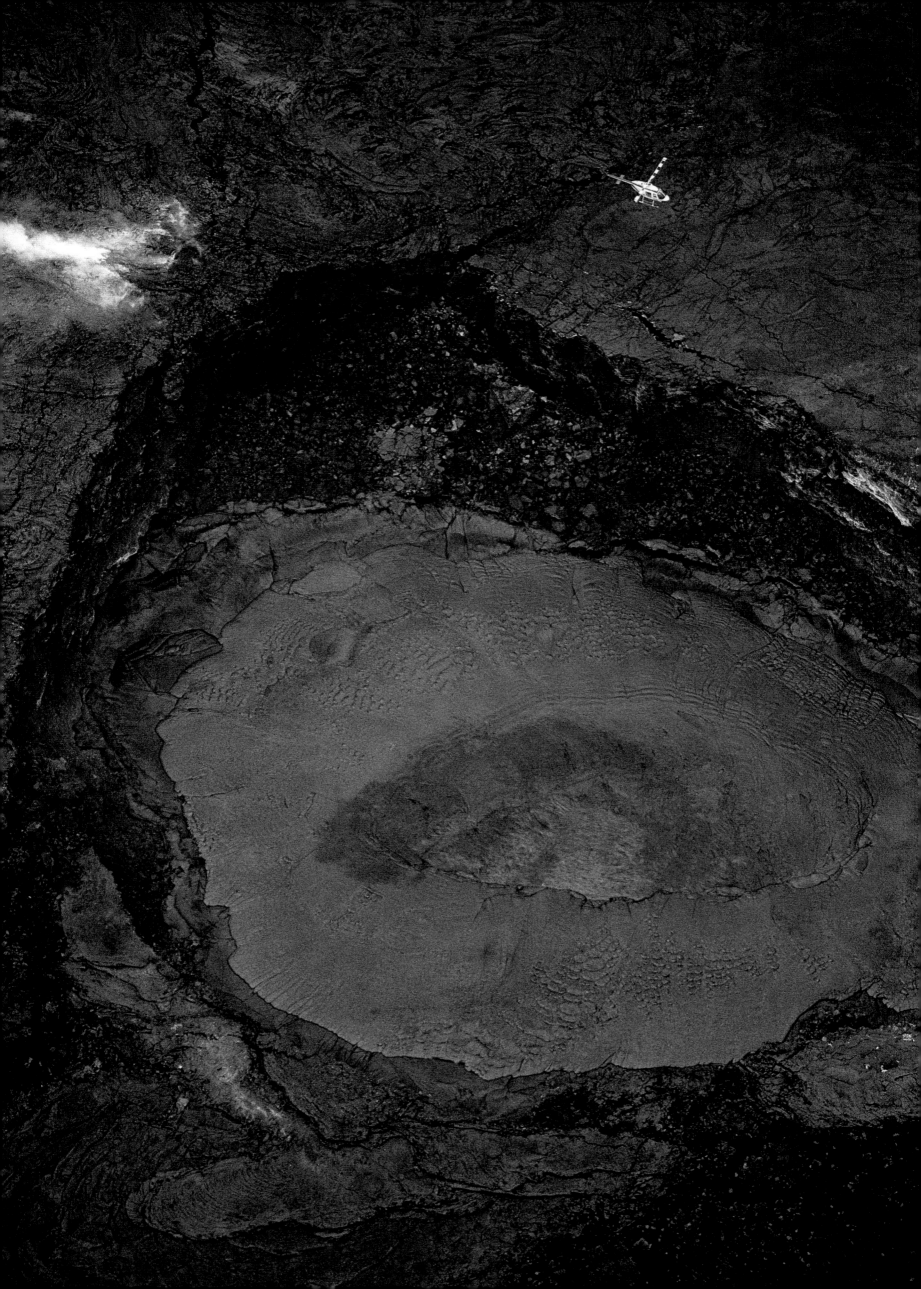

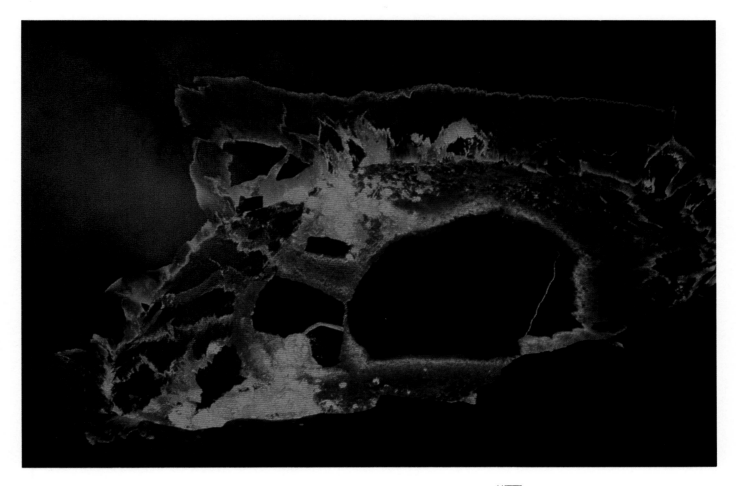

Above: "The blood of the earth" scabs over in a lava sink near Kūpaianaha at Kīlauea. Such depressions occur when a subterranean tube of fast-moving pāhoehoe (liquid) lava burns a cooled flow above.

Left: Cooling lava crusts over one of Kīlauea's newest pits. Residents of nearby towns can tell how active eruptive phases are by the way the helicopter traffic increases. "It starts to look like a war zone, there are so many choppers coming in," says a geologist at Hawai'i Volcanoes Observatory.

Previous pages: Cloud shadows limn the corrugated ridges of the Kalalau Valley on Kaua'i. Difficult access has kept Kalalau relatively unspoiled.

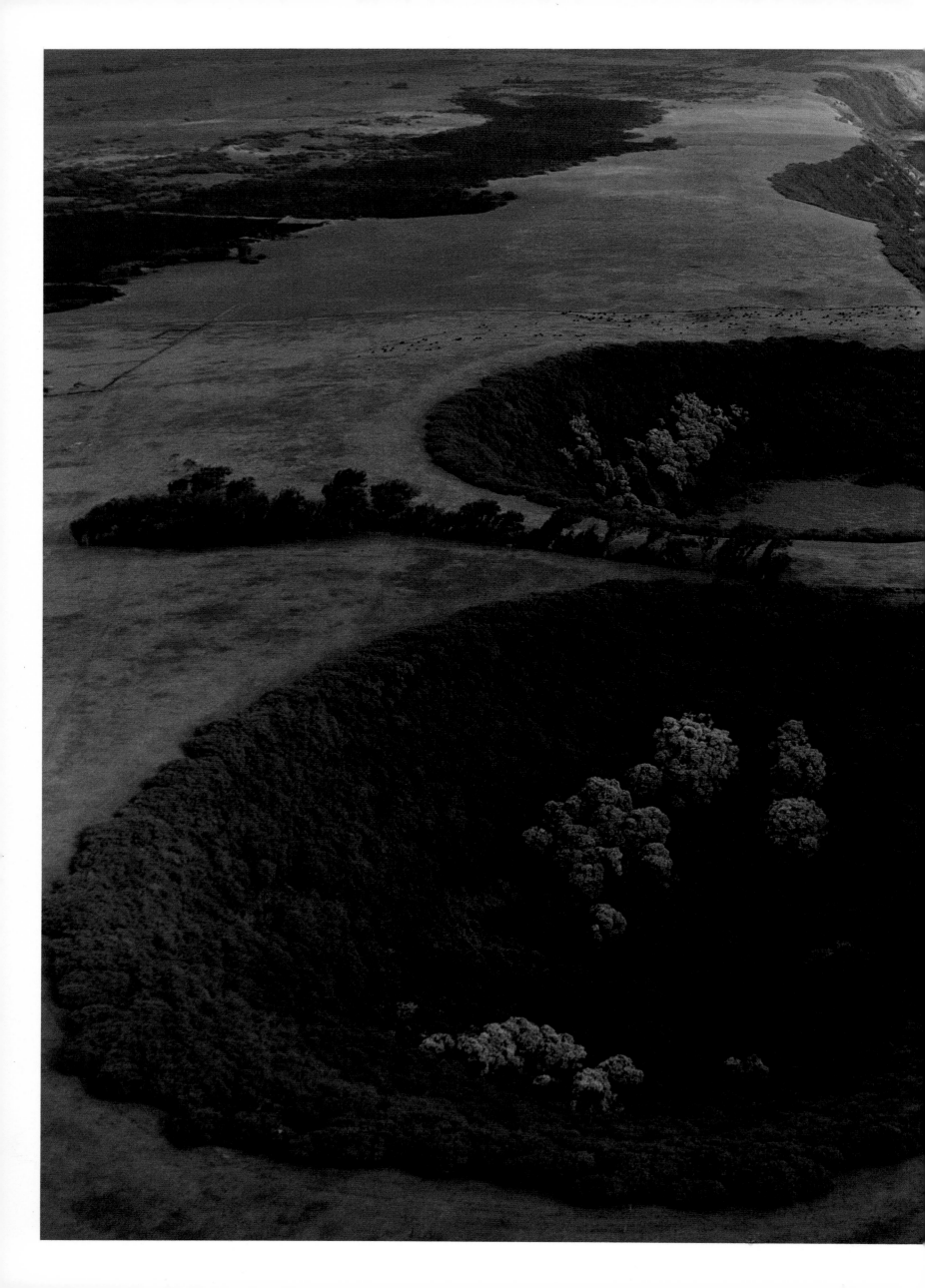

Left: Images of the volcano goddess Pele appear continually in her eruptions. Visible in the lower left lobe of this new lava flow is Pele's head in profile, with her long hair streaming behind. Also discernible in the flow are a bat, a Menehune dwarf, a tropic bird and a shark.

Right: A brief archipelago of fire fountains flares in an ocean of smoking lava, near Puʻu ʻŌʻō crater, Kīlauea, Hawaiʻi. This geologic phenomenon, known as a rift eruption or "curtain of fire," occurs when lava blasts up through a fissure in the rock. Such energetic eruptions usually last no longer than a few days.

Previous pages: Ancient craters along the Pali o Kūlani near South Point, Hawaiʻi. The dark green vegetation lining the bowls and hugging the cliffside is Christmas berry. The light green clusters are kukui (candlenut) trees.

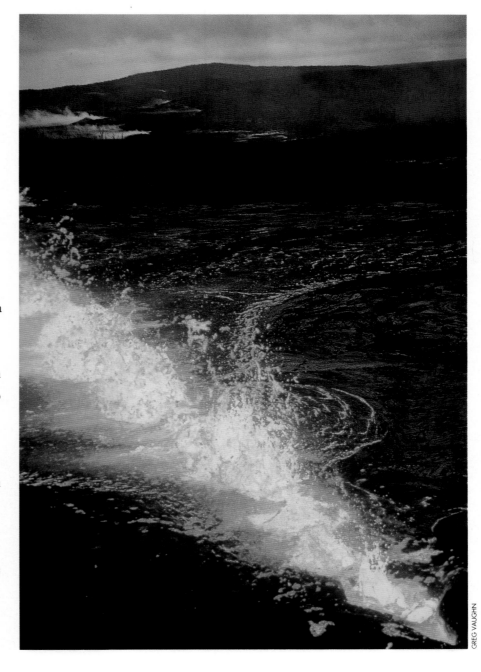

GREG VAUGHN

Above: On rare occasions a lava flow will split and later converge, leaving in the middle of the destruction a plot of untouched land known as a kīpuka. People whose homes have been spared in this way feel blessed by the volcano goddess Pele. The residents of this doomed dome in Kalapana were only teased, however. The kīpuka lasted just a few hours.

Right: In the volcanic arena of Haleakalā Crater, the legendary demigod Māui performed two of his greatest feats: battling the sun god, and lifting the sky. The two symmetrical cinder cones pictured here are Puʻu Naue (earthquake hill), on the left, and Ka Moa o Pele (the chicken of Pele). The odd-shaped cone in the center is named Hālāliʻi, after a famous trickster of Oʻahu or a Niʻihau chief whose name became synonymous with fun-making.

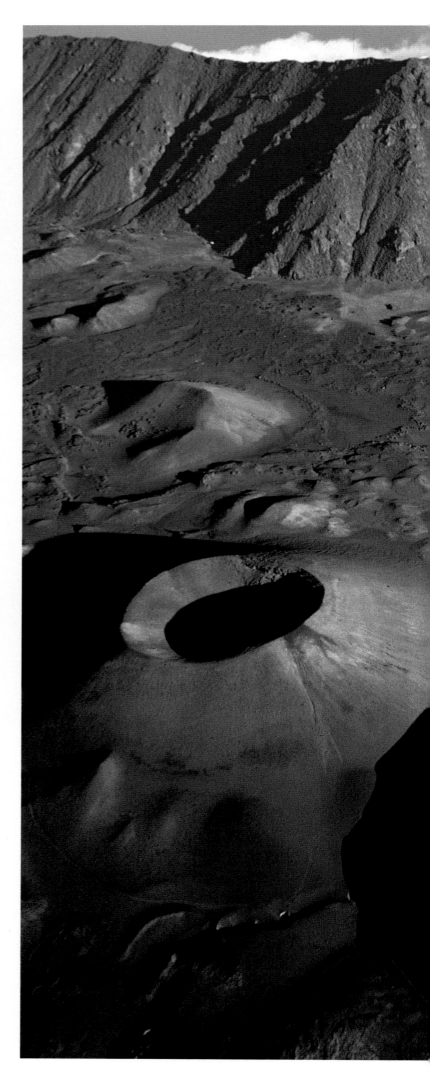

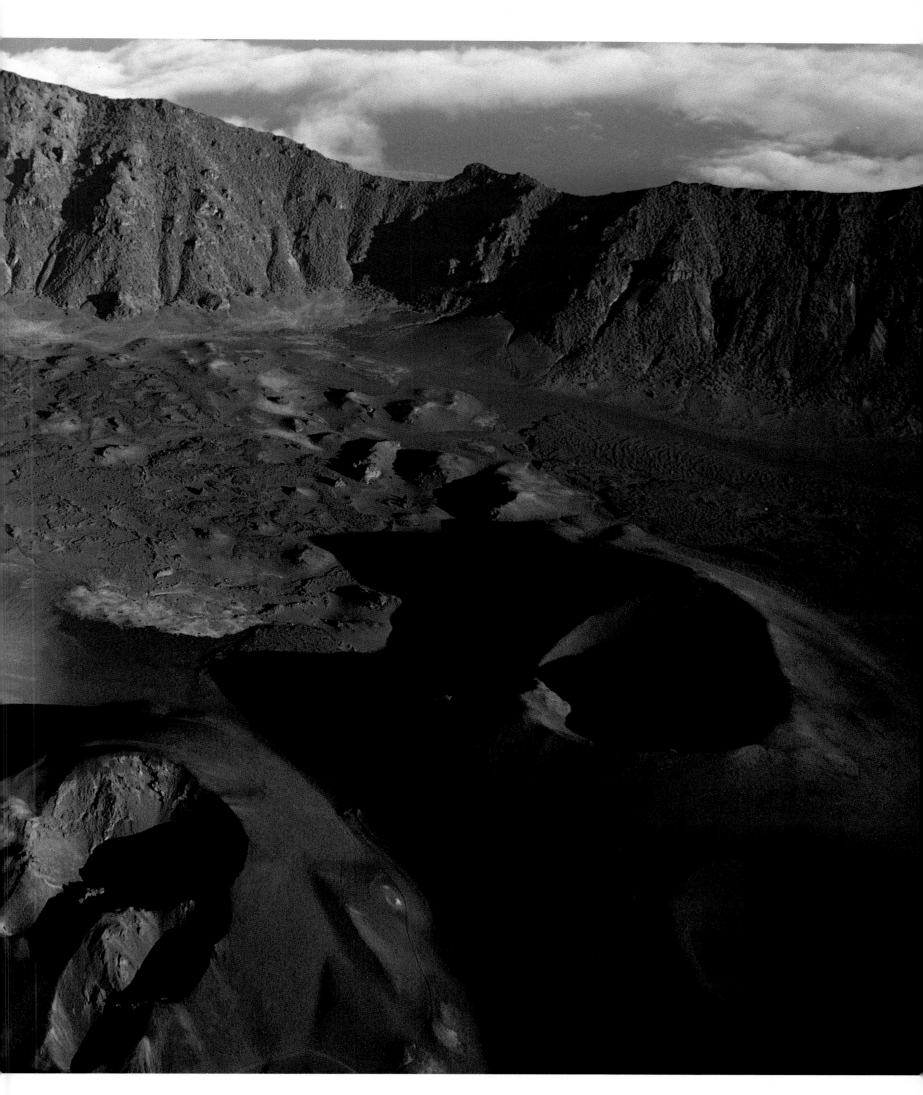

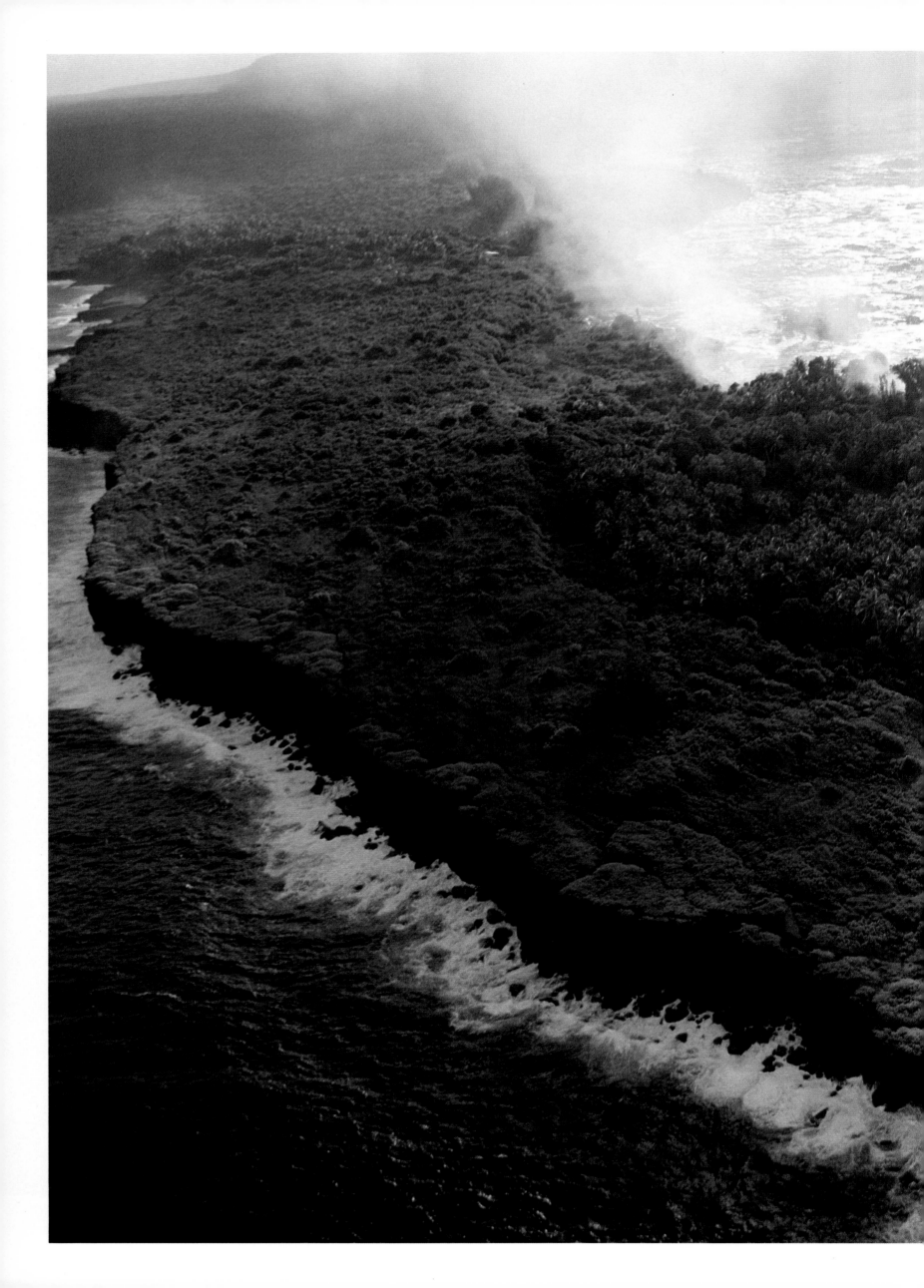

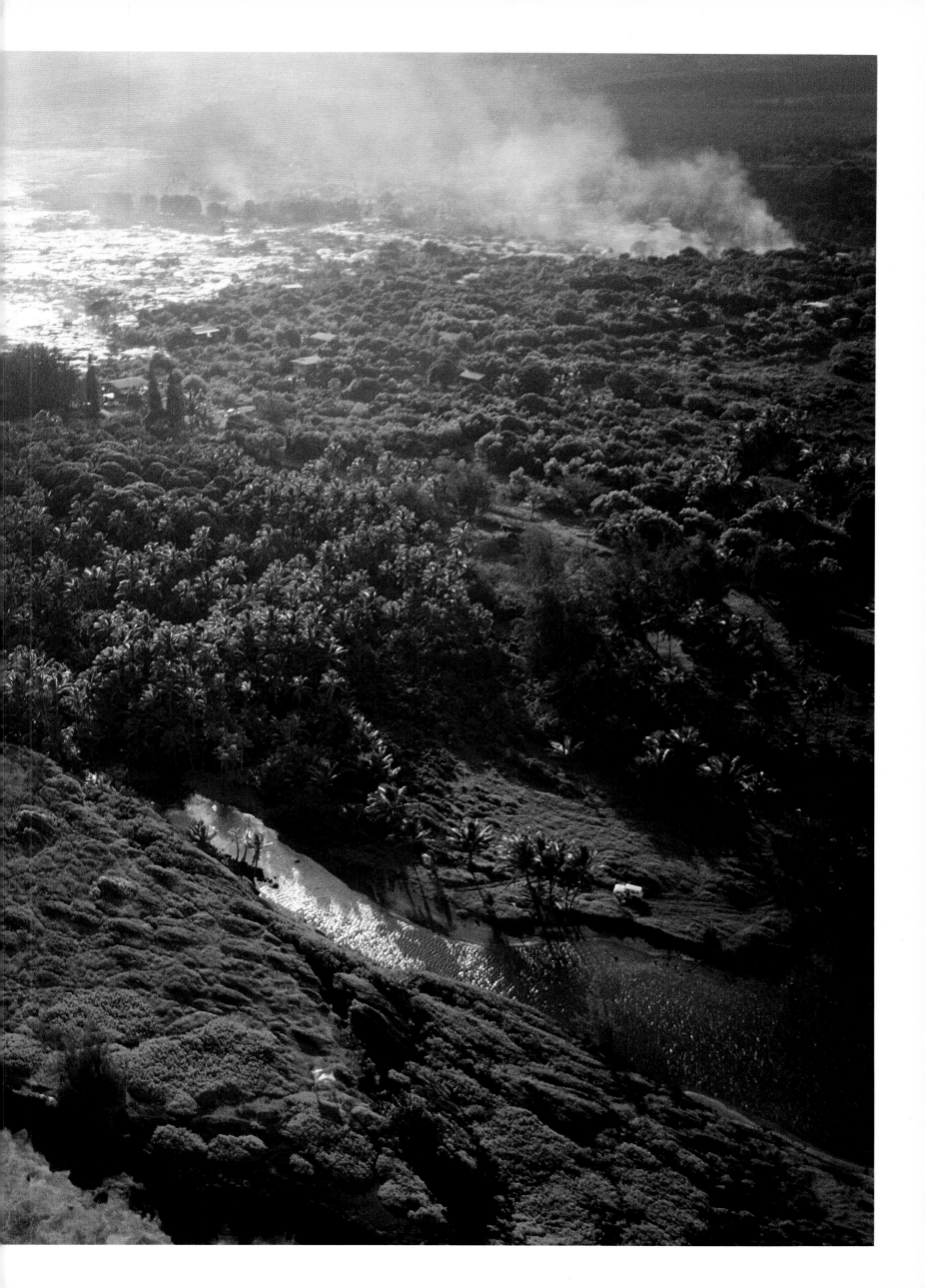

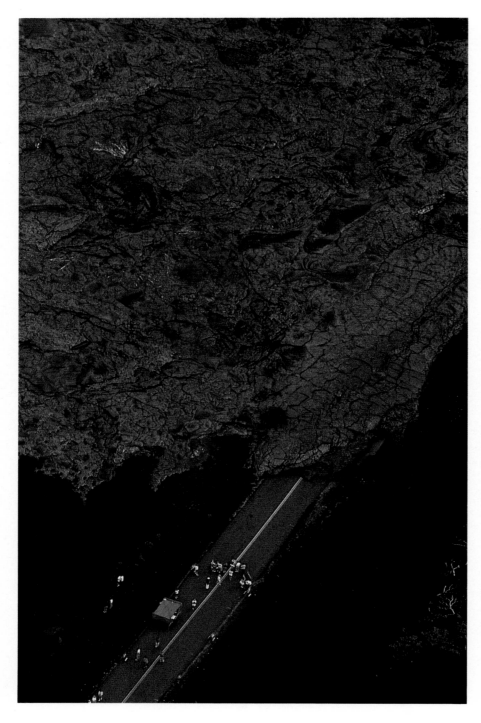

Left: Tourists gather on the Kalapana Highway on the Big Island to view the progress of a lava flow. The blue tarp shades civil defense officials, who have set barricades across the road. Oil in the asphalt ignites when lava hits it. "It's like some weird game," says Dan Cunningham, a geology student on the Big Island. "Pele puts down a road, and we put one down. Then she puts down another one. Et cetera."

Previous pages: Moving at a rate of 5 to 30 feet a day, lava advances through the Royal Gardens subdivision at Kalapana, Hawaiʻi.

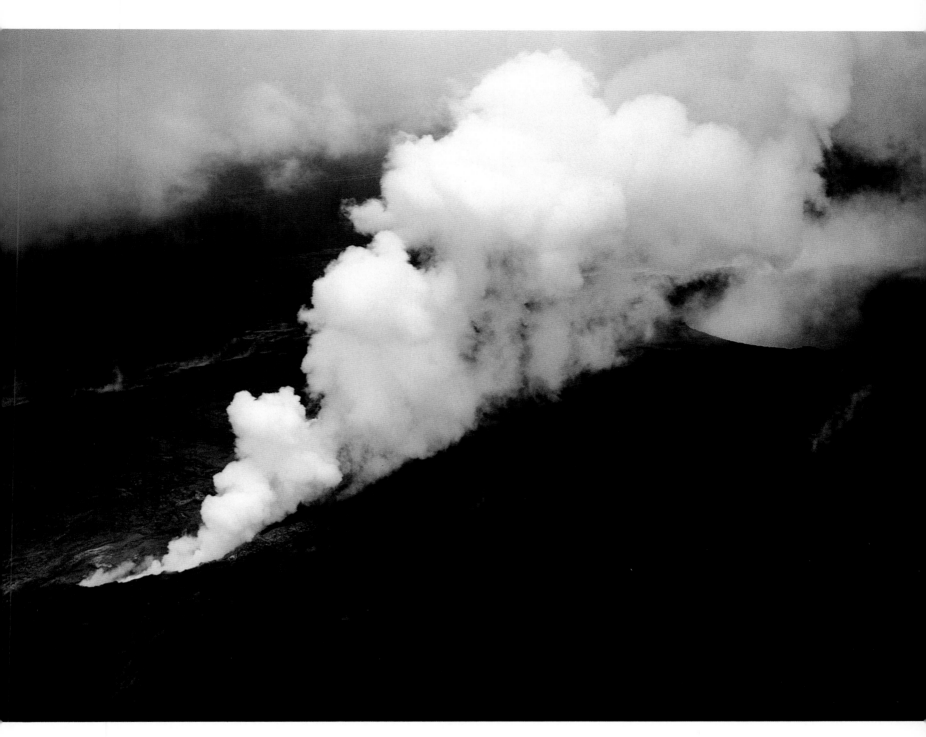

Above: The Pu'u 'Ō'ō vent of
Kīlauea volcano on the Big Island.
The hot spot never cools. For as
long as people have lived in
Hawai'i, not a single generation
has passed without someone
witnessing an eruption.

Above: At the Kāhala Hilton Hotel, on Oʻahu's south shore, a dredged reef and man-made peninsula and island give tourists a safe venue for ocean activities. *Left:* Coral polyps attach themselves to submerged lava and begin the long process of reef building. It will take thousands of years before this baby reef along the Big Island's Kona coast becomes as mature and complex as Oʻahu's reefs.

Following pages: Hunkering down into the clouds, the southwest flank of Haleakalā features a string of cinder cones that open along a fault line from the summit to the sea.

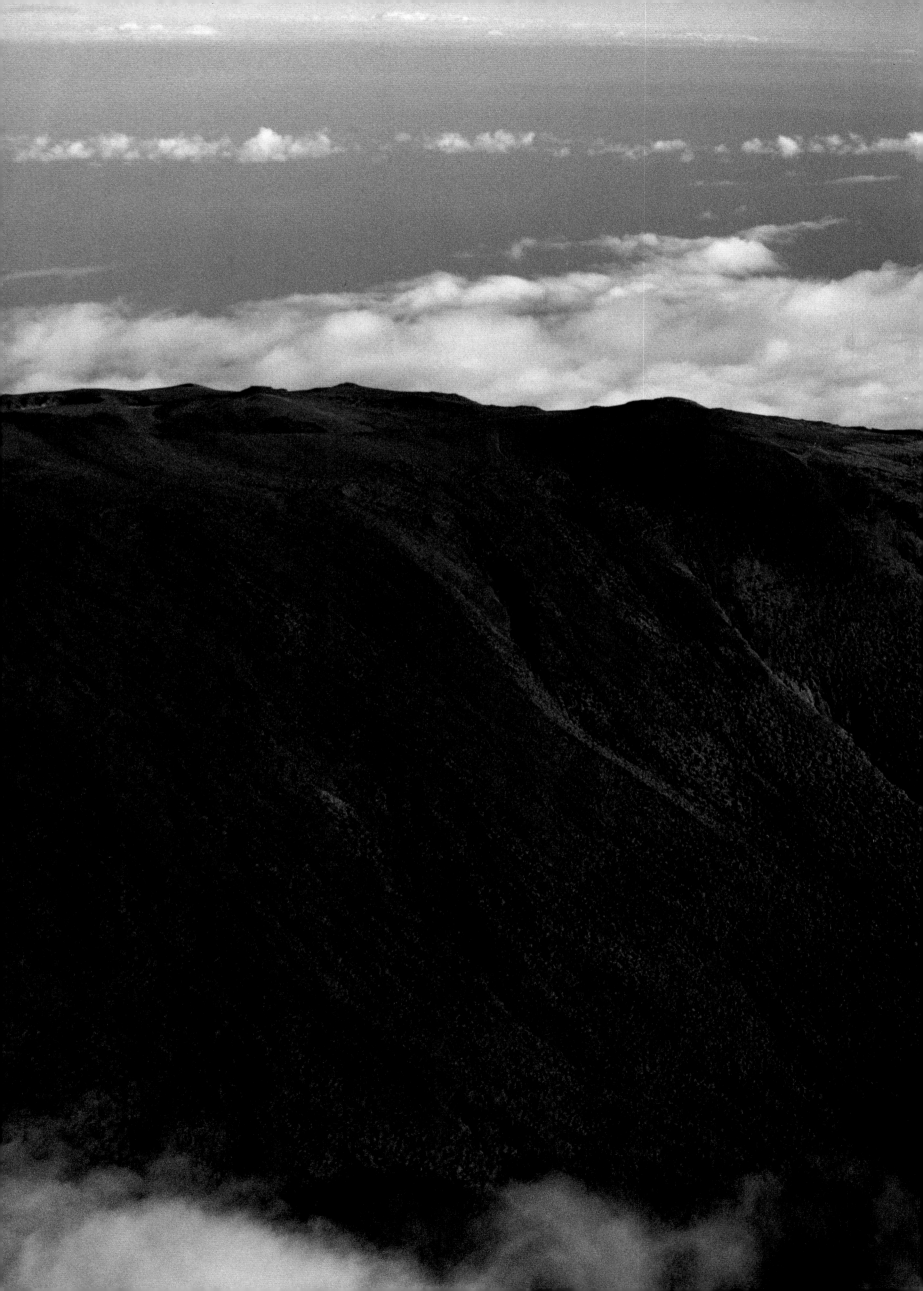

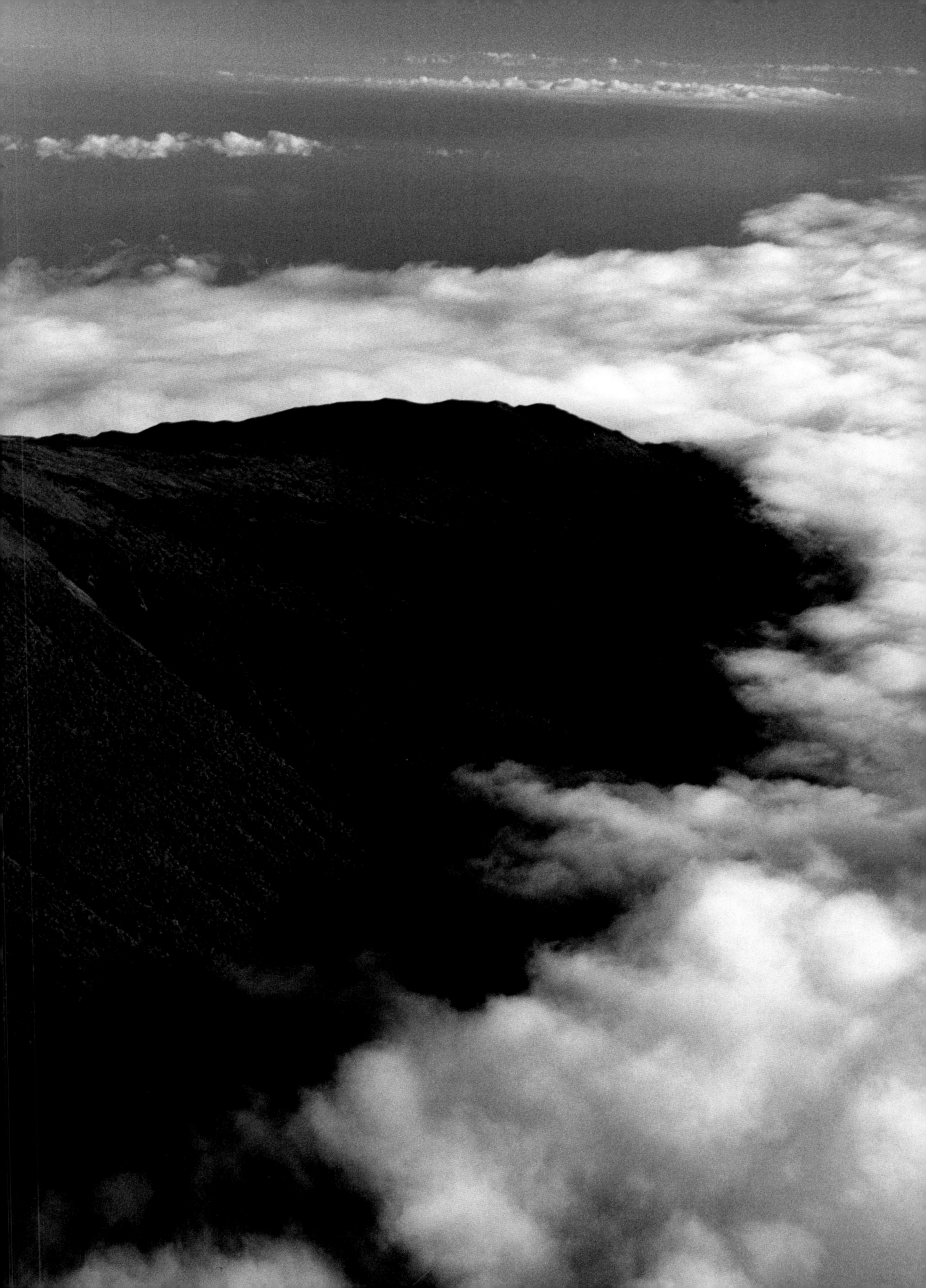

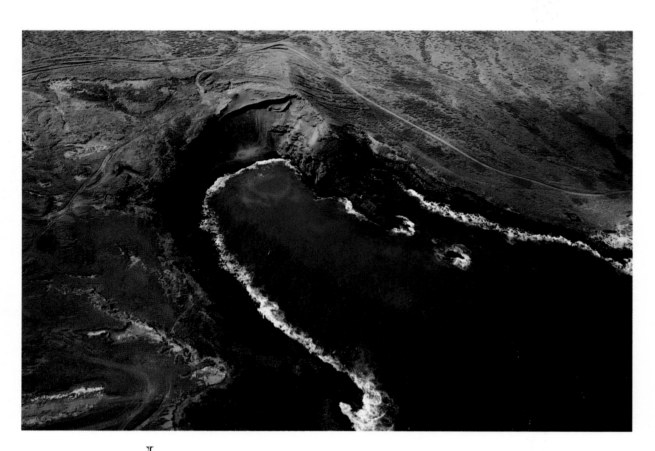

Above: Lava hitting the ocean explodes to create instant beaches, like this one of green olivine crystals at the base of a littoral (coastal) cone at Papakōlea, South Point, Hawai'i.

Right: An anvil of iron-rich runoff on Kaua'i near Waimea, which means "reddish water."

Opposite: Several sea-breached volcano craters, like Molokini Island off Maui, and Hanauma Bay on O'ahu, took form when the ocean rose to its present level. This crab claw–shaped island is Lehua, off the north end of Ni'ihau.

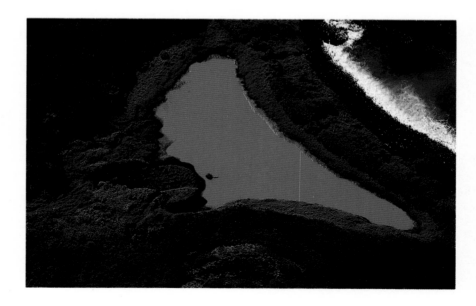

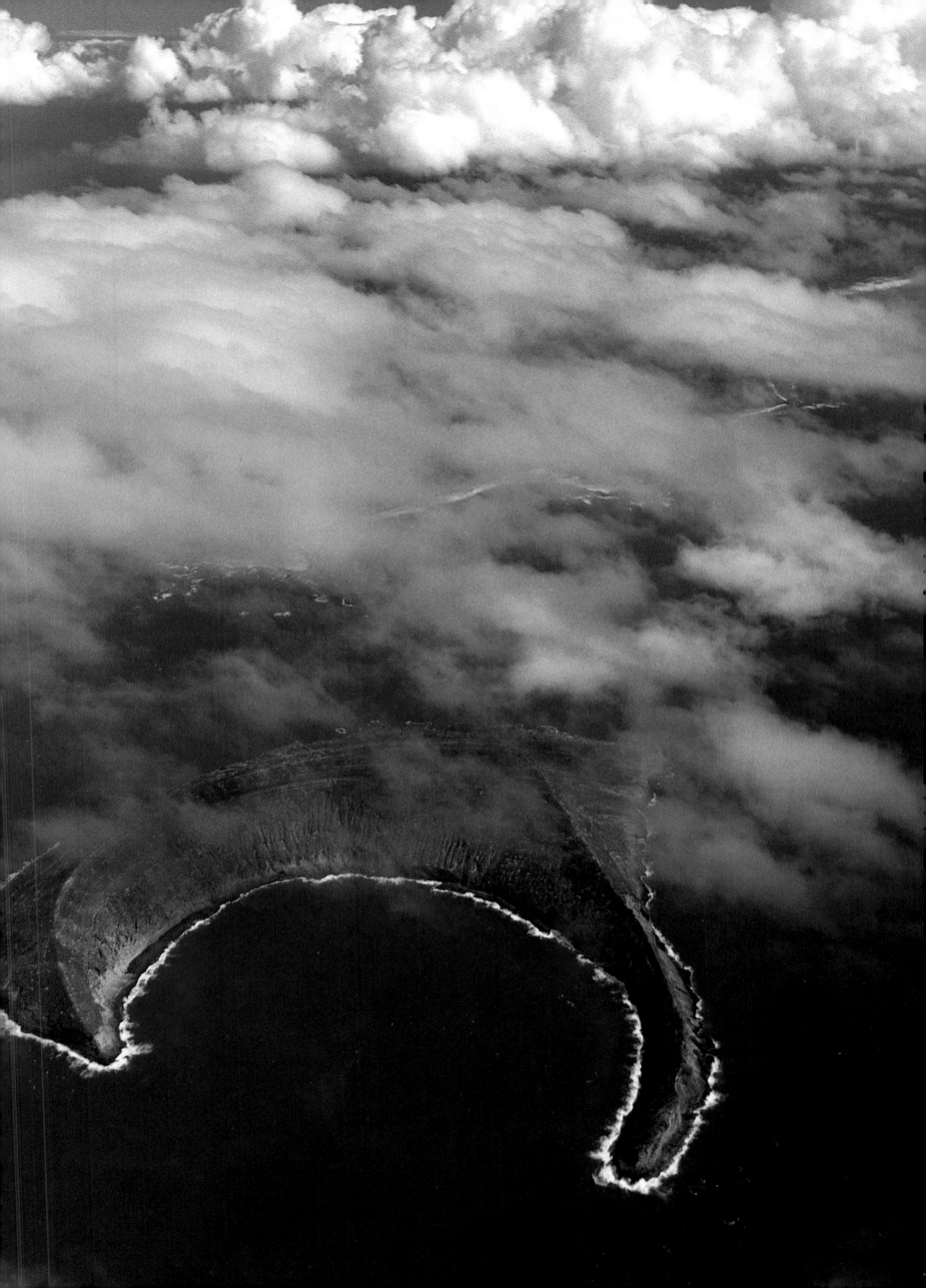

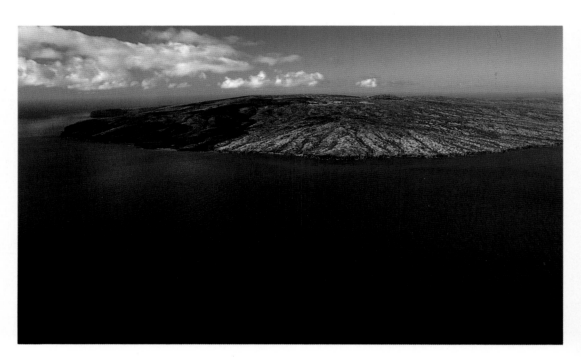

Above: Kahoʻolawe, a short-lived shield volcano that never rose high enough to attract much rain. The two points on the left, Ule Point (foreground) and Hālona Point (behind), bracket Kanapou Bay in the pit of the original caldera. Lua Makika, the highest elevation, is only 1,477 feet. The island was used from 1941 to 1990 as a U.S. Navy bombing target, and much of its soil still contains unexploded shells.

Right: Some geologists theorize that the high cliffs of Molokaʻi's Pelekunu Valley were carved by a massive earthquake that cracked the old volcano and dumped the northern half of the shield into the sea. They cite as evidence submerged debris slides reaching into the Hawaiian Deep. The prevailing theory, however, is that pounding surf undercut the cliffs, causing the upper rock to shear off.

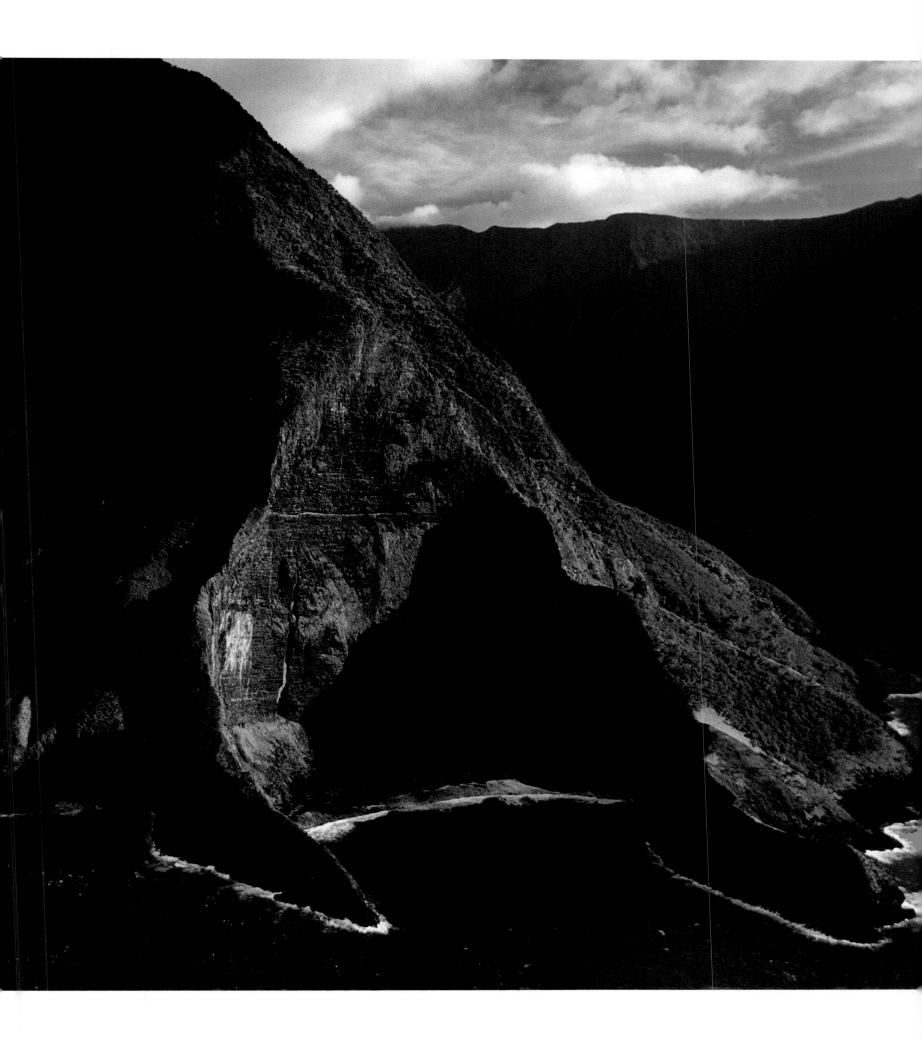

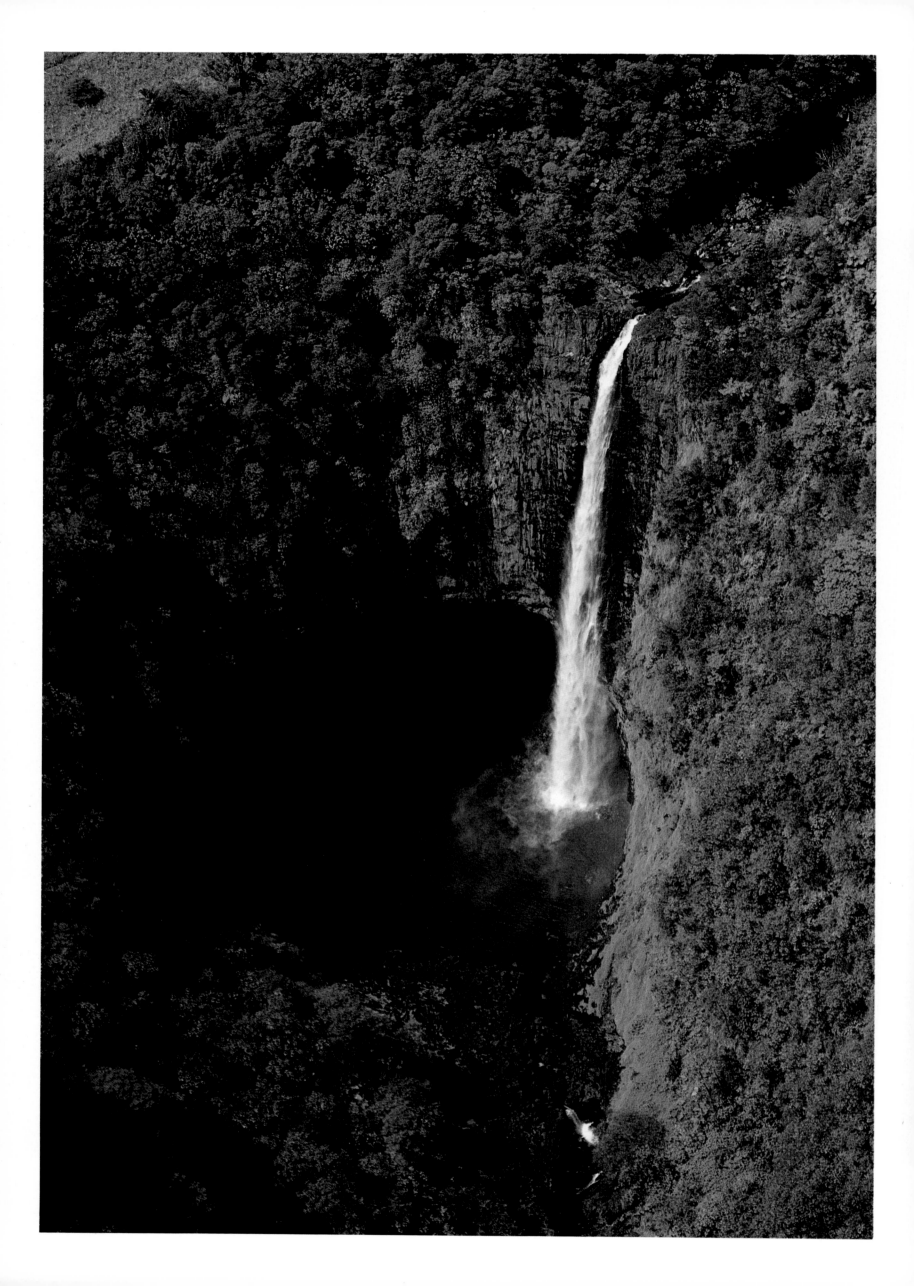

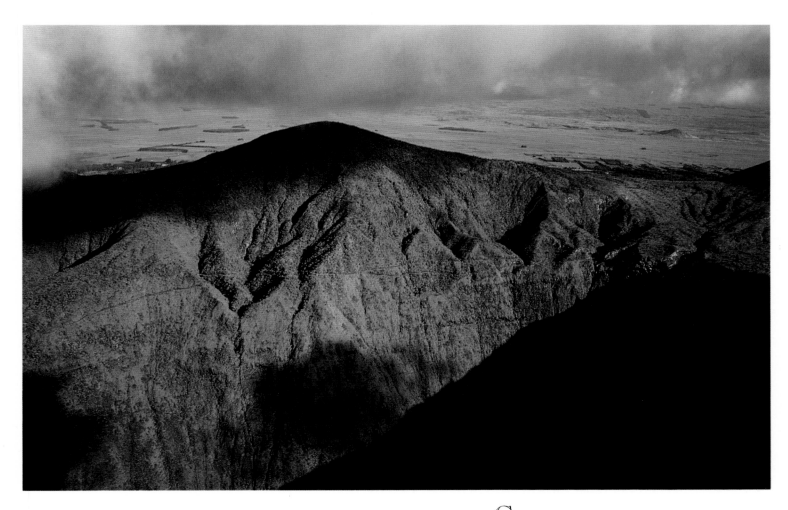

Above: Cloud shadows skim the rain-cut ridges above Waipi'o Valley on the Big Island. The Waimea upland (in the background) has been eroded only slightly. The plains were converted into prime subtropical pastures for the Parker Ranch.

Left: A layer of dense basalt resists the erosive force of 'Akaka Falls in the South Hilo District of the Big Island. The plunge-pool action at the waterfall's base has eaten a deep cavity into the softer rock below.

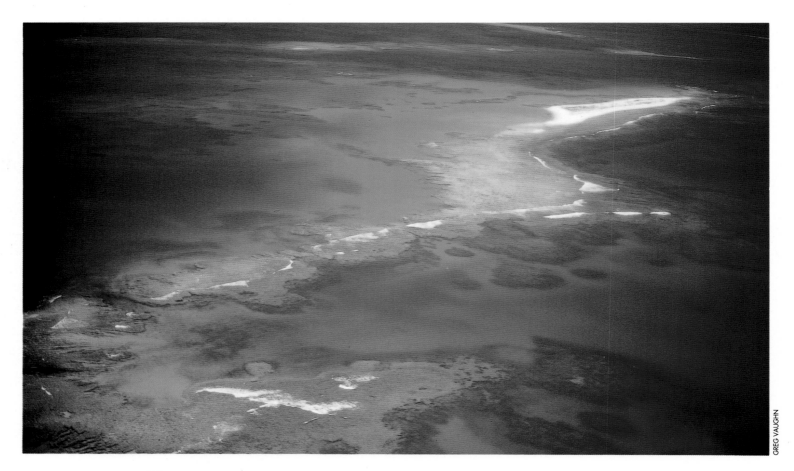

GREG VAUGHN

Above: East Island, French Frigate Shoals, the Northwestern Hawaiian Islands. Named after two frigates captained by J. F. G. de la Pérouse, the French Frigate Shoals almost sank the vessels in 1786. La Pérouse is credited with the discovery of the sixteen sand islets and a 120-foot-high rock, La Pérouse Pinnacle.

Right: Nihoa Island, at 910 feet the highest of the Northwestern Hawaiian Islands. Archaeologist Kenneth Emory found unique stone images and 66 house sites here in 1928. The people of Nihoa, who were possibly Menehune retreating from the invading Tahitians on the main islands, disappeared centuries before Western contact.

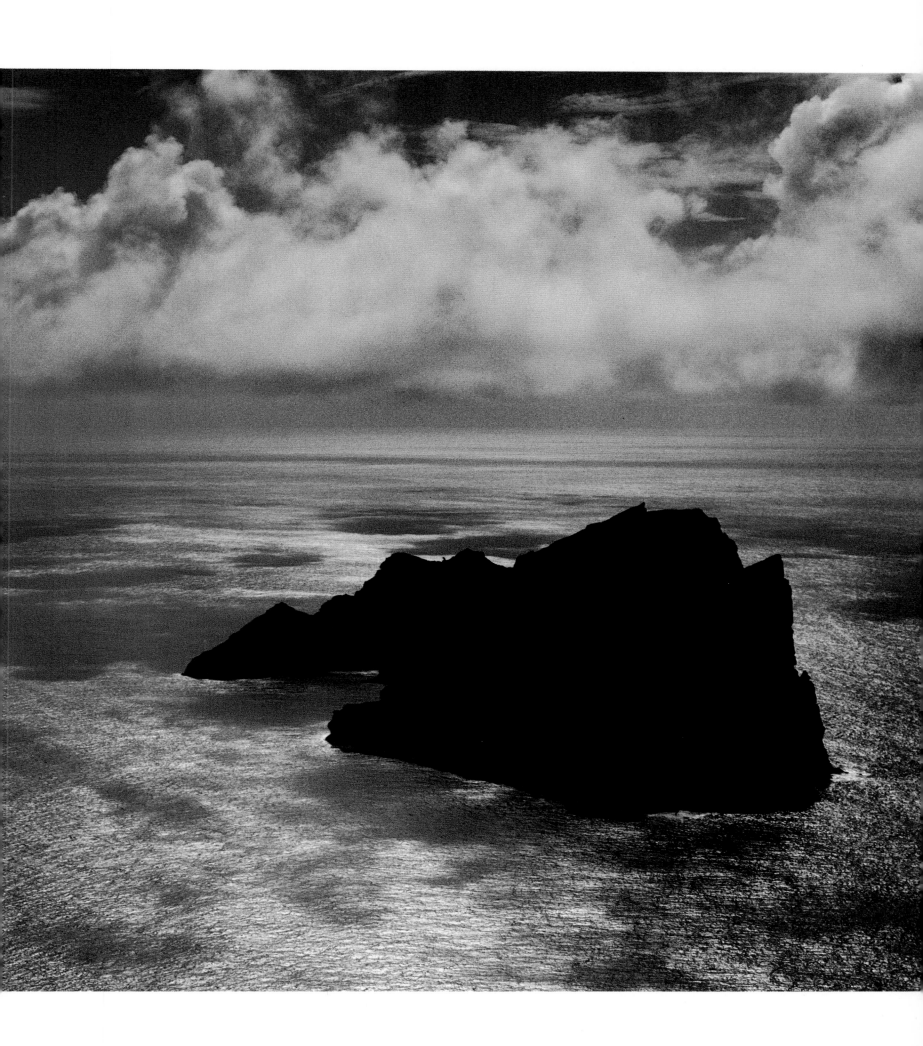

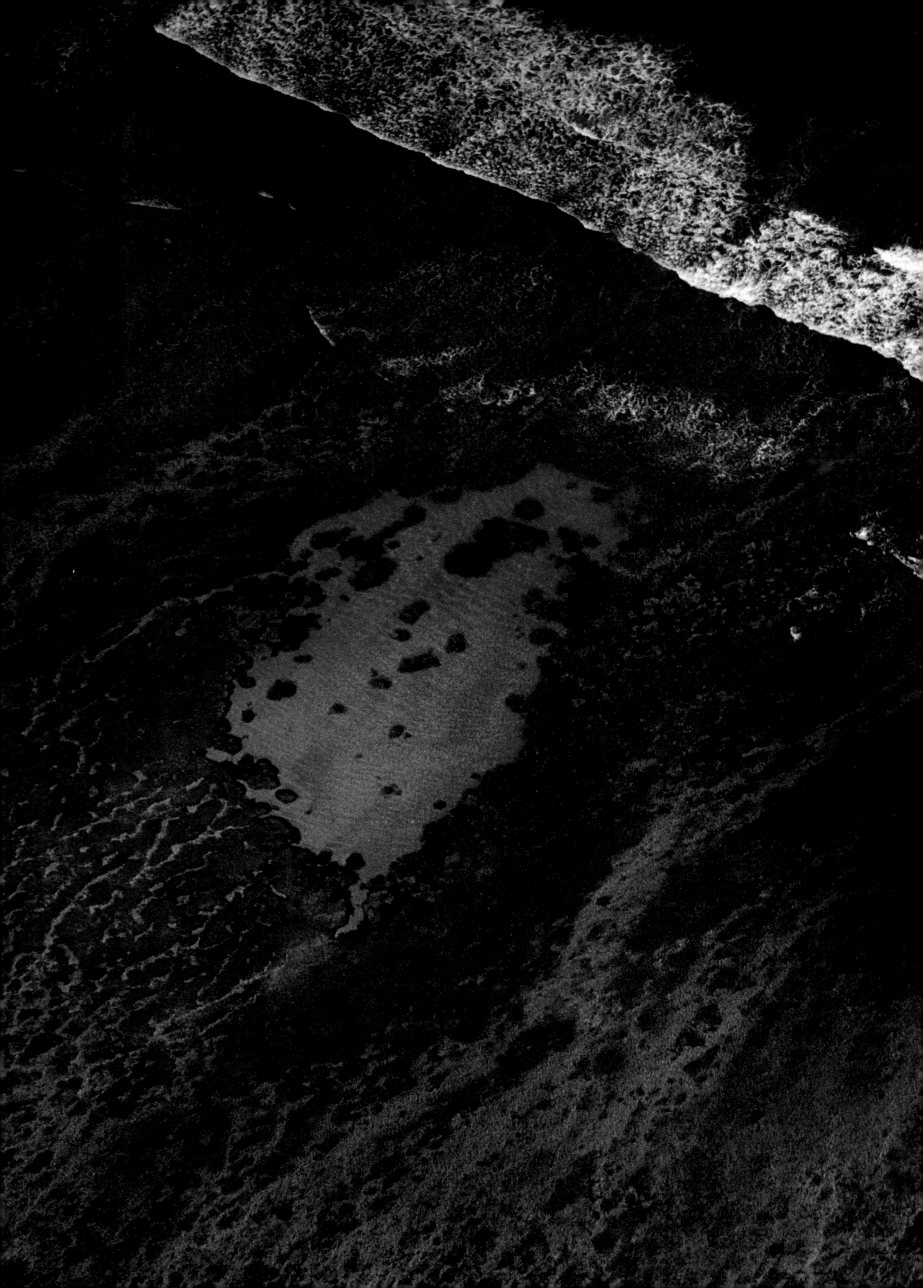

Left: Reef fish spawn in sand pockets like this one at Onomea Bay on the Big Island.

Right: The reefs of Kāneʻohe Bay on Oʻahu. The growth of these high-rising coral heads is influenced by currents.

Below: Sea caves forming on the western arm of Lehua Island, off Niʻihau. Further wave action will hollow the caves into sea arches, and then into sea stacks when the tops fall in.

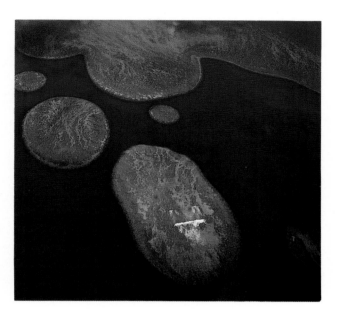

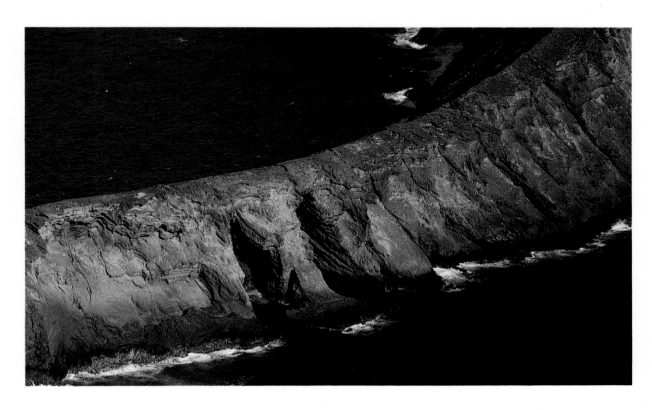

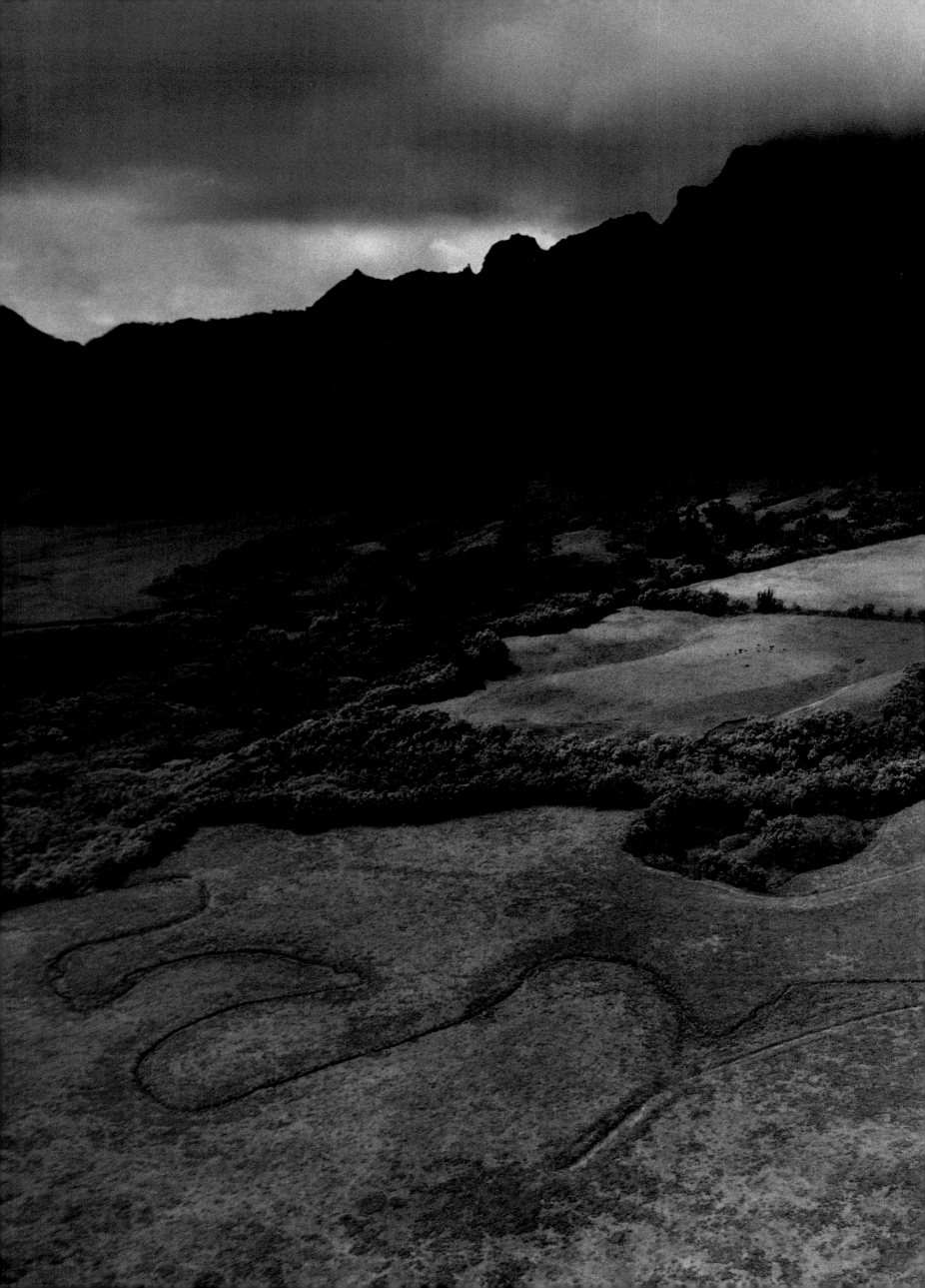

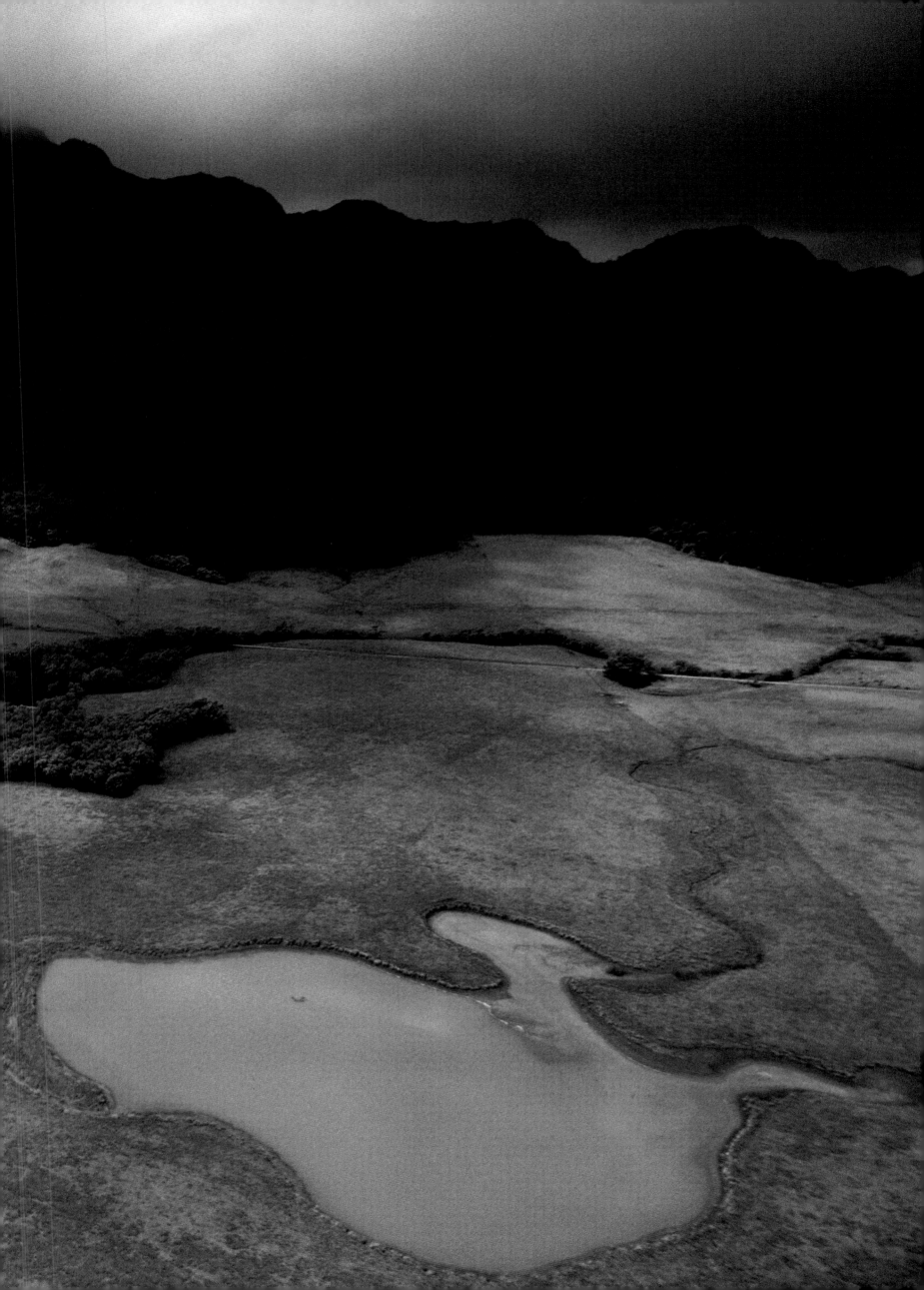

Left: Constellations of iliau (genus *Wilkesia*) spread their particular shade of green over the ridges of Waimea Canyon on Kaua'i.

Right: According to a Hawaiian proverb, "The gods build houses in the sky, and no human may visit." Much of Kaua'i's landmass remains untrekked, like these upper reaches of Waimea Canyon. Crumbling rock and flash floods discourage climbers.

Previous pages: Meandering streams and pastures cover the sedimentary plains beneath the Hā'upu Range on Kaua'i.

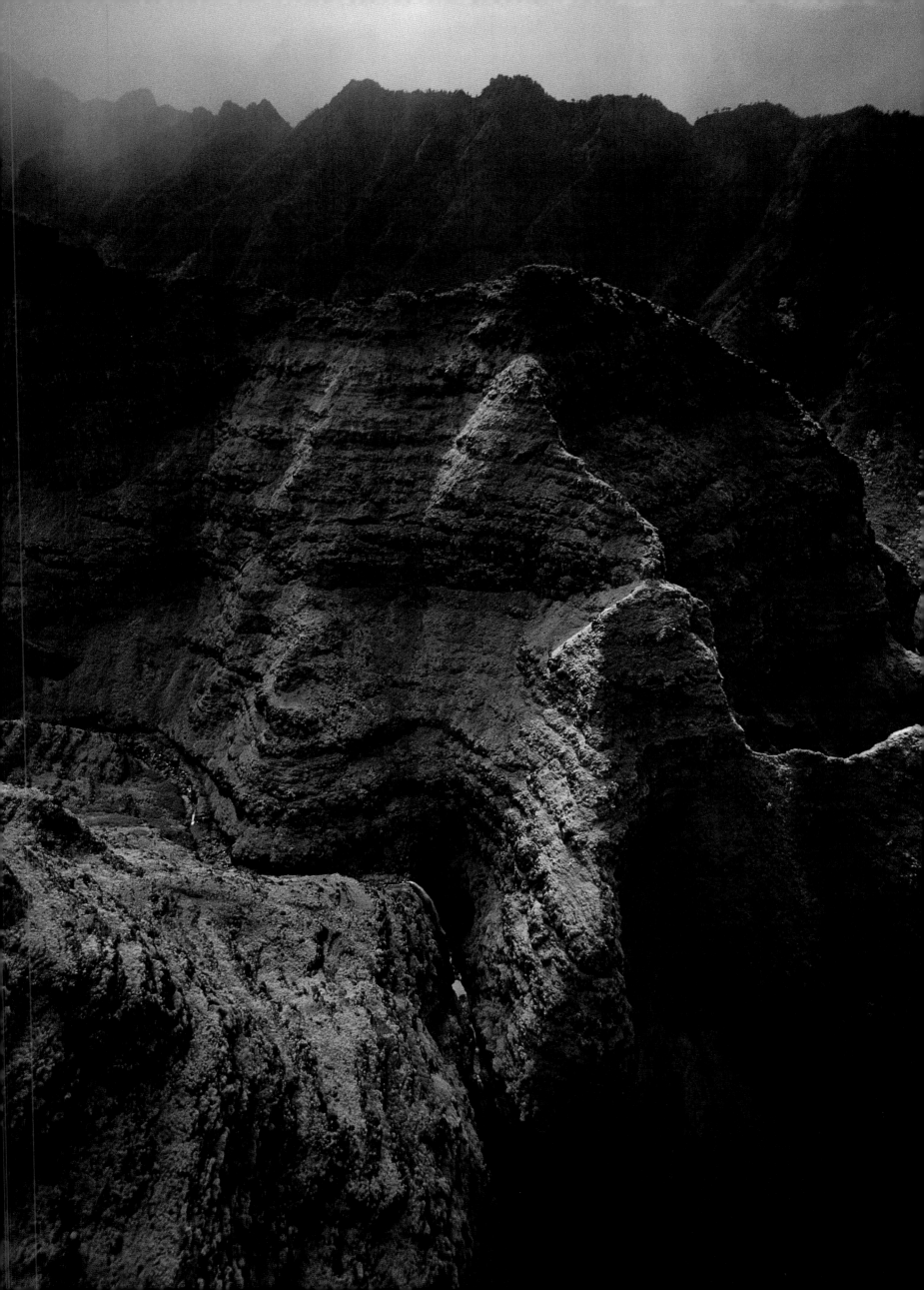

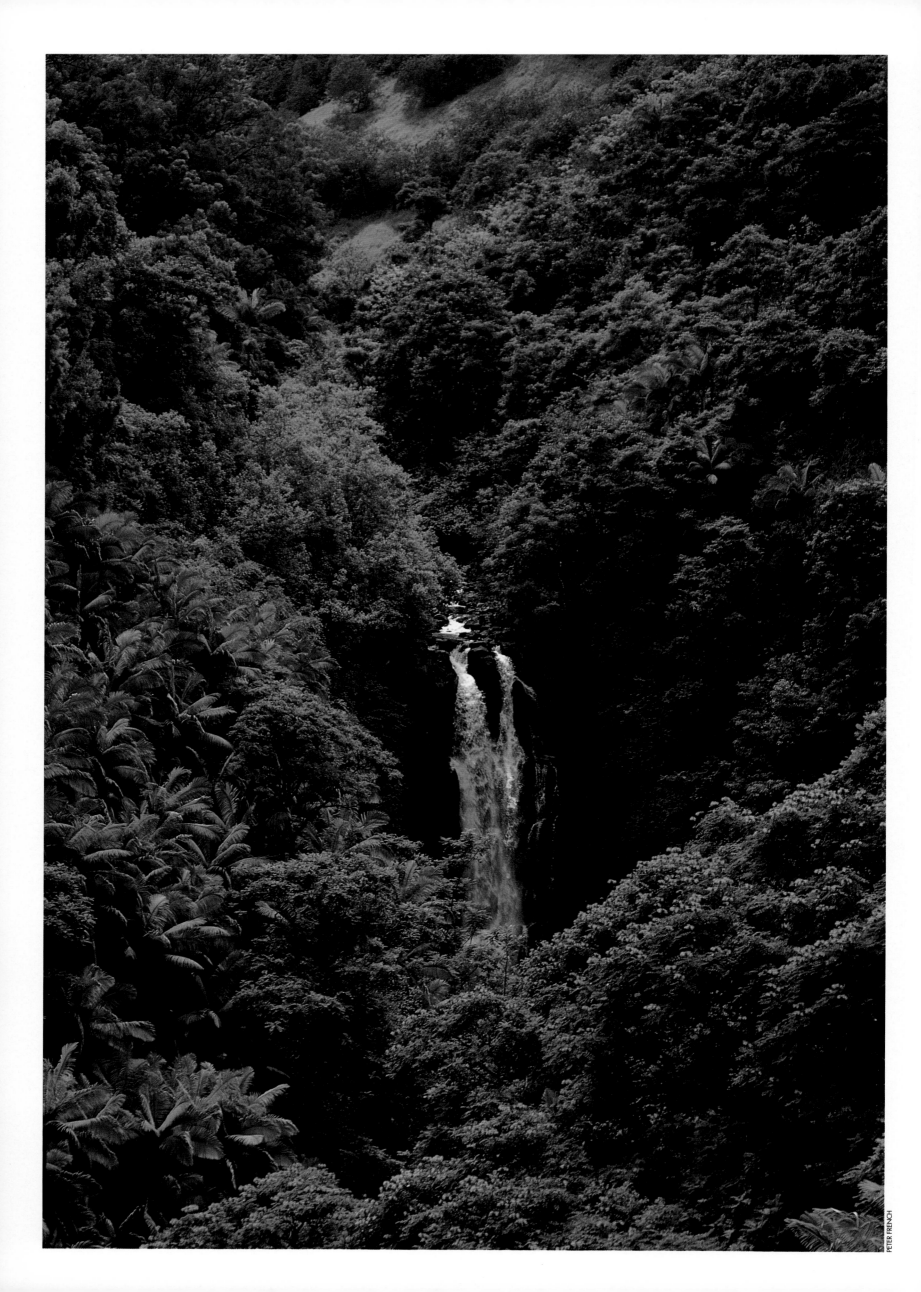

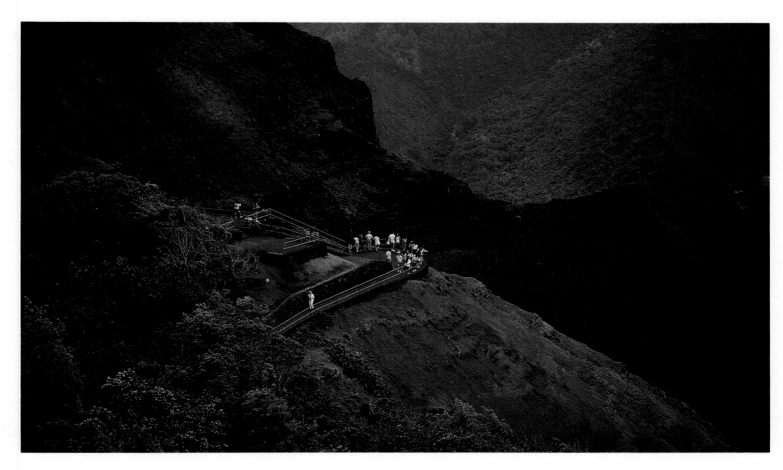

Above: Tourists line the rails at a lookout above Waimea Canyon. *Left:* Alexandria palms and the red-orange blossoms of African tulips encircle Nānue Falls, Nānue Stream, on the Big Island. Every detail of this scene contradicts the meaning of the name Nānue: nauseating.

Following pages: Black sand beaches, like this one on the Hāna side of Maui, are created when hot lava hits the ocean and explodes. The particles settle as sand, and a beach forms instantly.

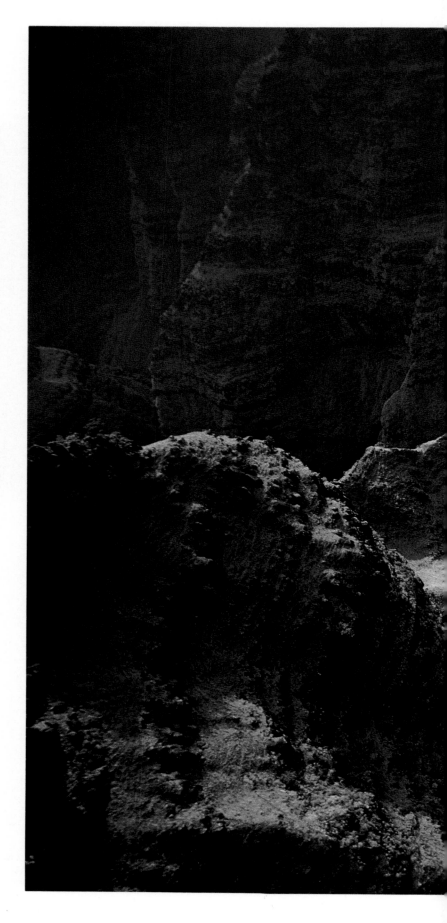

Above: If Waimea Canyon on Kauaʻi is reminiscent of the Grand Canyon, then this wild landscape west of Kānepuʻu Forest on Lānaʻi compares with Utah's Cedar Breaks. Wind, more than water, has caused the erosion here.

Right: Only the rains of Waiʻaleʻale, the wettest spot on earth, could cut so precipitous a gorge. This Nā Pali stream drops 4,000 feet in two miles.

Following pages: The northern end of Nā Pali, at Hāʻena on Kauaʻi. Sculpted by freshets cutting ever-expanding V-shaped valleys into the lava shield and by surf biting into the cliffs, Nā Pali exhibits the grooved or "fluted" valley walls found on many high islands of the Pacific.

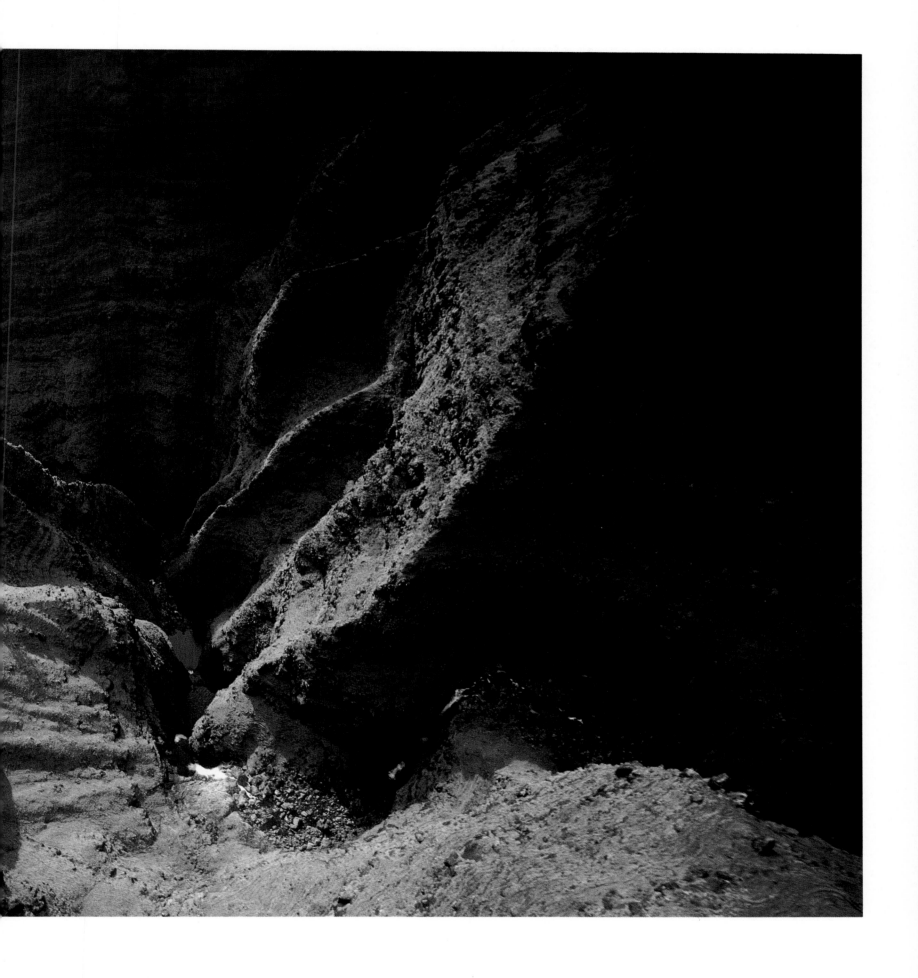

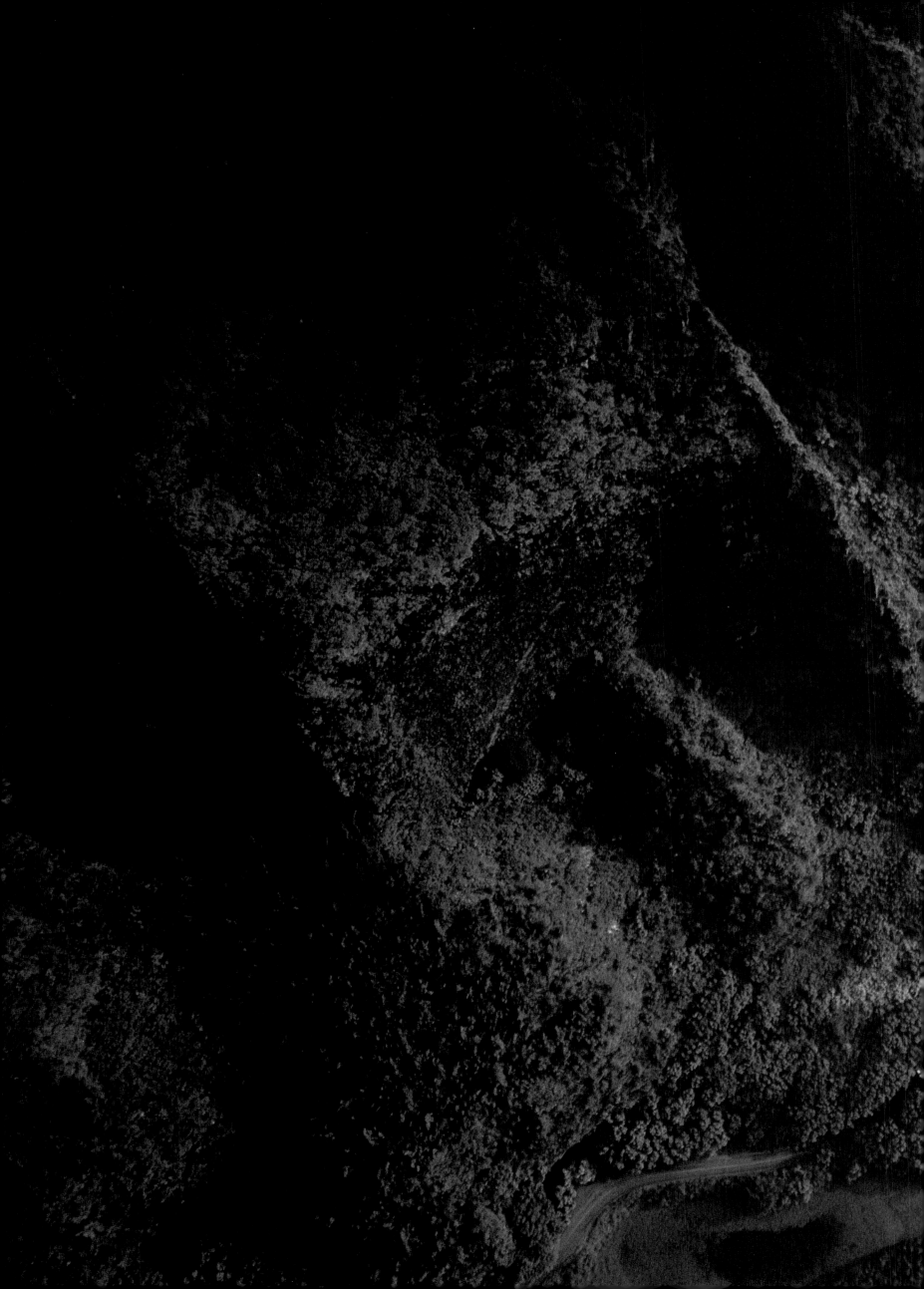

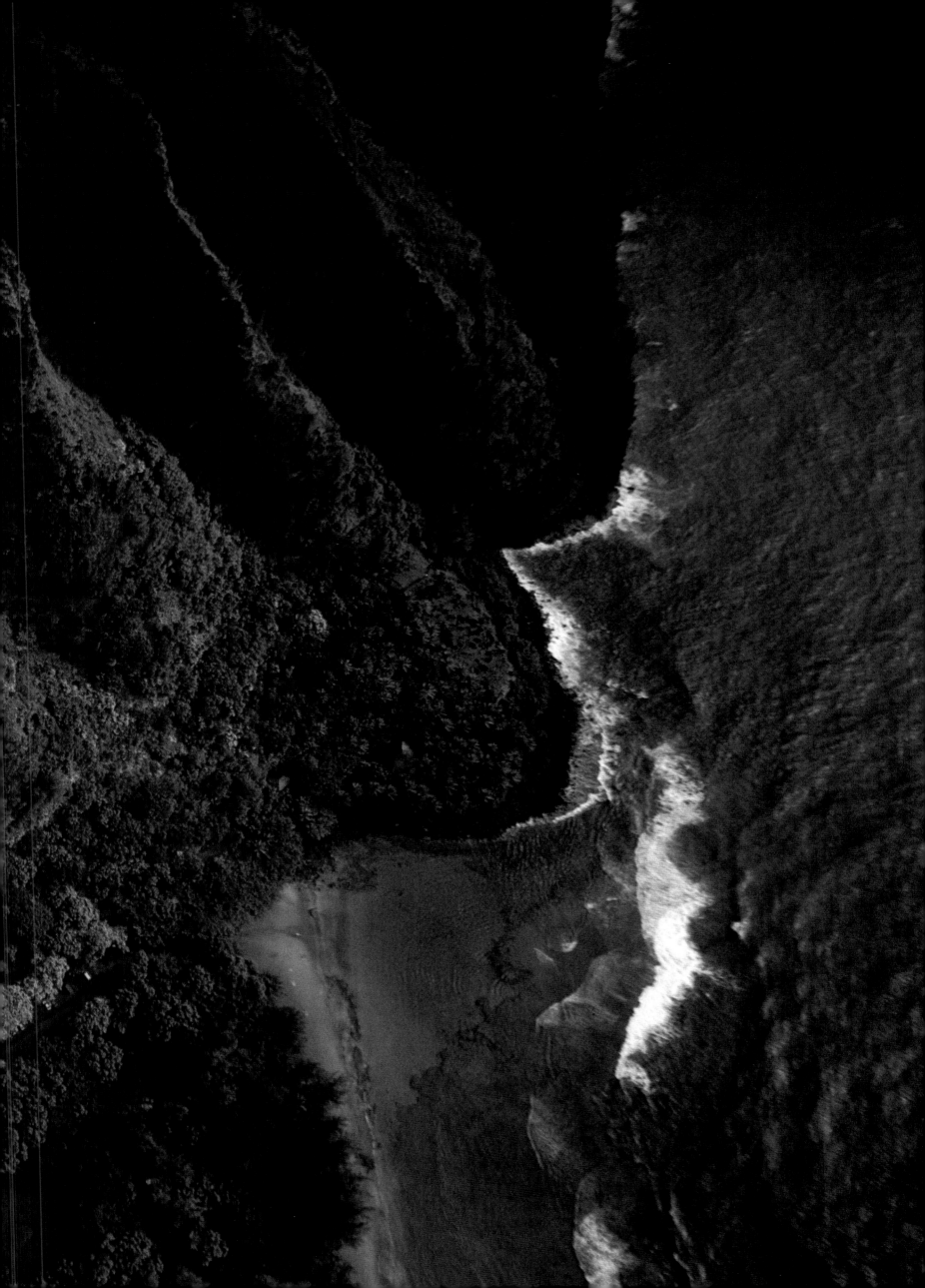

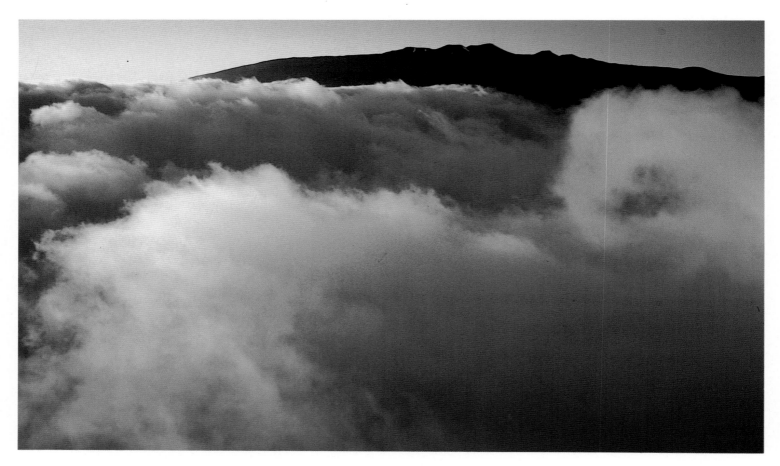

Above: Like a barnacled hump-
back, Mauna Kea and its cinder
cones rise above a sea of early
morning clouds.

Right: The upper elevations of
several Hawaiian islands are
covered by "cloud forests,"
vegetation so high that it receives
moisture directly from clouds
instead of falling rain. This cloud
forest upslope of Hāna, on the
eastern side of Maui, grows over a
stream-etched base of old cones
and lava flows.

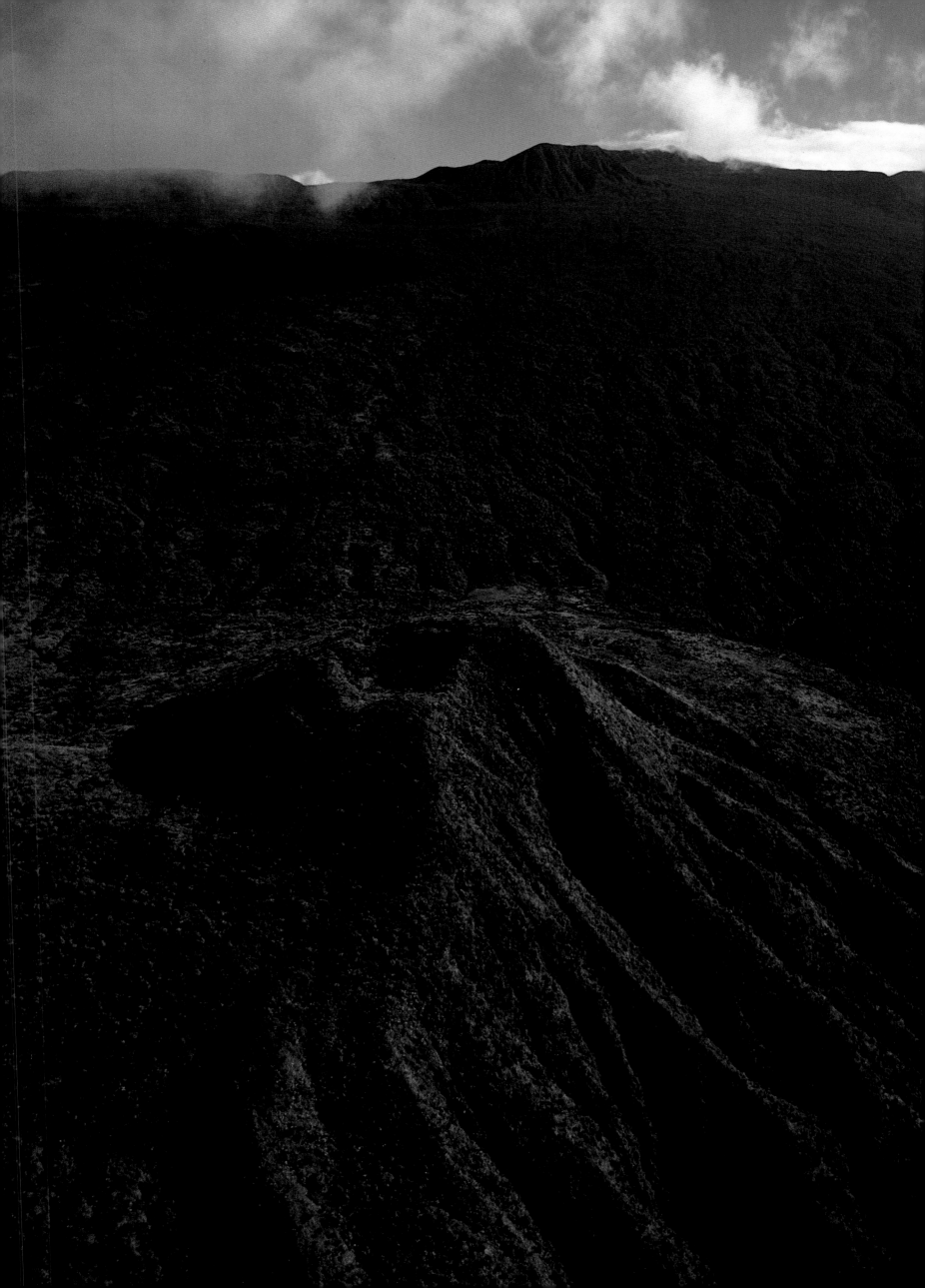

Pinnacles and bluffs, like this one in Waimea Canyon, are the remains of volcanic cones of dense, erosion-resistant lava.

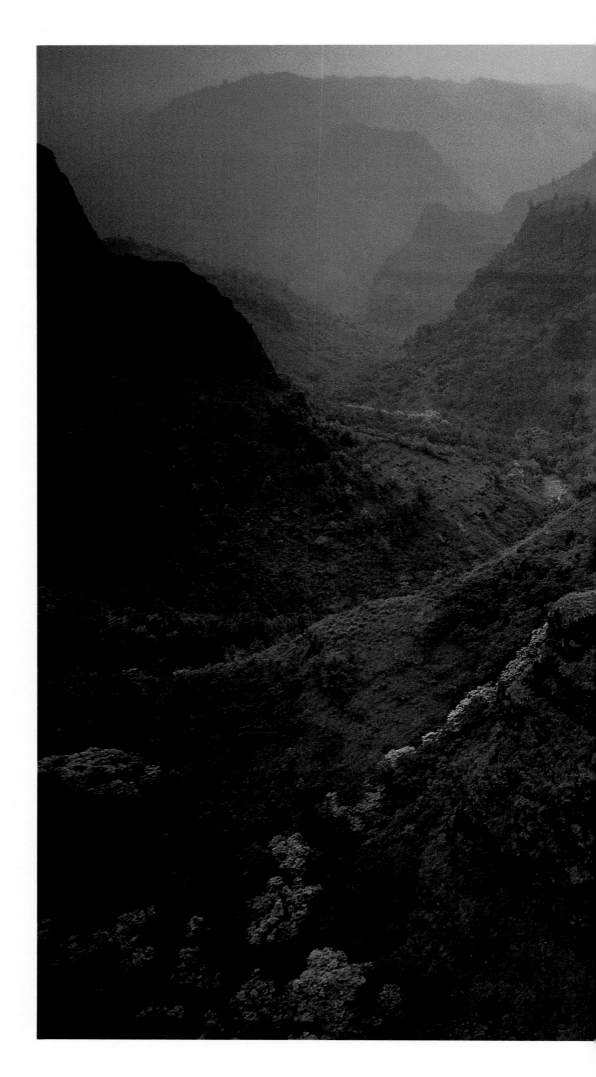

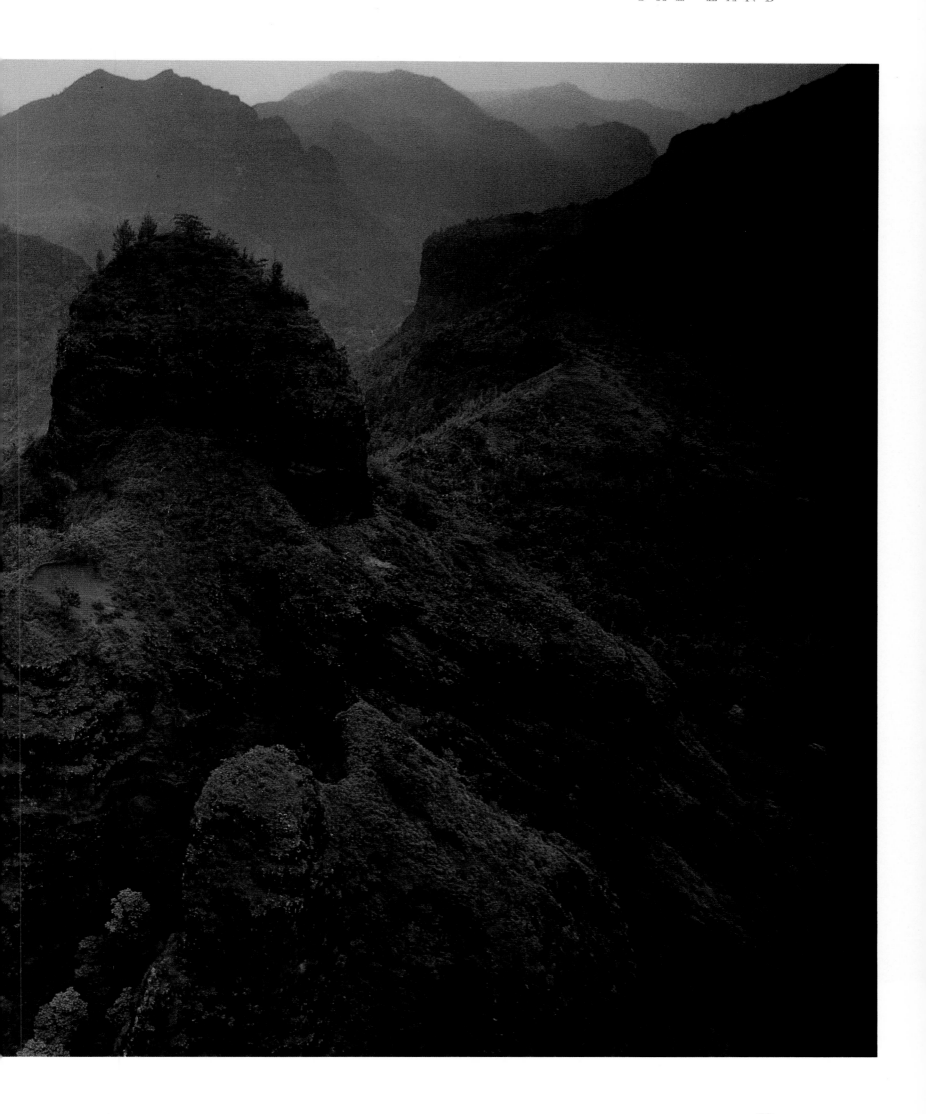

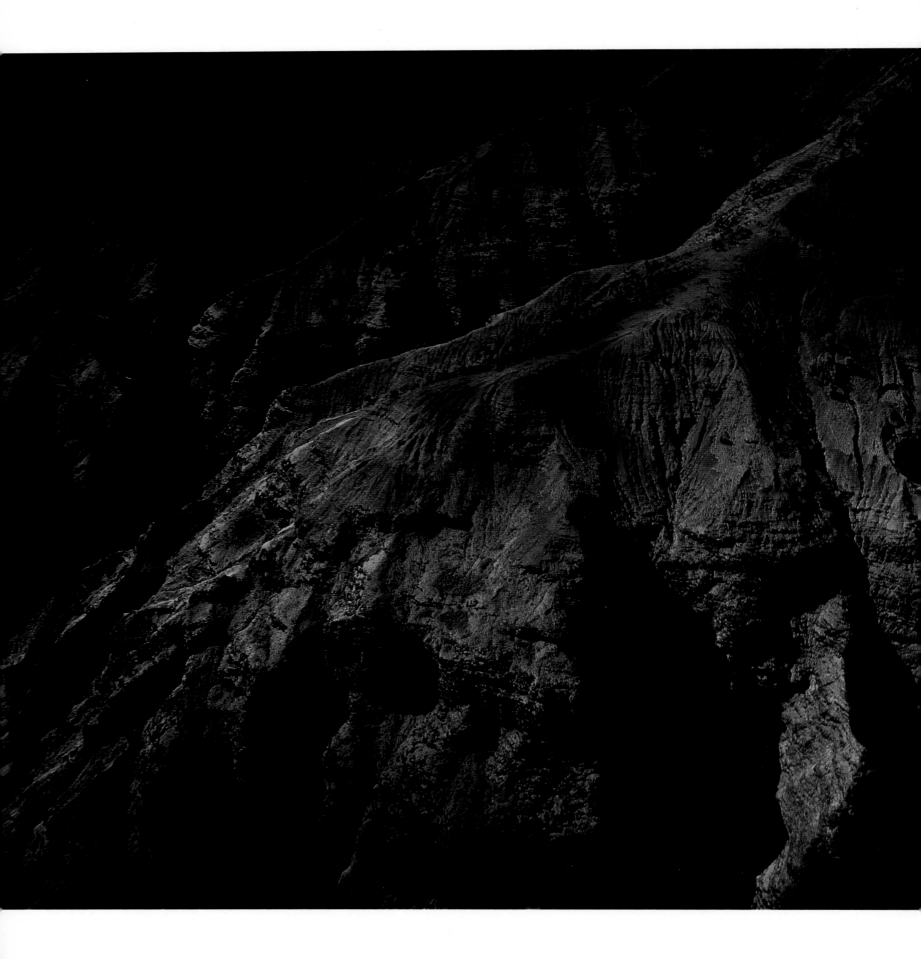

OVER HAWAI'I

Left: Ferrous-cloaked bluffs of Waimea Canyon.

Right: Usually shrouded in rain clouds and mist, this verdant canyon north of Waimea, Kaua'i, is just a few miles below Wai'ale'ale peak, the wettest spot on earth.

Below: The Bell Jet Ranger helicopter of Jack Harter, founder of Hawai'i's oldest helicopter service, flies close to a Waimea Canyon cliff.

Following pages: Mākua Valley, one of the last undeveloped valleys on O'ahu, is a typical amphitheater-headed valley exhibiting alluvium slopes and fluted walls. In the distance Ka'ena Point sticks out like a bird beak.

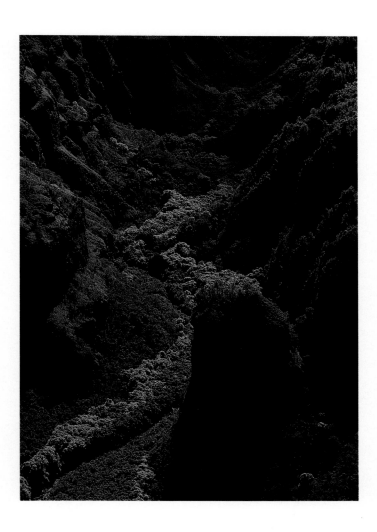

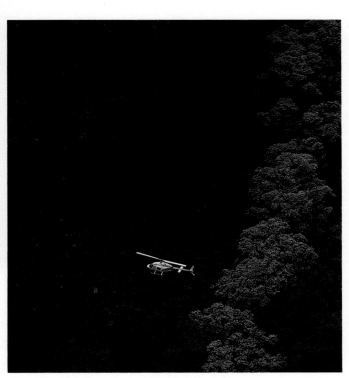

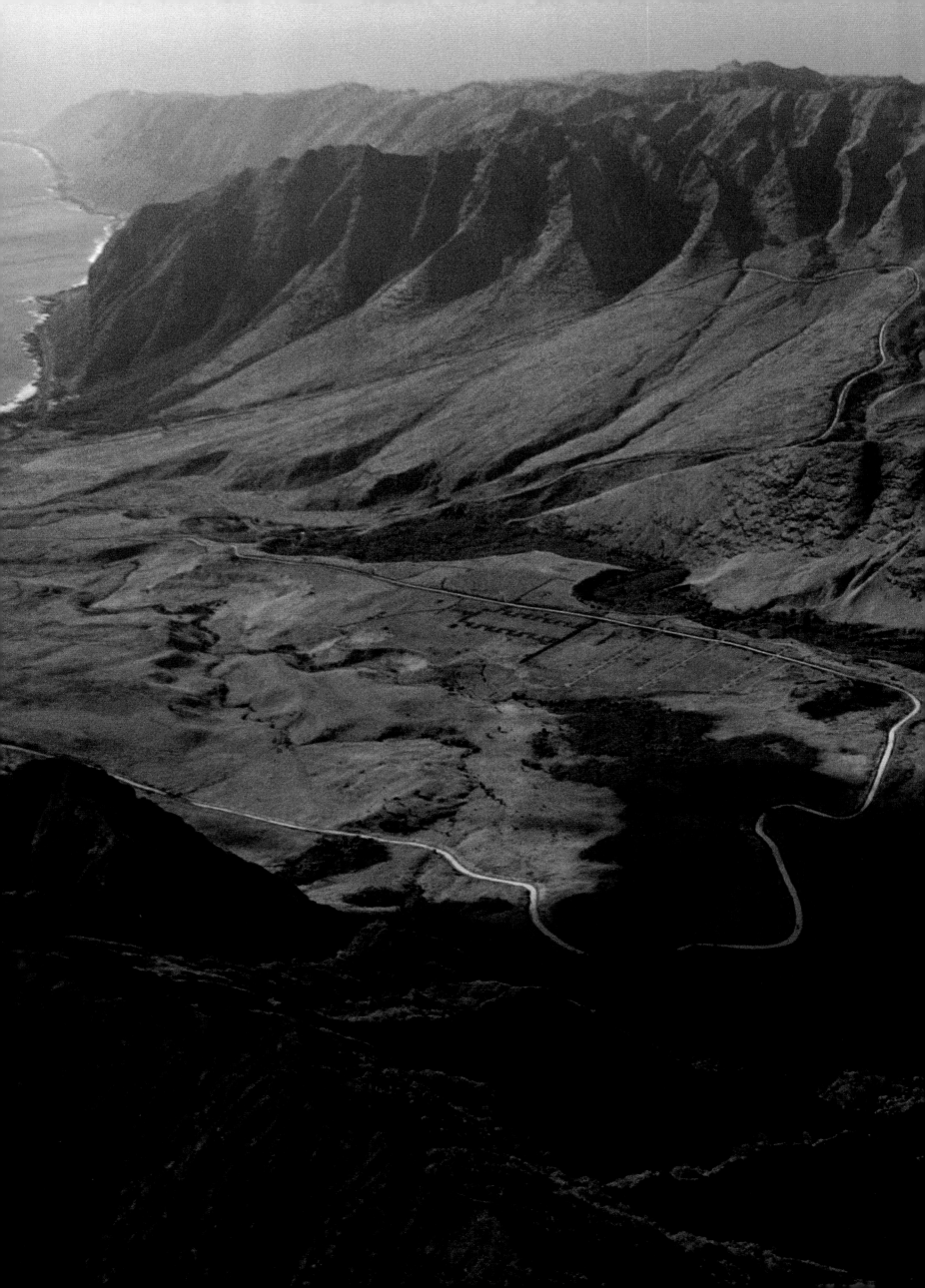

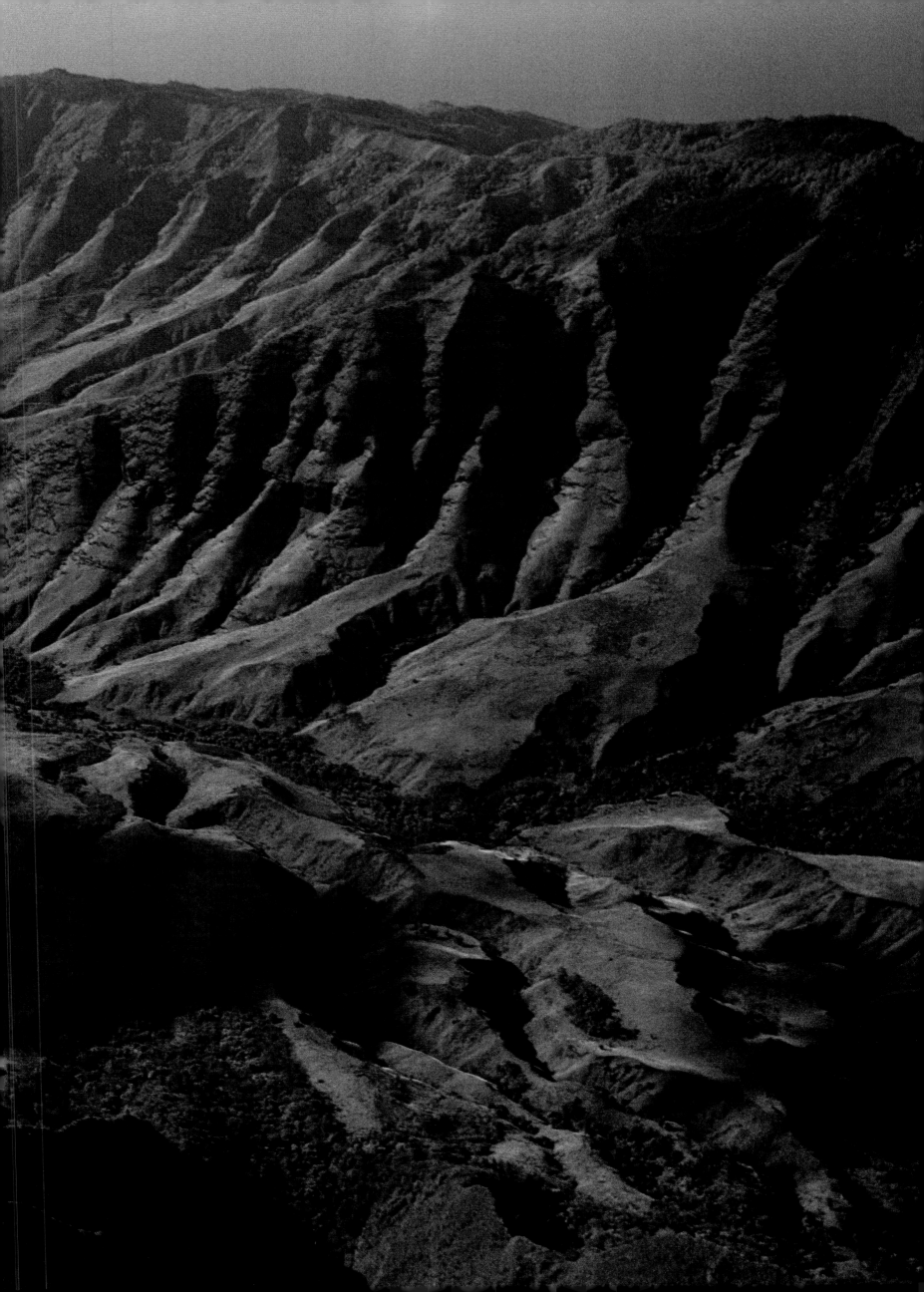

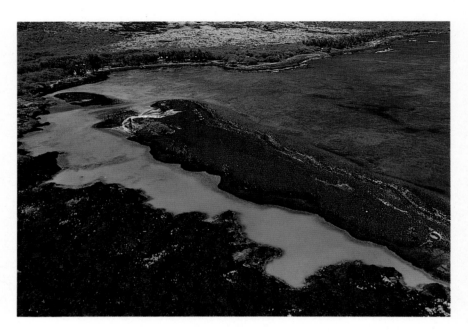

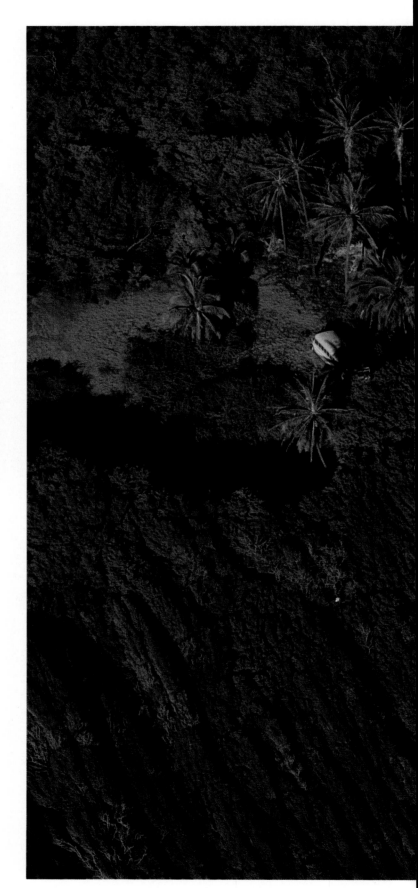

Above: A hot stream of dense pāhoehoe (liquid) lava slid over an earlier flow of more porous ʻaʻā (clinker) lava, and wave action undercut it to create this luminous tidal pond at Kīholo Bay, Hawaiʻi.

Right: Wind-combed naupaka shrubs and ironwood trees adorn the coast of northeastern Lānaʻi. Trade winds funneled through the Pailolo Channel between Molokaʻi and Lānaʻi not only batter the coast but ships as well. Shipwreck Beach is not far from here.

Following pages: Napili blowhole, near Kapalua on Maui. There are several blowholes in the islands, created when erosion pops the top of a sea cave and the in-rushing waves power mist through the opening.

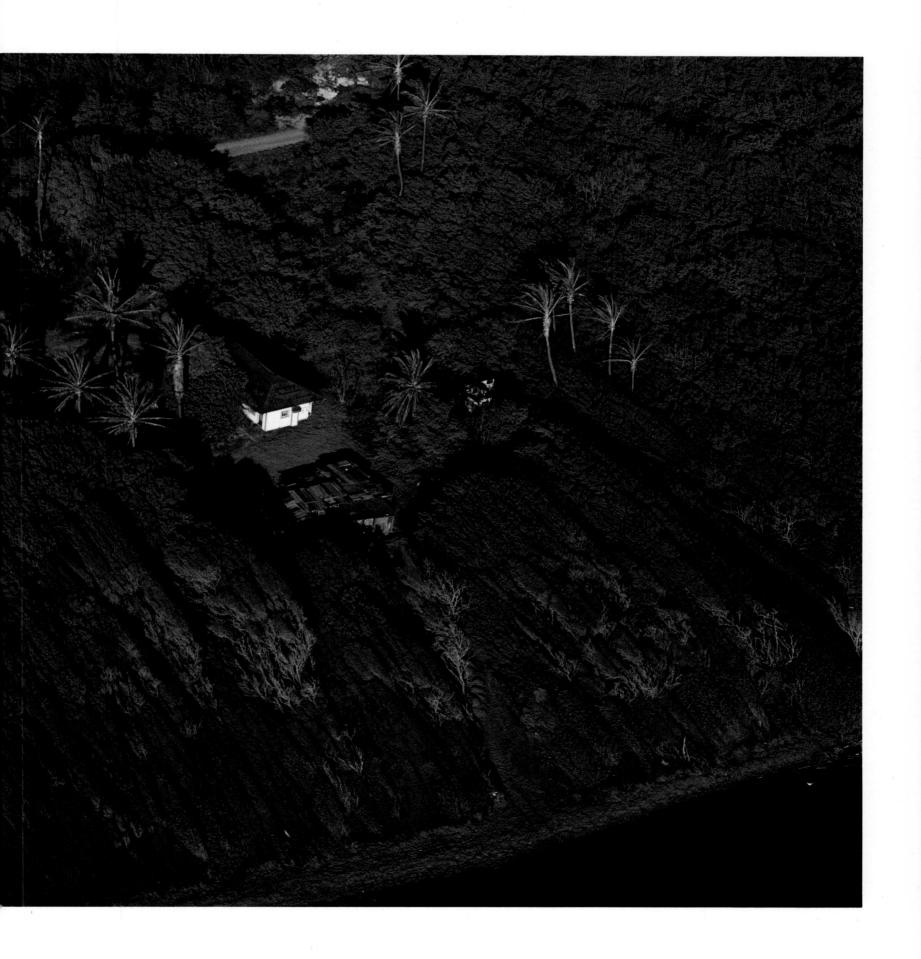

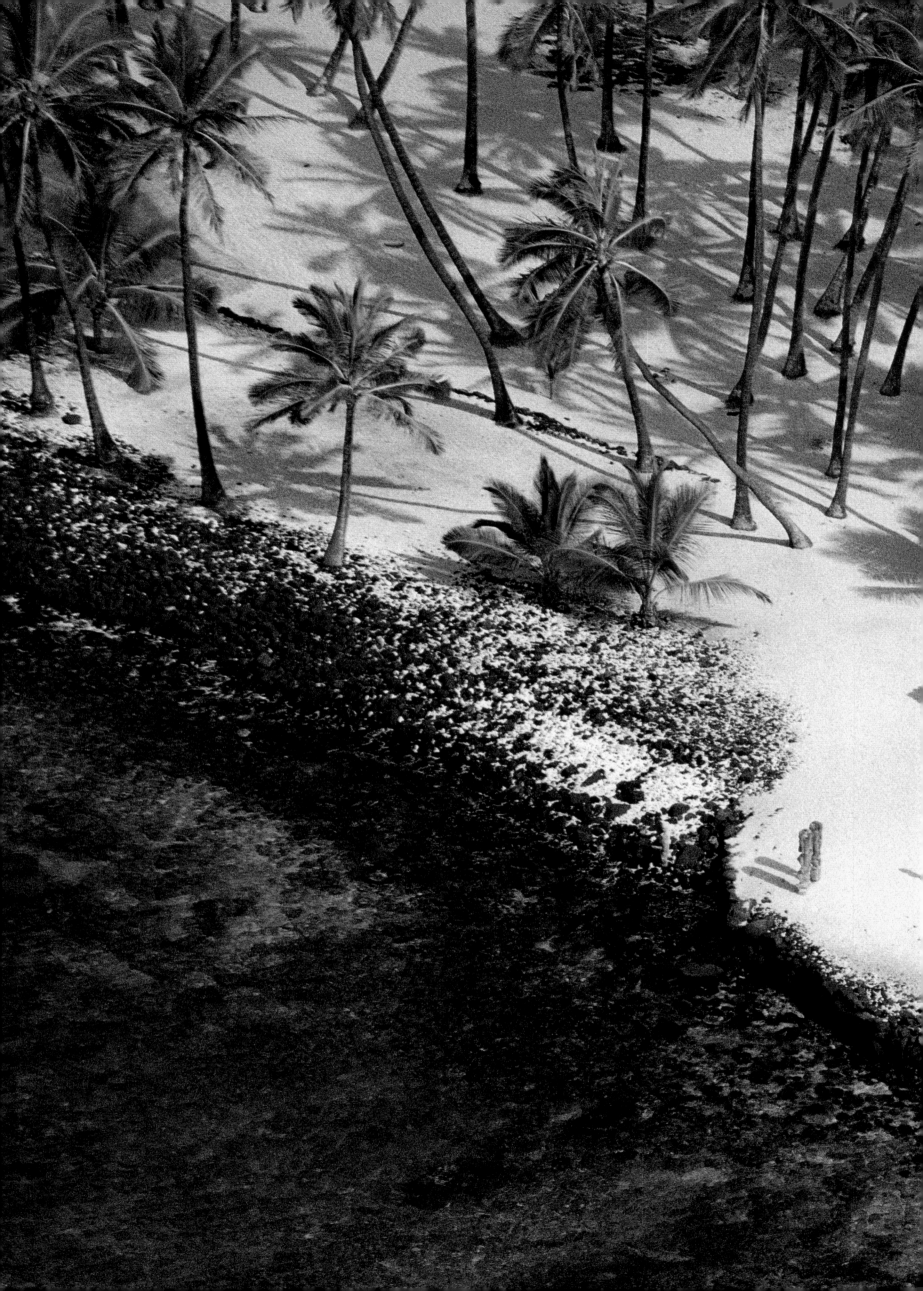

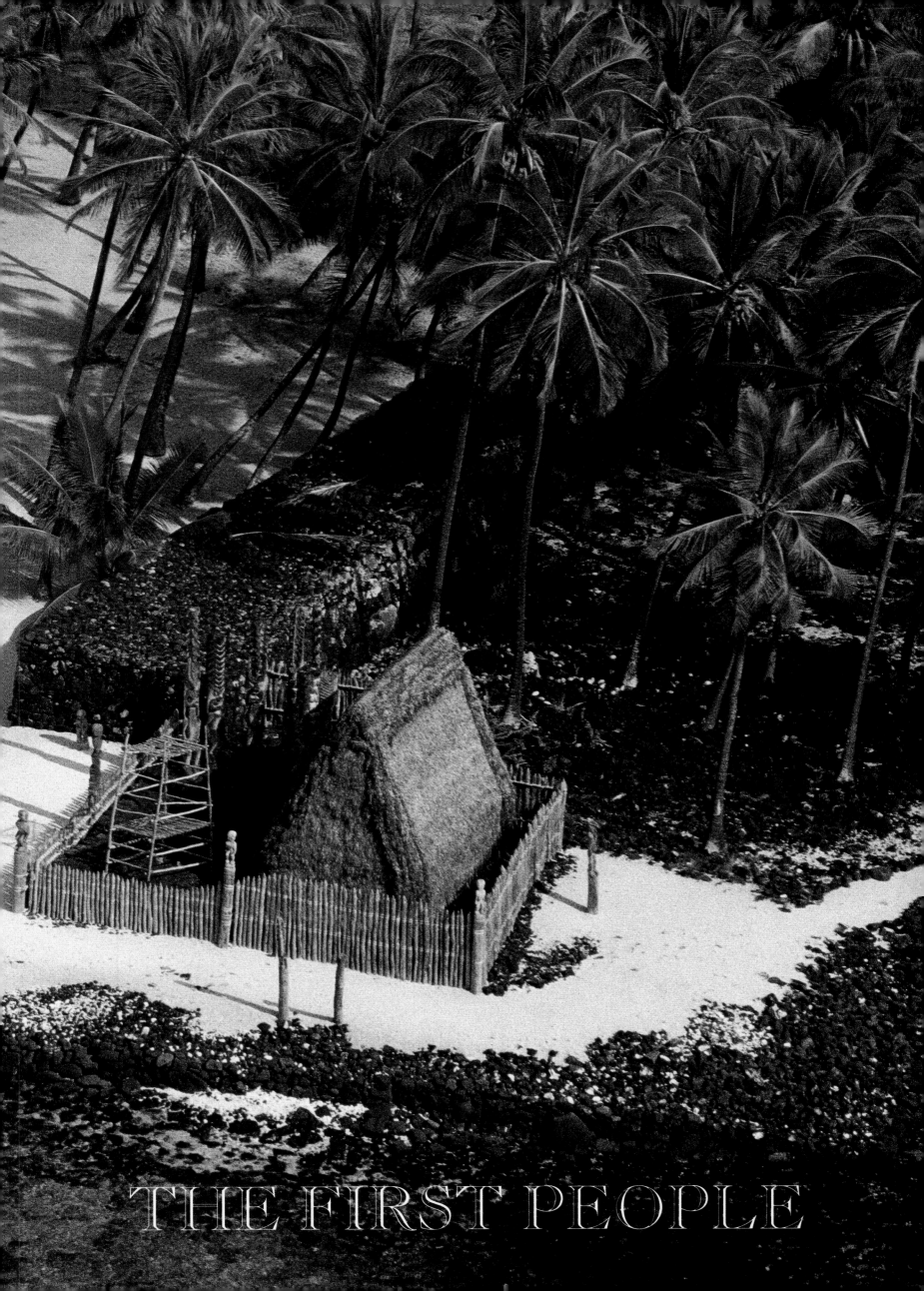

THE FIRST PEOPLE

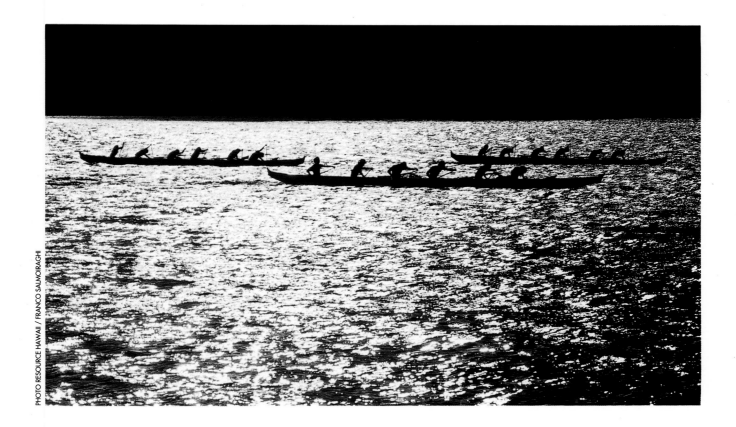

THE FIRST PEOPLE

In the myths of Hawaiʻi man rose from the earth and reached for the heavens. He was the striver, rooted in the practical but aspiring to his dreams. His body came from the gods, who created him out of dirt, air and water, the four basic elements: dirt for substance, air for breath, and two kinds of water—the ocean and rain—for movement.

Like the islands, the race called ka poʻe (the people) sprang from their earth mother, Papa, and lived beneath the sky father, Wākea. The water that fell as rain, the seeds of Wākea, blessed the ground with streams and springs and brought forth life. Each island was a basin that filled with the rainwater and gave birth to wao kele (the rain forest). Ka poʻe believed they too sprang from the land, not just as walking plants or walking earth, but as manifestations of everything in their world: roots, branches, mud, rock, wind and sky, the children of the rain forest, the children of the volcano. Theirs was a sexual universe in which the mingling of all cosmic dualities—male and female, light and dark, high and low—were explained in human terms. They saw the thighs of Wākea in a cloud shape with his rain shaft pounding the land. They saw Papa spread her legs in the sea and give birth to a mountain.

Ka poʻe grew and prospered. They learned to change their bodies into other shapes, as the clouds and lava did. There were shark people, eel people, bird people. They carried their spirits into death and back into life as ʻaumakua, family gods that inhabited animal bodies and guided their descendants. In the ancient forests the bird ʻaumakua showed the people where to find the great koa and mēhamehame trees that contained canoe hulls. Ka poʻe cut out the hulls with basalt adzes. They wound coconut fibers into sennit cords, weaved hala leaves into sails, and set off for unknown lands beyond the horizon.

These are the legends of how the people came to find the isolated islands called Hawaiʻi.

Previous pages: In 1650, Chief Keawe constructed this house to store the bone bundles of dead aliʻi (chiefs) at Puʻuhonua (place of refuge) on the Big Island. *Left:* The face of the sky god Wākea (visible in the cloud in profile: eyebrow, eye, nose, mouth and chin) peers into a valley above Seven Pools on Maui. *Above:* Outrigger canoe paddlers race across the sparkling waters of Kāneʻohe Bay, Oʻahu.

Scientific studies suggest that Hawai'i was the farthest point in a string of islands colonized by eastward-sailing Indonesians who had ventured into the Polynesian triangle sometime before the tenth century B.C. The kinds of plants and animals they brought and the similarities in language among the island cultures suggest that the groups that became dominant in Hawai'i migrated from the Marquesas and Society Islands. The Tahitians referred to the distant volcanic chain to the north as Hawai'ia, Burning Hawai'i.

The discoverers and first settlers of Burning Hawai'i sailed over the greatest body of water anyone had seen. What we know about Hawai'i's aboriginal Polynesians is sketchy, but they were not the same culture that Captain Cook discovered inhabiting the islands in 1778. Ongoing archaeological research keeps pushing back the estimates for initial human contact here. The latest digs on O'ahu have unearthed evidence of artificially altered landscapes and the presence of exotic pollens (of kukui, ti and taro—all plants introduced by humans) that suggest a settlement date between A.D. 100 and 100 B.C. or before. Common to many oral histories of Hawai'i are tales of aboriginal tribes that "the first people" found already living here. These were the Mū, the Wao, the Wā and the Menehune, described variously as forest-dwelling, banana-eating, wild, shy peoples, short or otherwise inferior races that the new colonizers wiped out through warfare and interbreeding. All that remains of their culture are stories told centuries later by their conquerors, and a few stone structures attributed to their craftsmen.

The established, more "modern" Hawaiian traditions began with the new wave of settlers who entered the archipelago around the tenth or eleventh century. They came in large, double-hulled voyaging canoes that carried whole families, and dogs, pigs, chickens, water gourds, coconuts, sweet potatoes, kukui nuts. The navigators kept star charts made of wicker and shells. They watched the fish, sharks, dolphins and whales, all 'aumakua, and they read the movement and colors of the sea and sky. On the stern of each hull they carved tikis with staring mother-of-pearl eyes.

Where the first of the new wave of settlers reached landfall is uncertain, although one of the ancient chants names Lāna'i, the small island west of Maui. Lāna'i means "day of conquest," possibly because it represented the dawn of conquest over the original inhabitants.

Right: Pu'uomahuka heiau in the hills above Waimea stream and bay on O'ahu's north shore. Credited to Menehune builders, and a birthing site for royalty, this is probably the place where three of Captain George Vancouver's crewmen were offered in sacrifice in 1794.

Opposite: Looking over Mānana Island to Makapu'u Point, O'ahu, which the goddess Pele's sister Hi'iaka praised in a chant: "We love the place, the watch tower, from which we can see the canoes, with their jibbing triangular sails, sailing back and forth between here and Moloka'i."

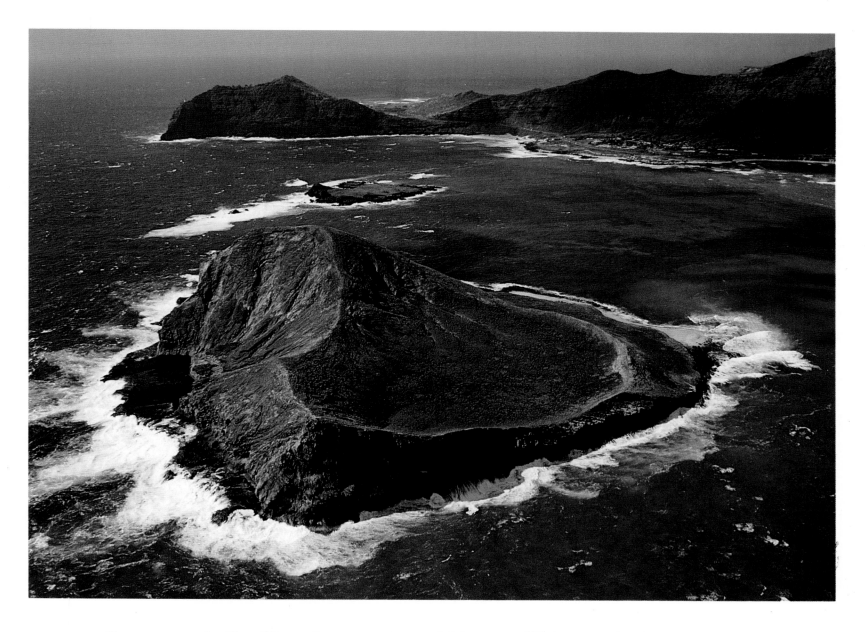

For some people, Hawai'iloa, a famous mariner and fisherman of Tahiti, was the discoverer of the Hawaiian Islands. He found the Big Island first and sailed home to fetch his relatives. They settled on all the islands, and many places bear their names: the volcano Hualālai after Hawai'iloa's wife, Hāmākua District after their last child, the rock islets Lehua and Nihoa after men in Hawai'iloa's entourage. On one of his return visits south, Hawai'iloa discovered his brother Kī had abandoned the family gods in favor of the man-eating god Kūwahailo (Kū of the maggot-dropping mouth). Hawai'iloa therefore made a declaration called Papa'ena'ena (forbidden with red-hot rage) that cut communication with the Tahitian homeland, and for centuries there were no voyages between the two island groups.

Hawai'iloa is also said to have undertaken a voyage to the cold lands of the "slant-eyed" people. He brought back two members of this peculiar race to Hawai'i, where the natives admired the strangers' eyes and pale skin.

Of subsequent migrations the two most notable, and those from which Hawaiian legends derive the best stories, are those of Māui and Pele.

The explorer Māui was also a fisherman. He carved a fishhook from the enchanted jawbone of his half-living half-dead grandmother and pulled up islands with it. Some say he fished up the entire Hawaiian chain. Then he stood on the summit of Haleakalā on the island named for him and pushed back the sky. He wrested from the 'alae (the sacred mud hens) the secret of which trees had fire hidden in their branches; the 'alae taught him how to make a fire plow, a pointed stick that he rubbed in the groove of a dry limb until it made embers.

The Māui stories may be metaphors. A figurative way of saying Māui was a great navigator who discovered new islands: he fished them out of the sea. He expanded the horizon by lifting the sky. He learned the secrets of the forest, which plants held fire and which held various herbal remedies. His exploits earned him demigod status throughout the entire Polynesian pantheon.

The Pele myth cycle is the most extensive one recorded. Pele was born as a flame on the tongue of her mother Haumea. Pele's youngest sister, Hi‘iaka, emerged as an egg. Babies sprang from Haumea in strange ways, from her breasts, from her forehead.

Pele had an older sister named Nāmakaokaha‘i, a jealous, merciless virago whose husband fell in love with Pele. Nāmaka wanted to kill the lovers, but they escaped, along with most of the family, including Pele's parents and cousins. To avoid Nāmaka's wrath, they had to abandon their home islands. The group sailed north in the double-hulled canoe Honuaiakea, looking for a distant group of islands they had heard of. On the voyage Pele carried the Hi‘iaka egg nestled between her breasts to keep it warm. Hi‘iaka's full name after birth became Hi‘iaka-i-ka-poli-o-Pele (Hi‘iaka in the breast of Pele). Meanwhile, Nāmaka's rage grew. She built her own canoe and followed the fugitives' sea path, hoping to catch Pele and exact her revenge.

Honuaiakea crossed the ocean and landed first at Nihoa in the Leeward Islands. Pele had already learned volcano sorcery from her uncle, and she dug into Nihoa with a fire "divining rod" called Pā‘oa, looking for lava. She struck only water. They sailed on to Ni‘ihau and Kaua‘i, where Pele dug again and found more water. On O‘ahu, Pele's clan traveled down the windward coast. They discovered a beautiful cave on a narrow northern peninsula where the waves broke over an expansive, shallow reef. One of the travelers—a woman named Kahipa who was famous for having long breasts—stayed here and made her home. Farther down the coast at Kualoa several other members of the group, including Pele's parents Kānehoalani and Haumea, decided to settle. The rest moved on to Moloka‘i, where Pele again dug for and failed to find the earth's fires. On this shark-shaped island Pele's brother Kamohoali‘i remained. His kino lau (animal body) was a shark, and he had already become a shark many times to lead Honuaiakea through the unfamiliar northern waters.

From Moloka‘i's shores Pele could see the huge volcanoes to the southeast. She headed toward them. Her quest for lava ended on the island of Maui, in Haleakalā Crater. Here she opened cinder cones and spatter cones and lava rivers, and she shot the molten rock into fountains so high they lit up the night like rising suns.

By now Nāmaka had sailed within range of Hawai‘i, and when she saw the volcanic celebration firing up the sky she knew where Pele was. She caught Pele on the Hāna slope and killed her, burned her body and scattered her bones over the land. Pele's magic was so powerful, however, that she was able to restore herself. Her apotheosis came at Mauna Loa on the Big Island, where her spirit collected all the bodies a woman grows through, from young girl to haggard crone. People would see the goddess after this—and still do see her—in many of her manifestations. Usually her appearance exemplifies goddess: mature, radiant, sexually desirable. Sometimes she comes as an old woman with snow white hair, often walking a snow white dog. Sometimes she is glimpsed in the smoke rising from the volcano, or in the fire fountains and shifting lava.

Pele's power has fired the volcanoes of the Big Island almost unceasingly since the Hawaiians settled here. Her destruction and construction of the landscape are the source of many tales, including contemporary stories about the eruption she started in 1983, said to be an angry reaction to geothermal drilling in the Puna District.

The impact of Pele in Hawai‘i extends beyond vulcanism. She is credited with the wide dispersal throughout the islands of the hala, or pū hala (pandanus or screw pine) trees. It happened that when she landed her canoe on the shore of the Big Island it got entangled in the aerial roots of the hala. Pele

‘Ānuenue, the rainbow goddess, blesses Waimea Canyon.

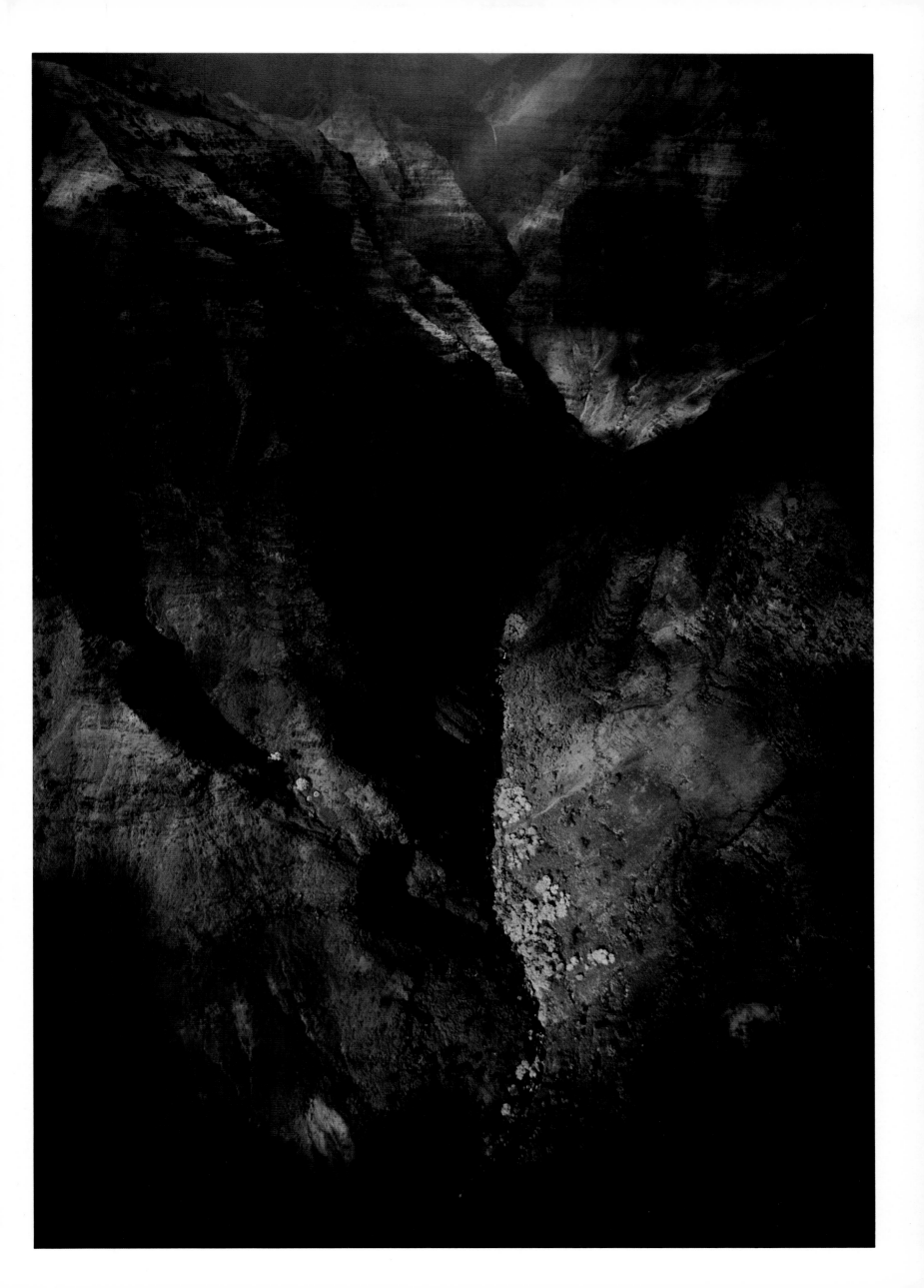

had so much trouble extricating her outrigger that she started tearing apart the trees and flinging bits all over. They landed on every island and sprouted.

The 'ulu (breadfruit) tree also spread in a legendary fashion. The first 'ulu were the oversized testicles of a man in the islands whose relatives cut them off somehow, cooked them in an earth oven and had their friends over for the feast. When the friends discovered they had eaten testicles they vomited everywhere for days, propagating the breadfruit.

In fact, the early settlers brought the 'ulu with them in their canoes. Each double-hulled wa'a carried 20 to 40 people, along with the agricultural seedlings and transportable foodstuffs the voyagers needed to survive. They brought the plants favored by their Indo-Malayan ancestors: yams, taro, gourds, ti, sugarcane, bananas, bamboo, mountain apple, coconut, sweet potato, paper mulberry, hibiscus, wild ginger, turmeric, kukui and hala. Animals shared the crowded canoe space as well—those pigs, chickens and dogs the Hawaiians packed in cages, and the rats and insects that rode as stowaways.

As more people landed on Hawai'i's shores and the established families grew, there began fierce competition for land. Raids escalated into border wars. There were times of peace as well when the chiefs, called ali'i, had the mana (spirit power) to establish just laws. They saw how dangerous their increasing population was to the forest and the fish habitats, and they expanded their system of kapu to include conservation. Overcultivated and overfished areas became forbidden, kapu, until the ali'i declared them abundant again. Then the maka'ainana (commoners) could harvest freely.

The ali'i governed with the guidance and consent of the priests. Kapu could not be enforced without the threat of supernatural punishment. Four great gods, called akua, ruled the world: Kāne, the god of sunlight, water and forests, the god of creation; Kanaloa, the god of the ocean; Kū, the god of war and other work by men; and Lono, the god of harvests. The gods watched over the islands from the clouds, and the kāhuna (priests) listened to their voices on the wind. Religion controlled every kind

Right: Sunset from Haleakalā, Maui, where, in one of Hawai'i's greatest legends, Māui the demi-god attacked the sun god Lā because Lā raced too quickly through the heavens and the days were too short. Lā agreed to go slow for half the year and race the other half, and this accounts for the long days of summer and short days of winter.

Opposite: Ka Lae (the point), the southernmost tip of the Big Island and the southernmost point of land in the United States. For decades archaeologists believed the South Point area contained the oldest evidence of human habitation in Hawai'i, dating back to A.D. 750. Recent findings on O'ahu, however, predate the South Point remains by at least 600 years.

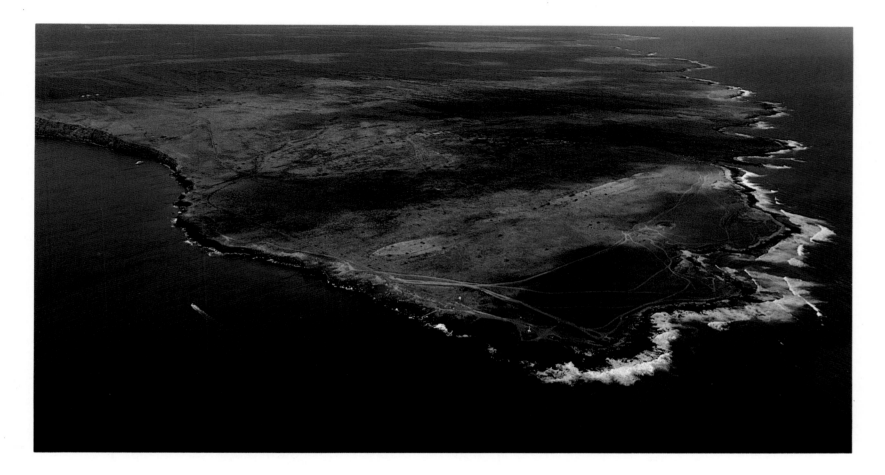

of behavior; in fact, it so permeated the culture that the Hawaiian language had no separate word for religion. Temples were built. These were rock platforms and walls with tikis (in Hawaiian, ki'i) standing guard over the altars and sacred huts. In oracle towers the kāhuna stood closer to the sky. With air above them and air below, the priests were in the element of divinity. They understood the currents of the sky the way navigators understood ocean currents. The temple was called a heiau: *hei* meaning to ensnare, *au* the energy of the sky.

In the twelfth century a new priest named Pa'ao migrated from Tahiti, bringing sterner laws. His akua was Kū, the war god. Pa'ao built a temple for Kū in Puna at Pūlama, and introduced human sacrifice. This luakini heiau (temple of human sacrifice) was called Waha'ula (red mouth), for the blood. Pa'ao quickly became a mighty warrior chief on the Big Island, and his second temple, the heiau of Mo'okini at Pu'uepa in Kohala, is a monument to his power. A line of workers passed stones from the coast to the temple site.

Having established his preeminence on Hawai'i, Pa'ao sailed to Tahiti to bring back a cousin of the purest ali'i blood to help him rule. His chant to his cousin must be like other chants sung by returning Hawaiians who hoped to lure their relatives to the new islands:

> Here are the canoes, come aboard.
> Return and dwell on green-backed Hawai'i,
> A land discovered in the ocean,
> Risen up out of the waves
> From the fiery depths of the sea,
> A piece of white coral left dry in the ocean,
> Caught by the hook of the fisherman. . . .
> When the canoes land, come aboard.
> Sail away and possess Hawai'i, a land.
> A land is Hawai'i.
> A land is Hawai'i for Lonoka'eho to dwell in.

Lonokaʻeho, the invited cousin, declined, but another named Pili accepted and returned with Paʻao to solidify the Tahitian presence in green-backed Hawaiʻi. Under Paʻao the Kū ritual and priesthood spawned a succession of kāhuna that ran unbroken through 28 generations to Hewahewa, the high priest of Kamehameha the Great.

Those two pale Asians that "the discoverer" Hawaiʻiloa brought back in the early days were precursors. Sometime between the thirteenth and sixteenth centuries (the oral accounts are difficult to date) a storm-blown boatload of what were probably lost Japanese traders washed ashore in Hawaiʻi—probably Japanese because they had with them a long sword that seemed made out of sunlight and that was sharper than the wind-honed ice of Mauna Kea. Possibly a samurai sword, it became a prized weapon among the chiefs. The stranded foreigners stayed and were absorbed into the race. What happened to the sword, after generations of passing from one hand to another, is a mystery.

Spanish galleons bound for Manila next touched the islands, possibly as early as the late 1500s. Their Hawaiian discoveries went unreported in the West, and only recently have scholars posited from old charts that Spaniards were the Leif Erikssons of this new world. Whether they actually landed in Hawaiʻi is questionable, although Cook's men were convinced the iron utensils they saw on Kauaʻi—including skewer-like iron daggers and a broken sword—were of Spanish origin.

For the most part, however, Hawaiians developed their culture in isolation. Theirs was a unique society that to this day has never been wholly understood or appreciated by the outside world. As a race the islanders lived like the birds of the high rain forest: virtually disease-free, happy and certain in their

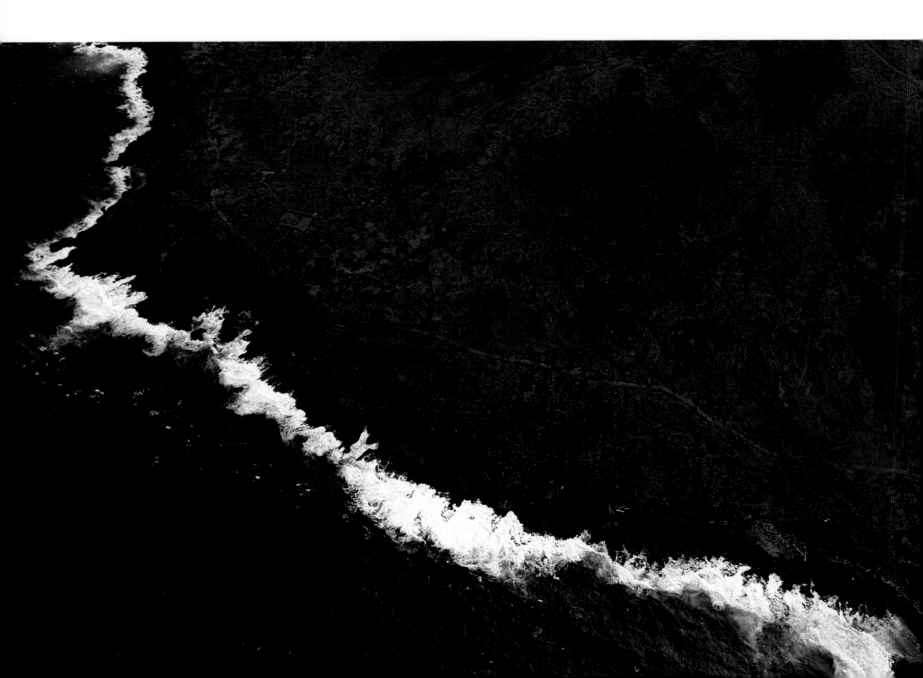

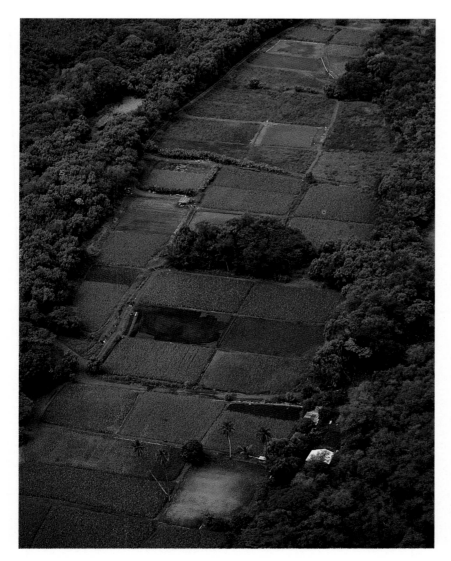

Opposite: Homes in village-style clusters were rare in ancient Hawai'i, except in coastal areas where the fishing was good. The quality and plenitude of fish were so important to life that fishermen would live on the most barren capes to be close to favored spots. *Left:* These dry-land taro plots above Waimea on Kaua'i are laid out in the shape of the hāloa (long root stalk) of the taro. In Hawaiian legend, Wākea's first son, Hāloa-naka, died at birth and was buried, and his body became a taro plant. People were descended from Wākea's second son, which makes the human race genealogically inferior to taro.

daily pursuits, and nurtured by a fragile environment over which they held a specialized mastery.

In the late eighteenth century their culture reached its zenith. It was Paleolithic, but so advanced were its craftsmen that every human need was met with artistic flourish. Food platters, pollen-stuffed woven pillows, tattoos, feather garments; boar tusk, whale ivory, and seashell jewelry; lime-bleached hairdos; stone mirrors, cowrie shell octopus lures, shark tooth daggers, carved spears of every wood; tikis, surfboards, musical instruments, tiny bows and arrows for shooting rats; ti-leaf rain capes, hala sandals, tapa cloth of pounded and stamped wauke bark, 'ie'ie baskets, mahi'ole helmets—every item and fashion had a singular and blessed existence.

The Hawaiians built terraces to grow their taro; they built smooth-faced walls and platforms of fitted stone inside shallow caves; they built rock house-platforms topped by houses thatched with pili grass; they built fortresses to guard their lands; they buried their exalted chiefs in wicker baskets and black tapa; they pecked petroglyphs in smooth lava rock; they erected shrines and altars for hundreds of gods; they found beds of dense basalt on the volcano slopes and turned them into adze-blade quarries; they danced hula and composed chants and were possessed of the most remarkable stories of any people, what the folklorist Nathaniel B. Emerson called "the unwritten literature" of Hawai'i. And just when their society seemed perfect but at the same time undercut by the seeds of revolution (not unlike the high point of any other human culture at any other time), the people living along the leeward coasts of O'ahu and Kaua'i gathered together because someone had spotted something, and they gazed at two strange objects moving across the water.

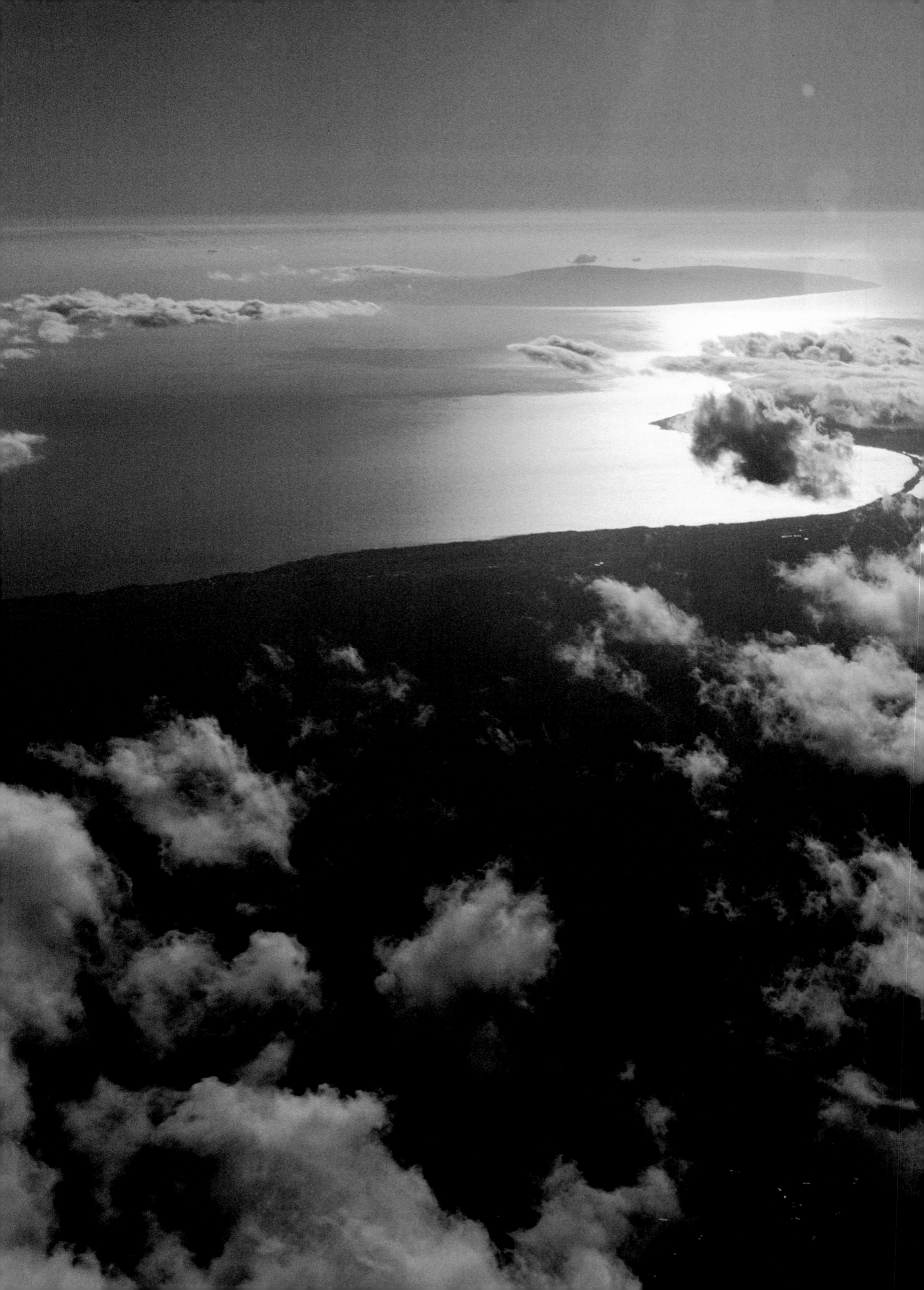

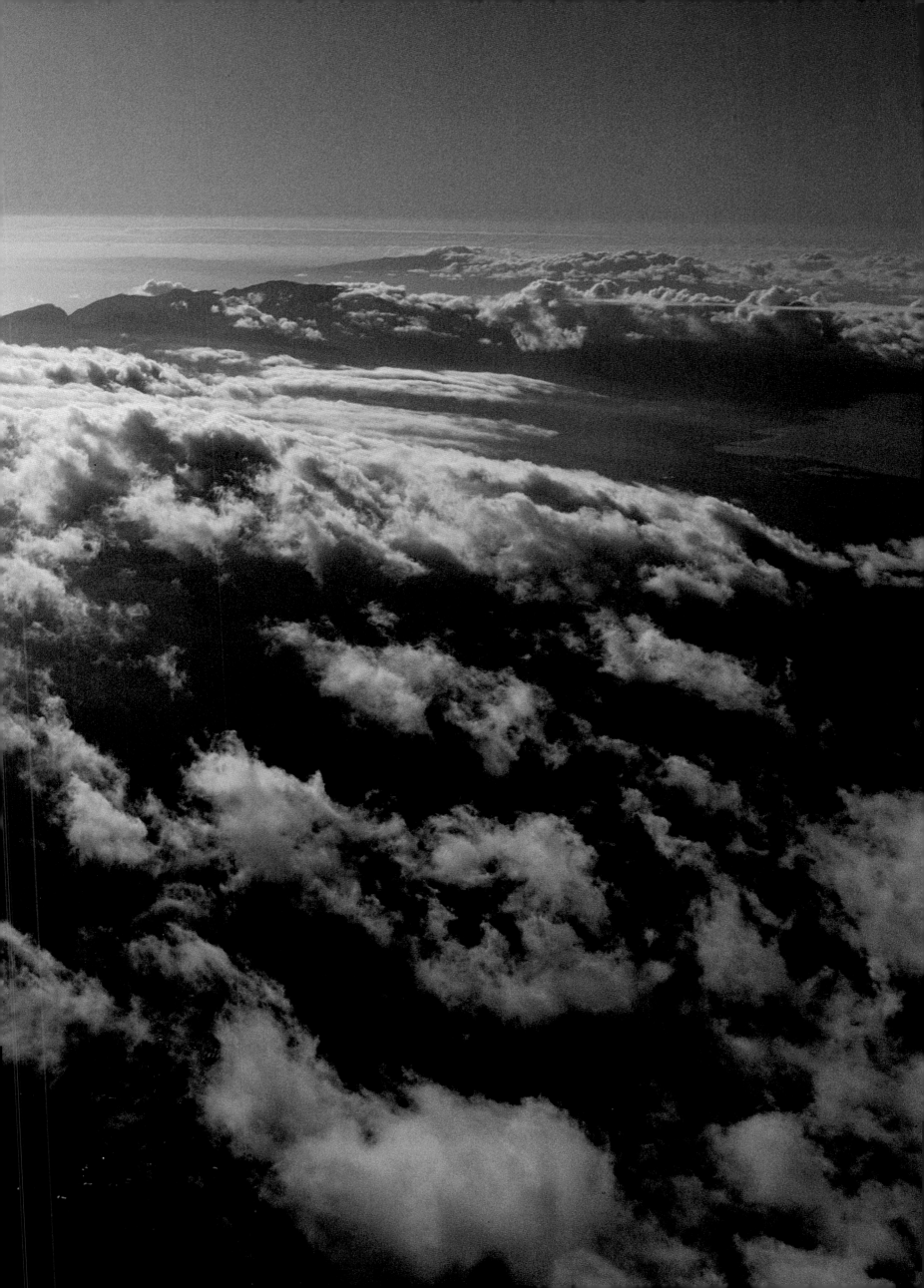

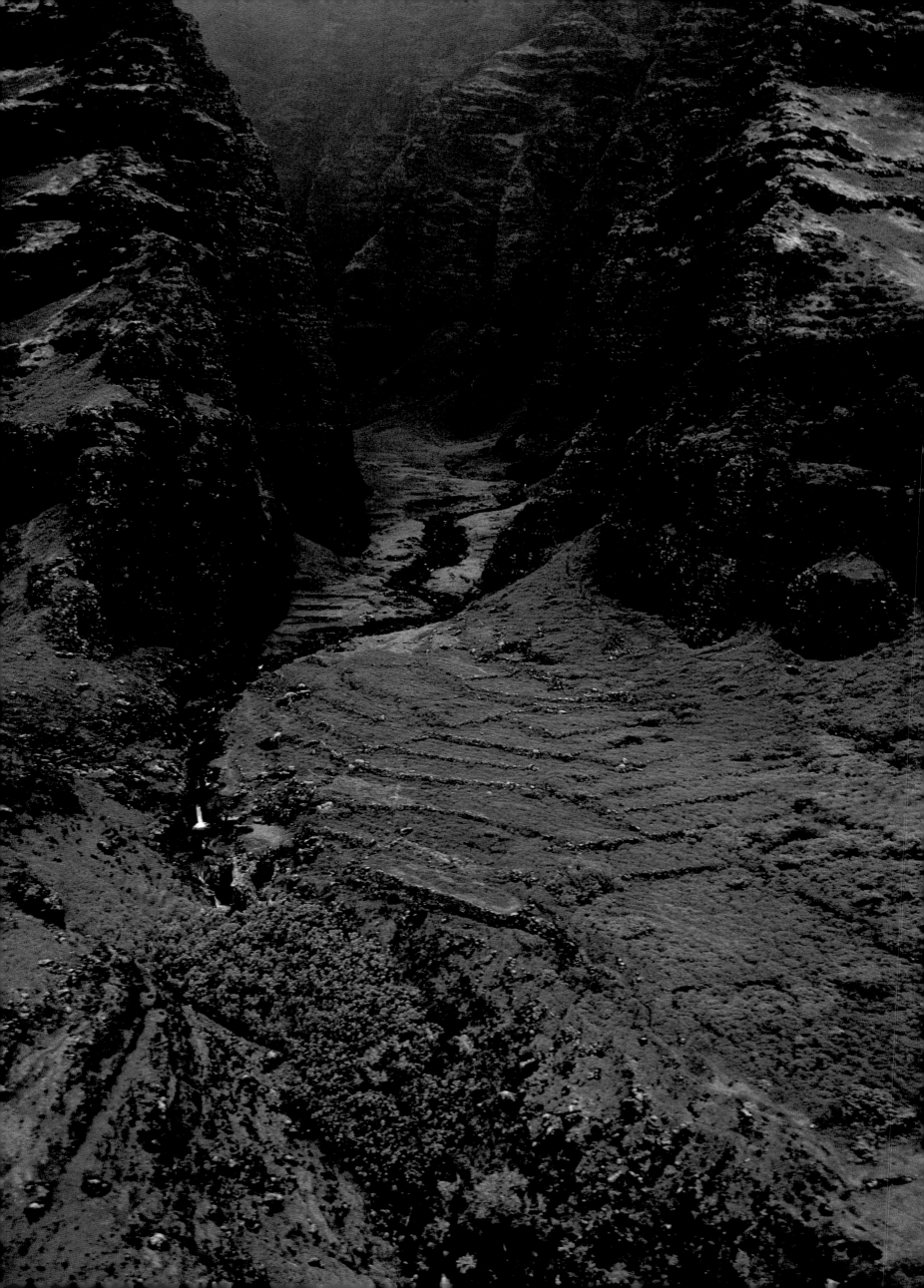

Left: Nuʻalolo Valley, the uninhabited "Valley of the Lost Tribe" on the Nā Pali Coast of Kauaʻi. The remains of terracing and a heiau indicate an active settlement, but the Polynesians who lived here disappeared inexplicably, possibly as long as 800 to 1,000 years ago.

Right: In Hawaiian legend Mokoliʻi Island, off Kualoa Point, Oʻahu, is the fluke of a giant moʻo (dragon-lizard) that Pele's sister Hiʻiaka killed and chopped to bits. Today Mokoliʻi is sometimes called Chinaman's Hat, but neither the Chinese nor the Hawaiians appreciate the name.

Previous pages: From above Haleakalā looking west across Maui's isthmus and south shore. The straight line cutting through the sun glare beneath the clouds is the seawall of Keālia Pond. Sections of four volcanoes of the ancient megaisland Maui Nui are visible in this shot (clockwise from top): Kahoʻolawe, Lānaʻi, West Maui and Haleakalā.

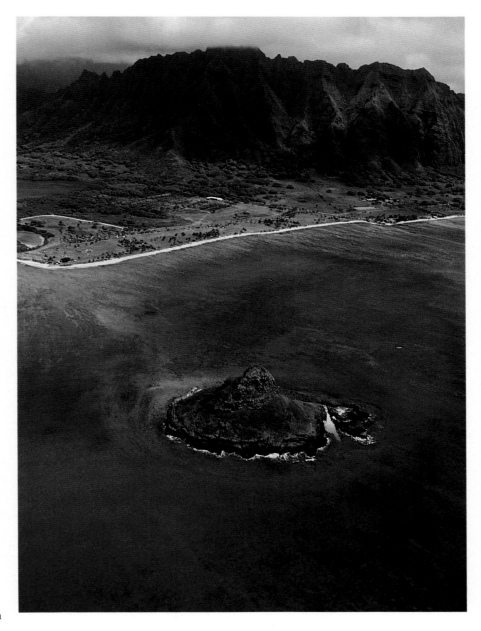

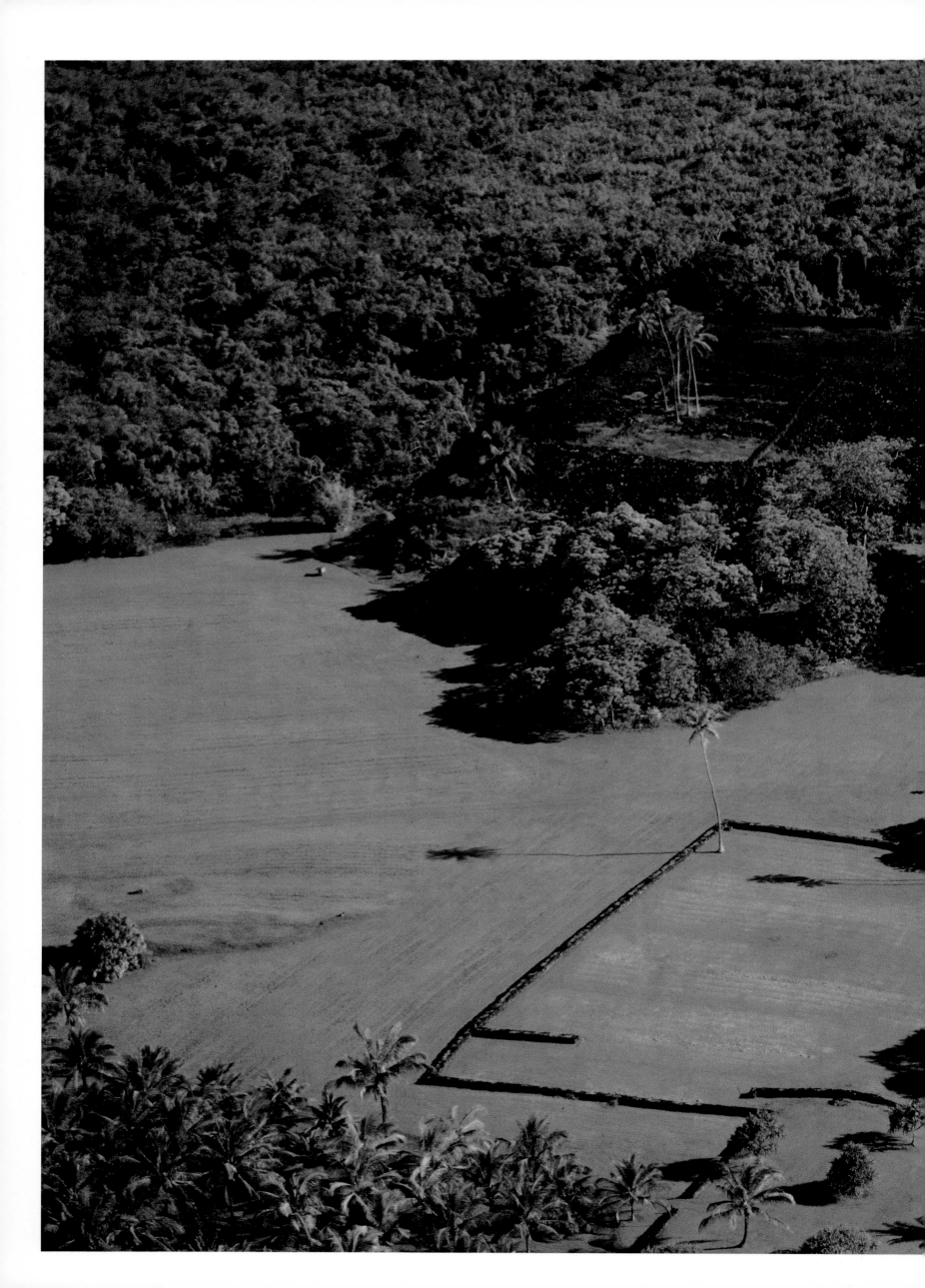

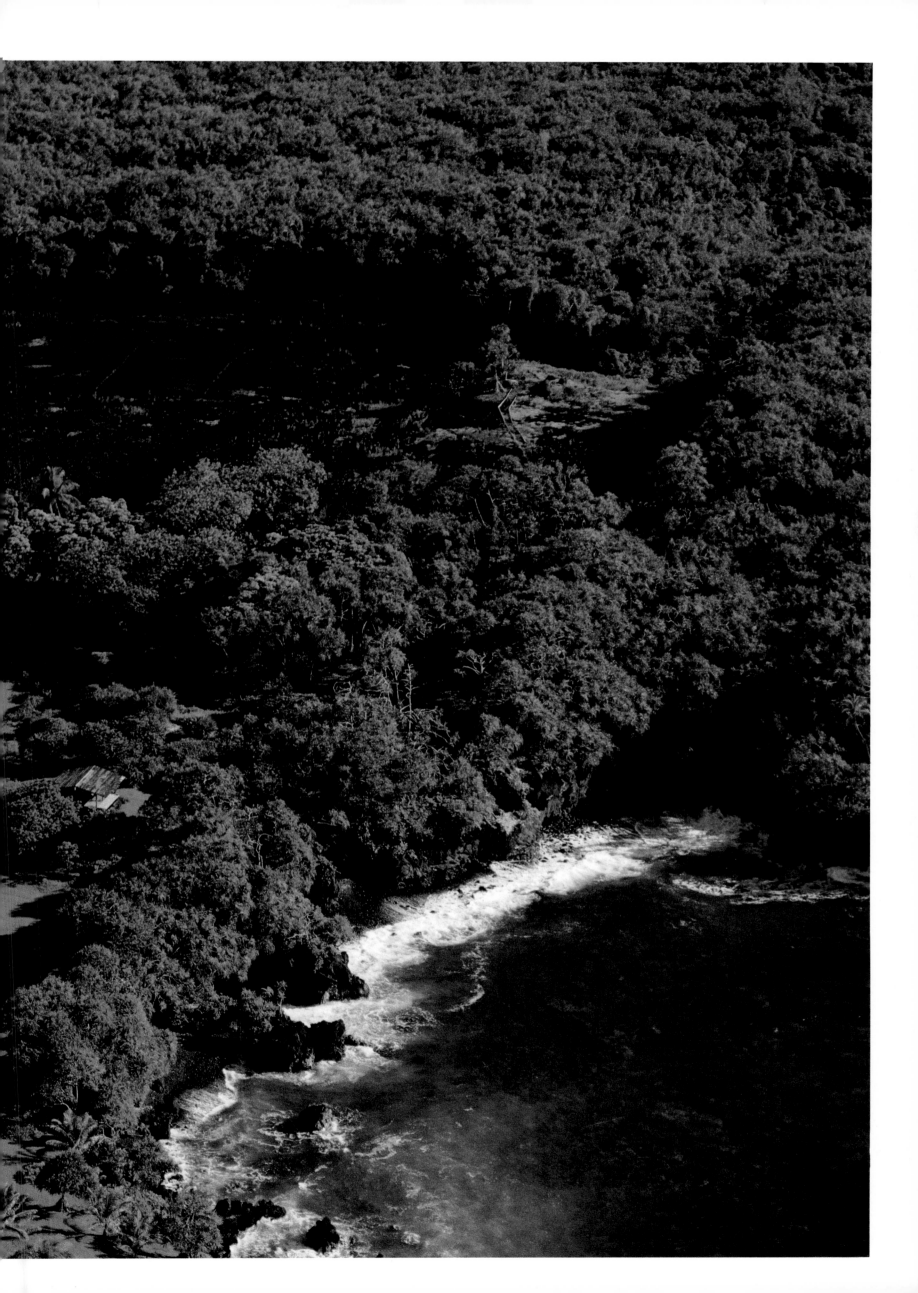

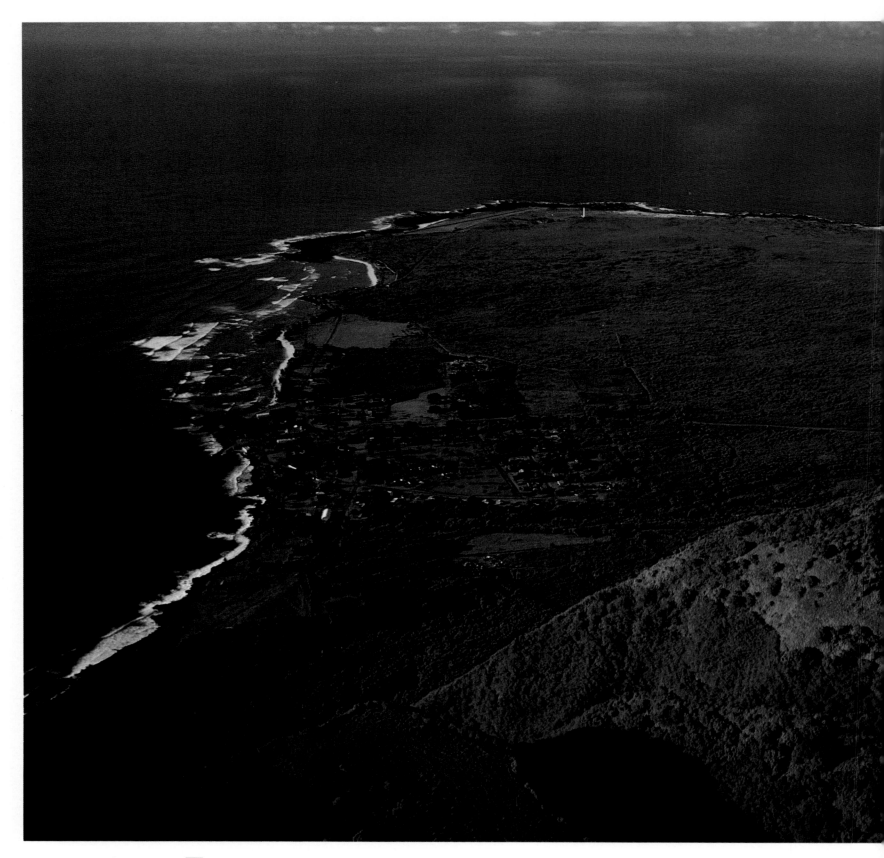

Previous pages: The forest-girdled rock platforms of Pi'ilanihale heiau, near Hāna, Maui, represent the largest preserved ancient temple in the islands. The heiau was erected by Maui's high chief Pi'ilani in the fifteenth century. A caretaker's house sits nearby.

Kalaupapa Peninsula, the fin of the shark-shaped island of Moloka'i. The crater (a close-up is pictured above) is Kauhakō, whose flows created the peninsula. A small brackish pool inside the crater is where the volcano goddess Pele first dug for lava on Moloka'i. After striking water she went on to Maui.

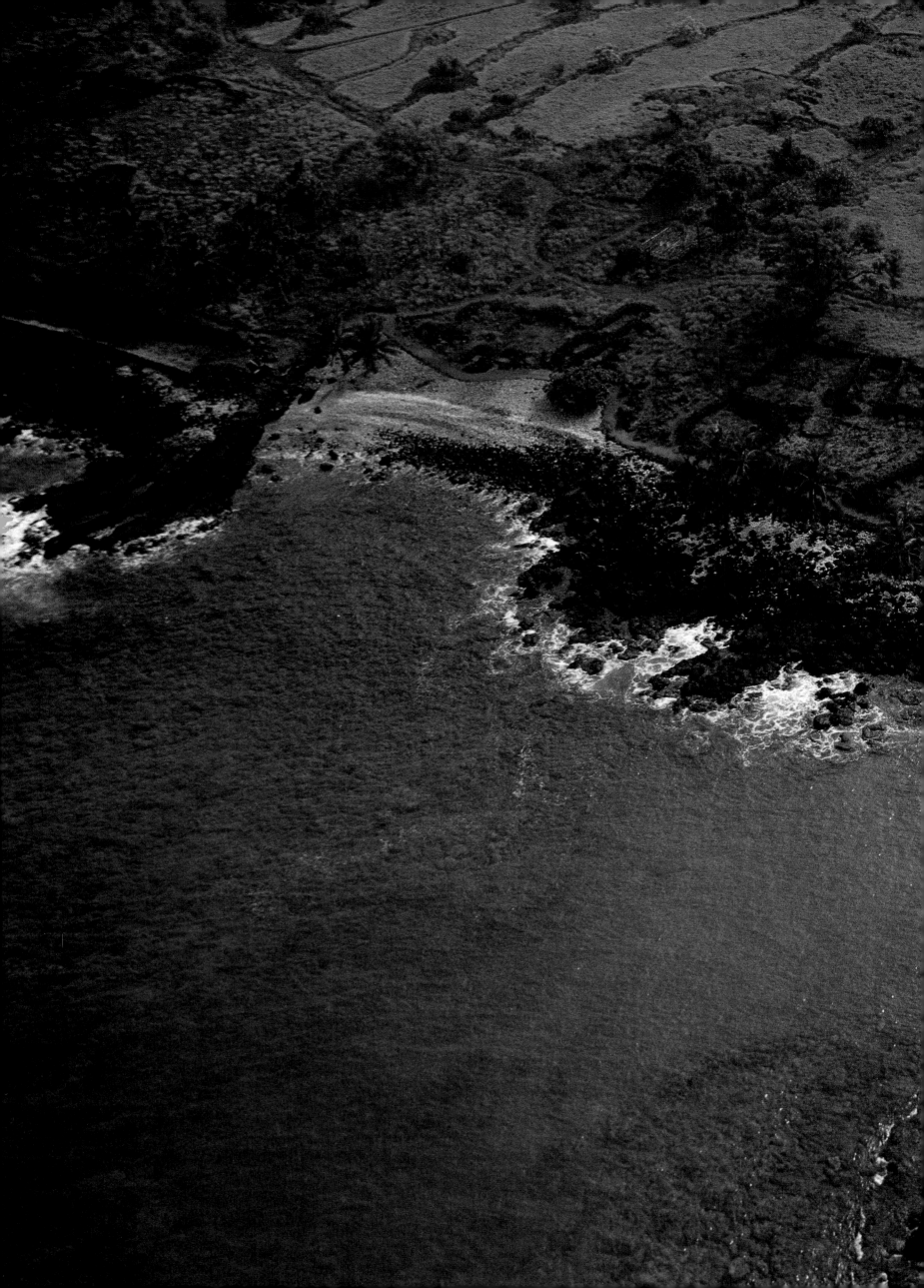

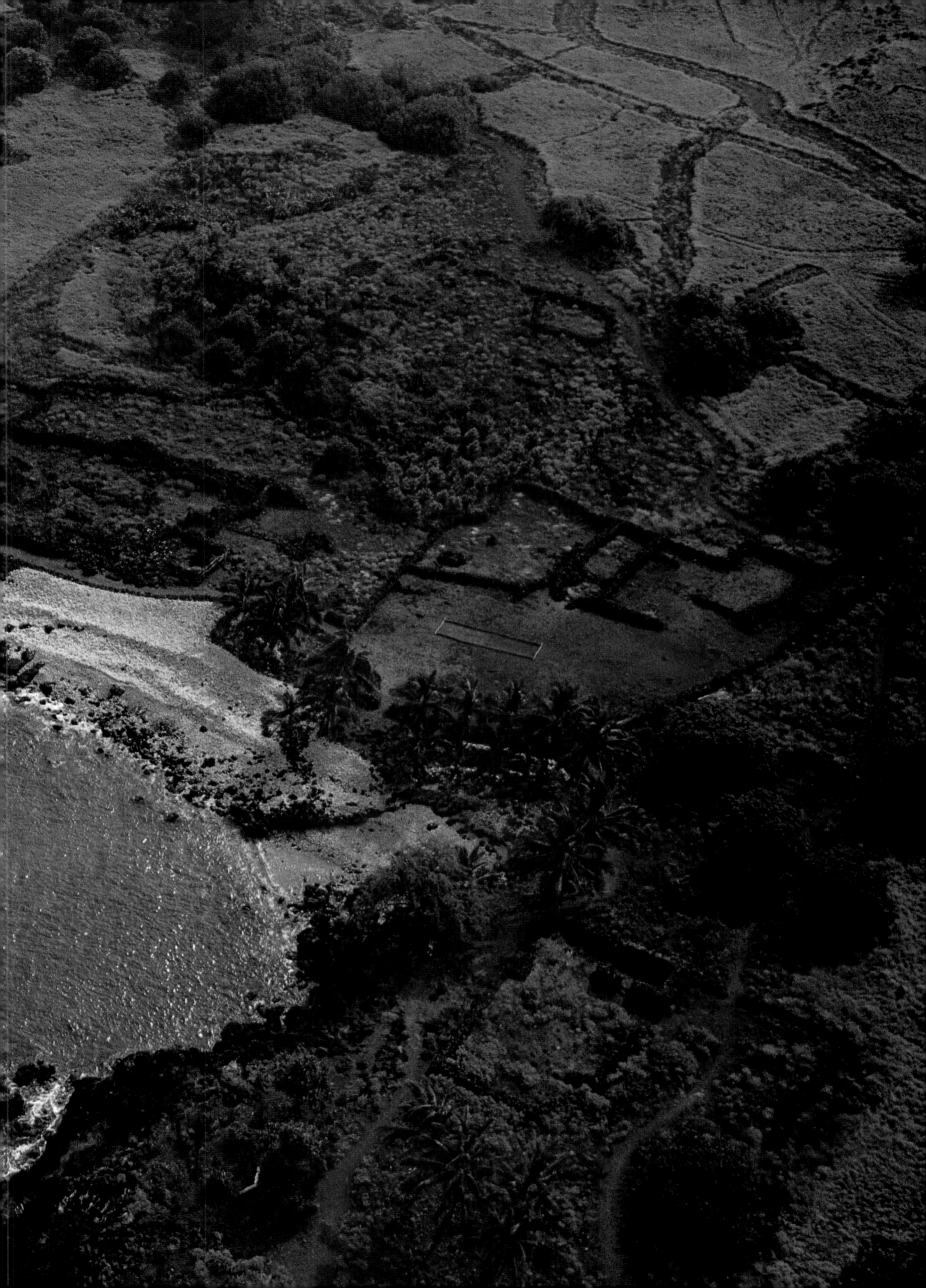

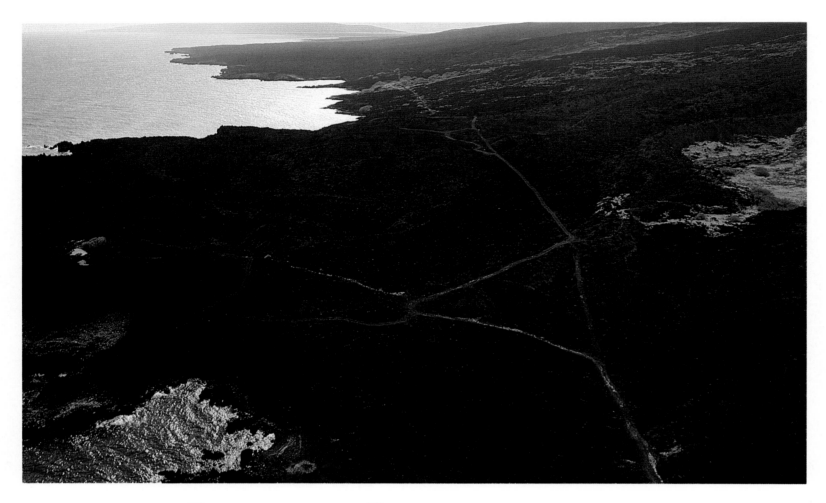

Previous pages: The fishing village of Lapakahi on the Big Island, site of 1968 archaeological diggings. Throughout Hawaiʻi the ancient aliʻi (chiefs) established wedge-shaped land divisions called ahupuaʻa, which ran from coast to mountain peaks. The people of each ahupuaʻa lived in a cooperative community, fishermen trading with farmers and craftsmen. There were no "villages" in the traditional sense of the word, except for the clustered houses of fishermen. The rest of the population lived on plots spread throughout the ahupuaʻa.

Above: "Long Road" (Alaloa), which, unlike those on other islands, made a complete circle around Maui. Over 400 years ago, Chief Kiha-a-Piʻilani directed the construction of this stone path, often called King's Road.

Right: Waiheʻe Valley, West Maui Mountains. The remote elevations in the islands were called wao akua (wild forests of the gods). Supernatural influences found their source in these cloud forests, as did all life. The water from the sky fell to the mountains, the water from the mountains fell to the streams, and the streams filled the irrigation ditches for taro, the Hawaiian staple.

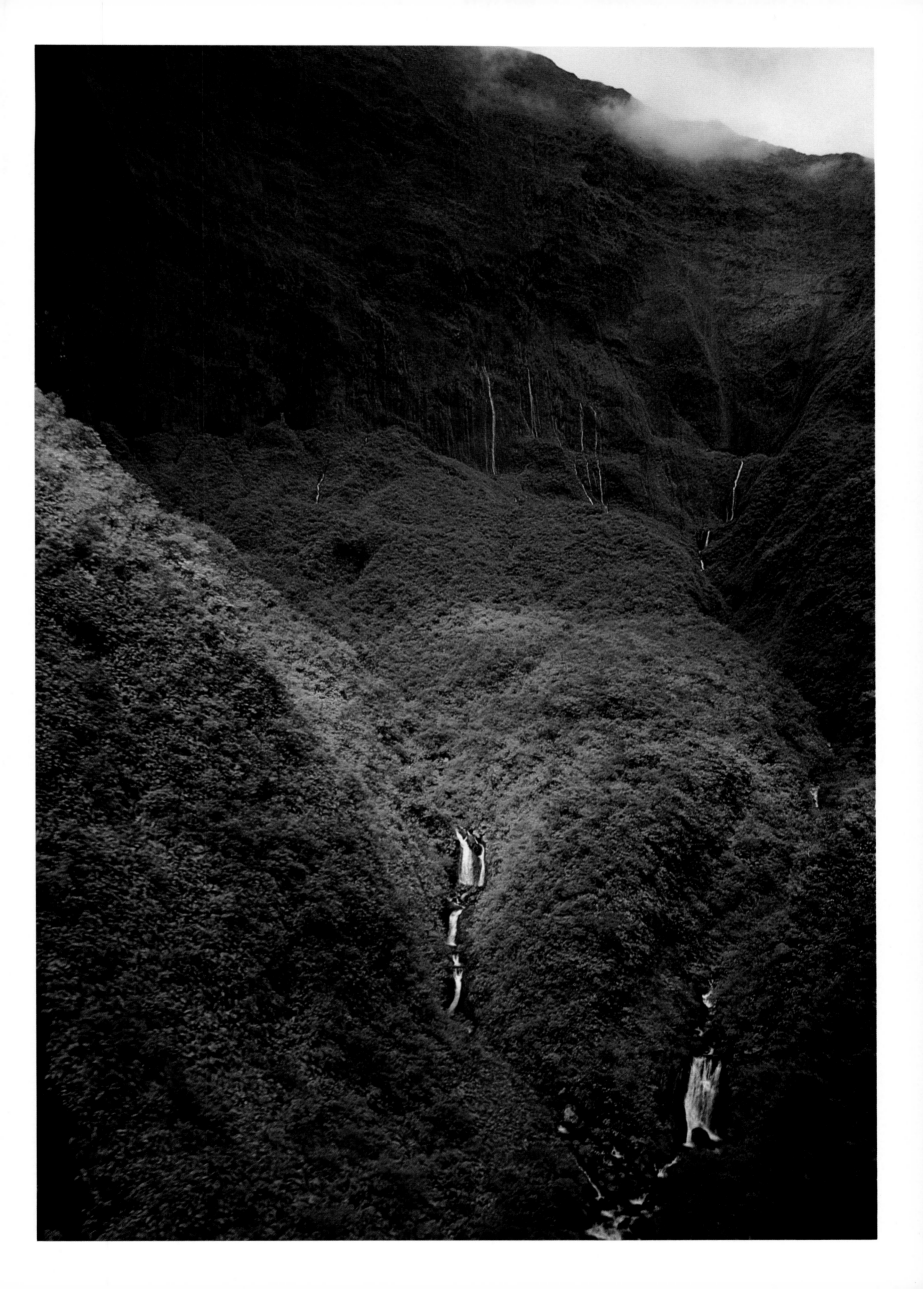

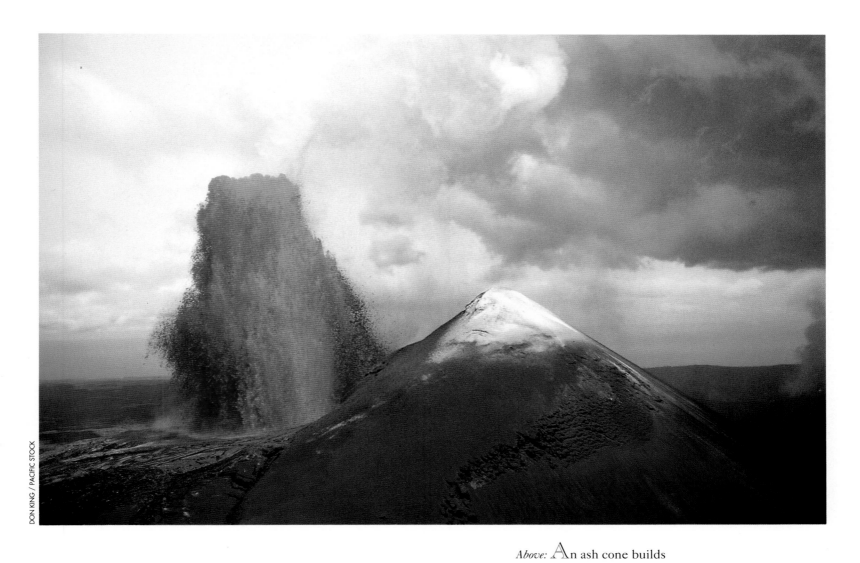

Above: An ash cone builds downwind of the fountaining vent of Pu'u 'Ō'ō, Kīlauea, Hawai'i. Writers have found the pyrotechnic splendors of Hawai'i's volcanoes incredibly challenging to describe. Mark Twain toured Kīlauea in 1866 and came away saying that the great Vesuvius was by comparison "a mere toy, a child's volcano, a soup kettle." *Left:* The volcano goddess Pele made her homes in firepits similar to this one. Her favorite is Halema'uma'u (house of the ma'uma'u fern), an older pit at Kīlauea volcano that had overgrown with ferns until she rekindled its fires and burned everything away.

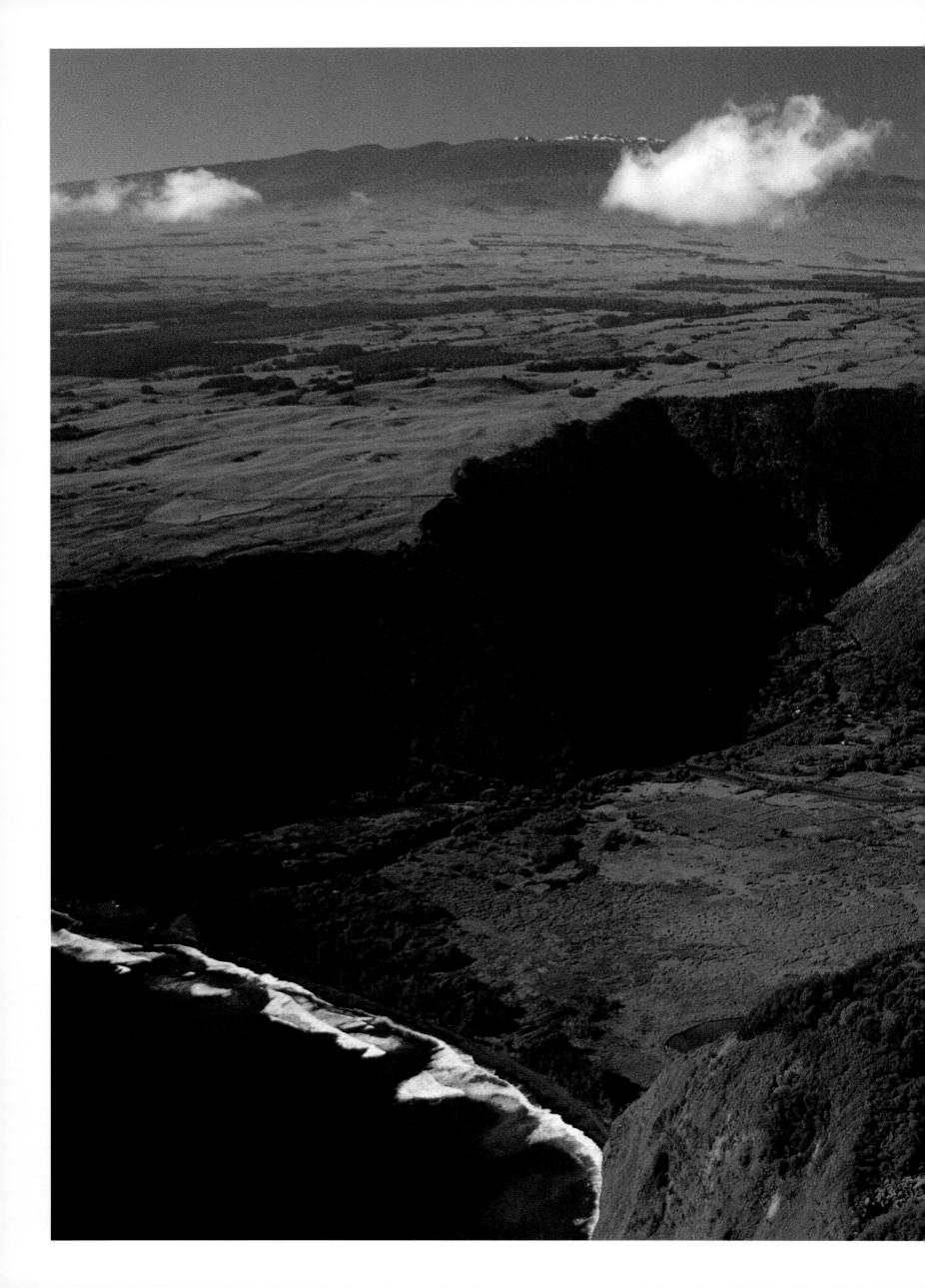

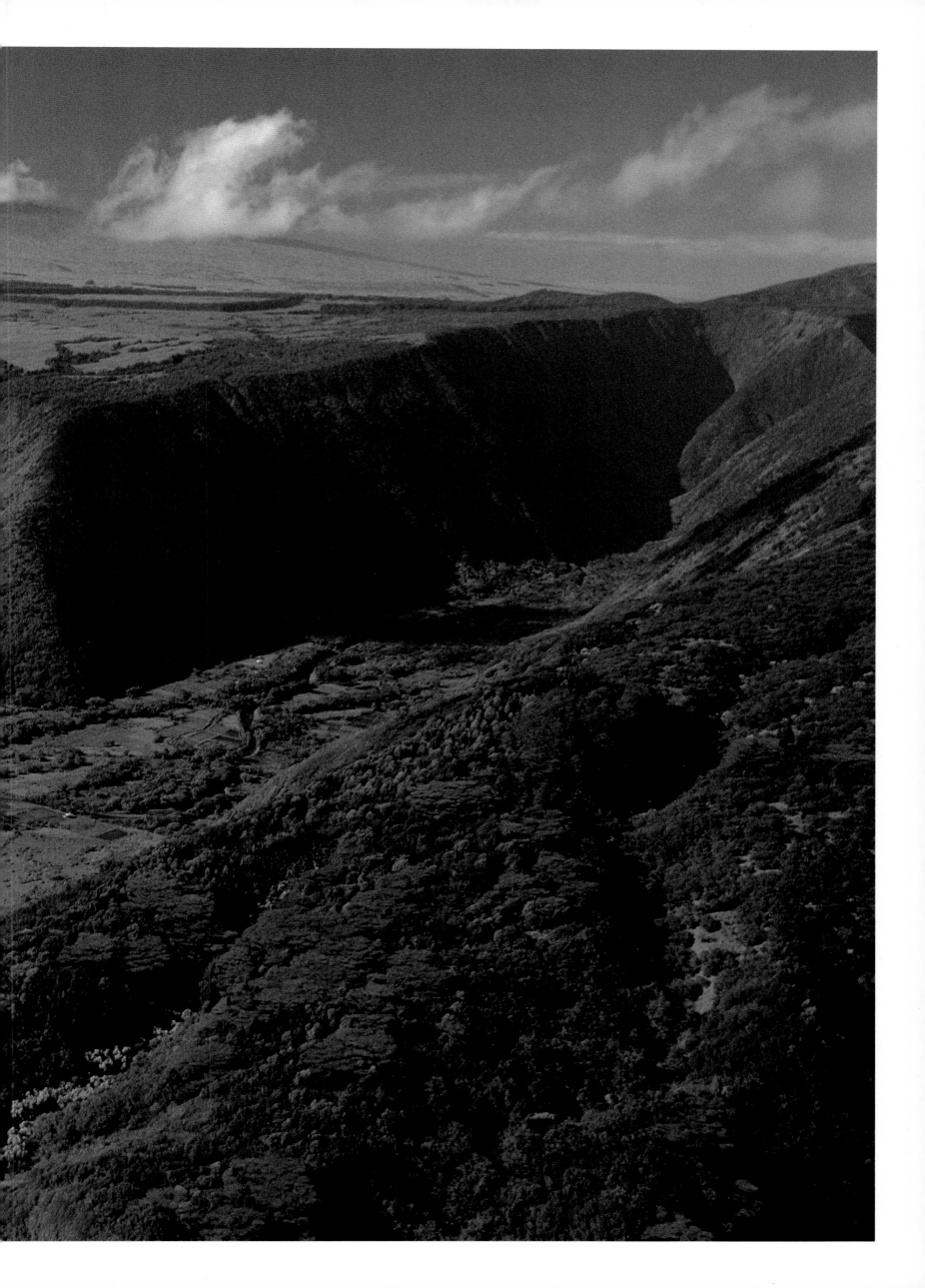

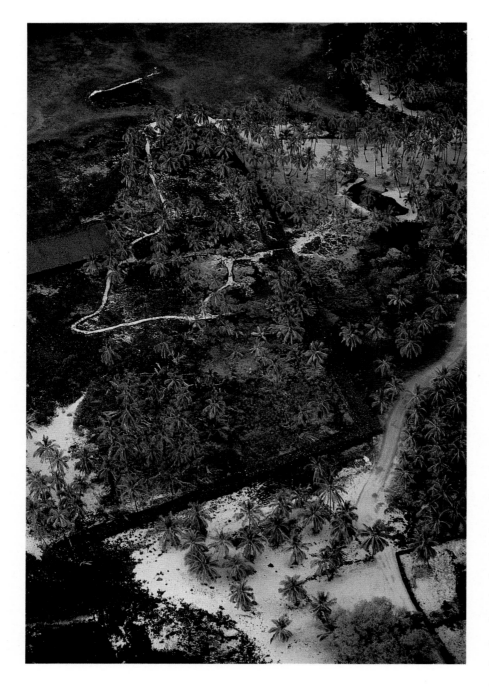

Left: The Great Wall of Pu'uhonua o Hōnaunau (1,000 feet long, 10 feet high and 17 feet thick), behind which fleeing enemies of angry chiefs could find sanctuary. The National Park Service administers the 180-acre City of Refuge at Hōnaunau, Hawai'i, and directs its archaeological projects. Originally the entrance to the Pu'uhonua (place of refuge) was only by sea.

Right: This rock enclosure on the parched southern flank of Haleakalā was probably an agricultural plot that was abandoned several centuries ago.

Previous pages: According to Hawaiian legend, Waipi'o Valley was slapped flat by the tail of a great fish. It was probably a tidal wave that gave rise to the myth. Waipi'o frequently endures tsunami, which have struck twice within the last 50 years alone. Waipi'o is the southernmost of a windward row of six amphitheater-headed valleys cutting their way into the Big Island's oldest volcano, Kohala.

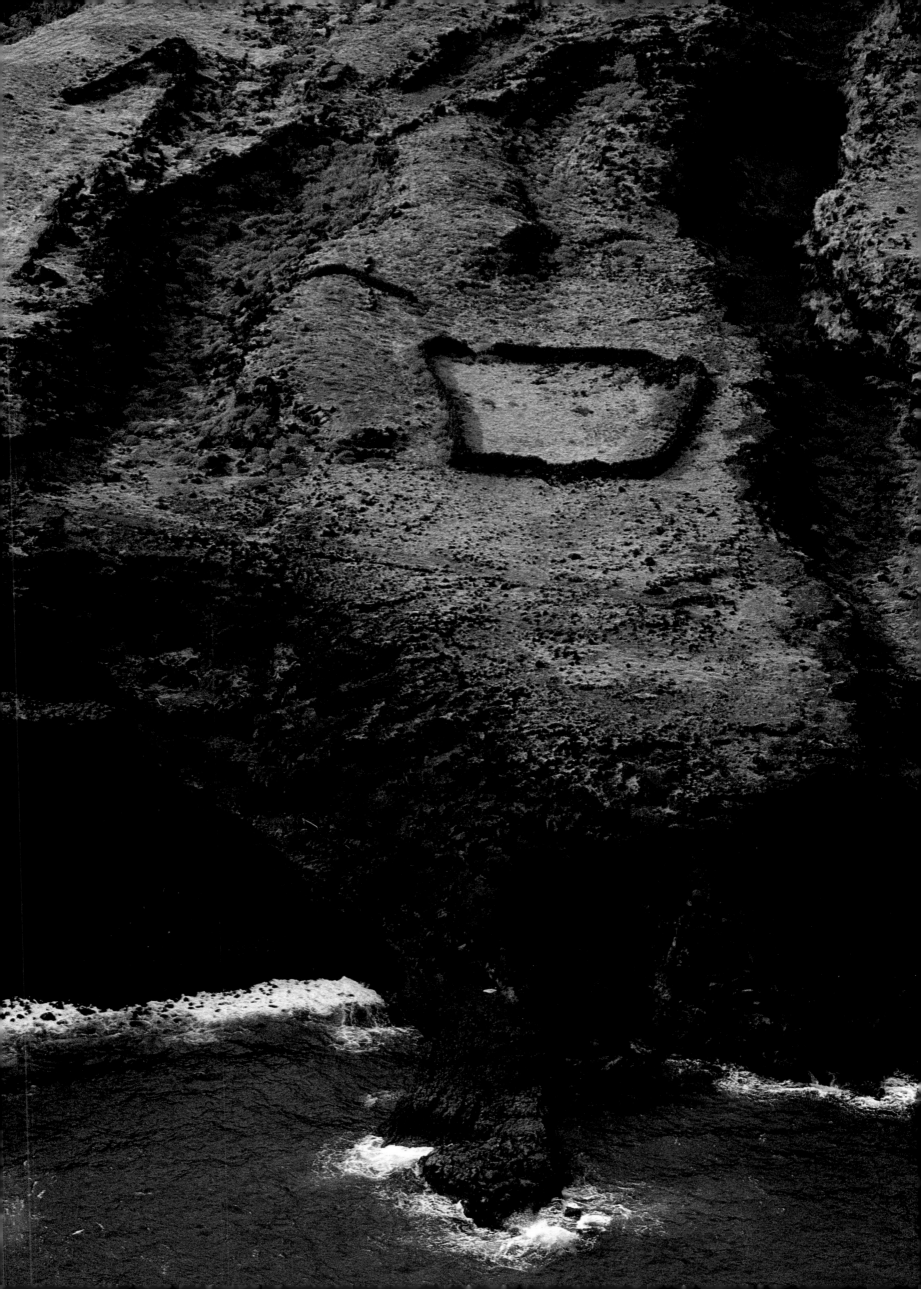

Remains of rock walls and platforms near Mamalu Bay, Maui. The masons of ancient Hawai'i, using no mortar of any kind, built structures of remarkable precision and durability.

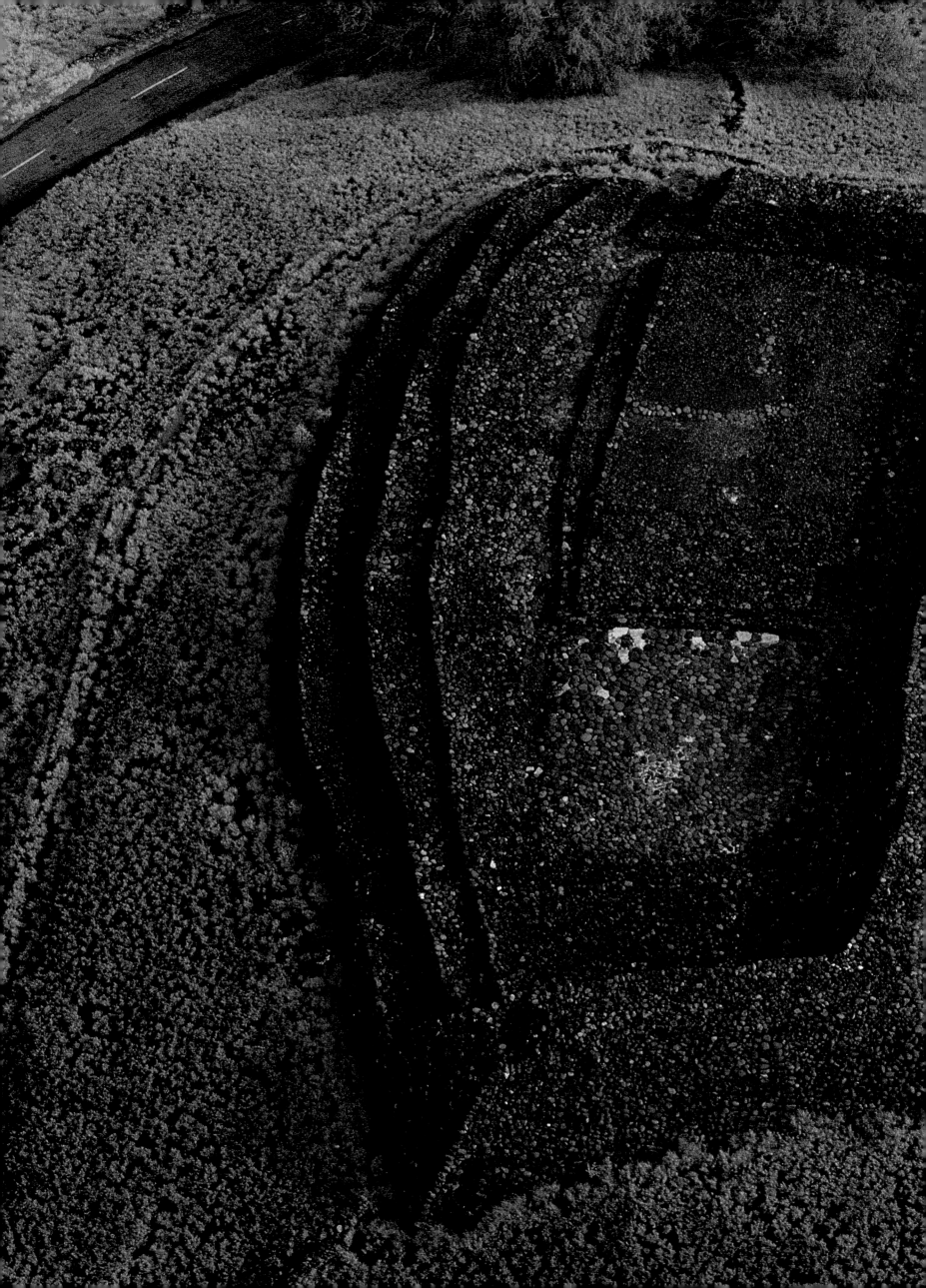

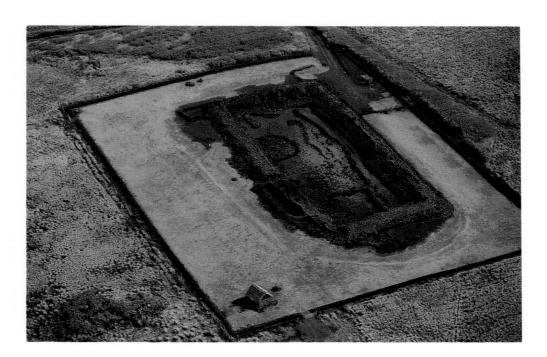

Above: Moʻokini heiau, erected
by the warrior chief Paʻao in the
twelfth century in Kohala,
Hawaiʻi. Kamehameha the Great
was born near here, at a stone
called Pōhakuhānaualiʻi (stone of
royal birth). The oracles had long
predicted the coming of a fierce
warrior who would unite the
islands by force.

Left: Puʻukoholā (hill of the
humpback), the most famous
restored heiau in the islands. This
was the temple Kamehameha
built at Kawaihae, Hawaiʻi, for his
feathered war god Kūkāʻilimoku
(Kū devourer of islands), and the
place where Kamehameha's rival
Keōua was sacrificed.

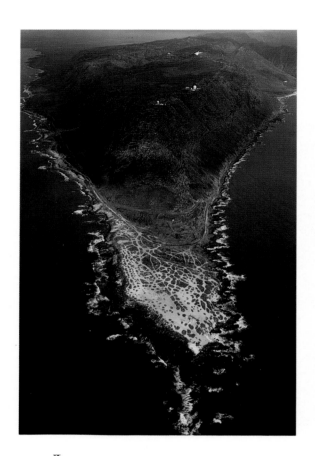

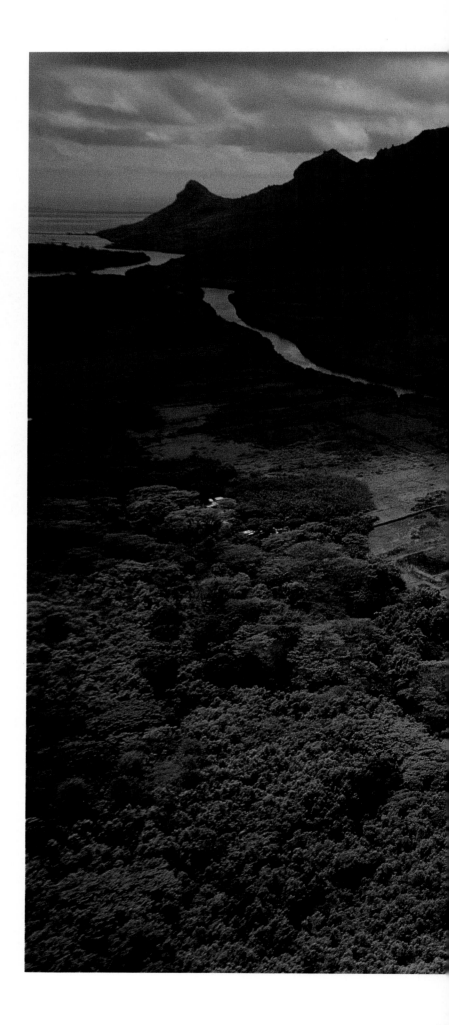

Above: Like the barbed tip of a warrior's spear, Ka'ena (the heat), O'ahu, points toward the heart of Kaua'i, a hundred miles away. For ancient Hawaiians, Ka'ena was a leina-a-ka-'uhane, a land's end where the souls of the dead leaped into the spirit world.

Right: Several mountain ranges in the islands were said to be the backs of ancient mo'o (giant flesh-eating lizards). In his book *Pele and Hi'iaka*, the folklorist Nathaniel B. Emerson described mo'o as "dragonlike anthropoids, the spawn of witchcraft, inflamed with the spite of demons." This one is Hā'upu Ridge, on Kaua'i.

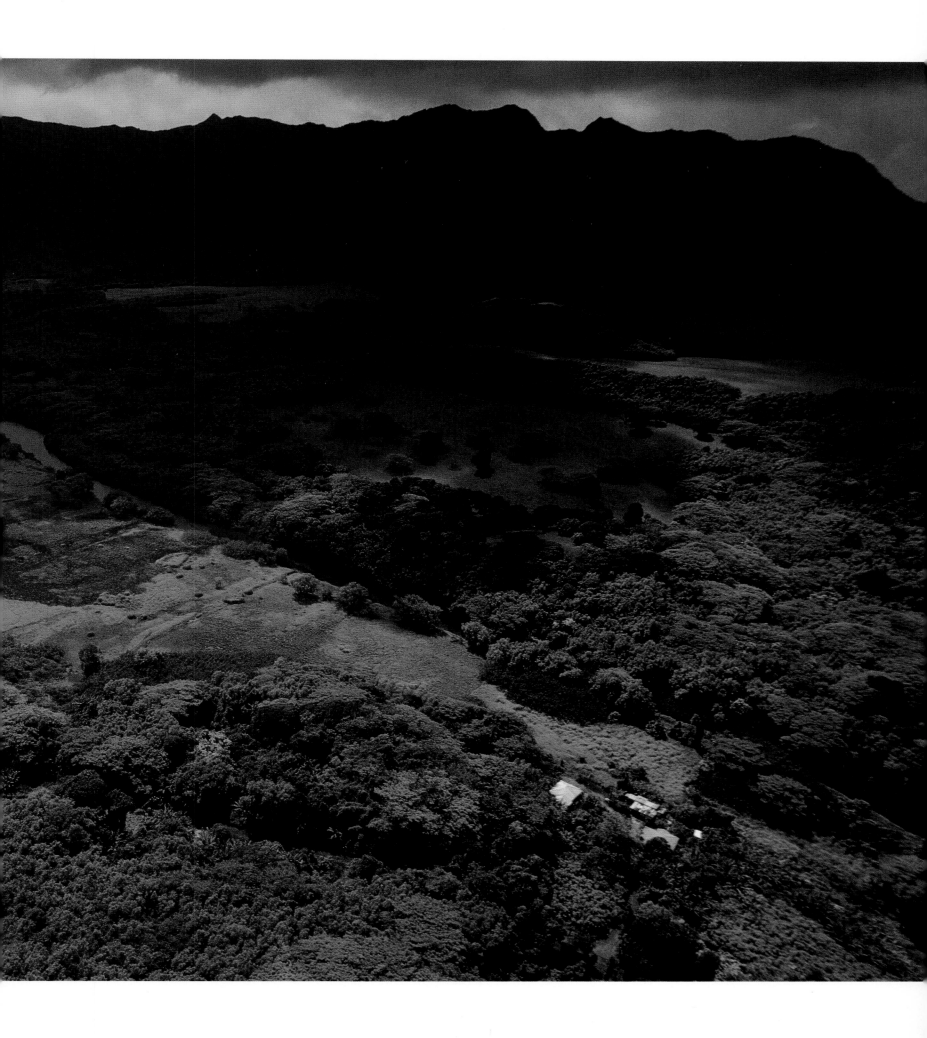

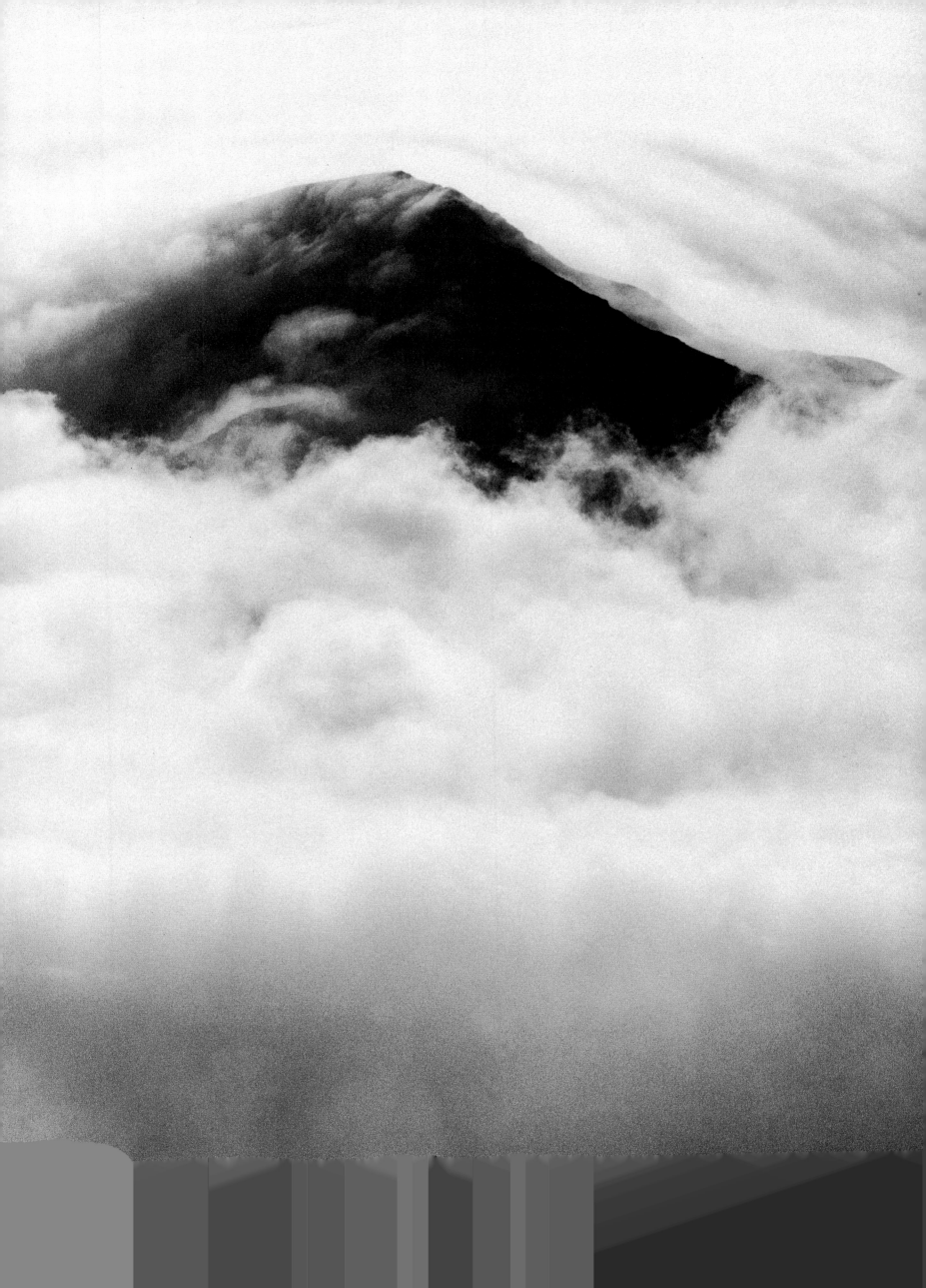

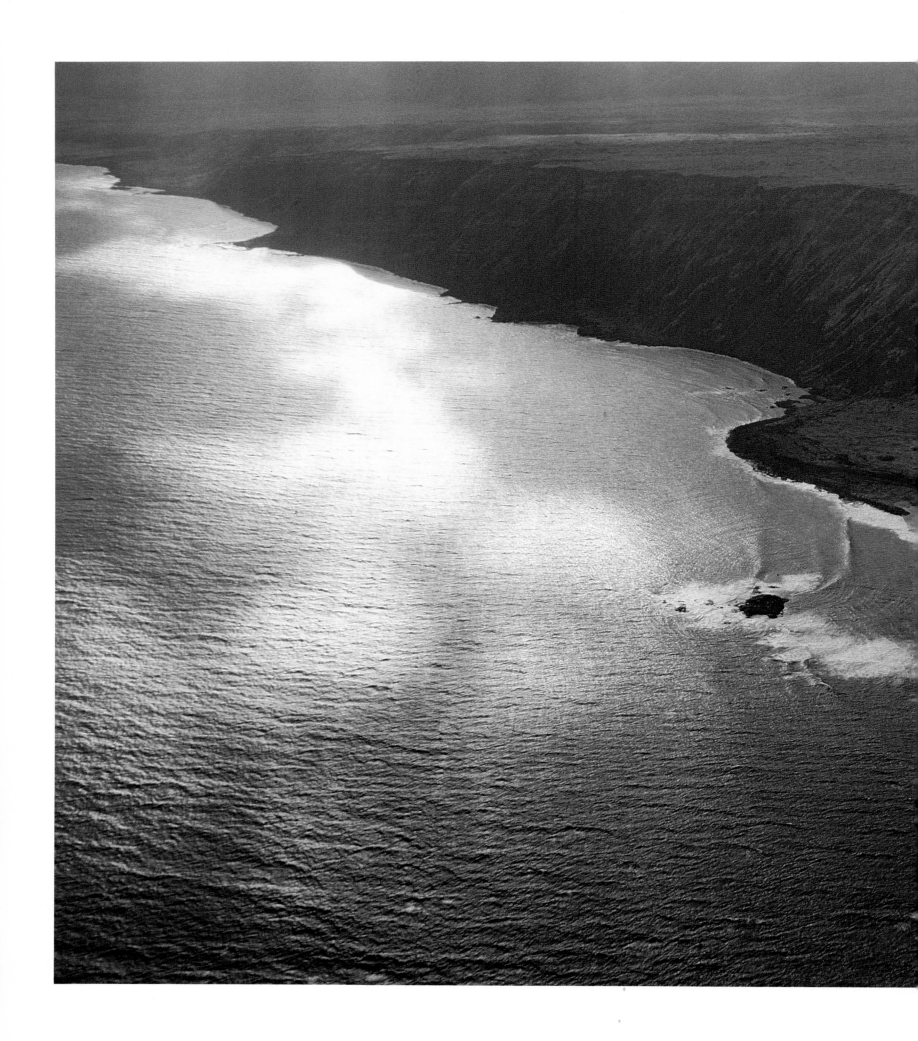

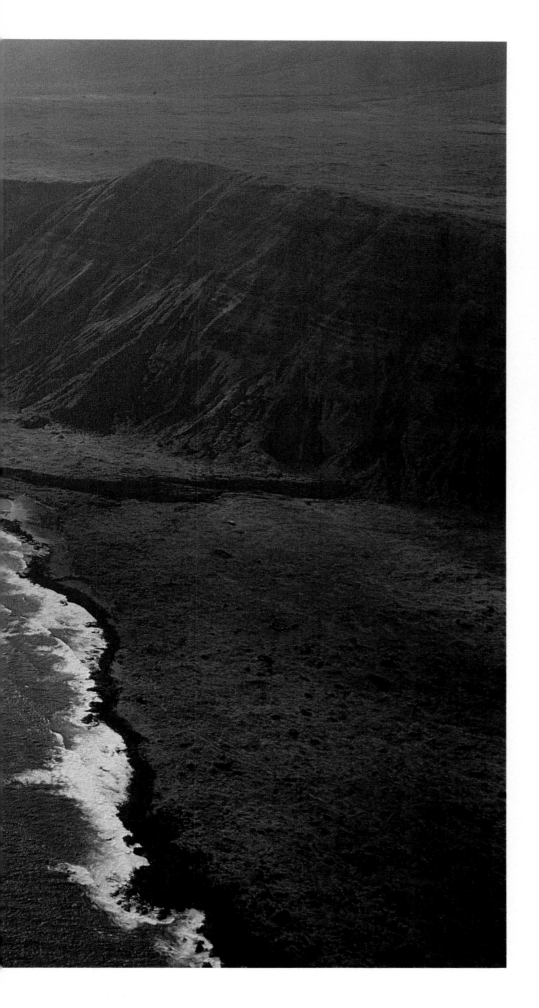

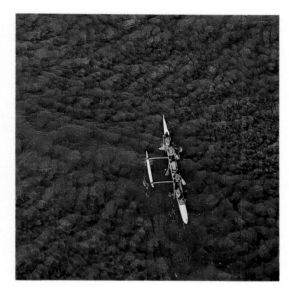

Above: An outrigger canoe paddling team trains in the smooth, aquamarine shallows of a reef near Kona, Hawai'i.

Left: Black lava meets the sun-burnished Pacific near Halepē on the Big Island. These flows, ranging in age from a hundred to several hundred years, are too young to support much vegetation.

Previous pages: A river of clouds tumbles over Kalapawili Ridge and pours into Haleakalā Crater. The demigod Māui, in whose honor the island was named, is said to have climbed to the uppermost ridges of the great volcano and there performed the feat of pushing the sky away from the earth.

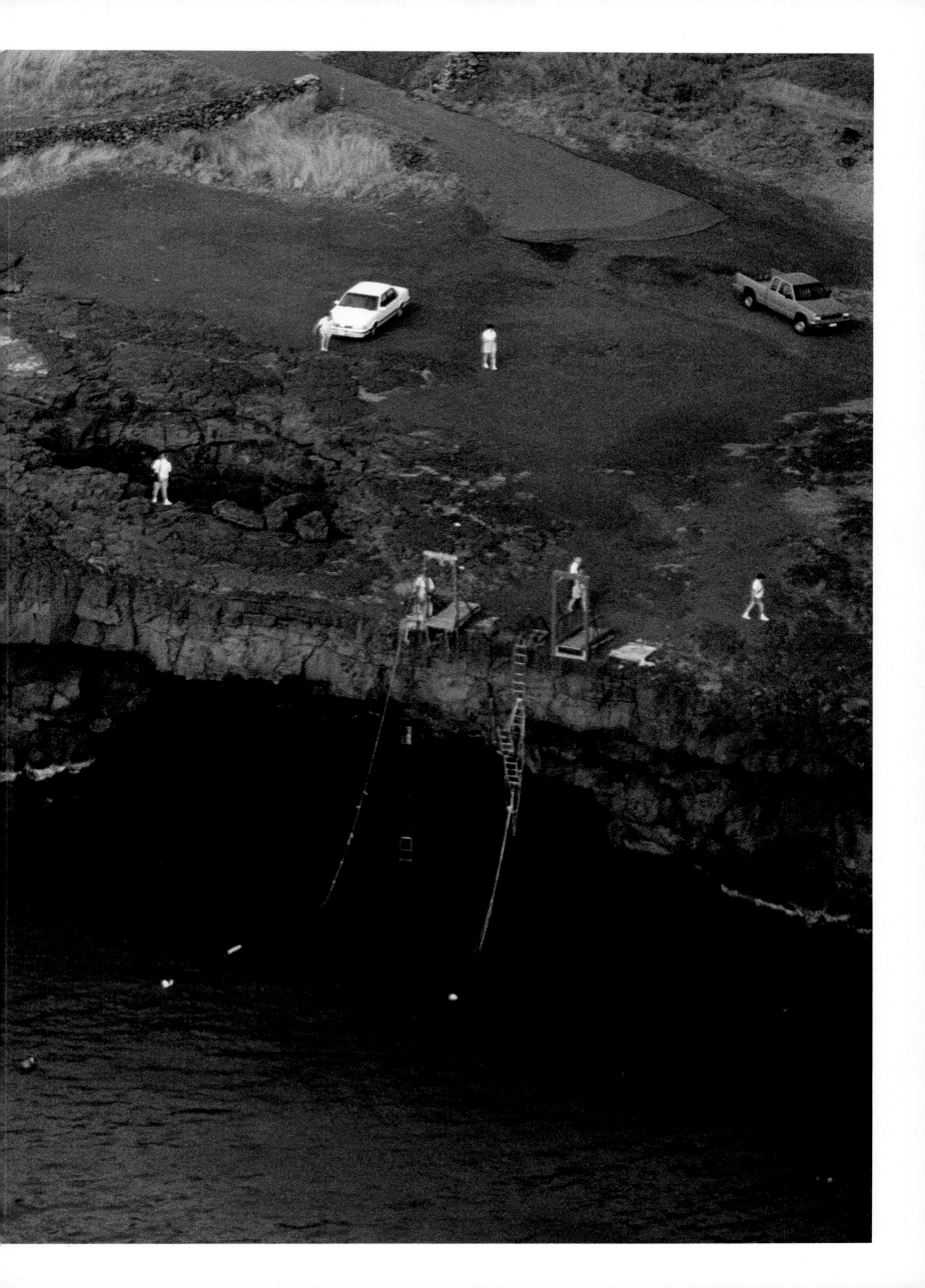

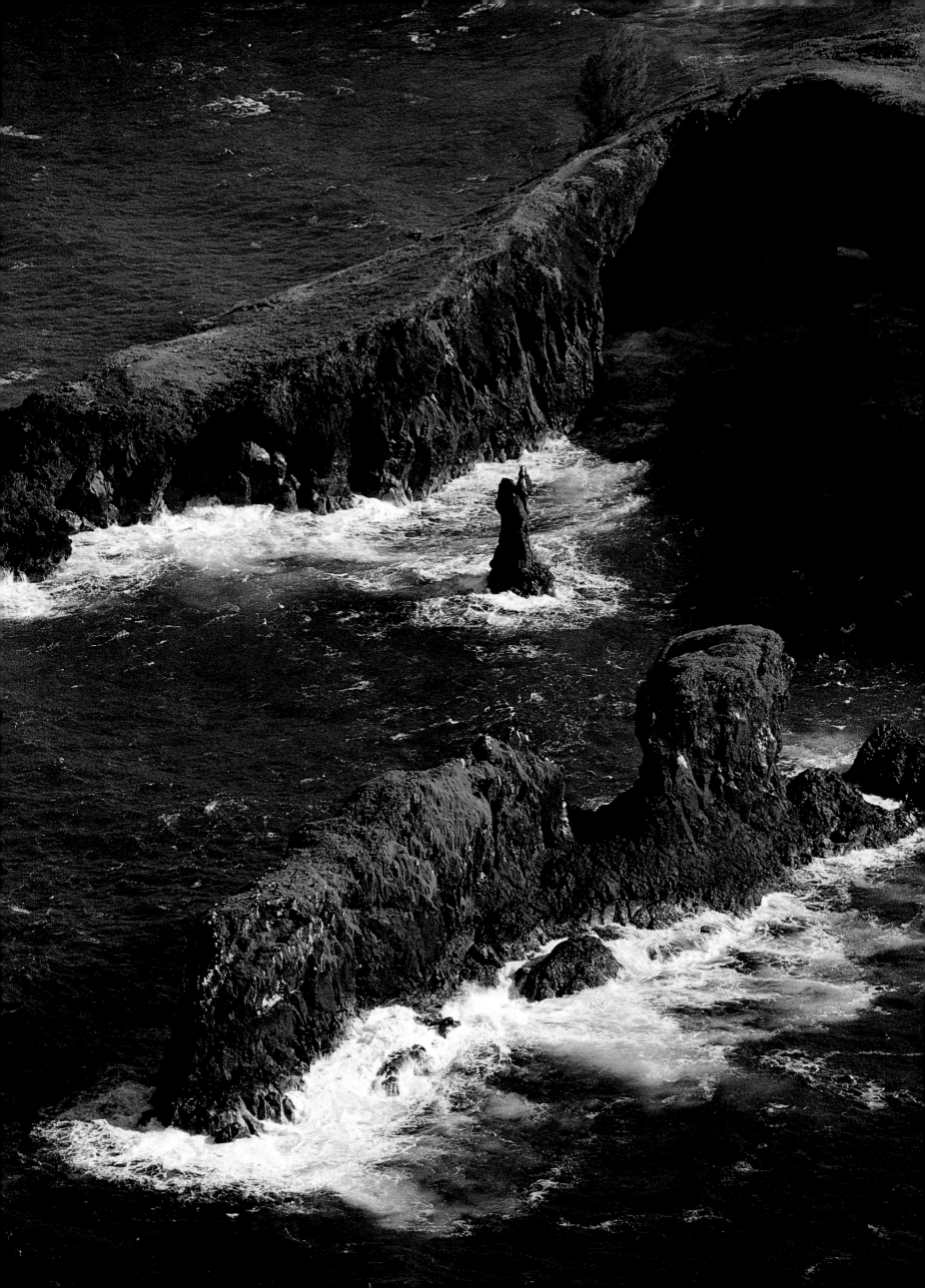

Left: Moku Mana seabird sanctuary near Keʻanae, Maui. *Right:* A cascade stairway on the Hāna coast of Maui. There are literally thousands of waterfalls in this district, fed by the abundant rainfall across Haleakalā's upper slopes. Because of the water, Hāna was prized as a settlement area by ancient chiefs. The Hawaiian word for wealth is waiwai (water water).

Previous pages: Fishermen's platforms and ladders near South Point. The incredibly clear, deep water along the Big Island's southern shore teems with ulua, a species of crevalle or jack fish that grows to five feet and 100 pounds. Prized varieties are the ulua-aukea (red ulua), the largest; ulua-ʻeleʻele (black ulua); and ulua-paʻopaʻo (yellow and green with vertical green bands), a favorite fish for eating raw.

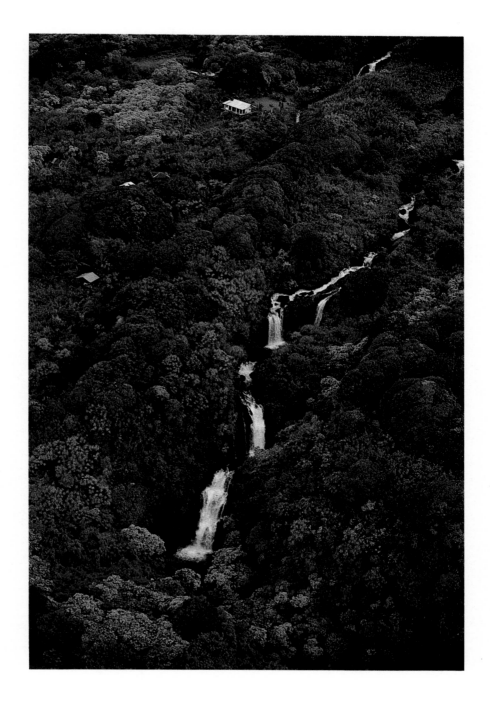

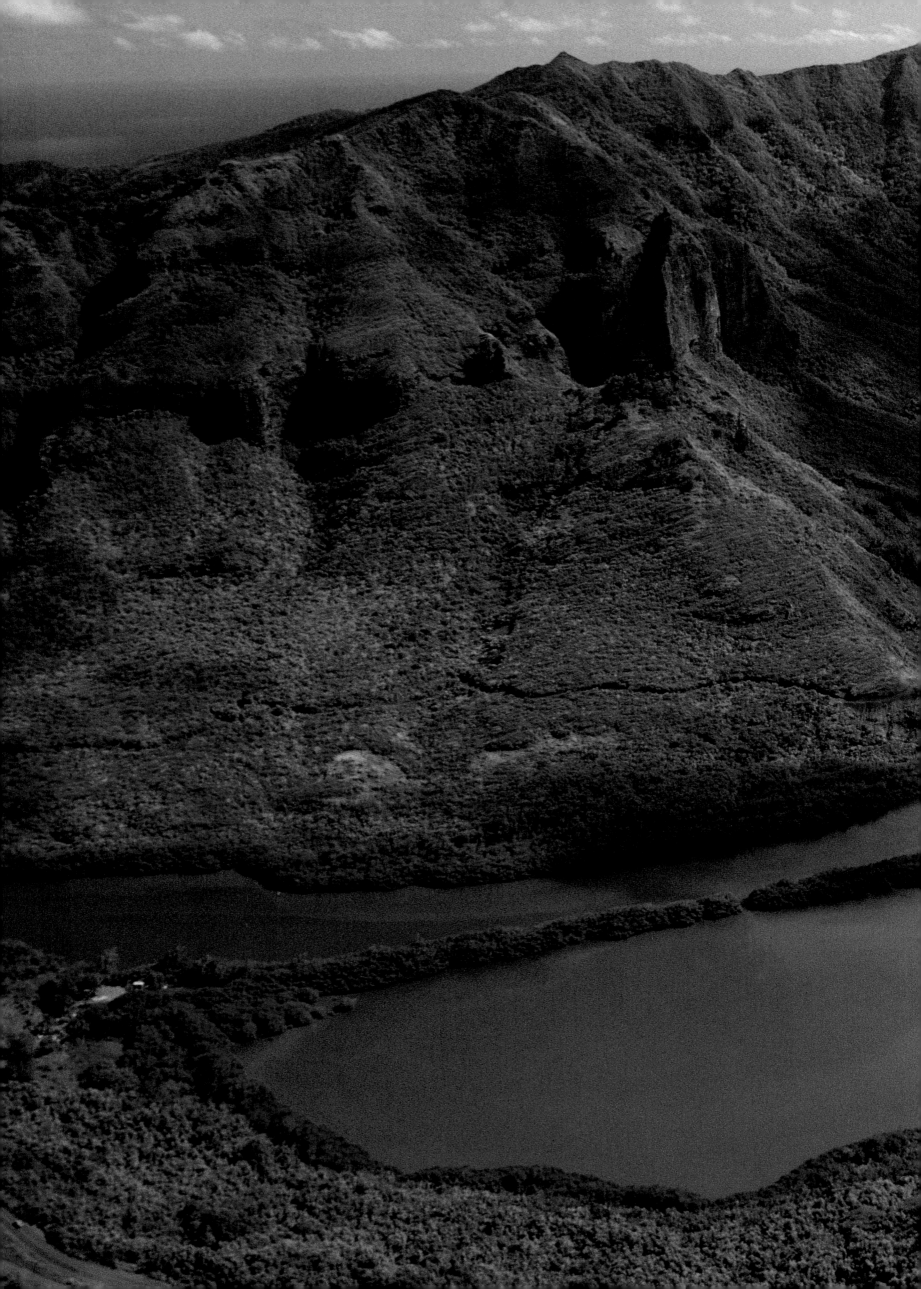

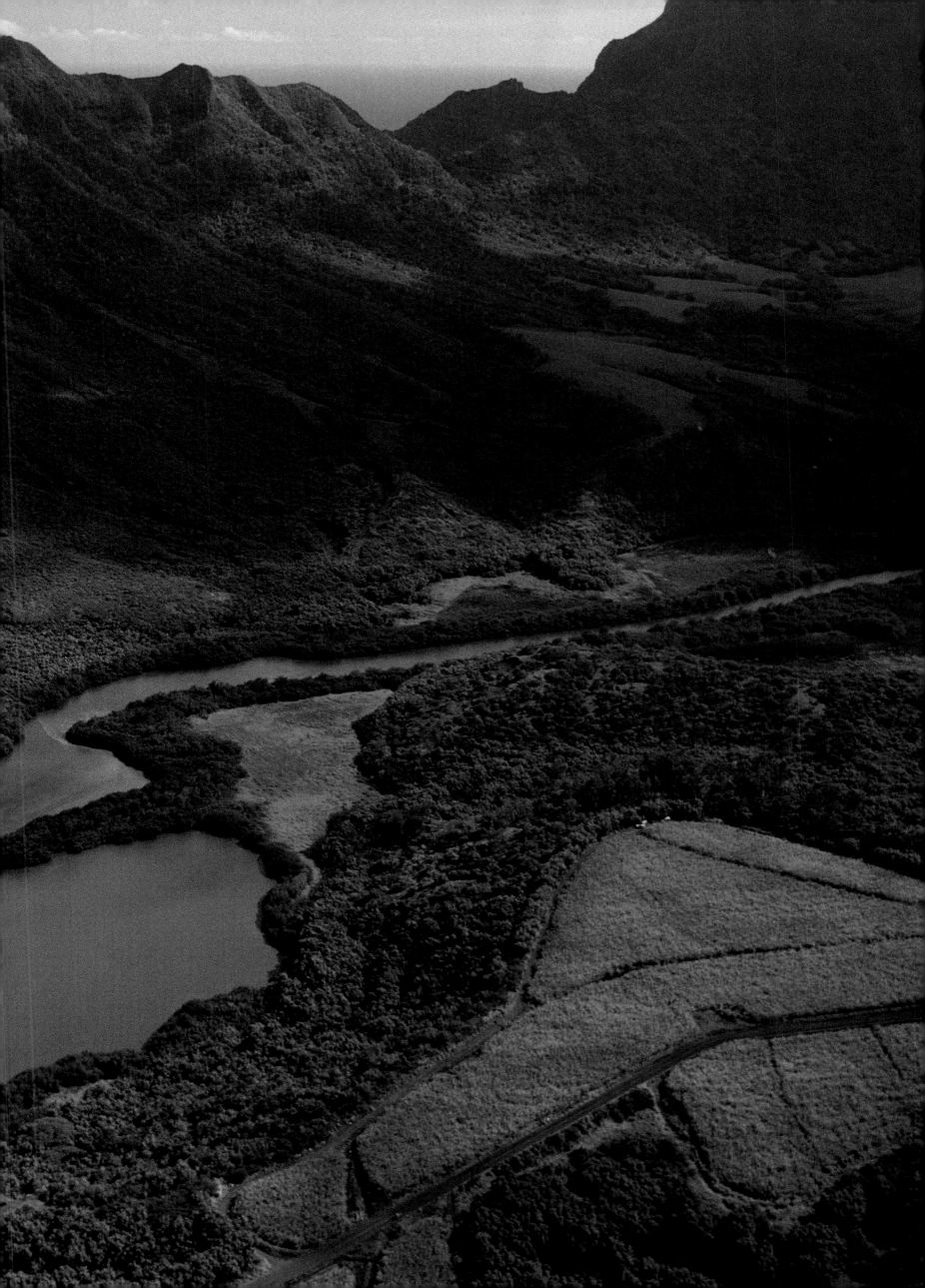

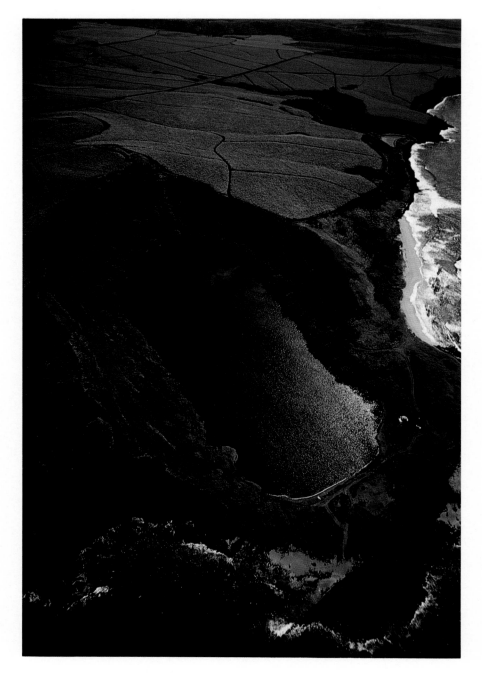

Left: Nōmilu fish pond, Kōloa District, Kaua'i. Said to have been dug by Pele in her continuing search for lava, this crater of brackish water became a sacred fish pond guarded by two supernatural eels: Pūhi-pakapaka (scaly eel) and Pūhi-'ula (red eel). The lair of Pūhi-'ula is that crescent of red water up the coast (see page 54). When there is an eruption in Pele's home on the Big Island, these ponds smell of sulphur.

Right: Kamokila Hawaiian Village, on the north bank of the Wailua River, Kaua'i. In recent years several attempts have been made at re-creating ancient villages so that Hawai'i's young people can learn in a living environment the culture of their ancestors.

Previous pages: According to legend, Menehune people diverted an elbow of Hulē'ia Stream on Kaua'i and built the retaining wall for this freshwater fish pond in a single night. At high tide, fish swam into the ponds through a sluice gate. The trapped fish were bred and farmed.

Following pages: A fisherman, wearing reef shoes and a bait bucket, looks up to see what might be scaring away his fish. This reef lies 100 yards off the beach at Diamond Head.

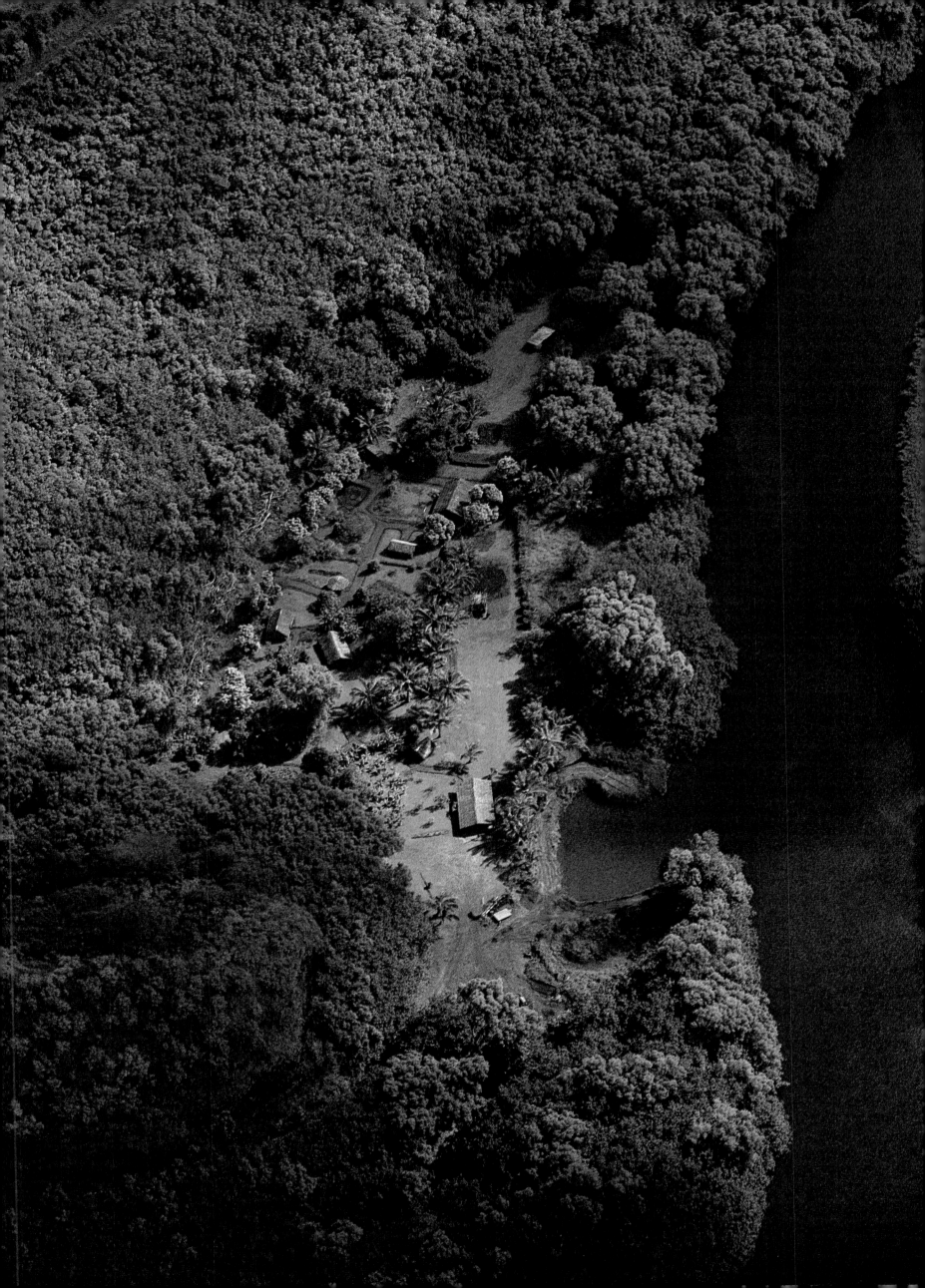

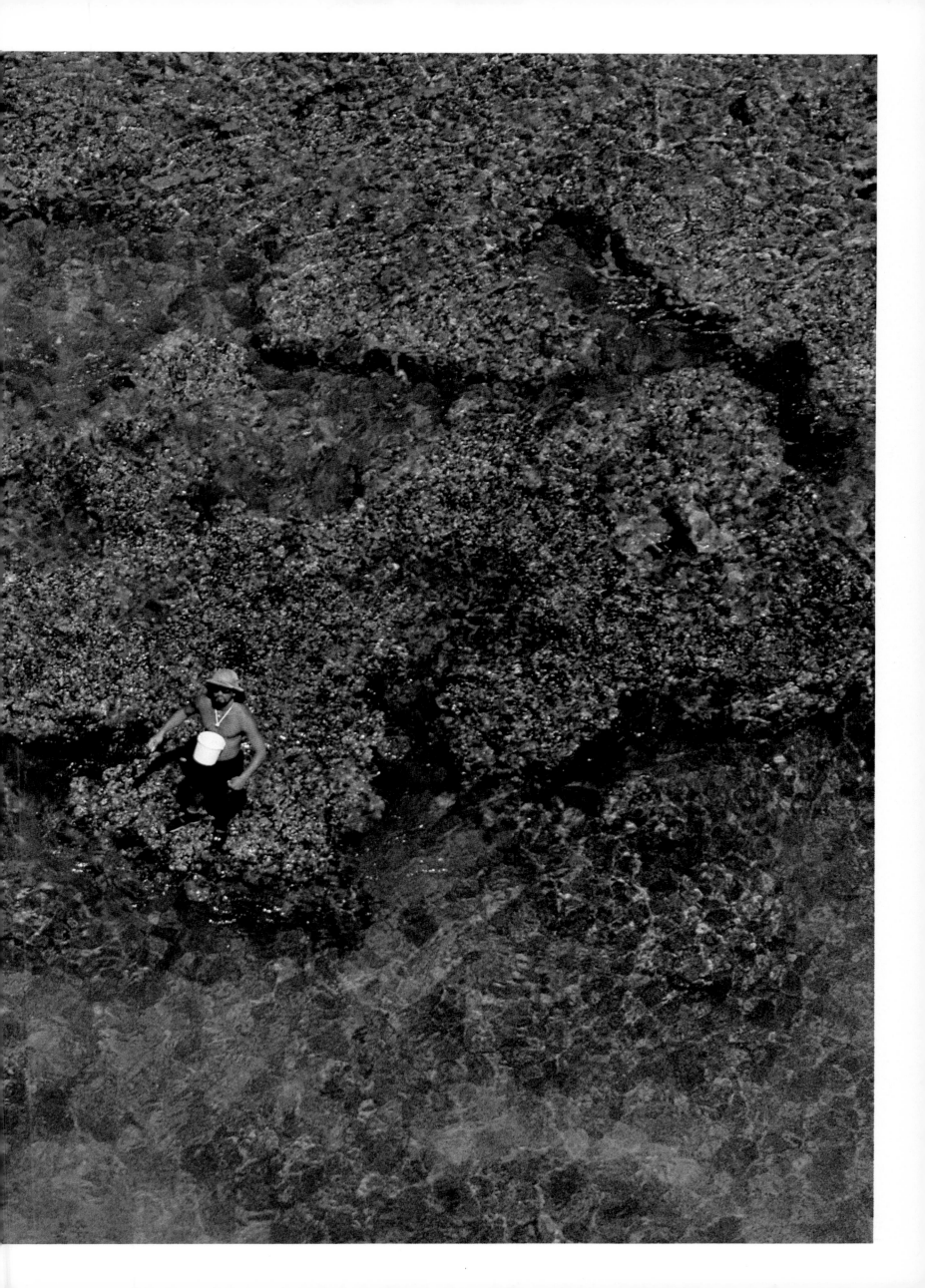

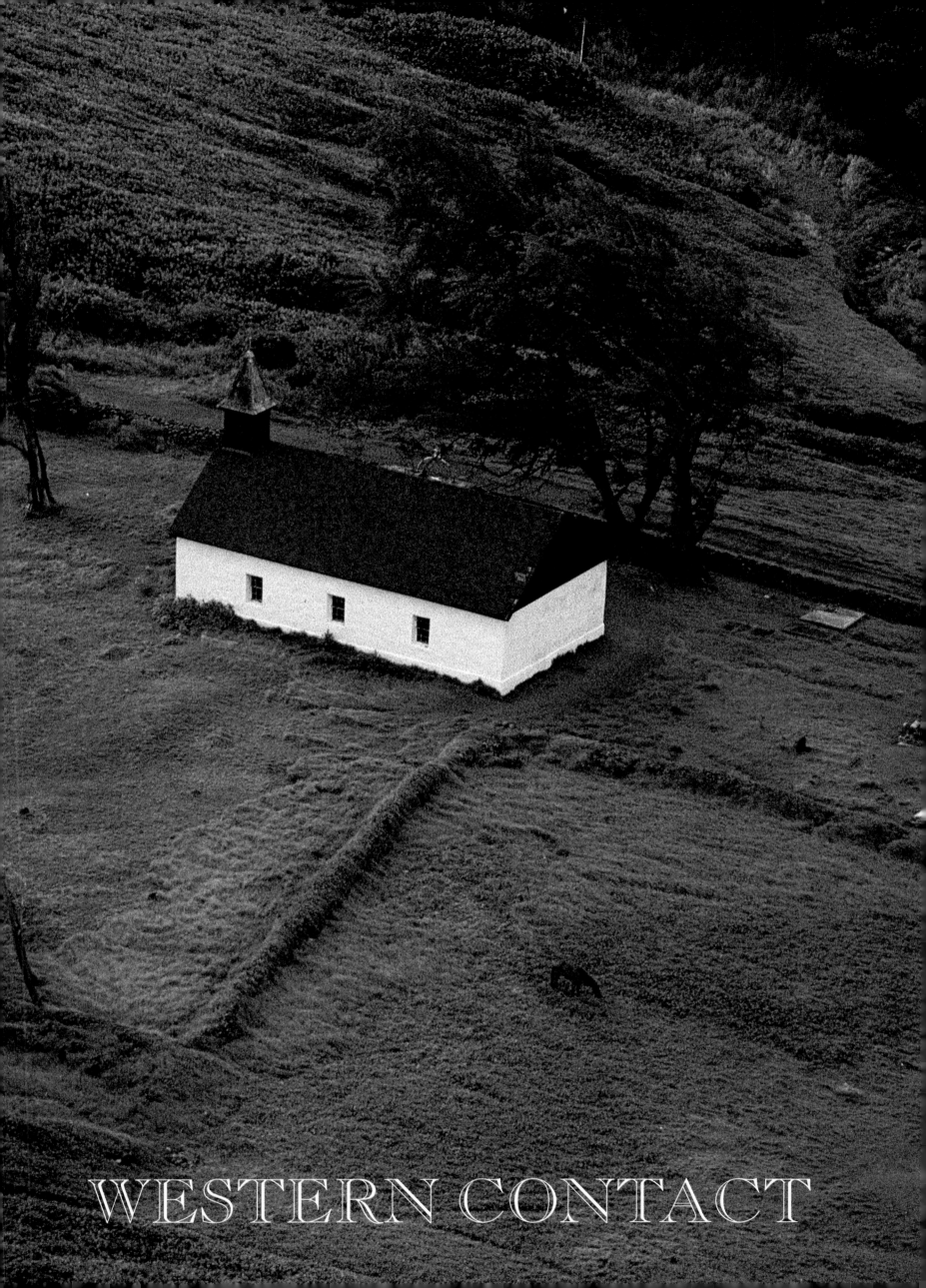

WESTERN CONTACT

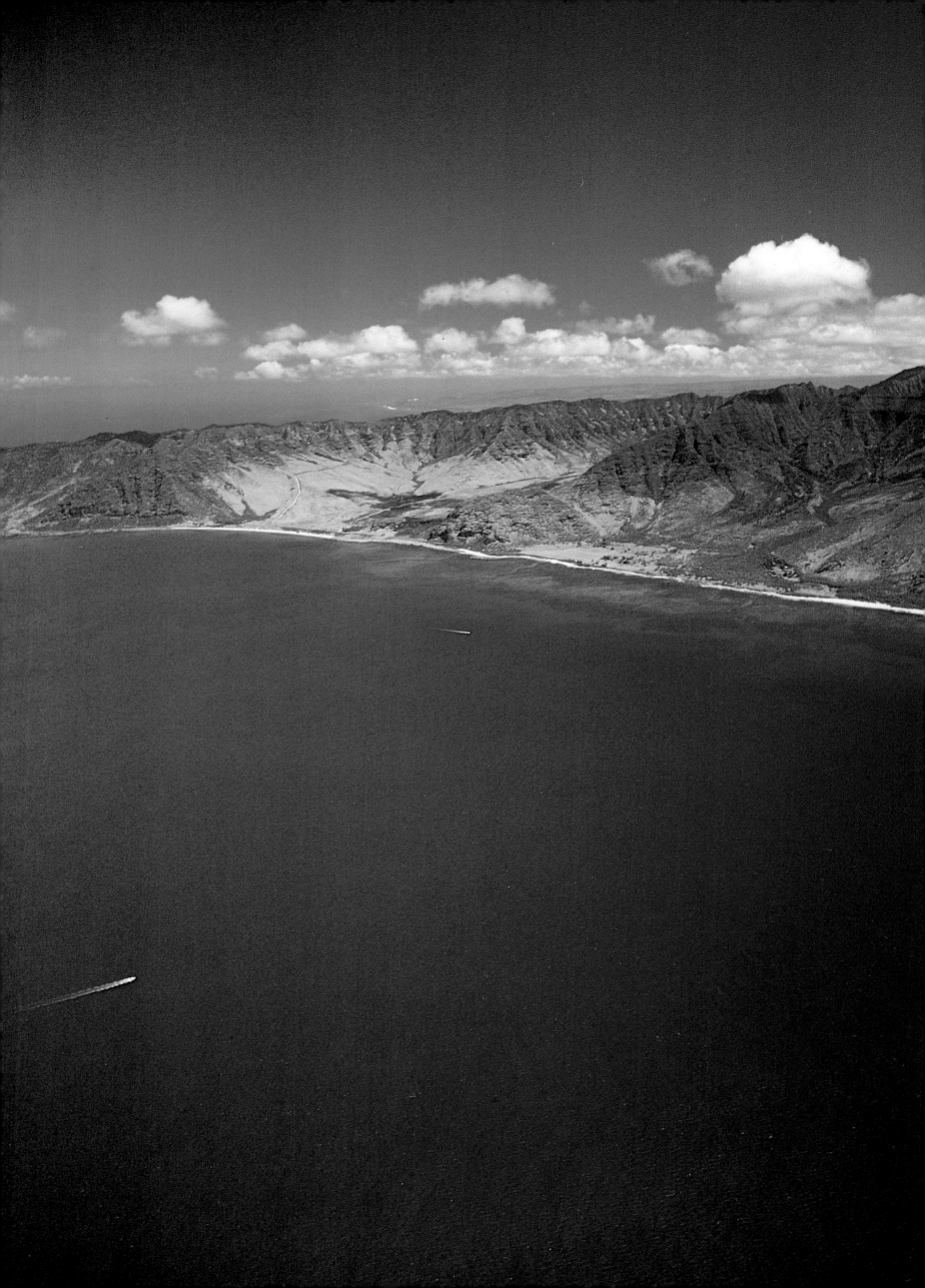

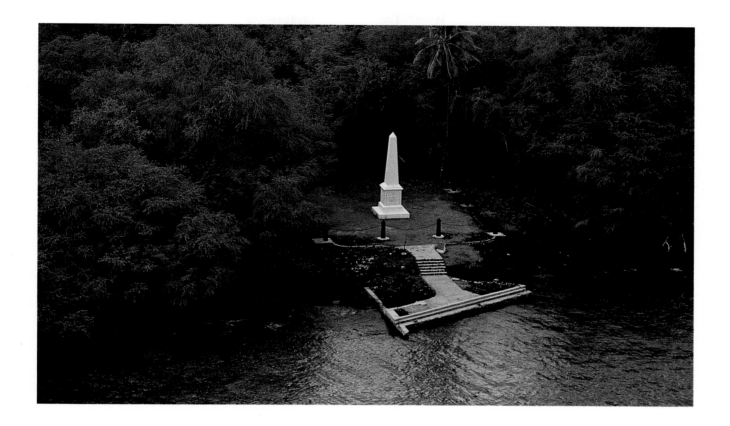

WESTERN CONTACT

It happened one rainy season, in a year their grandchildren would learn to call by a number—1778—that the people of the northernmost main islands saw something floating offshore, something odd like "trees moving on the sea."

On January 18 that year the trade winds blew in the future in the shape of Captain James Cook and his ships the *Discovery* and the *Resolution*. They sailed within view of the island of O'ahu. Weather conditions forced the British vessels into a heading off Kaua'i and Ni'ihau and finally back to Kaua'i before they could reach landfall at Waimea two days later.

It was the season of Makahiki in the islands, the period of harvest, games and relaxation. During Makahiki the people raised the standard of Lono, a billowing white tapa cloth hoisted on a tall pole and kept in the most sacred section of the heiau dedicated to the god. When the Hawaiians sighted the strange objects on the horizon they were frightened at first: "trees moving on the sea." But as the vessels came closer they seemed more like floating islands pushed by multiple cloudlike sails, then like marvelous outrigger-less canoes. The crews, they discovered, were brightly dressed white men (haoles) who carried exploding sticks and traded with beads and iron. A kahuna saw the sails as the standards of Lono and announced that Lono's blessing attended these voyagers.

Captain Cook named this group of islands after the Earl of Sandwich, a sponsor of his expedition. There were resemblances in body type and language between the Hawaiians and the islanders of Tahiti, New Zealand and the Easter Islands, and Cook declared these peoples one far-flung race. He wrote in his journal, "How do we account for this Nation spreading itself so far over this vast ocean?" Cook's first visit was brief. He left Kaua'i and headed for the northwestern coast of America. When winter set in, the Great Navigator returned to the Sandwich Islands. His ships appeared off windward Maui in November 1778. After two months of trading offshore and taking a difficult tack down the Hamakua coast of the island of Hawai'i, Cook sailed around South Point and northward into the only safe anchorage he could find, at Kealakekua Bay.

Previous pages: The recently restored Huialoha (gathering of love) Church, at Kaupō, east Maui, was built in 1859 as a Congregational "circuit" church. *Left:* Mākua Valley and the Wai'anae Range on leeward O'ahu. This was the first Hawaiian coastline revealed to Captain Cook's ships in 1778. *Above:* Although the actual spot where Captain Cook was killed is now underwater, this monument on Kealakekua Bay, Hawai'i, commemorates the event.

The people were gathered again for Makahiki. A small fleet of double-hulled canoes carrying the chiefs, escorted by hundreds of smaller outriggers and thousands of swimming natives, greeted Cook, calling him "Rono" (Lono). From this point the story of what happened to Captain Cook has been exaggerated. Because the Hawaiians called the haole captain "Rono" it has been assumed they thought he was their god Lono or a manifestation of the earlier chief Lonoikamakahiki, who promoted the Makahiki festival, and that they worshiped Cook as a god. But according to artist-historian Herb Kawainui Kane, "the myth of Cook as a Hawaiian god originated not in Hawaiʻi but in Britain several years after Cook's death, when the official account of the voyage was published." British writers, creating a role model for future generations, made Cook into a classical hero complete with a death caused by hubris: Cook's pride led him to believe he was a god, so he was struck down. Hawaiians called him "Rono" only because he commanded such advanced technology that they received him as a chief of the Lono class. Their gods, as they informed the British at Kealakekua, were invisible and lived in the clouds.

The white visitors spent several days in the bay, filling their stores with fresh water and food in exchange for trinkets and iron—"two pigs for one nail"—then they set sail for the Arctic. But foul weather and a broken mast forced them back to Kealakekua. That evening one of the cutters of the *Discovery* was stolen. Cook and ten marines went ashore the next morning to retrieve it, and they tried to take high chief Kalaniʻōpuʻu hostage. The chief's warriors moved in. One aimed a dagger at Cook, who fired both barrels of his gun. His men began shooting. In the melee, someone clubbed the captain with a fencepost; someone else stabbed him. The warriors killed Cook and four of his men, stabbing the captain repeatedly. Of the Hawaiians, four chiefs and thirteen commoners died. The English sailors retreated.

Among the warriors involved in the attack was Kalaniʻōpuʻu's nephew, Kamehameha. This young chief wanted to rule the Big Island and possibly Maui. He had spent many hours on Cook's ships and learned there the mighty magic of iron and cannons and gunpowder. His destiny as a conqueror became clear.

Four years after Cook's ships sailed away from the hostile islanders, Kalaniʻōpuʻu died, and Kamehameha became entangled in a land war on the Big Island with his cousin Keōua. Their bloody battles led to a standoff. An unsettled peace was declared. By this time Kahekili, the ruler of Maui, had

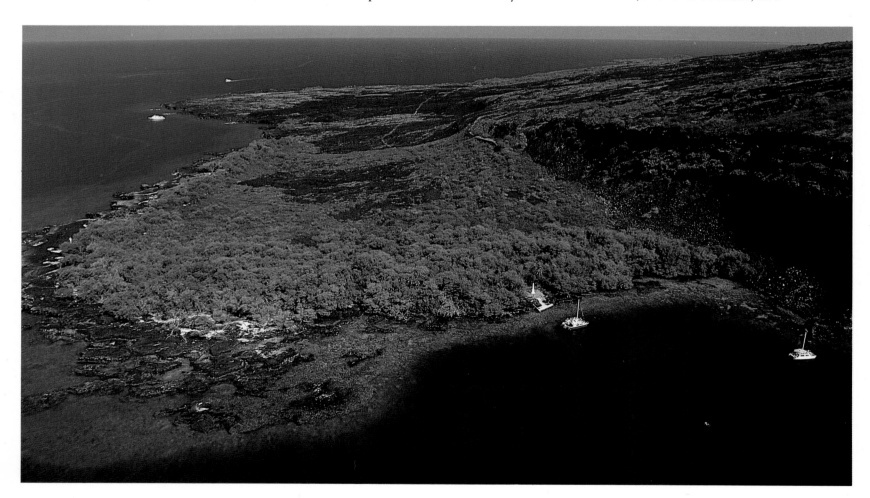

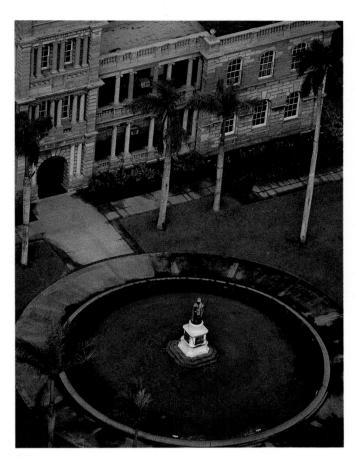

Opposite: Kealakekua Bay, Hawai'i, where Captain Cook made his final port of call. In a skirmish on shore the Hawaiians killed Cook. It was 8:00 A.M., February 14, 1779.

Left: With a spear in his left hand and wearing the feathered helmet, cape and malo (loincloth) of rank, a statue of Kamehameha, the first ruler of all the Hawaiian islands, stands before the Judiciary Building in Honolulu.

conquered the islands of O'ahu and Moloka'i and married into the family of the high chief of Kaua'i and Ni'ihau, securing his rule over all the islands except Hawai'i.

The winter of 1789–90 brought the American vessels *Columbia* and *Lady Washington.* The latter supplied several chiefs with guns and ammunition. Later in 1790 a chief of the Big Island seized the schooner *Fair American,* equipped with muskets and two field cannons. He gave the prize to Kamehameha. One officer from the *Fair American* and one from its sister ship the *Eleanora* were taken prisoner. John Young and Isaac Davis became Kamehameha's advisers.

Kamehameha sailed with his men to Maui first, and while they fought toward the decisive battle in 'Īao (where the valley stream turned red with blood), Kamehameha's districts were being attacked and ravaged by Keōua back home on the Big Island. Kamehameha returned and drove Keōua south. When a rare explosive eruption of Kīlauea killed many of Keōua's retreating warriors, he lost heart, thinking that Pele and the other gods opposed him.

Meanwhile, with Kamehameha driving against Keōua, the enemy armies of Kahekili from Maui, Moloka'i and O'ahu, and those of Ka'eo from Kaua'i, combined and attacked Kamehameha's strongholds in north Hawai'i. Kamehameha assembled all his double-hulled canoes and the *Fair American* and set out to confront the invading forces. They met in a sea battle off the shore of Waimanu. Cannons blasted from both sides, but Kamehameha's superior firepower won.

On the northwest coast of Hawai'i, Kamehameha had built a huge heiau to honor his war god. He invited Keōua for the dedication ceremony. Keōua went, undoubtedly knowing his fate. He and his men were killed and sacrificed on the heiau altars. Kamehameha finally ruled the Big Island.

With the 1792 arrival of Captain George Vancouver and his undaunted preachings of peace, Kamehameha acquired the wisdom and skills of a king and declared a truce that lasted four years. He asked for the protection of the British. Vancouver agreed, in exchange for the cession of the island of Hawai'i. England never accepted the agreement, but it led to British influence in the islands for many years.

After Vancouver departed, Kamehameha continued collecting islands, beginning with the complete conquest of Maui, Moloka'i, Lāna'i and O'ahu. Kaua'i was still out of reach. Between 1796 and 1809 Kamehameha built three fleets of battle canoes and sailing ships. He was stopped first by foul

weather, then by a pestilence. War on Kaua'i would be difficult. In 1810, long after the death of Ka'eo, his son Kaumuali'i, knowing the power of Kamehameha's third fleet, accepted a treaty, and Kaua'i joined the kingdom.

During Kamehameha's reign, many countries sent explorers and settlers to the islands, and the fur trade between the Pacific Northwest and China brought in hundreds of "stopover" ships. Kamehameha welcomed those he judged beneficial and banished all others. The British successfully settled here, but the Russians, when they started building stone fortresses on O'ahu and Kaua'i, were asked to go. They left behind their forts as reminders of the ongoing threat of foreign military power in Hawai'i. The French arrived and baptized Kalanimoku, one of Kamehameha's chiefs, into the Christian faith. But Kalanimoku never appreciated the haole religion and continued to obey kapu.

On May 8, 1819, Kamehameha the Great died. His powerful wife Ka'ahumanu and his son Liholiho shared the reign. Liholiho, called Kamehameha II, brought many changes to the kingdom. Kamehameha I had traded sandalwood for considerable wealth, but he kept a tight hold on its harvesting and sale, and used the money to purchase guns and ships to protect his power. When he died his heir spent the revenue in a frantic buying spree. Liholiho allowed other chiefs harvesting rights so they could purchase, not guns, but the fine china and mirrors, the precious jewelry, chandeliers, French wines and brandies, and the dandified clothes they had come to love. They built and furnished great houses. They raped the forests and literally enslaved their people to collect and deliver the sandalwood to waiting ships. Soon many chiefs were in ruinous debt, and their crop began to disappear; the abused workers in the forests destroyed the sandalwood seedlings.

Liholiho could not have ruled without Ka'ahumanu's help. His most important decisions as king were made with her guidance. Because of her and his mother, Ke'ōpuolani, the old system of kapu was abolished. Liholiho ate freely with women, a forbidden practice. He outlawed the ancient ceremonies and ordered every heiau destroyed, every tiki burned. But his pulling down of the old beliefs with no planned structure for new ones began a chain of events that led to the loss of Hawaiian identity and lands.

In 1820, in the spiritual vacuum created by Liholiho's smashing of kapu, the first Christian missionary company arrived in Hawai'i. Their goal was to "save the savages." They would eventually acquire land from the kings and build hundreds of churches. They translated the Bible into Hawaiian, produced the first written form of the language, and took on the task of teaching the people to read. The missionaries were tireless zealots whose strict morality and unwavering belief in the superior God of the Testaments won many converts. Among those baptized in the haole faith were Ka'ahumanu, Ke'ōpuolani, Kapi'olani and other powerful ali'i. Hawai'i soon became a Christian nation, complete with persecution of nonbelievers.

Left: The black-roofed Lahaina Library and red-roofed Pioneer Inn face the Lahaina boat harbor on Maui, once the whaling capital of the world. Here the *Carthaginian II*, a 93-foot replica of a Swedish whaler, is permanently moored as a museum. Mark Twain, Herman Melville and Jack London once walked these streets.

Opposite: To retain moisture, pineapple starts are planted beneath sheets of plastic. North of Schofield Barracks on O'ahu, these fields exhibit the rich red soil that attracted James D. Dole to the area. In 1899 he planted the first 60 acres of this South American fruit, and by 1906 he was building the Dole cannery at Iwilei near Honolulu Harbor.

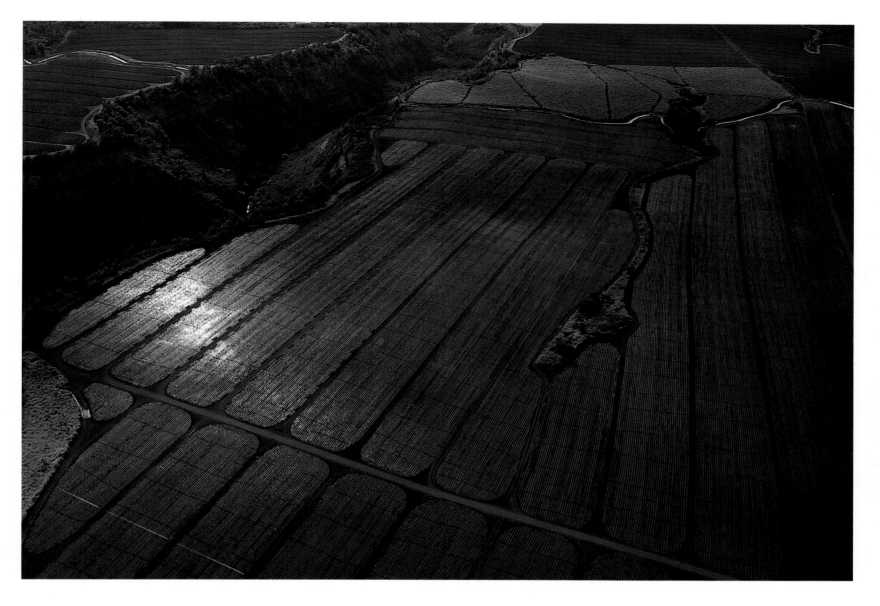

Liholiho loved traveling and decided to journey to the British Isles to see the home of his foreign friends. On November 27, 1823, Kamehameha II, his favorite wife, Kamāmalu, and their attendants boarded the English whaling ship *L'Aigle* bound for Britain. In London the Hawaiians attended gala parties in their honor. They beheld the dazzling architecture of this "advanced" culture. But then the royal couple contracted measles. With no immunity whatsoever, both Liholiho and Kamāmalu died. The British returned their bodies to Honolulu, to be buried in their homeland.

Liholiho's death brought his younger brother Kauikeaouli to power as Kamehameha III. He was very young, and his long reign was a troubled one. At first he relied on Ka'ahumanu to rule, but on June 5, 1832, she died. To succeed her in the position of regent (kuhina nui), the missionaries selected Kīna'u, a half-sister and wife of Liholiho. This was not Kauikeaouli's choice, and he rebelled with drink, gambling and sexual excesses that were frowned on by the elders and the church. The principal reason for the young king's wildness, however, was said to be his love for his sister Nāhi'ena'ena. The two siblings had been betrothed since birth in a customary arrangement among ali'i that would ensure "purer" progeny. They lived together as teenagers and were secretly wed, but the Congregational missionaries forced them apart and convinced Nāhi'ena'ena to marry a Big Island chief. She quickly bore a son, most probably sired by her brother. But the baby died within hours, and the brokenhearted Nāhi'ena'ena never recovered. She died a few months later, in December 1836. The effect on Kauikeaouli, after many gloomy days of mourning, was to snap him out of his hedonism. When he came of age to officially take the throne, he accepted Kīna'u as his regent and set about a long reign that was characterized by judiciousness.

As sandalwood stocks dwindled, other trades started. Whaling ships found Hawai'i to be a perfect place to make repairs and stock fresh food and water. Whalers spurred the growth of an increasingly Western economy. Blacksmiths, sailmakers, carpenters, cattle ranchers, farmers, grog shop proprietors, prostitutes and merchants found the ports of Honolulu and Lahaina to be extremely profitable havens. With an increasing foreign population in Hawai'i, written laws were needed to help maintain order. Kauikeaouli had a declaration drawn up that defined punishable crimes; the penal code included murder, theft, fraud, sexual misconduct and drunkenness.

Haole commercial enterprise brought with it a notion entirely new to Hawaiians. In the old days all land belonged to the king, who let his subjects use it "on loan." Suddenly every merchant in the nation wanted deeded land. It was just bad business to invest in an establishment without a guarantee of land

usage. If the merchants could not buy land they threatened to take their companies away. The new God, as well, required deeds in paradise. Missionary descendants eventually bought such great tracts of land they became the barons of Hawai'i's land-based enterprises. As the saying goes, "The missionaries came to do good, and they did well."

American missionaries became important counselors to the king. They advocated stronger ties between the United States and Hawai'i, but the British and French would not release their claim to the islands. Lord George Paulet, through a series of power moves, wore down Kauikeaouli and replaced the Hawaiian flag with the British Union Jack. This lasted about five months. London again rescinded the cession conducted by one of its captains. Both France and Britain, long known for their mutual mistrust, shortly after declared Hawai'i an independent state. Mounting interest on sandalwood debts pushed the young government into a financial hurricane. Income was collected without record, and accounting in general was poor. But as Hawaiians and foreigners added branches to the evolving constitutional monarchy, the government became more effective.

In 1846 a Land Commission began to set up a means to validate land claims and opened a test market for fee simple tracts on Maui and O'ahu. They offered the parcels to the commoners and explained the concept of free and clear ownership. The commoners bought all of the available land in those tracts. With this response, Kamehameha III and his counselors were faced with the problem of dividing the remaining lands fairly among the people of Hawai'i.

In March 1848 the Great Māhele, or Land Division, was held. The king received parcels for his private use, and the remaining land was divided three ways: government lands, chief lands and commoner lands. The legislature of 1850 gave the right of land ownership to foreigners as well, an act that prompted a revival of industry. Markets flourished. Whaling, sugar, cattle and coffee boomed. The government's gross income soared.

Good times encouraged religion and education. Protestant missionaries built Punahou School in Honolulu for their children. The Mission Seminary at Lahainaluna on Maui expanded. Moku'aikaua Church in Kailua-Kona went up, as did the mission schoolhouse in Honolulu, the Catholic Normal School in 'Āhuimanu, O'ahu, the first Mormon chapel in Pūlehu, Maui, and a number of common schools for the children of the kingdom. By 1866 English was the language of instruction in all schools in Hawai'i.

In 1853 a smallpox epidemic hit the islands and claimed at least 6,000 lives, most of them Hawaiian. The disease was the latest in a series of introduced illnesses that devastated the Hawaiian people. Because of their isolated development, the islanders had no immunities against foreign germs. Captain Cook's sailors had introduced venereal disease, which spread so quickly through the free-loving, bisexual society that when Cook returned to Hawai'i in 1779 he discovered to his horror that the syphilis and gonorrhea his men had left on Kaua'i a year before had spread to Maui and the Big Island. Over the next hundred years foreigners brought to Hawai'i deadly strains of measles, influenza, tuberculosis and other diseases, the last and most terrifying of which was the ma'i-Pākē ("Chinese disease" or leprosy). Not until the late nineteenth century would disease rates slow among the native population. By then most people with Hawaiian blood had other bloods as well, and today the number of "pure" Hawaiians is counted only in the hundreds.

On December 15, 1854, Kauikeaouli died, and Alexander Liholiho was crowned king. He was twenty years old. Five years earlier he had traveled to Europe and America with his brother Lot Kamehameha.

Hawai'i was undergoing a new period of upheaval. France had begun negotiations for another land treaty; sugar interests imported foreign workers from China; the United States was moving toward civil war; and the native Hawaiian population had decreased to only 70,000 by 1855, down from perhaps 600,000 or so when Cook arrived. Kamehameha IV set about the multiple tasks of encouraging commerce and agriculture, strengthening the schools for Hawaiian children, improving roads and

A flower farm on windward O'ahu. With its tradition of lei giving, Hawai'i is one of the world's most "flowerful" lands. The flora here are as varied and beautiful as the island's landscapes.

146

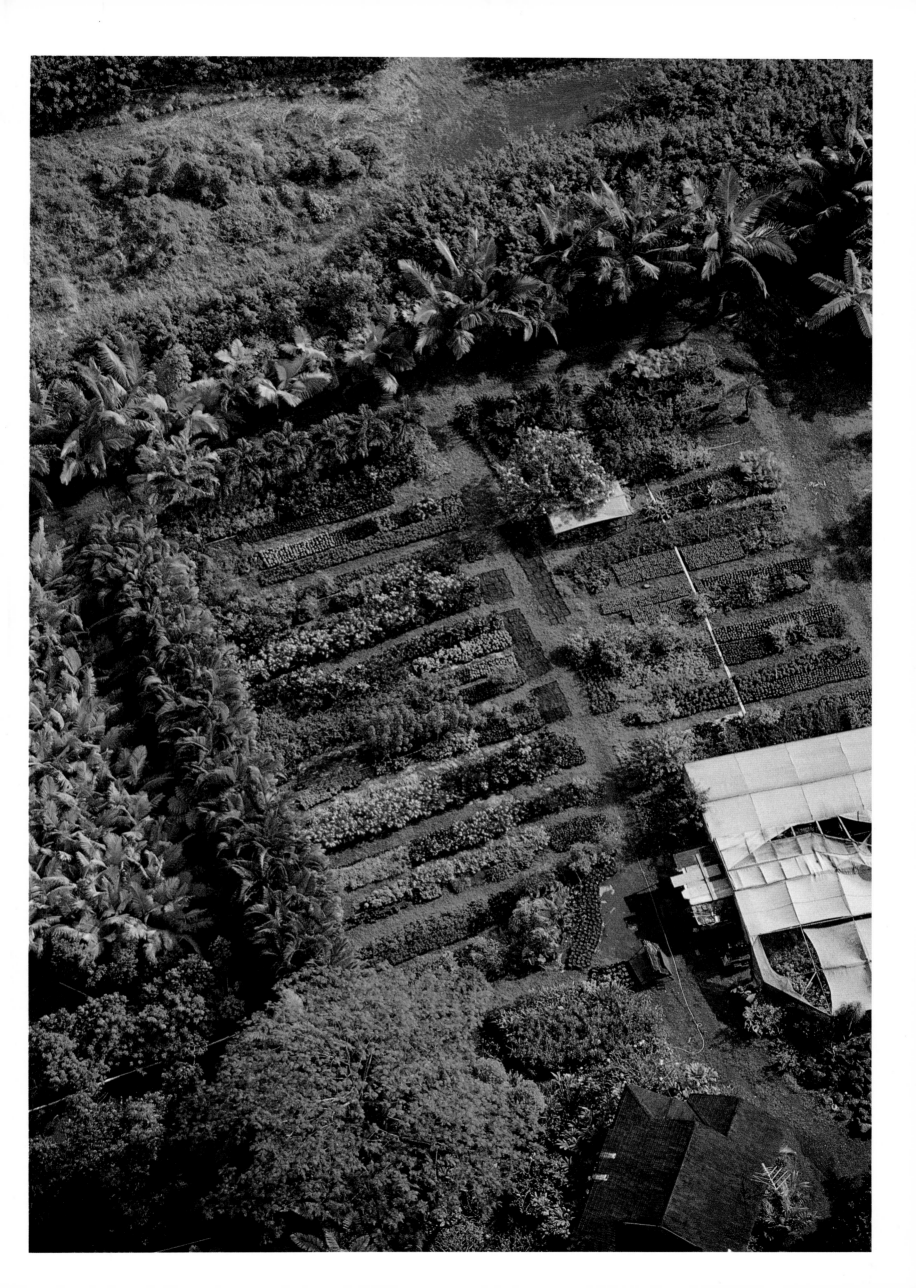

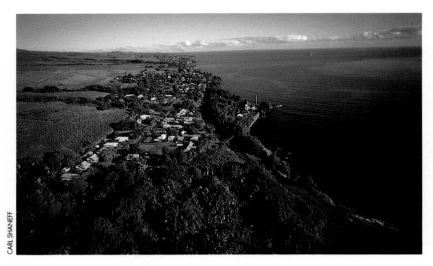

CARL SHANEFF

Left: Claus Spreckels and William G. Irwin founded the Hilo Sugar Company in 1884, and two years later built the Wainaku Mill on a triangular point just north of Hilo town. The old-fashioned mill became obsolete and phased out operations during the 1970s, and is now abandoned.

Opposite: Pineapple pickers wear thick layers of clothing, gloves, hats and bandannas to protect themselves from the spikelike pineapple leaves. This field is part of the Del Monte plantation in central O'ahu. Unlike Dole, the Del Monte company has no canning facility in Hawai'i, so its workers harvest the fruit without removing the leaf crowns.

harbors, and establishing in 1859, with his wife's help, the edifice that would be a lasting monument to their rule: the Queen's Hospital.

On May 20, 1858, King Kamehameha IV and Queen Emma had a son. They named him Prince Albert Edward Kauikeaouli Leiopapa a Kamehameha, and hoped his birth was a blessing from God and a sign that the Hawaiian race would be increased. The whole country celebrated the birth of the heir. But only four years later Prince Albert contracted a sudden fever and died. He was the last child in the line of succession of the Great Kamehameha. Following the death of his son, the king fell into a depression that, coupled with asthma, finally killed him at the age of 29.

In 1863 Alexander's older brother Lot, the last ruler of the royal line of Kamehameha I, ascended the throne as Kamehameha V. Lot was strong willed and powerful, and he took it upon himself to reclaim the authority of the crown that had been given away by Kauikeaouli. He refused to recognize the Constitution of 1852, stating that he would write another, and he appointed a cabinet that shared his views. With the new constitution, Lot Kamehameha addressed national dignity, strength in the foreign arena, and literacy and land requirements for voting.

Commerce expanded under Kamehameha V. A new post office and government offices were built, along with 'Iolani Barracks, a quarantine station and an insane asylum. By the 1860s petroleum had cut into the whale oil market with a cheaper, cleaner substitute, and sugar took over as Hawai'i's major industry. The growth of the plantations and the dwindling of the native Hawaiian population forced the sugar barons to bring in more Asians to work the fields.

Although he was urged to do so for the sake of producing an heir, Kamehameha V never married. The Constitution of 1864 named his sister Victoria Kamāmalu successor, but she died in 1866. On his forty-third birthday Lot fell victim to an unexpected, fast-moving illness. From his deathbed came no statement of who should be his successor, and the mighty line of Kamehamehas ended.

In 1873 Hawai'i held its first election to name a king. The winner was William C. Lunalilo, a personable member of the ali'i class whose great wit made him a popular monarch. But he too fell ill, in November of that year when he was in Kailua-Kona on the Big Island, and upon his return to Honolulu in February 1874 he died. His reign had lasted only thirteen months. He was interred in the Lunalilo Mausoleum adjoining the Kawaiaha'o Church. In his honor, and by the terms of his will, the government established Lunalilo Home for the poor and ailing people of Hawaiian ancestry.

Following the death of Lunalilo, another election pitted two strong candidates against each other: Queen Emma (the widow of Kamehameha IV) and David Kalākaua. On February 12, 1874, the Legislative Assembly elected Kalākaua to the throne, possibly because his opponent advocated stronger ties to Britain. Queen Emma's supporters were enraged and stormed the courthouse. British and American marines landed, called in from three vessels in Honolulu Harbor. They put down the riot and remained ashore for a week while the new regime became established.

Kalākaua was a peaceful man. His wife, Queen Kapi'olani, accompanied him on his trips throughout the island chain to speak to his people. He urged them to work hard for the betterment of the kingdom,

but his strongest message was for the Hawaiians to restore their culture and increase their numbers. For the first time in many years, since the missionaries had compelled laws against it, the hula was performed for the king.

Kalākaua petitioned the United States for support, requesting a reciprocity treaty stating that no other country would have dominion over the islands. The treaty opened free trade for sugar with the United States and eventually gave the American navy the right to use the Pearl River Harbor. But although he acknowledged and hoped to benefit from American power, Kalākaua preferred to pattern his government after European monarchies. He built the very Victorian and resplendent 'Iolani Palace and held there a grand coronation following his trip around the world. The jeweled crowns that the king set upon his own head and Kapi'olani's were worn only at the coronation and never again. Mark Twain characterized the ceremony as "all the workings of an ocean liner crammed into a sardine can."

For all the good Kalākaua did to preserve Hawaiian culture by recording ancient legends and restoring the hula to social prominence, his regime became riddled with corruption and scandal. Walter Murray Gibson, a brilliant but misguidedly self-serving politico, came to Hawai'i originally as an emissary of the Mormon church, and soon ingratiated himself with the government. He became Kalākaua's principal adviser, and in ten years the two of them drove the national debt up from $388,900 to $2,600,000. Nearly all the foreigners and many native Hawaiians became disenchanted with the government.

A group of disgruntled businessmen formed a secret organization: the Hawaiian League. In 1887 they armed themselves and in a show of force made Kalākaua sign a new constitution called the Bayonet Constitution, which extended greater powers to the legislature and provided voting rights for resident haoles. Gibson was arrested and allowed to leave the country; he died in San Francisco six months later. After three more years in which factions for native rule vied against foreign businessmen, Kalākaua fell ill and also traveled to San Francisco, hoping a change of climate would restore his health. It did not. He died there January 20, 1891, and his sister Lili'uokalani was proclaimed queen. She was the last native Hawaiian monarch to reign over the islands.

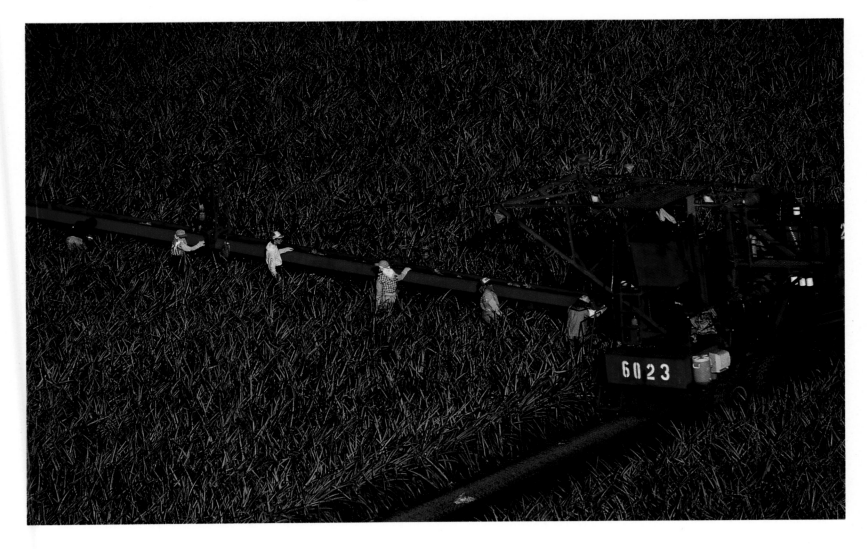

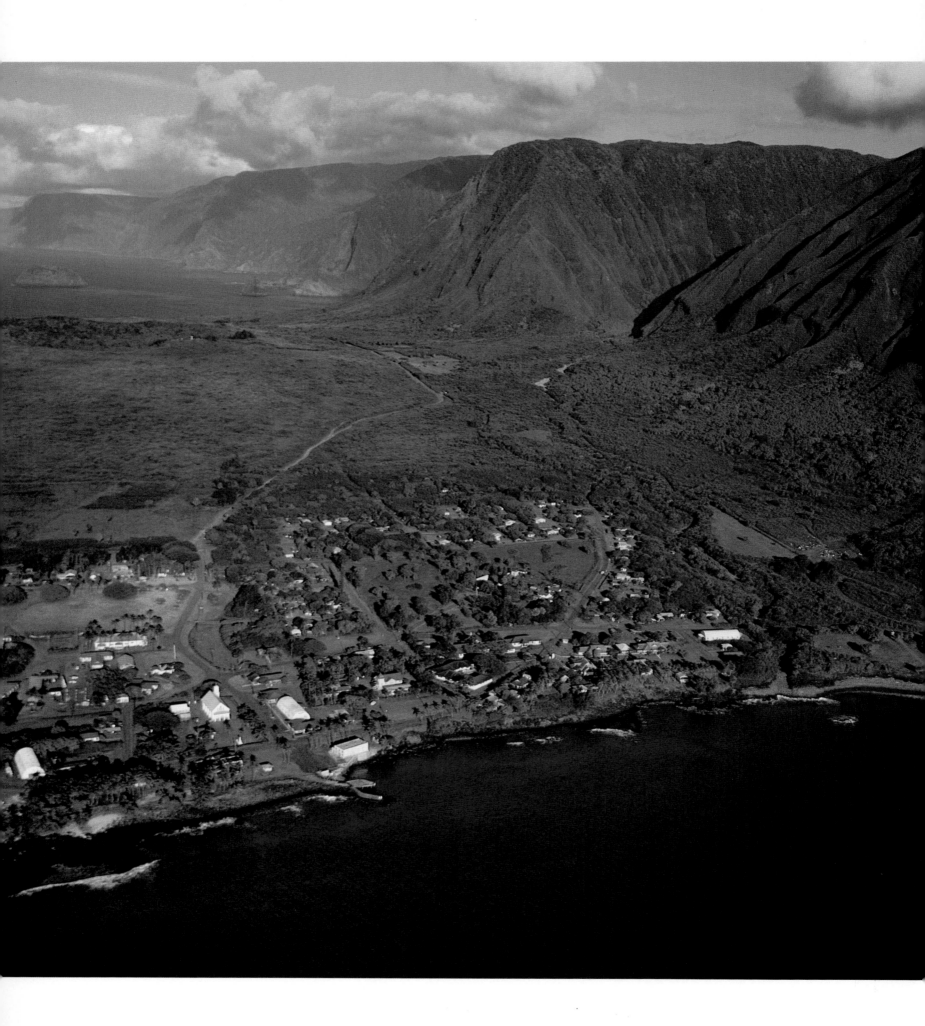

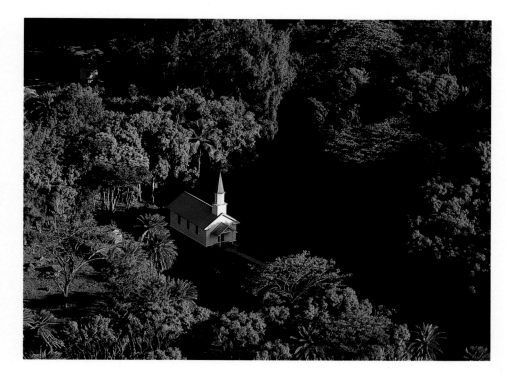

Left: Kalaupapa settlement, Moloka'i. The dirt road leads east to Kalawao, the original town for lepers on the peninsula. In 1888, when a water pipeline was extended from Waikolu Valley, the exiles abandoned Kalawao and moved here to the drier, less windy Kalaupapa side. Fewer than two hundred people live in Kalaupapa today, half of them lepers. Sulfone drugs arrested the disease in the 1940s.

Above: Siloama, the Church of the Healing Spring, a Protestant chapel founded in 1871 by 35 of the first lepers exiled to Kalawao.

Previous pages: A patchwork of cane fields and creeping subdivisions hug some of Kaua'i's last cinder cones on the Po'ipū plain. The reservoir is called Waita, an unusual word combining Hawaiian (*wai*, water) and Japanese (*ta*, rice paddy).

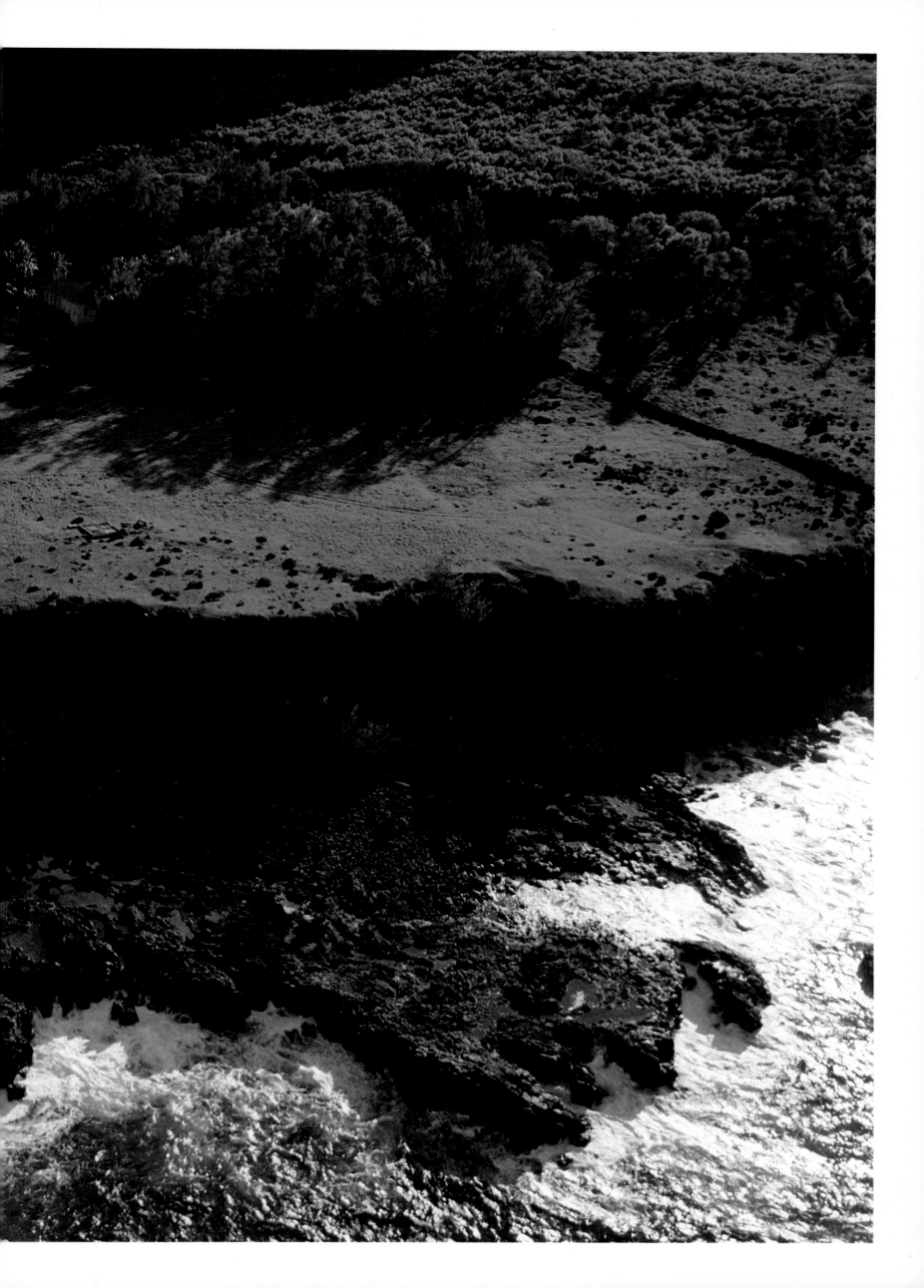

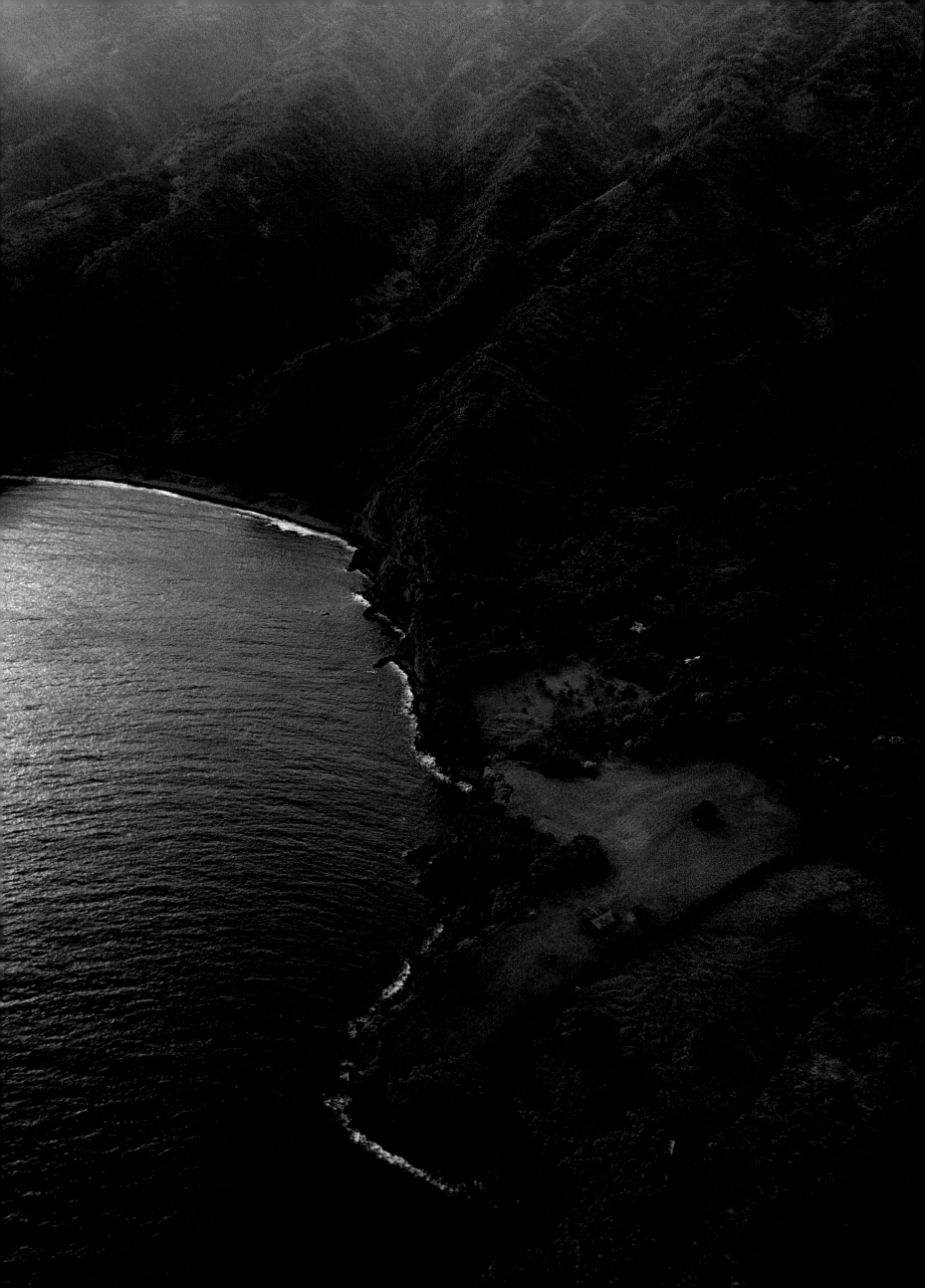

Previous pages: Hidden in the trees on Moloka'i's Kalaupapa Peninsula is St. Philomena Church, built by the famous leper priest Father Damien. In the decades after the 1819 abolition of the ancient Hawaiian religion, Christians established churches in every corner of the islands.

Above: Built in a tidal wave zone—like most structures along Hawai'i's coasts—this house in a coconut grove in Pohoiki, south of Hilo, looks out optimistically at the pounding Pacific.

Left: Just a few Zen masters, xenophobes, contemporary kāhunas, truck farmers, media stars, determined hippies, and Hawaiians who trace their gene-alogies to the gods and demigods of the region make the remote countryside of Hāna, Maui, their home. These houses near the end of the paved road represent the farthest retreat into the kua'āina (backcountry).

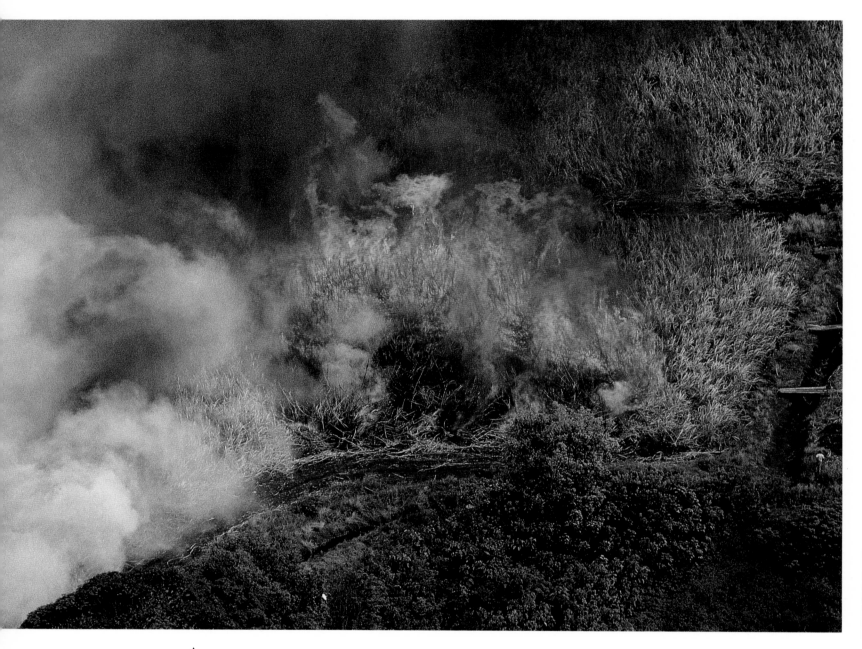

Above: A cane fire near the
Wailua River on Kaua‘i. Sugarcane
workers wait until the winds are
right to help them direct the
flames. The sugar is easier to
harvest after it has been burned.
Right: Macadamia nut orchards
began to appear on the Big Island
in the 1920s as farmers sought an
alternative money crop to sugar.
The trees in this orchard above
Laupāhoehoe are sculpted to
allow truck access.

Left: The Mauna Loa macadamia orchards south of Hilo, unlike other "mac" farms, feature tightly planted trees surrounded by Norfolk pine windbreaks. The lime-colored plots in the nursery are young macadamia seedlings.

Top right: In this sugarcane field near Hanapēpē, Kauaʻi, egrets have learned to follow tractors for the bugs they expose. Burned sugarcane stalks are loaded into trucks and hauled to the mill.

Bottom right: The philosophy for spacing macadamia trees has varied over the years. Older orchards like this one near Līhuʻe, Kauaʻi, were planted with 30-foot spaces, about 50 trees to the acre.

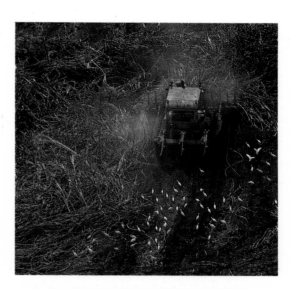

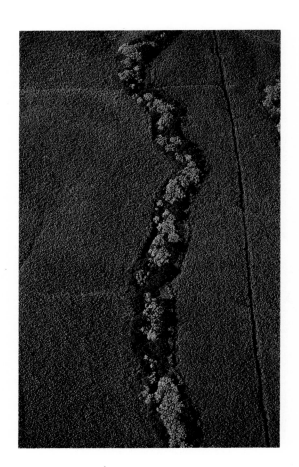

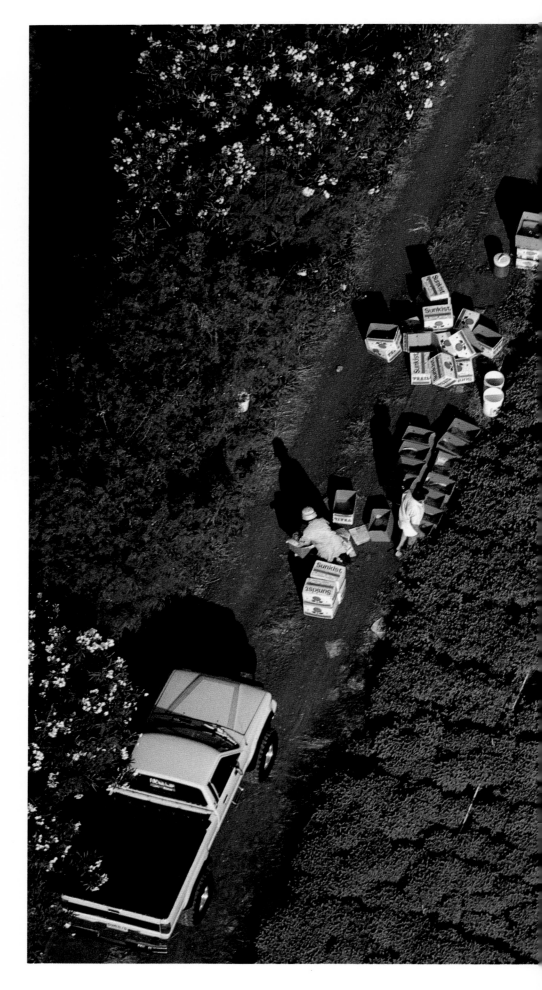

Right: A truck farm in Wai'anae Valley, O'ahu. Although enough arable land exists on the islands to meet Hawai'i's market needs, 75 percent of the produce consumed in the state is imported.

Above: Like a broken lei, a kukui-laden streambed crosses a Hāmākua, Hawai'i, cane field.

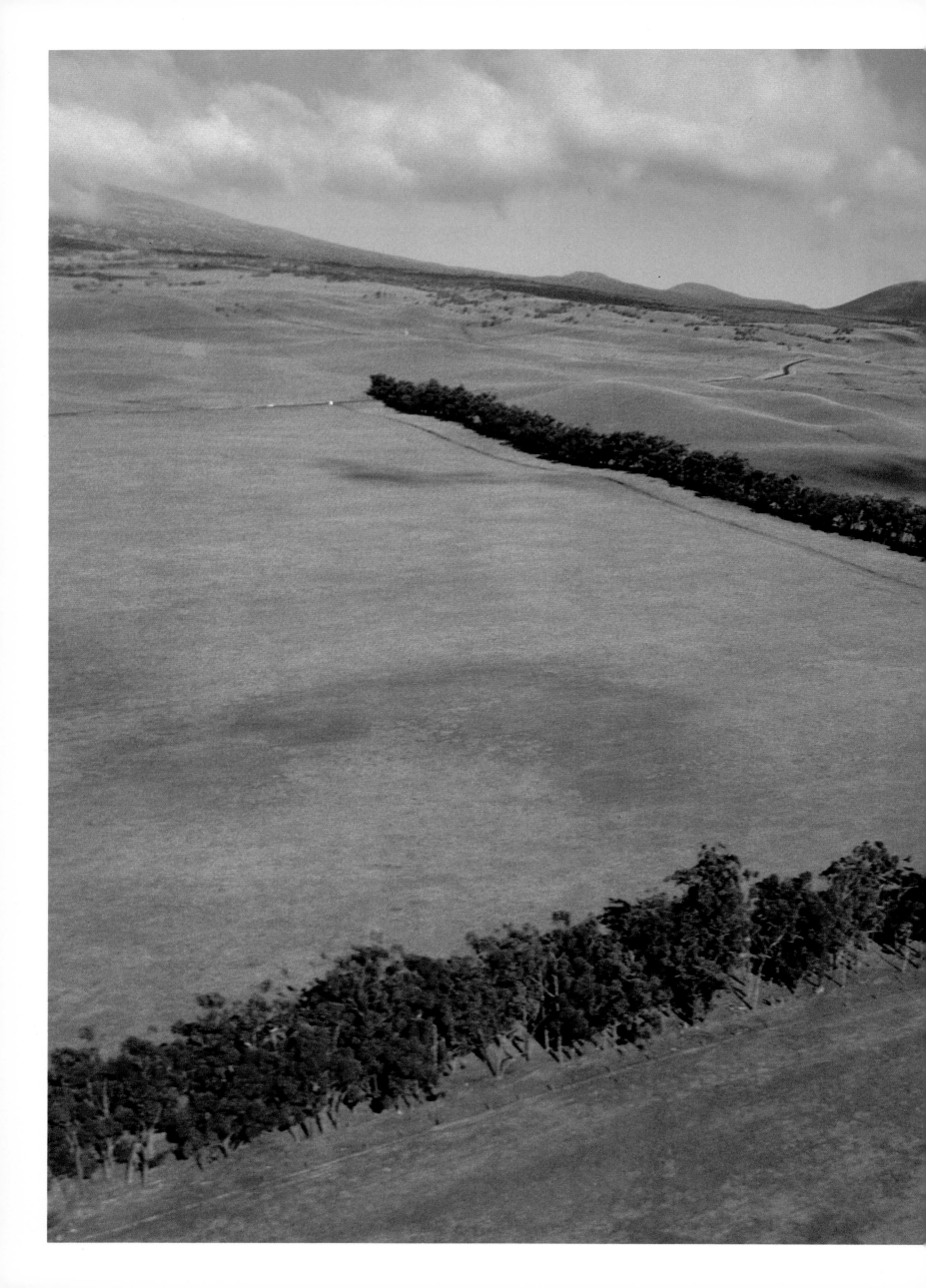

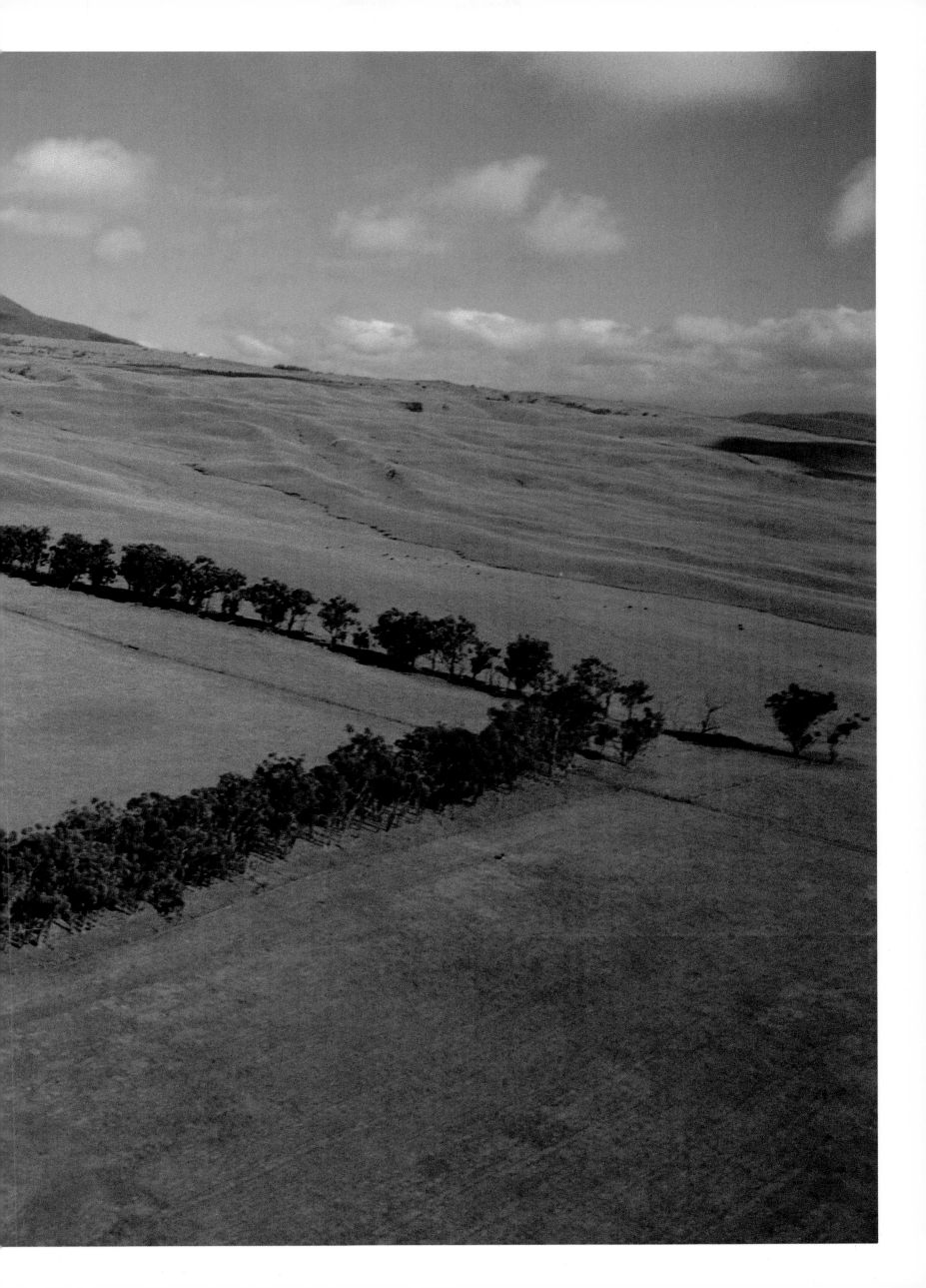

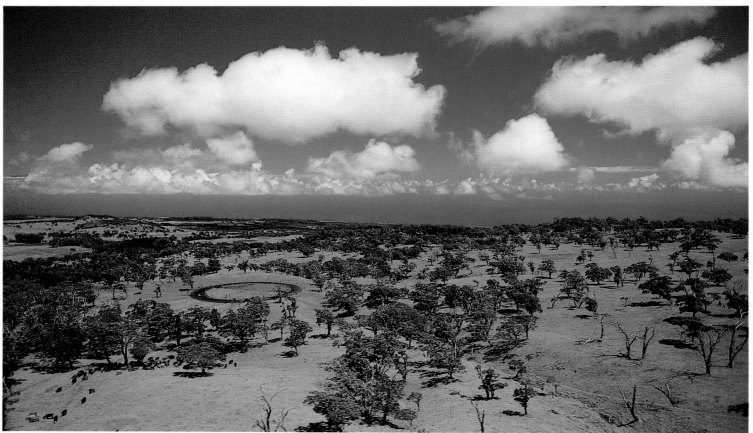

PETER FRENCH

Above: Cattle feed in a "wagon-wheel" grazing cell at the 225,000-acre Parker Ranch, Big Island. "The largest privately owned ranch in America" was established in 1847 by a New Englander, John Palmer Parker, who had promised King Kamehameha to capture and contain the herds of feral haole animals that were ravaging the land. Parker imported Spanish-American cowboys that the Hawaiians came to call paniolo (after *Español*).

Right: The title of this masterpiece: *Blue Tidal Pool, Red-layered Sea Cliff and Yellow Field with Cattle.* Near Pā'ia, Maui.

Previous pages: A corner of eucalyptus marks a high pasture at Waiki'i Ranch on the Big Island.

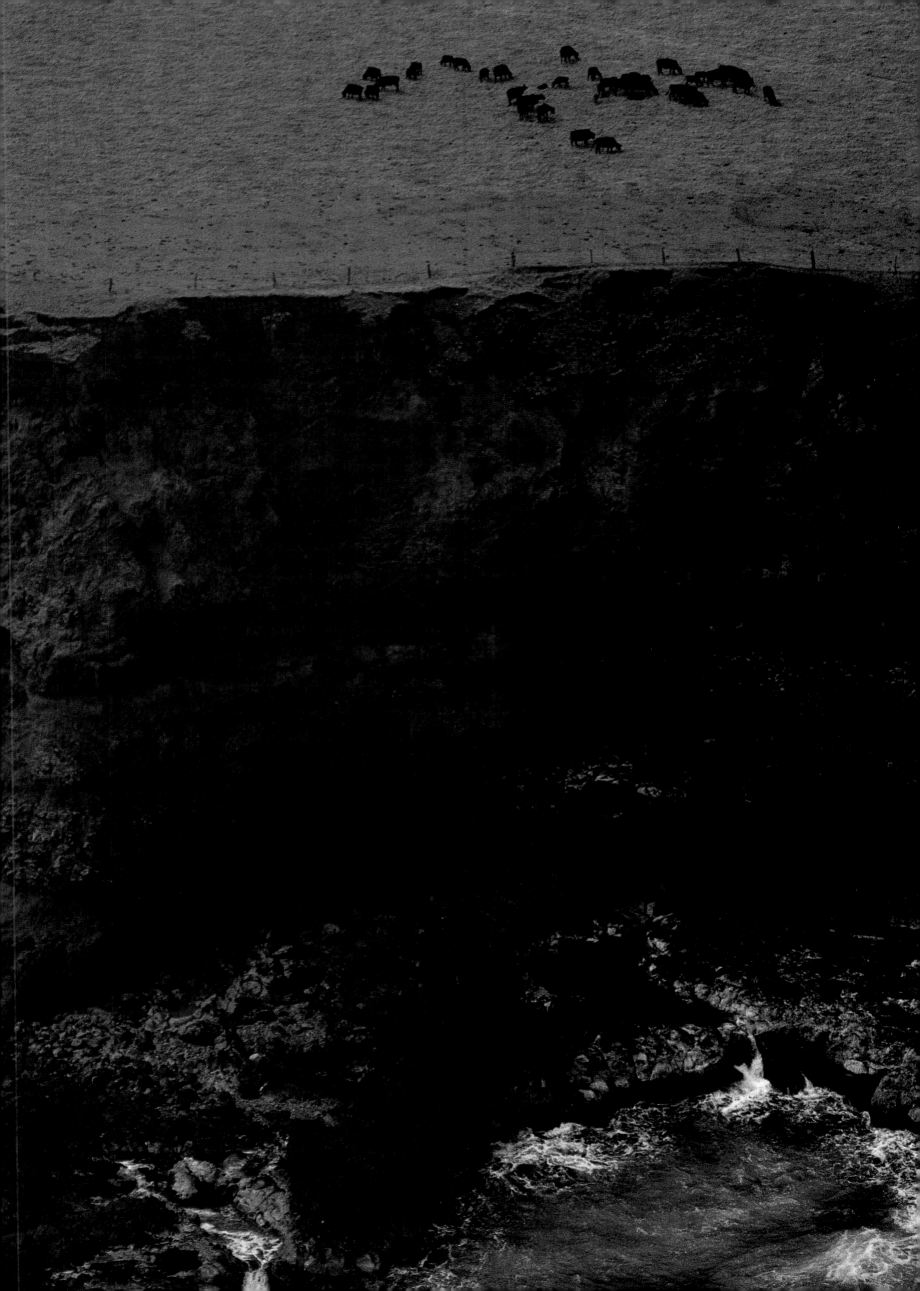

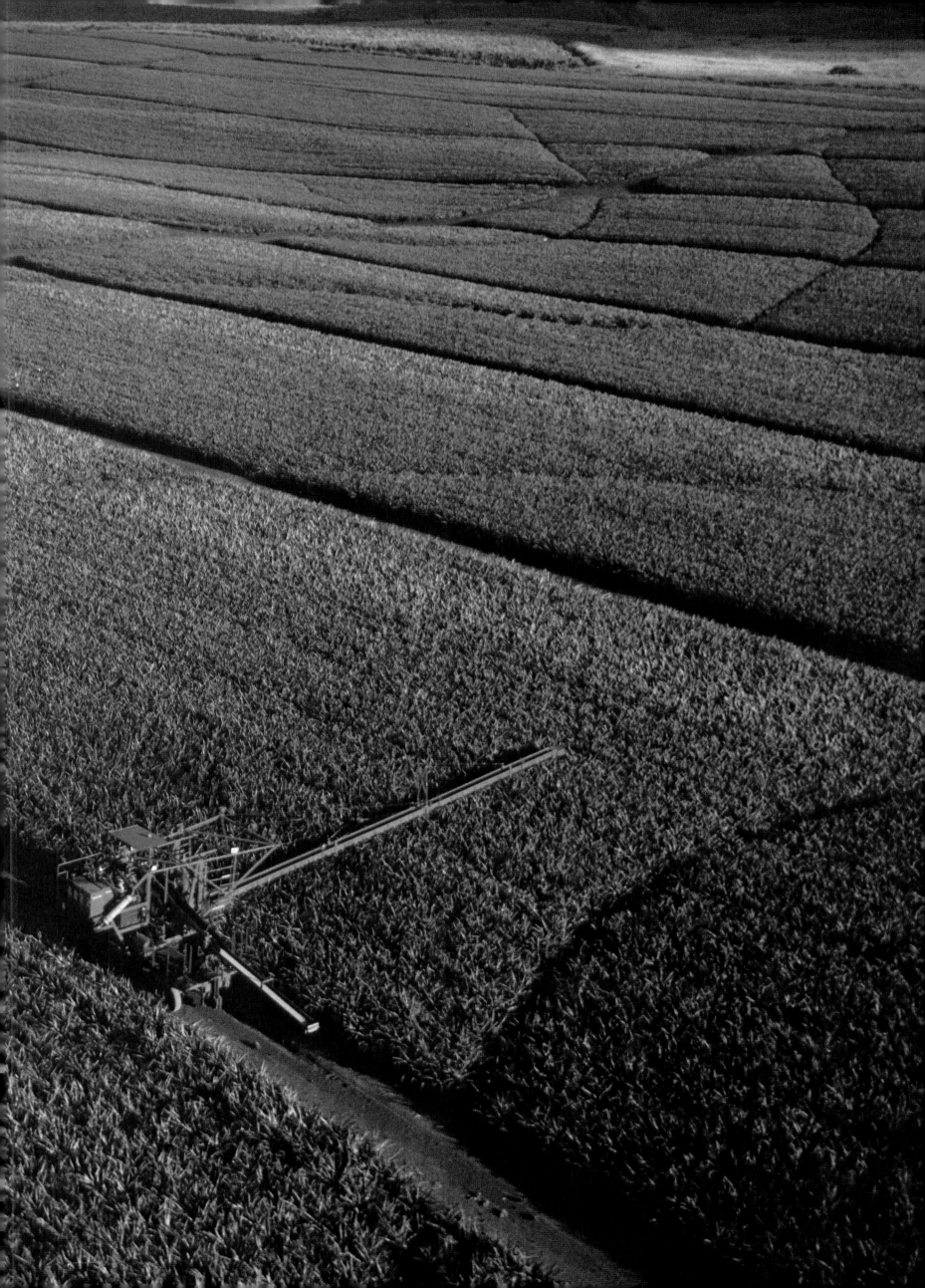

Previous pages: Late afternoon, and the pineapple workers have left this harvesting machine where they can start again tomorrow. During harvest, the workers follow behind the long-armed conveyor belt.

Above: Father Damien, known as "the carpenter priest" because of all the churches he built in Hawai'i, established this one, St. Joseph's, in Kamalō, Moloka'i, in 1876. To the right of the chapel entrance, a lei-draped statue of Damien casts a familiar shadow.

The three-tiered pagoda over-looking Honolulu Memorial Park is an enlarged replica of one of Japan's architectural treasures, the Minami Hokko-ji, built near Nara during the Momoyama Period (1574–1602). Beneath its copper spire and lichen-stained roofs is a columbarium with 1,750 niches for urns bearing ashes of the dead. The nearby haka monuments will someday cover the lawns. In 1958 the businessman Herbert Monte Richards, the fourth generation of a missionary family, established this park in the traditional style of an Asian Buddhist cemetery.

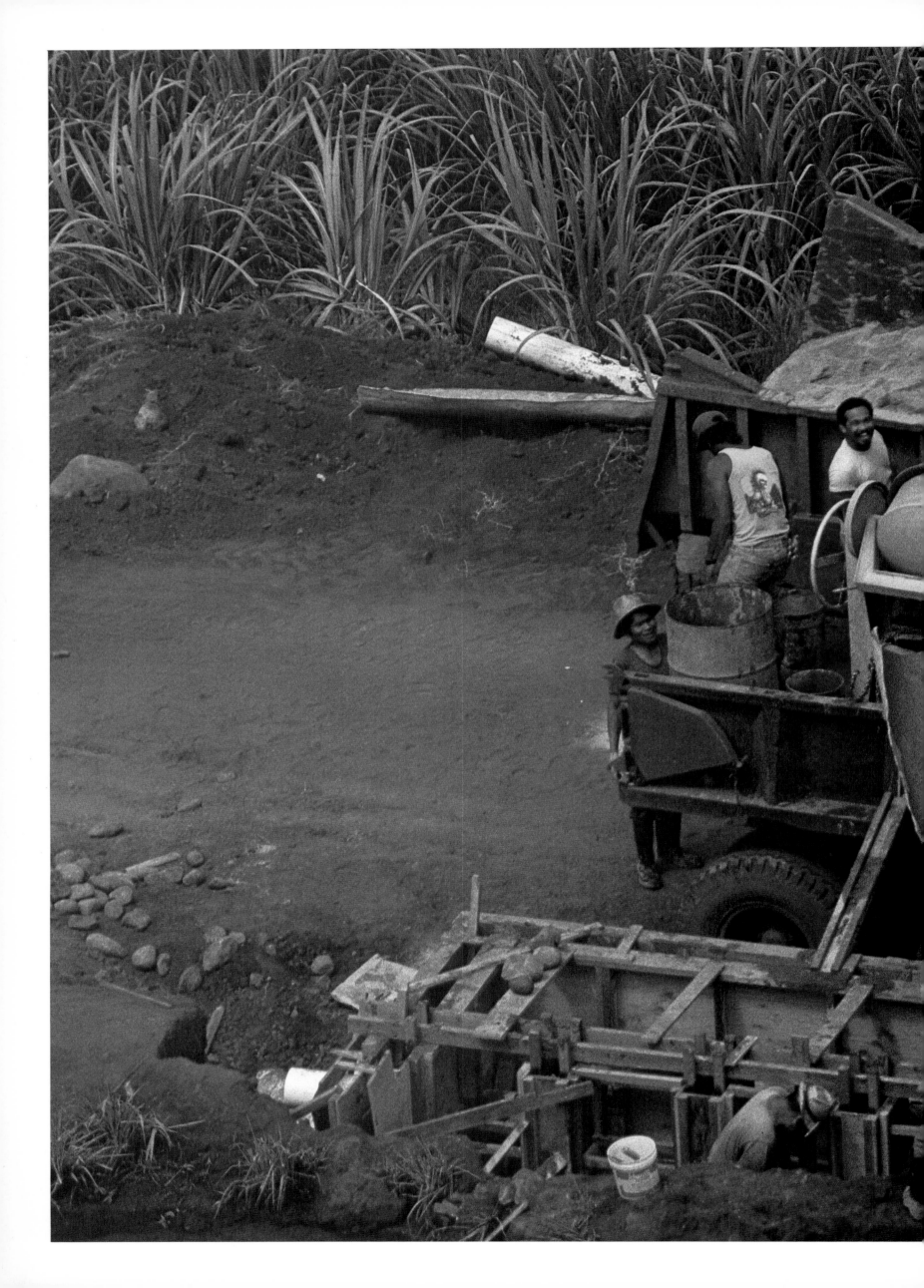

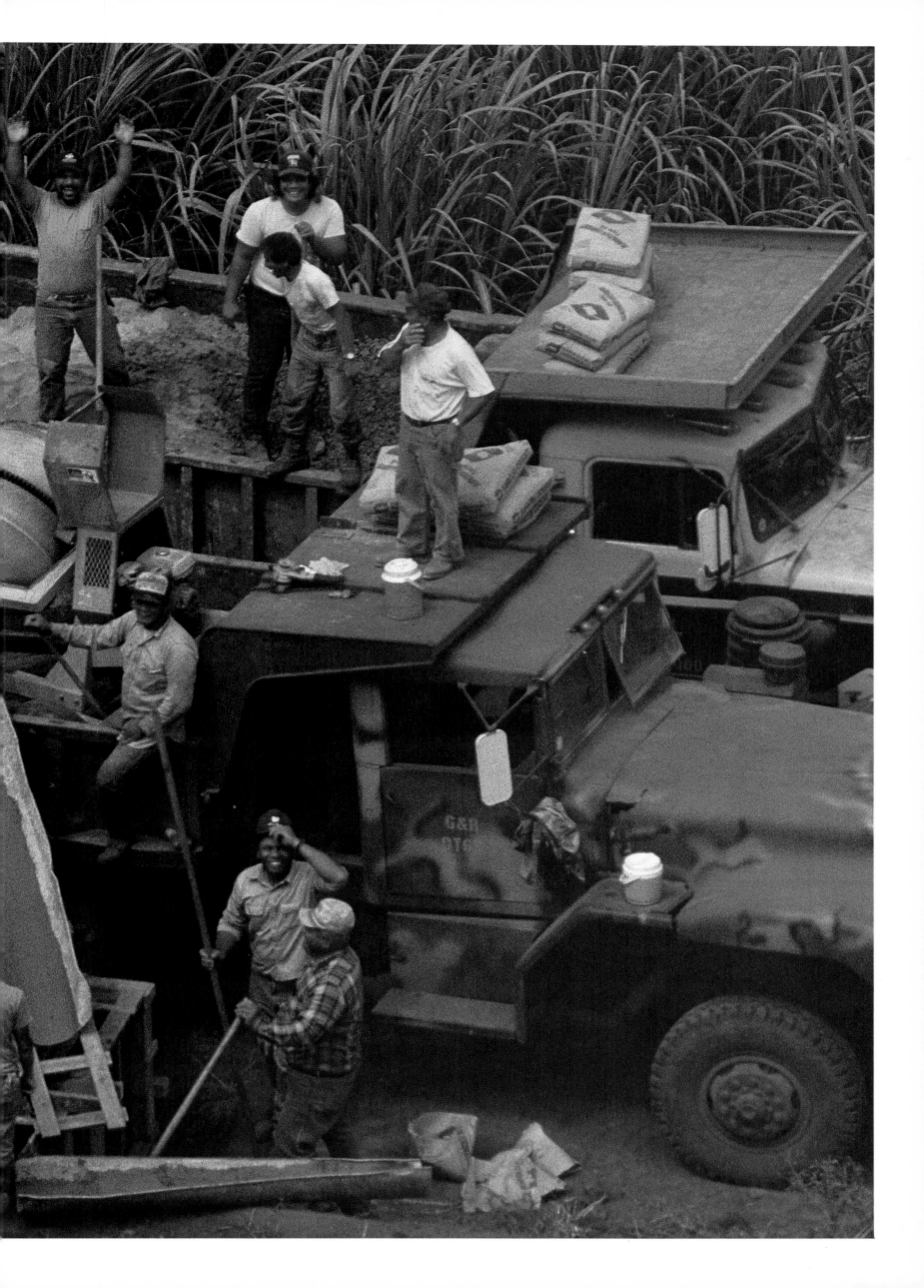

Left: Probably the most famous water tower in the world, the Dole pineapple was erected above the Honolulu cannery in 1928. Turn the photo upside down and see the faces on the pineapple sections. *Right:* The Waialua Sugar Mill, one of two remaining cane mills on O'ahu (the other is in Waipahu). Built in 1897, the mill today employs 475 workers, oversees 12,000 acres of cane, and annually produces 70,000 tons of raw sugar, which is shipped to the C&H Refinery in Crockett, California. The striped bin near the smoke-stack stores bagasse (the dried pulp of juiced sugarcane stalks), which is used to fuel the mill's furnaces.

Previous pages: Pouring cement for a new irrigation system in a cane field east of Waimea, Kaua'i, these workers take a break to smile for the photographer in the helicopter.

Above: Workers preparing a field in Wahiawā, Oʻahu, for a new crop of pineapple. When Europeans, Americans and Asians came to Hawaiʻi they brought plows and other machines that worked the land harder than the hands and digging sticks of the native Hawaiians. By the twentieth century, sugar and pineapple covered most of the arable land that makes up seven percent of Hawaiʻi's total acreage.

Left: Harvesting sorghum outside Pāʻia, Maui. Sorghum is used in Hawaiʻi as feed for dairy cows and other livestock.

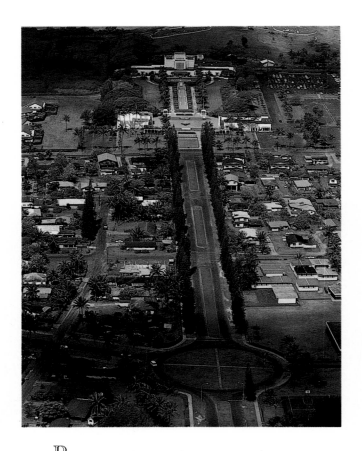

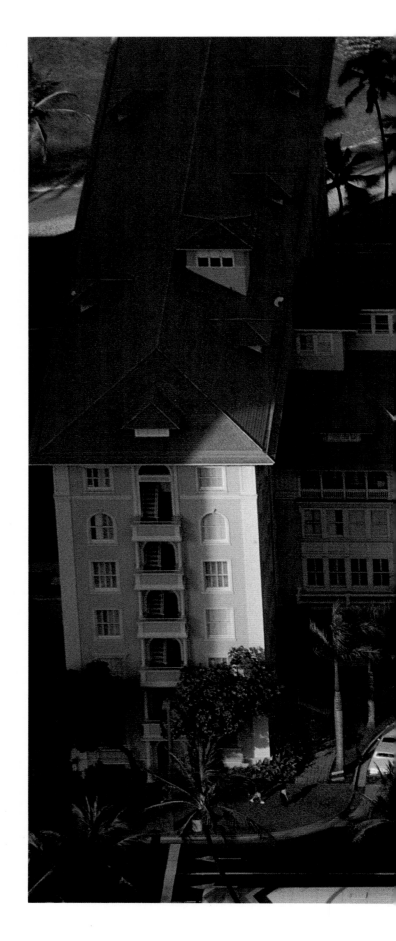

Above: Burdened with the epithets "Taj Mahal of the Pacific" and "Hawai‘i's Lincoln Memorial," the Mormon Temple at Lā‘ie, O‘ahu, faces east down a Norfolk pine–bordered avenue that runs straight to the ocean. Lā‘ie became a gathering place for Latter-day Saints in 1864, after the church lost its ownership of Lāna‘i. Labor missionaries erected the temple in 1919.

Right: The newly restored Moana Hotel. Built in 1901 of Douglas fir from the Pacific Northwest, the Moana was Waikīkī's first "country hotel," so far from downtown Honolulu it had its own icehouse and electric plant. On this day a shadow cast by the west tower of the Hyatt Regency cuts across the Moana's north wing and its famous banyan tree, planted in 1886.

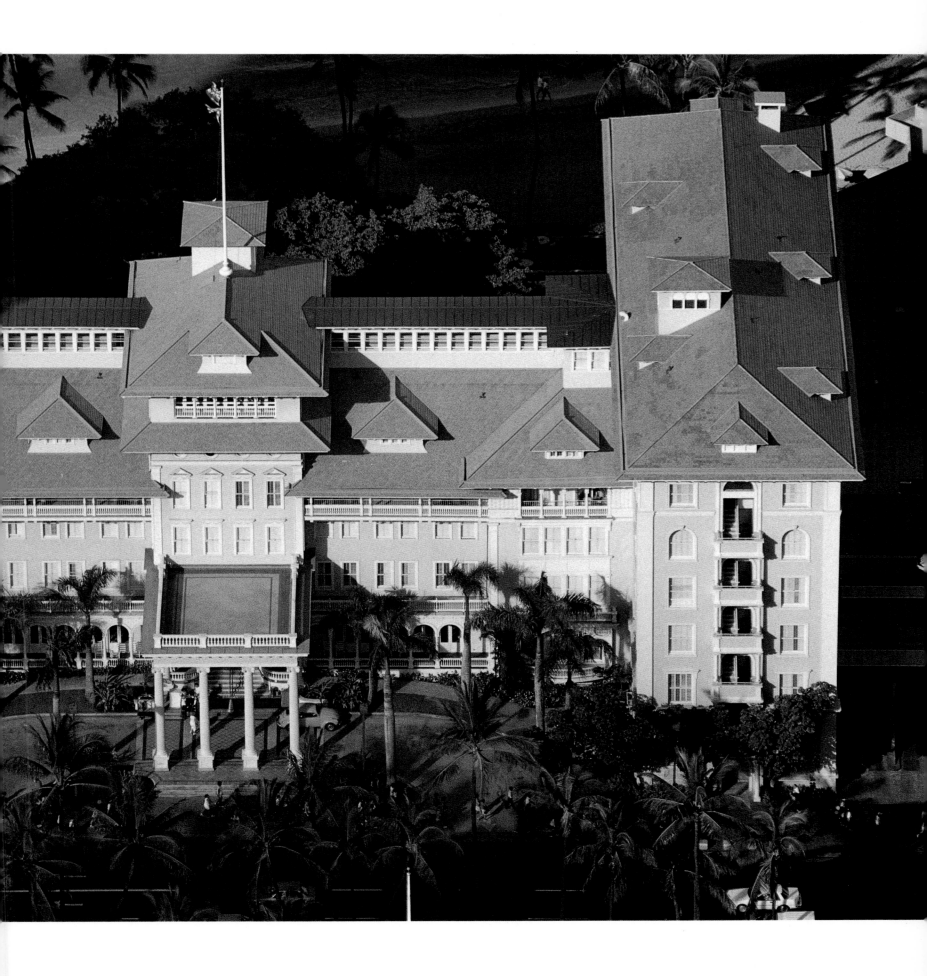

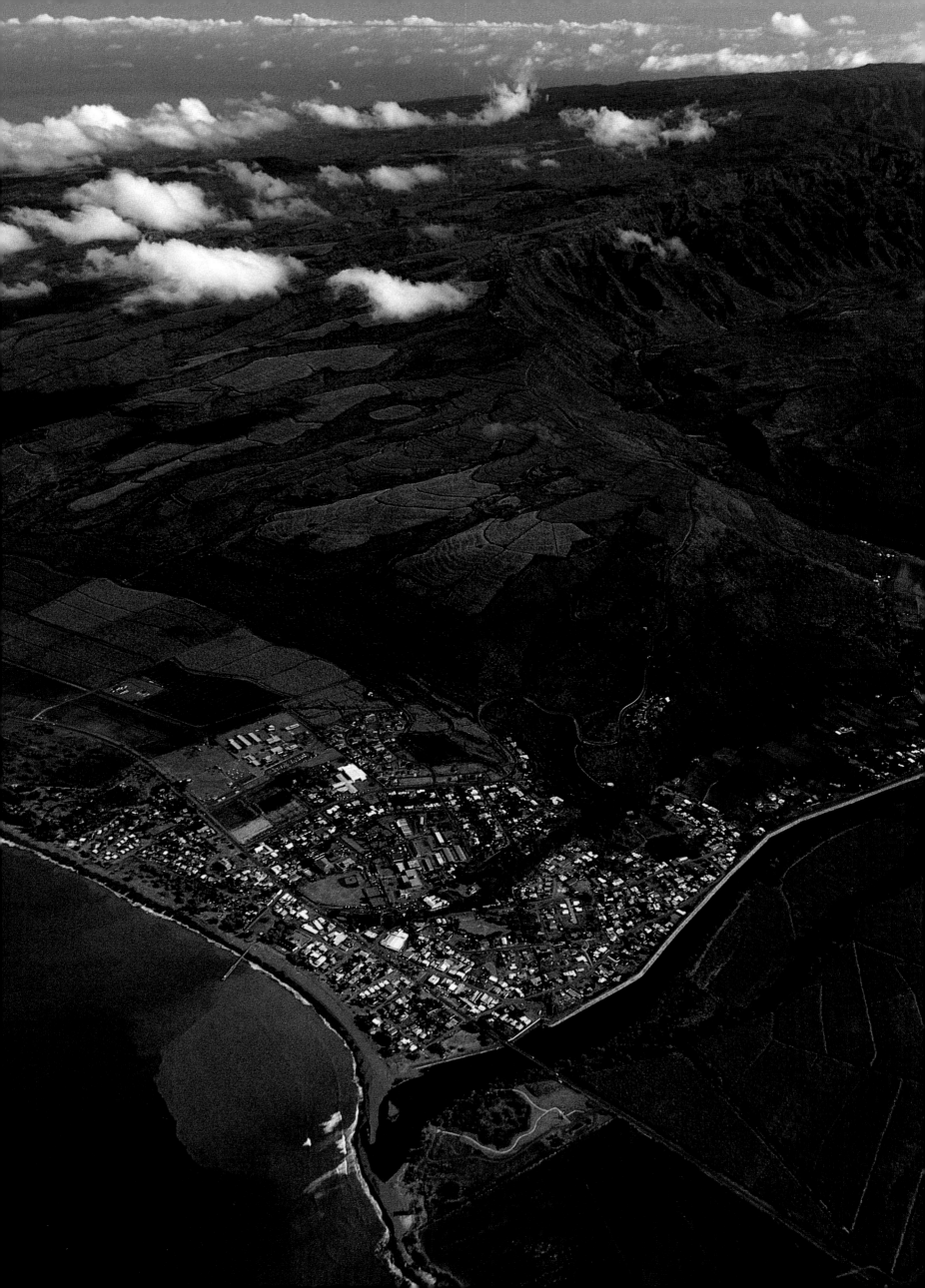

Left: The town of Waimea, on the southwest shore of Kaua'i, and the beach where, on the afternoon of January 20, 1778, Captain Cook first set foot on the islands.
Right: Fort Elizabeth, named for the wife of Russian emperor Alexander I, combines a star-shaped Russian-designed fort and traditional Kaua'i stonework. This was the fourth fort begun in the islands by Dr. Georg Anton Scheffer, the agent for the imperial Russian government. The first was started at Honolulu Harbor in 1816 and completed by Kamehameha after he expelled the Russians from O'ahu. A year later two smaller forts at Hanalei on Kaua'i's north shore, and this stronghold on Waimea River, built with the cooperation of High Chief Kaumuali'i, raised Kamehameha's ire again and he deported the Russians from the kingdom. For more than a year (1816–17) the Russian flag had flown over Kaua'i.

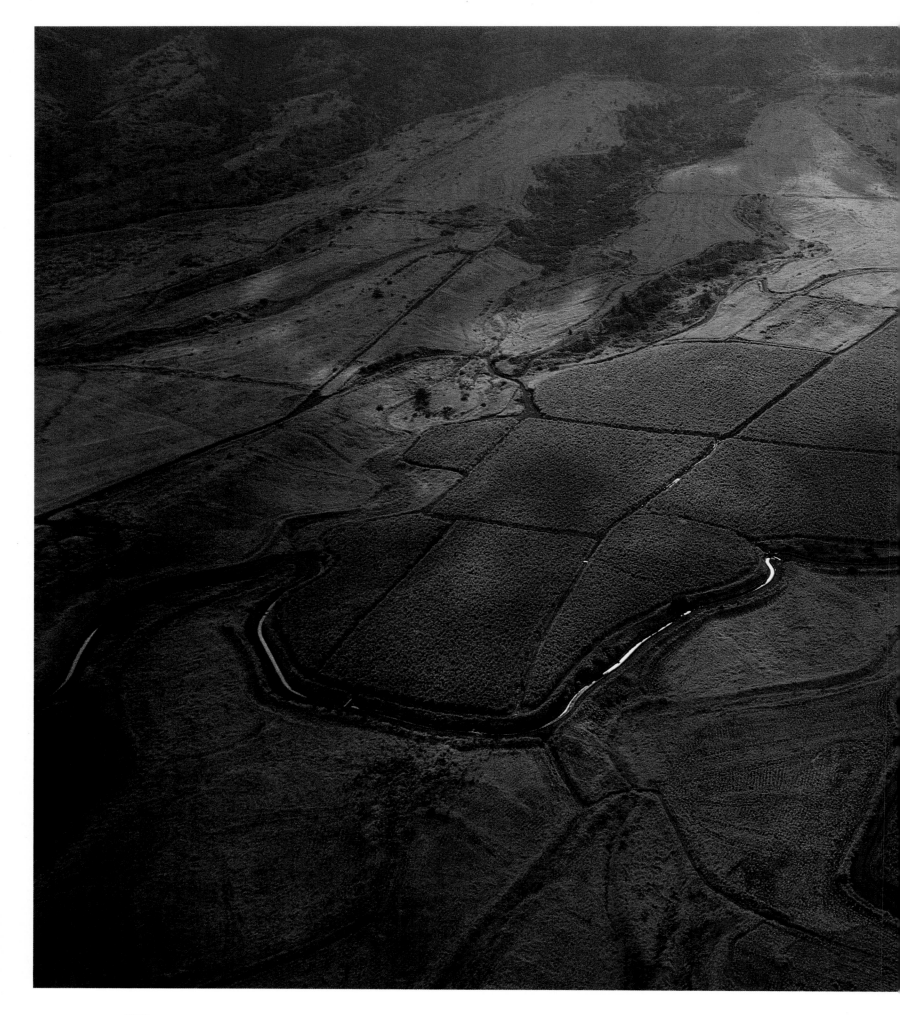

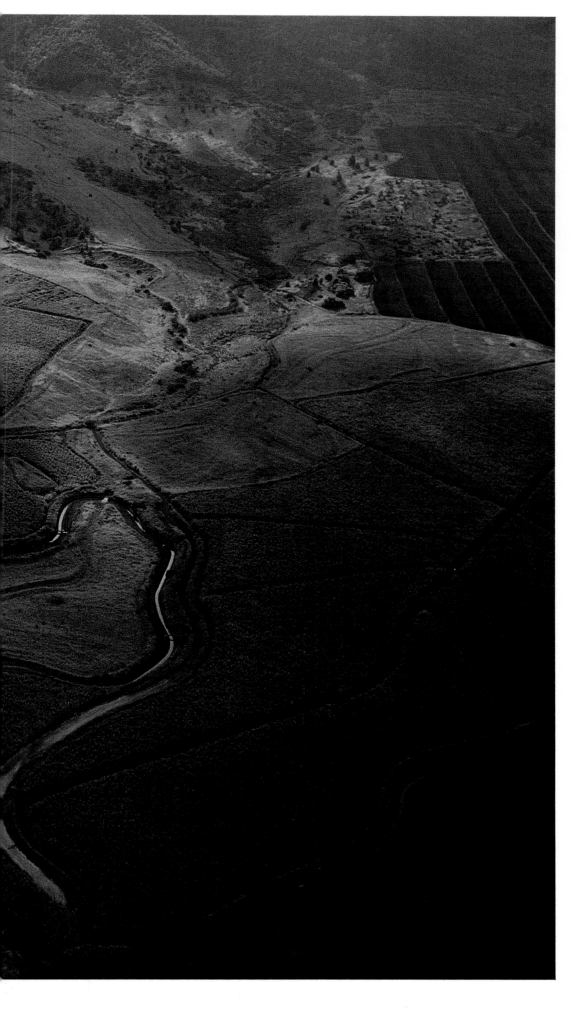

Cane fields and irrigation ditches in the foothills of the Wai'anae Range on O'ahu. Some fields have not been replanted, because of cutbacks in production. Cheaper foreign sugar threatens to completely destroy the Hawaiian sugar market.

Above: Tides and waves challenge
this ramshackle kauhale (cluster of
dwellings) on the south Kona coast
of the Big Island. Notice the dog,
the TV antenna, and the white roof
weighted down by lava rock.

Right: Hidden away somewhere in
the Hāna District of Maui, a model
of modern kua'āina (backcountry)
living: windmill, power line, battery
storehouse, solar water-heating
panels, TV antenna and a sturdy car.

Opposite: A semi-modern kauhale
built in 1977 on a cliffside near
Pelekunu Valley, on northern
Moloka'i. Believing the 1893
Overthrow and the 1898 Annexation
to be illegal seizures by the United
States, several contemporary
Hawaiians have retreated from the
government into remote settle-
ments on ancestral homelands.

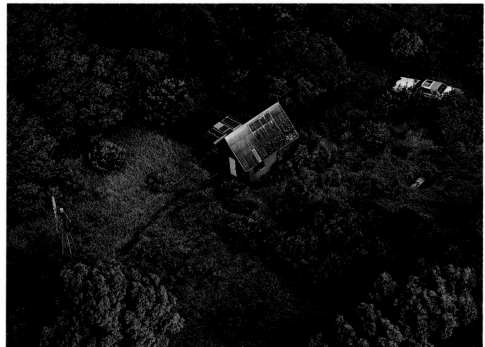

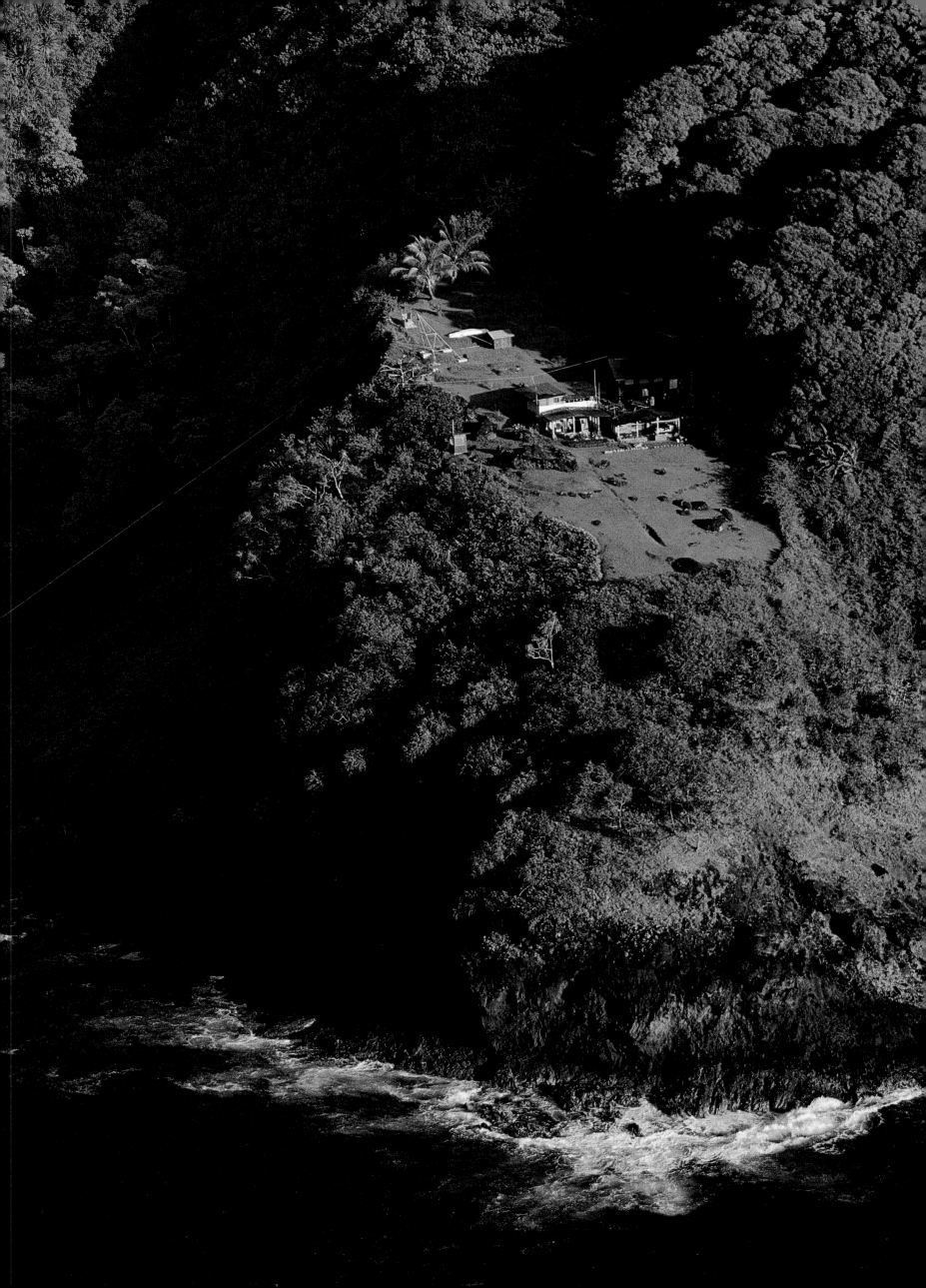

MODERN HAWAI'I

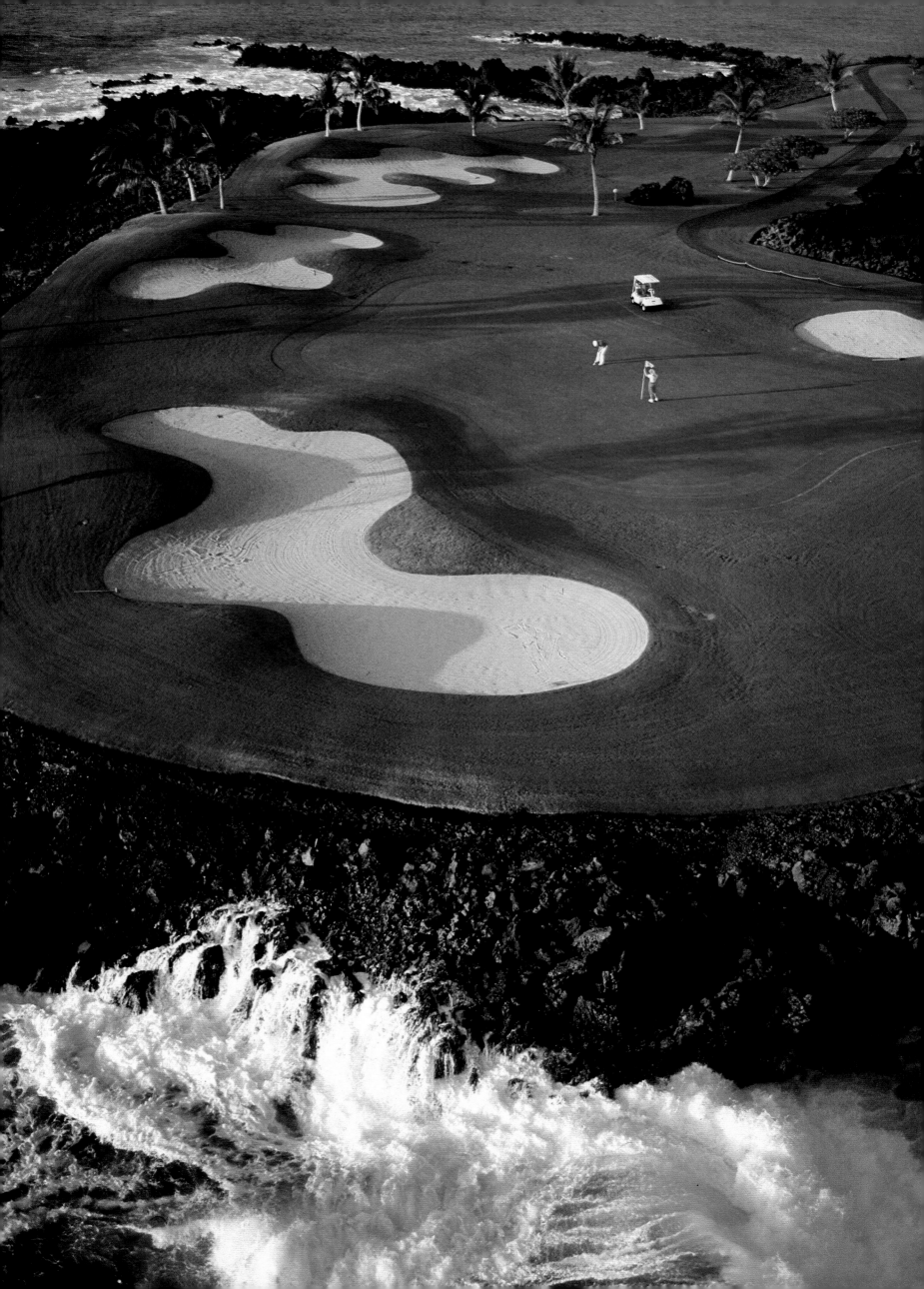

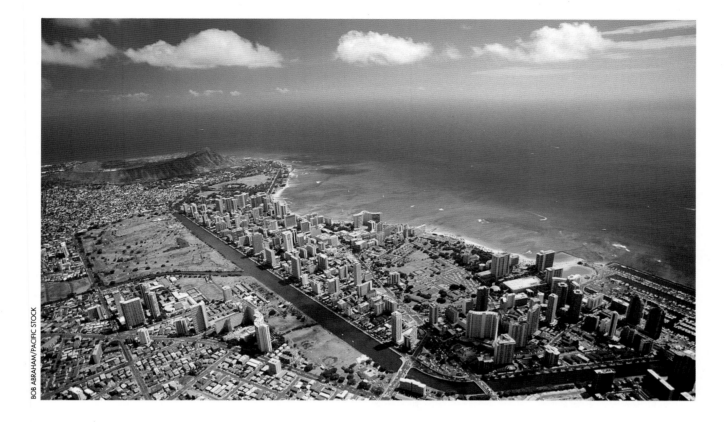

MODERN HAWAI‘I

Queen Lili‘uokalani, known for her musical talent, her regal dignity and the tragedy of her reign, struggled to preserve her people's sovereignty and watched helplessly as the islands were stolen by American forces. Actually, the bloodless, day-long revolution that overthrew the queen was not engineered by the U.S. government. In 1887, before Queen Lili‘uokalani ascended the throne, Hawai‘i's haole community had imposed its Bayonet Constitution to curtail the monarchy. Lili‘uokalani wanted to be more than a figurehead ruler of her people and announced her intention to abolish the Bayonet Constitution and reclaim her powers. This alarmed the planters and merchants, who feared for their prosperity and the long-hoped-for annexation of Hawai‘i to the United States. They organized a hasty and secret committee—the Committee of Safety—that decided that only the end of the monarchy could protect haole interests.

Aided by the U.S. minister to the kingdom of Hawai‘i, John L. Stevens, the committee organized a provisional government. One hundred sixty marines from a visiting American gunship stood ready to man artillery positions. The mere show of firepower was enough. On January 16, 1893, Lili‘uokalani submitted to the committee's order to abdicate the throne. ‘Iolani Palace became the seat of the new government, headed by Judge Sanford B. Dole.

When President Grover Cleveland learned of the overthrow, he denounced it. But it was too late. Neither Cleveland nor his new emissary, James Blount, could dismantle the provisional government and restore the queen's power. Cleveland did, however, refuse to consider annexing Hawai‘i to the United States. The haole politicians created a new constitution and a new, sovereign Republic of Hawai‘i. And they waited until July 7, 1898, when the new administration of William McKinley signed a Joint Resolution of Annexation and made Hawai‘i a U.S. territory.

To the planters, annexation meant development, and growth sweetened the sugar and new pineapple industries. Plantations grew. Additional workers arrived from Japan, China, the Philippines and Europe. Most immigrants came from Japan, and, though as laborers they received few rights, the Japanese and their descendants would grow to dominate government and education in Hawai‘i.

Previous pages: A surfer carves a hard backside bottom turn at a secret spot on Maui. *Left:* Waves grind the rocks beneath the fifteenth hole at the Mauna Lani Golf Course on the Kohala coast, Big Island. *Above:* The various ocean blues fronting Waikīkī contrast with the stagnant, algae-tinted waters of the Ala Wai Canal behind.

Along with the housing provided by the plantations, slum areas like Chinatown emerged around Honolulu to accommodate the large numbers of poor immigrants. Overcrowding and lack of sanitation made Chinatown a hotbed of troubles. In 1899 an epidemic of imported bubonic plague broke out; Board of Health officials began to burn certain rat-infested buildings in the area. On January 20, 1900, one of the fires got out of control and blazed for three days over 38 acres of Chinatown, leaving thousands of people homeless. The famous Chinatown fire did not manage to halt the plague, however, which continued in Honolulu for three more months.

The day the plague's end was announced, April 30, also marked the beginning of a new political era. President McKinley's administration passed the Organic Act, a document that established the form of Hawai'i's government for the next 59 years. The terms of the act would be modified later to give island citizens a more just balance of rights and responsibilities, but the stable framework would endure, gradually replacing the monarchy in citizens' minds.

Early voting laws provided means to exclude Asians from political participation. However, the plantations continued to bring in Asian laborers. In 1901, James D. Dole established the Hawaiian Pineapple Company, opening successful markets on the U.S. mainland. Soon after, in 1904, a group of Hawaiian sugar growers gained control of a California sugar refinery, establishing the California and Hawaiian Sugar Refining Corporation.

The increasing consolidation of agricultural interests coupled with poor wages and working conditions led to increasing labor dissatisfaction and, inevitably, to workers' unions. At first, laborers grouped themselves by nationality. The Japanese proved most actively militant, organizing at least fourteen strikes between 1902 and 1905. Slowly they succeeded in improving labor conditions and wages, and their effectiveness foreshadowed the future victories of the ILWU (International Longshoremen's and Warehousemen's Union), the AFL and the CIO. Also foreshadowed, perhaps, was the effectiveness of the Japanese at political activity.

Though many years would pass before it reached its lofty position as Hawai'i's premier industry, tourism began in Hawai'i by the early twentieth century. The Moana Hotel, on Waikīkī Beach, opened its doors to visitors in 1901 and was followed 26 years later by the grand, pink Royal Hawaiian Hotel. The hinterland of Waikīkī then was a tranquil marsh, not to be fully drained until the late 1920s, when the Ala Wai Canal was dug.

Conservation in the islands also traces its roots to the early years of the century. In 1909, President Theodore Roosevelt declared the Northwestern Hawaiian Islands a national wildlife refuge. Hawaiian

Left: Pausing to wave and flash "shaka" signs, these Honolulu sailors enjoy a nautical lunch. There are about 700 yachts moored at the Ala Wai Small Boat Harbor in Waikīkī.

Opposite: A long shadow has fallen over the future of Hawai'i's sugarcane farms. As island populations grow and domestic sugar production declines, housing tracts have begun to cover cane fields like these beneath the West Maui Mountains.

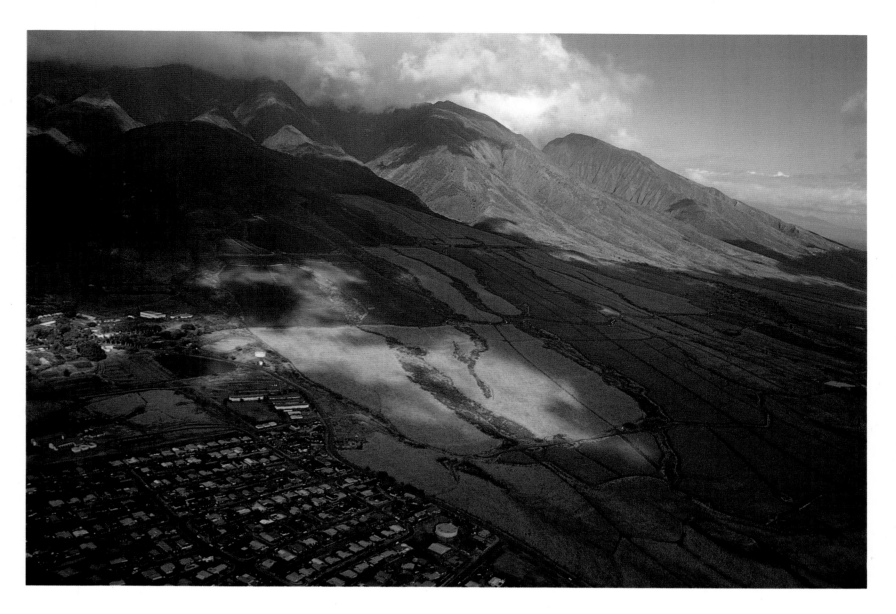

prince Jonah Kūhiō Kalaniʻanaʻole, the territorial delegate to Congress, was concerned as well with the conservation of the Hawaiian race. He sponsored the Hawaiian Homes Commission Act, which marked 200,000 acres to be allocated to needy Hawaiians who had been dispossessed by takeovers of their land. Hawaiians of at least 50 percent native blood were encouraged to apply for inexpensive leases on agricultural and pastoral lands. But because of bureaucracy and mismanagement the program failed. Less than five percent of the allocated land was actually leased to Hawaiians. Only recently have there been signs that the commitments would finally be honored, but to date an estimated 30,000 people have died while on the Hawaiian Homes waiting list.

Another foundation laid during this period promoted the ascendance of the "Big Five"—large corporations that began as factors or agent companies of the sugar interests but expanded to gain holdings in public utilities, shipping, banks, department stores, resort development companies and other concerns. The Big Five are Amfac (American Factors; it was recently sold to mainland interests), C. Brewer, Alexander and Baldwin, Castle and Cooke, and Theo. H. Davies. Though smaller businesses were able to coexist with these giants, the Big Five set the rules for Hawaiian commerce and exercised considerable control over the island economy and politics.

In the antitrust atmosphere of the Depression era, the Big Five and affiliated interests faced economic competition. Matson Navigation, a Big Five–backed company, enjoyed dominance of the freight and passenger shipping business in Hawaiʻi through 1938, but even its monopoly was finally challenged. Hawaiʻi's big business and political communities are still charged with cronyism today. Outsiders can usually find a niche in the corridors of power, however, and by today's estimates 95 percent of the registered businesses in Hawaiʻi employ five or fewer people.

World War II irrevocably propelled Hawaiʻi onto the international scene. Japan's bombs on December 7, 1941, not only damaged the U.S. Pacific fleet at Pearl Harbor, they also exploded the lives of Hawaiʻi's people. Many Japanese Americans in the islands, like those on the mainland West Coast, were detained and interned in camps. The Pacific war brought an influx of American soldiers for duty assignments and R&R. And throughout the war, Hawaiʻi's citizens were subject to martial law—including military courts and the suspension of habeas corpus.

Despite hardship, and despite persistent doubts about the annexation only 43 years before, Hawaiʻi responded to the war with patriotism and dedication. Thousands of Americans of Japanese ancestry

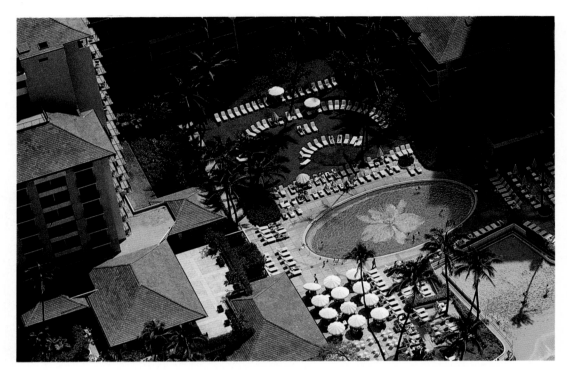

Left: Over 1,125,000 glass tiles make up the *Cattleya* orchid mosaic in the swimming pool at the Halekūlani Hotel in Waikīkī. The complex of five buildings on five beachfront acres has been AAA-rated as the only "five-diamond hotel" on O‘ahu.
Right: Its sails filled with light, a yacht makes an escape from stacked-up, busy Waikīkī. Between Diamond Head and ‘Ewa runs an urbanized, almost entirely artificial shoreline of dredged channels, canals, jetties and beaches of trucked-in sand.

(AJAs) volunteered for active military service. Soldiers in the 100th Battalion and the 442nd Regimental Combat Team, in particular, were highly decorated and praised for uncommon bravery in the European theater. Other AJAs enlisted as interpreters and undoubtedly saved thousands of lives by intercepting enemy messages. Back home, citizens bought war bonds, submitted to rationing, and offered cheer and hospitality to soldiers. And the sugar and pineapple industries gave not only their crops but also laborers and machinery to the war effort.

Hawai‘i's contribution to the Second World War was crucial, and its people demonstrated an extraordinary allegiance to the United States. Following the end of the war, the cause of statehood was all the more easily defended, and in 1959 President Eisenhower signed the long-awaited legislation naming Hawai‘i the fiftieth state of the union. The same year, jet service from California to Hawai‘i was inaugurated, cutting travel time from nine hours to less than five. The doors to the tourism boom were thrown wide.

Hawai‘i's postwar, early statehood period also saw the decline of the Republican party, champions of big business and vested interests, and the emergence of the Democrats as the party of power. The change can be attributed to the political energy of the Japanese-American community. Local Japanese are conscientious voters who tend to vote en bloc. After years of subordination as plantation laborers, they developed an allegiance to the labor-friendly Democratic party.

In 1963, John A. Burns became the first in a line of Democratic governors to dominate Hawai‘i politics. Burns had spoken in defense of the loyalty and rights of Hawai‘i's Japanese during World War II; as a result, he enjoyed their critical support in gaining the governorship. Burns's successor, George Ariyoshi, became the first American of Japanese ancestry to be governor of an American state. Ariyoshi served three terms starting in 1974 and passed the office to the next Democrat, John Waihe‘e, who is the first person of native Hawaiian ancestry to be elected governor of the islands.

After two hundred years of pursuing things new, Hawai‘i in recent years has begun to reassess the value of things old. Sparked by John Dominis Holt's book *On Being Hawaiian* and by resurging interest in ancient crafts, chants and hulas, native Hawaiians and non-Hawaiians alike have discovered a new passion for the values of traditional island culture. The "Hawaiian Renaissance" is celebrated through hula and native art festivals and Hawaiian language study; a growing activist movement focuses on preserving cultural sites and natural resources, and on the restoration of Hawaiian sovereignty.

A hundred years ago the sun shone on an island kingdom where Hawaiian monarchs ruled their own people. The land was unmarred by highways and high rises. In the hands of American planters, pineapple and sugar flourished. Today the sun shines on a modern American state, governed according to American tradition. Shores and valleys bear the thorny crowns of sky-scraping hotels, condominium complexes and office buildings. Roadways cut through ancient mountains and watersheds. The

current major crop is tourists; the millions who travel to this wonderland outnumber Hawaiʻi's residents nearly six to one.

In the far-flung areas, nā kuaʻāina (upcountry retreats) retain a timeless grace and enchanting beauty. But as more people crowd the islands even the most remote forests are threatened. The 1990s are witnessing a struggle between those who would save our precious lands and those who would pave them. Hawaiʻi's roads swarm with cars. On Kauaʻi, the "Garden Isle," the biggest problem is traffic. On Oʻahu, if all the cars on the island hit the street at the same time, every inch of asphalt from Waikīkī to the North Shore would be covered.

In many ways we have reached a saturation point. Today's population in Hawaiʻi, including residents and a tourist count that constantly renews itself, has reached the level at which our natural resources—especially water—are being used beyond capacity. Attendant upon the population increase is a host of varied environmental problems. Every ecological danger on earth is played out locally in Hawaiʻi.

To describe what man's accelerating industries are costing the planet there has come a neologism: terracide. It means killing the earth. In Hawaiʻi our terracidal activities range from overdevelopment to release of man-made toxins into the air and water. Oʻahu's petroleum-burning power plants and our chemical factories, jet planes and automobiles pollute the atmosphere. Tanker ships occasionally spill oil into the ocean. The islands' natural reservoirs of fresh water are increasingly threatened, as exemplified by Oʻahu's aquifer.

The two mountain ranges on Oʻahu pull in rainwater from cloud-bearing trade winds and deposit some of it in a pool floating within a lens on the saltwater-permeated bedrock of the island. The lens, contained by reef and ocean and capped by lava, was formerly the purest body of water ever discovered. "Formerly" because toxins from pineapple and sugar plantations, road maintenance, marijuana spraying, golf courses, and industry have polluted it.

Now the water system is further threatened by new highway construction and tunneling. The two tunnels already piercing the Koʻolau Range have affected the basalt infrastructure of the old volcano, accelerated draining and caused the upper elevations of the mountains to dry measurably. Water is gregarious. When the peaks contain water they attract more, pulling the moisture from the clouds. Further tunneling causes additional drying on the peaks, limiting rain catchment and reducing the island's water supply.

Left: The True geothermal well in Puna, Big Island. Seen by some as a blight on the land, and by others as a powerful energy source, geothermal drilling is becoming Hawaiʻi's hottest controversy.

Opposite: The landmarks of two governments: the Hawaiʻi State Capitol and ʻIolani Palace. The architects of the capitol designed the building with columns that suggest royal palms, conic legislative chambers like volcanoes, and a moat to make it an island, but some Hawaiians say it looks like a squid or jellyfish sneaking up behind the Victorian-style palace.

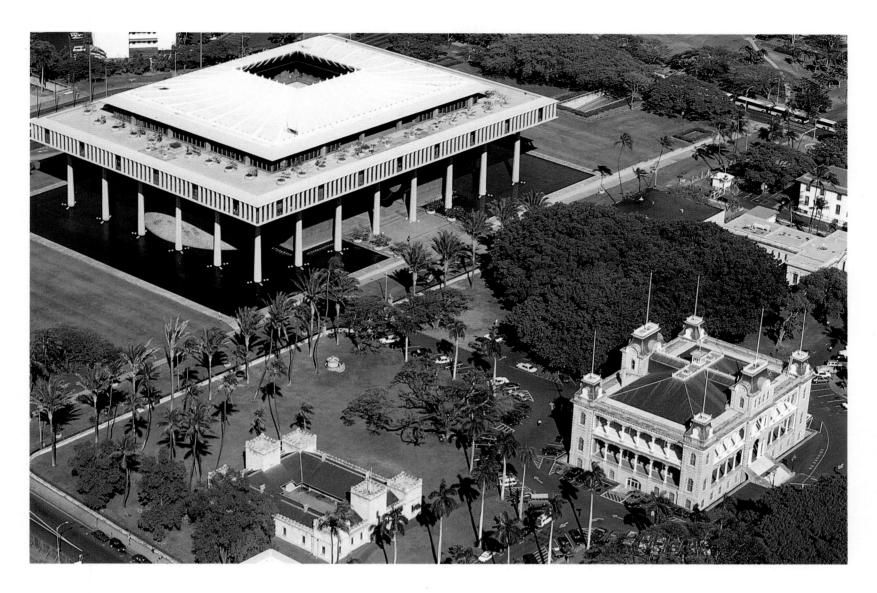

"Hahai nō ka ua i ka ululā‘au," the Hawaiians say, "the rain always follows the forest." It is not just the mountains but the trees that bring in the rains. Knowing this, the early Hawaiians went into the high forest and cut down only the trees they needed. They developed a more responsible husbandry because for them the land was—and still is—a sacred manifestation of the gods. A place to be cooperated with rather than subjugated, a place to be bound to.

As a modern people we have the technological power to completely sever what binds us to the planet. We can replace a forest of rain-gathering, oxygen-producing, medicine-rich flora with a river of internal combustion engines. We can replace the clear air and clouds with smog, the water with oil, the birds with nothing.

What is already lost to urbanization has brought particular suffering to native Hawaiians. Dana Nāone Hall, a Hawaiian activist and poet who has fought for native Hawaiian rights on Maui, articulates the position of her people: "The immense changes wrought by large-scale economic interests, while in many ways beneficial, have also been primarily responsible for the destruction of the Hawaiian environment and native Hawaiian culture. For Hawaiians, reverence for our ancestors is the same as reverence for the land. This points us in the right direction if we want to protect what is beautiful and mysterious about the place where we live."

As the twentieth century closes and the centennial of the 1893 Overthrow focuses our thinking, the people of Hawai‘i understand that we are beginning a new age. Today we know more than ever about the islands, how they grew out of the ocean and gave birth to this most diverse and astonishingly beautiful environment. We know how the human presence here has altered the life and spirit of Hawai‘i, and we understand the value of what we must preserve here.

Our choices have never been clearer. Sometimes we make the right ones. As a collective society Hawai‘i is a model. There is remarkable ethnic harmony in these islands where no group constitutes a majority. Grown from native and plantation cultures, Hawai‘i has become a modern place, with greater educational and employment opportunities for its people. It is the only state with a universal

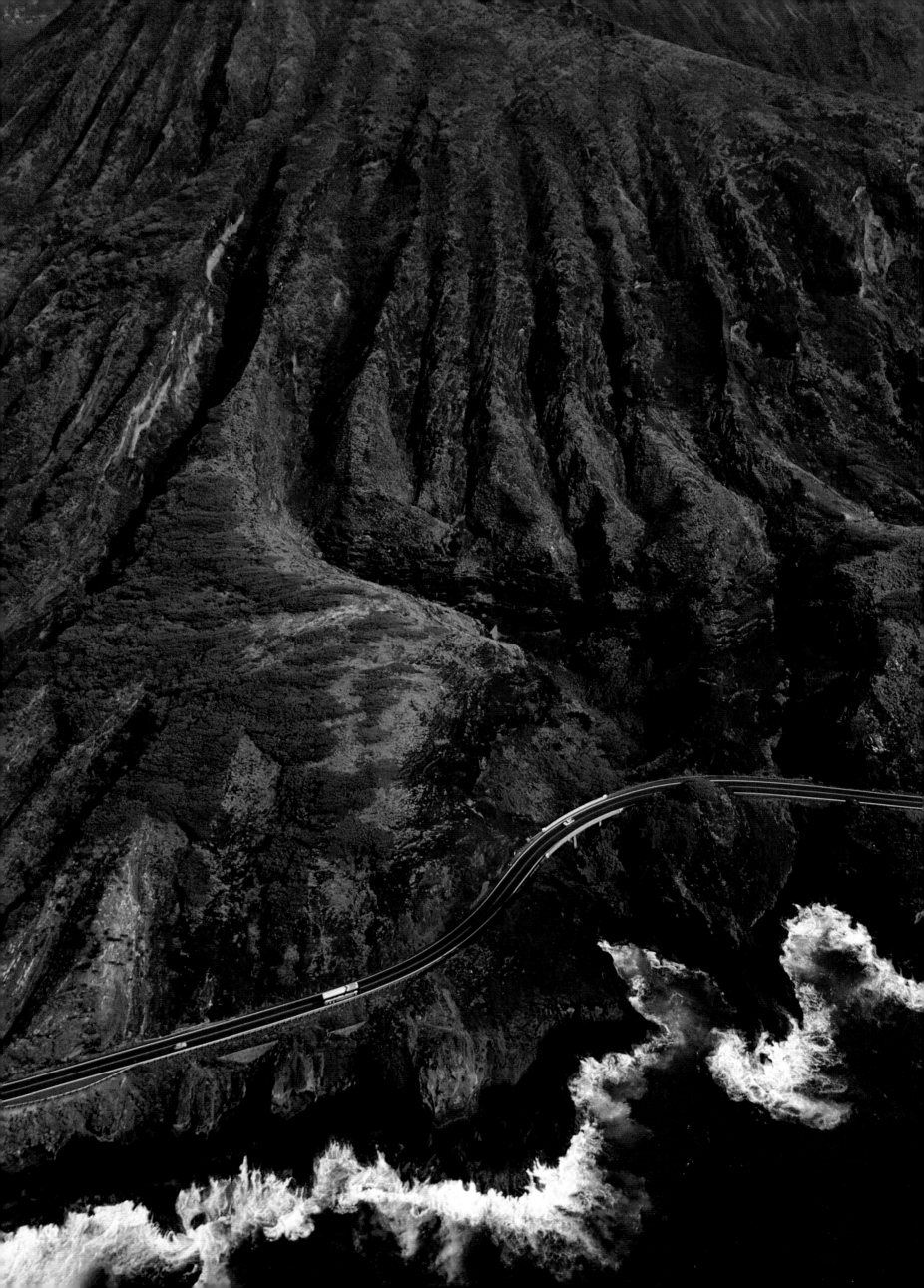

health system. It has more support programs for senior citizens than any other state. It is the only state with a subsidized after-school program for children. It has developed new industries, including aquaculture and selected high-technology enterprises. It is the home of a burgeoning film industry, fine museums, and study centers, with advanced research in oceanography, astronomy and Pacific-Asian affairs. Environmental issues are important too. Hawai'i is the only state without billboards cluttering the roads, and the local governments in the last ten years have acquired thousands of acres of land for conservation, park and recreational use. The privately funded Nature Conservancy has reserved huge tracts of pristine rain forest.

Local political leaders are sensitive to maintaining a guard against those developers who would tear the place asunder. "Preserving the pure naturalness of Hawai'i's mountains, valleys, air, beaches and water is vital to life here for us all," says Frank Fasi, Honolulu's five-term mayor. "We depend upon Hawai'i's unspoiled riches, not only for our major industry, tourism, but also for our very soul. The beauty of Hawai'i drew many of our ancestors here. It keeps us here too. Those of us in positions of public trust must be constantly aware of the threat 'progress' poses to our Aloha state and people."

U.S. Congressman Neil Abercrombie, who frequently opposes Fasi on major issues, agrees with him on this position: "All culture begins with word consciousness, and no people on earth were and are more acutely aware of this than the Polynesians who found Hawai'i and whose lives measure its vitality today. For the Hawaiians, the dictum of Kamehameha III—The Life of the Land is Perpetuated in Righteousness—is more than an admonition, it is the core value of communal existence. While land is inanimate in Western cosmology, an object to be controlled, manipulated and dominated, it is for the Hawaiians a living reality with which humankind must be in harmony. The task in our contemporary world is to make this manifest in ways that do not mock this imperative. The alternative," Abercrombie warns, "is nothing short of revenge by the land as we career into modernity."

The right choice is a simple one. We must commit ourselves to keeping a wise husbandry in Hawai'i, to consult with this beauty that is like no other, and to learn what the Hawaiians of old knew so well: to give back what we take. As Governor John Waihe'e has so eloquently observed: "We need to ask ourselves how our ancestors did so much with so little, and why we are able to do so little with so much. When it comes to the environment, let us remember our inseparability with nature. We are these islands, the sky and the sea, and it is our responsibility to take action which breathes life into the natural world around us. Let others discover what we already know: that our earth is a precious and glorious island of the universe, and humankind is her guardian."

E ola nō, e-e. Life, give us life.

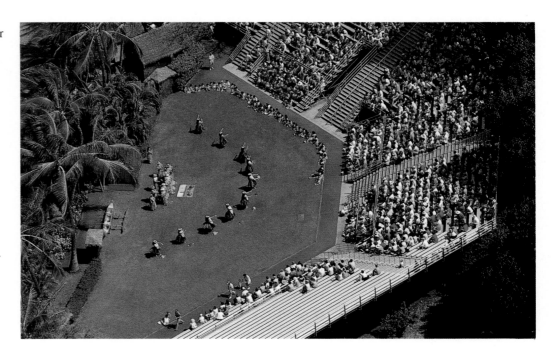

Left: Leaving Honolulu behind, a tour bus heads east along Kalaniana'ole Highway beneath Koko Crater. Koko means "blood," and the name derives from the red dirt in the area or from a legendary fisherman who was bitten by a shark here.
Right: The Kodak Hula Show, which every day features the kind of "Lei Day" program of dancing and singing held in Hawai'i's schools on May Day. Kapi'olani Park, Waikīkī.

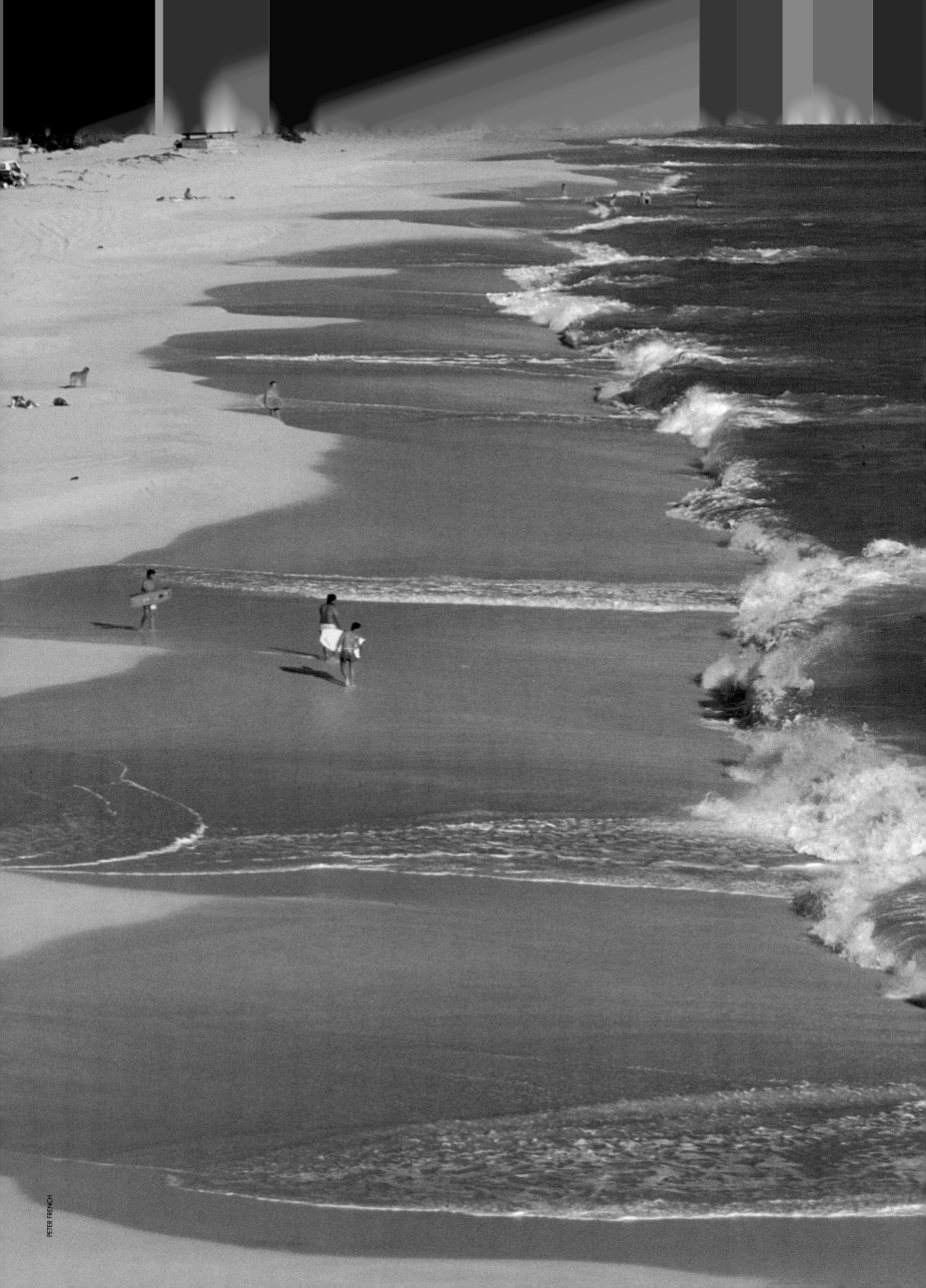

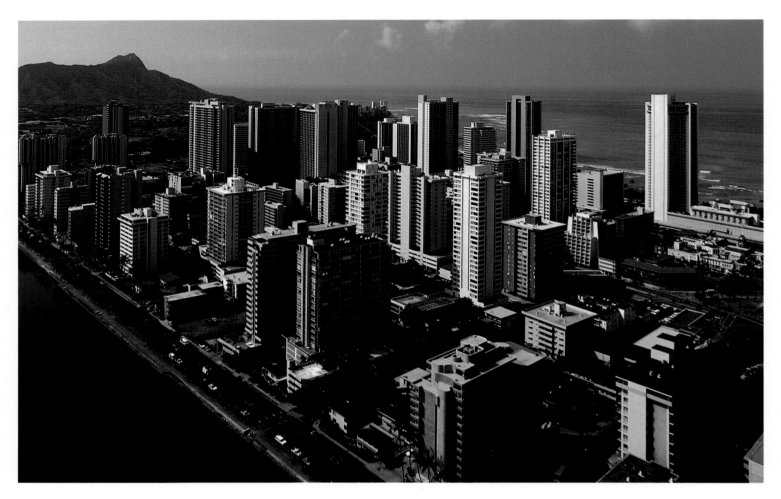

Previous pages: Pockets of under-tow suck up sand clouds from Oneloa (long sand) Beach near Mākena, Maui. Popularly known as Big Beach, it is the site of ongoing land acquisitions by the state of Hawaiʻi to establish a park. With accelerating urbaniza-tion of Kīhei and Mākena, the preservation of Big Beach has become especially important to local residents.

Above: Developers of Waikīkī, needing dry ground to build on, began a public relations campaign against the marshes, streams, pools, taro ponds and rice fields that lay inland from the beach. In 1919 they began diverting Waikīkī's waters into an artificial canal called Ala Wai (water path). Lack of circulation has caused the water to stagnate, and it is unsafe for swim-ming. Now plans are being drawn up to open the canal to the ocean on the Diamond Head side.

Right: Variously described as a cement beehive or a stack of coasters, the Contessa condominium rises high above Mōʻiliʻili, a suburb near the University of Hawaiʻi.

A collection of geometric
shapes arranged along the Big
Island's rugged Kohala coast: the
Hyatt Regency resort at Waikōloa.
About the Hyatt Regency pool
(above), one tourist said, "It's so
close to the ocean you could throw
a seashell into it." Most of
Hawaiʻi's vacationers remain
poolside—even in Waikīkī—
because they prefer the safety and
comfort of easy access and the
proximity of a bar.

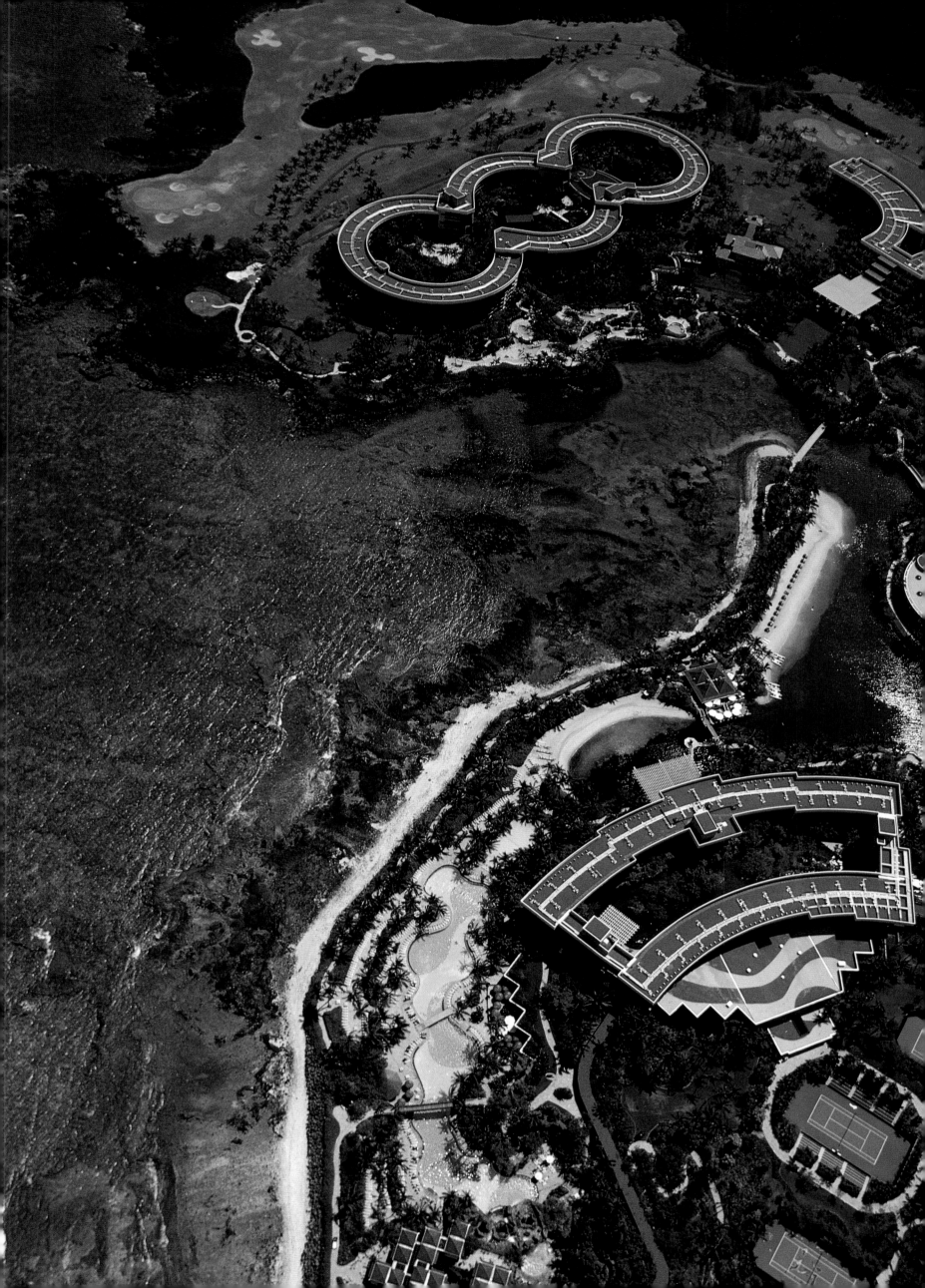

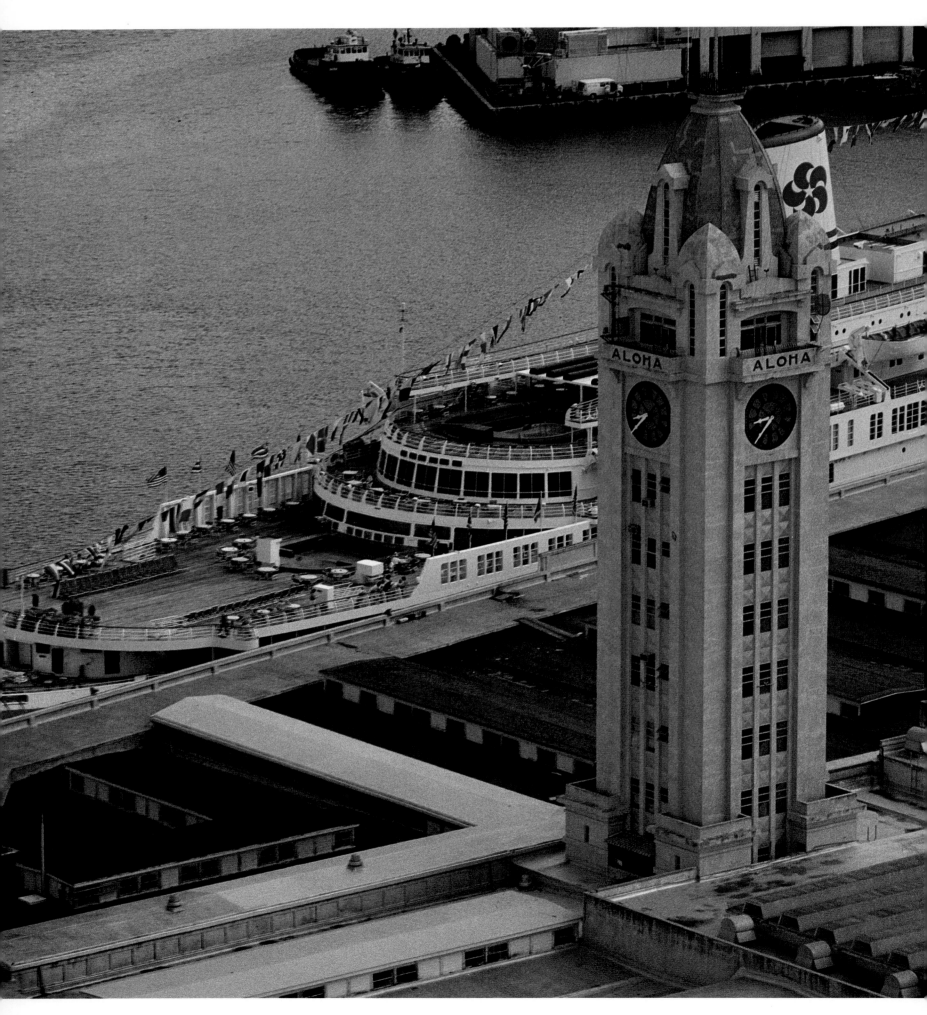

IRWIN C. MALZMAN

Above: Where the Manakai, Kahauiki and Kalihi streams converge to flow into Keʻehi Lagoon, the lanes of the H-1 freeway airport interchange carry morning commuters to Honolulu. Clogged roadways were named in a recent public opinion poll as the state's number-one problem.

Left: The SS *Independence* interisland cruise ship and the Aloha Tower. Built in 1926 to control maritime traffic in Honolulu Harbor, the ten-story Aloha Tower was for 30 years the tallest building in Hawaiʻi.

Above: Looking east across the submerged stream valleys that became Pearl Harbor: West Loch with mothballed destroyers, Waipi'o Peninsula, Middle Loch, Ford Island, East Loch, Southeast Loch with the Naval Shipyard to the right. Beyond are the high-rises of downtown Honolulu and Diamond Head.

Right: The troops salute at Palm Circle, Fort Shafter, Honolulu. From World War II until the mid-1980s, when tourism took over, the military was the biggest industry in the islands.

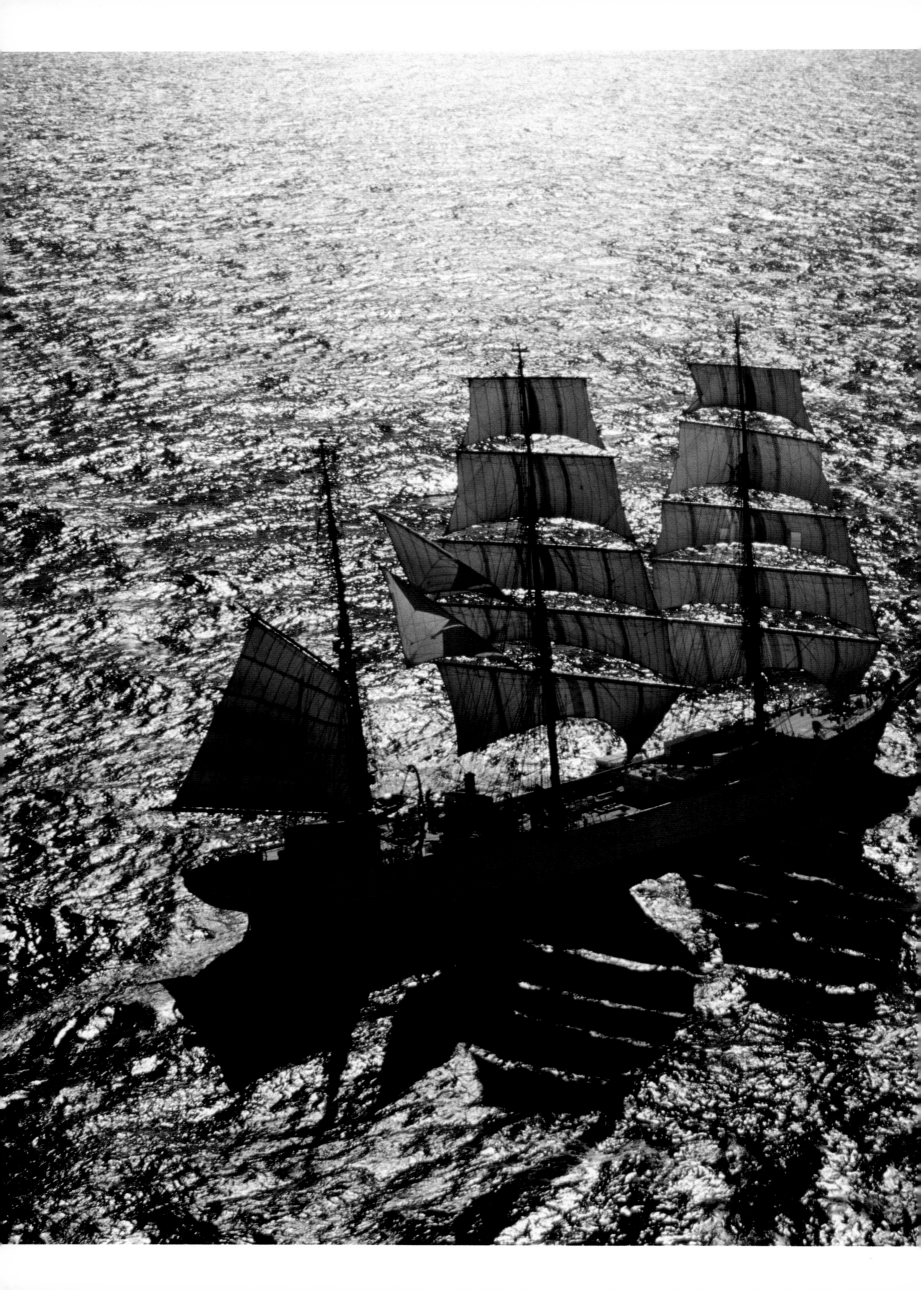

A reminder of Hawai'i's history of tall ships is the Coast Guard training barque *Eagle*, presenting a backlit study in white and black sails in waters off Diamond Head. Built in 1936 to train German navy cadets, the ship was seized by Americans as war booty following World War II and taken to New London, Connecticut, home of the United States Coast Guard Academy. Now a frequent visitor to the islands, the 295-foot vessel carries 20,000 square feet of sail and 20 miles of rigging.

IRWIN C. MALZMAN

Above: The 1960 wreck of a Navy concrete-hulled YO (yard oiler) tank barge lies on the reef of Shipwreck Beach on the north shore of Lāna‘i.

Left: On December 7, 1941, a flurry of torpedoes and bombs dropped from Japanese planes sank the battleship USS *Arizona*. The wreck was beyond salvaging, and the bodies of the 1,100 sailors who went down with her were left in the hold. Rainbow slicks from the ship's leaking fuel tanks still color the water. The white structure straddling the hulk is the Arizona Memorial, built in 1962 and designed by the Honolulu architect Alfred Preis.

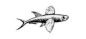

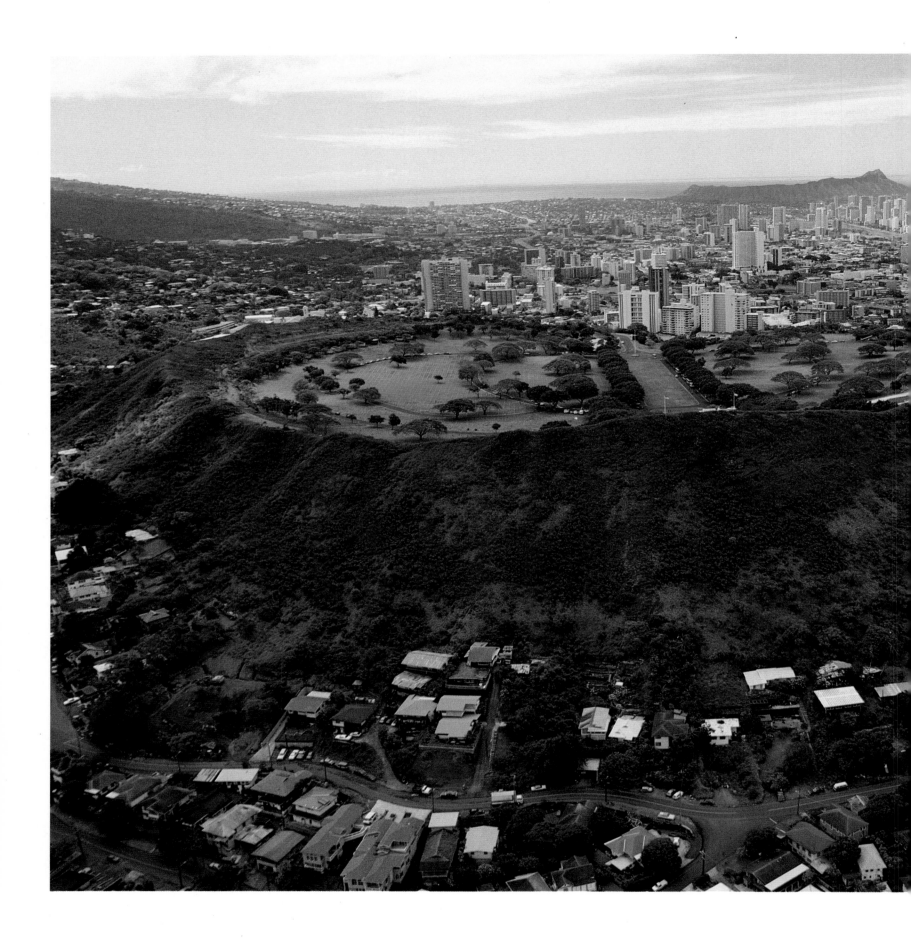

Above: Part of a mothballed fleet of submarines and destroyers sits in Middle Loch, Pearl Harbor, after more than 25 years of service. From left, the submarines ex-USS *Darter* and *Barbel;* and the *Edwards, Morten* and another of the Forrest Sherman class of destroyers. In 1987 the ex-USS *Edwards* was taken out of mothballs and used by ABC to film *War and Remembrance.*

Left: Punchbowl Crater, a sister to Diamond Head crater in the background, now cradles the National Memorial Cemetery of the Pacific, where more than 25,000 servicemen and women are buried.

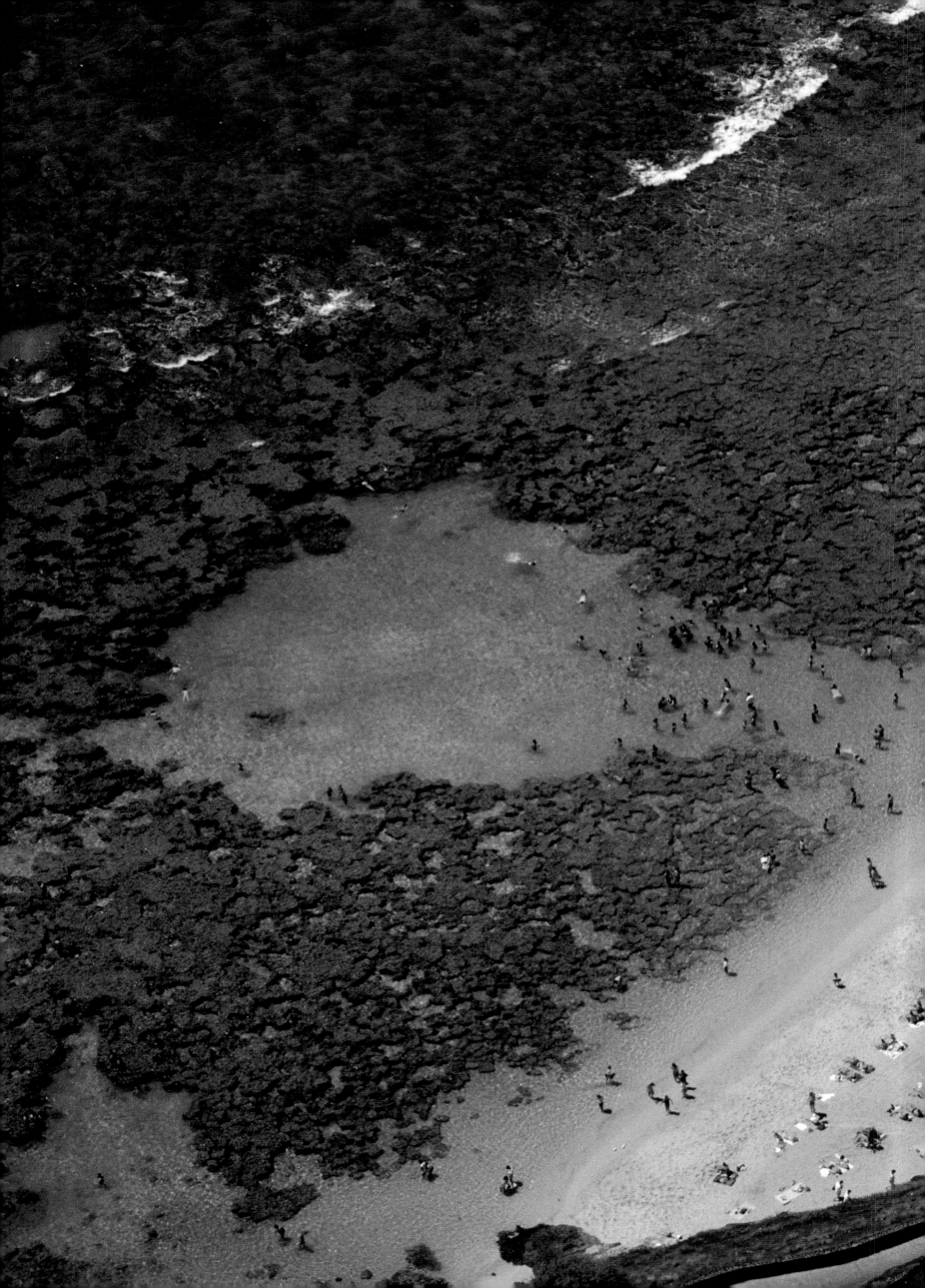

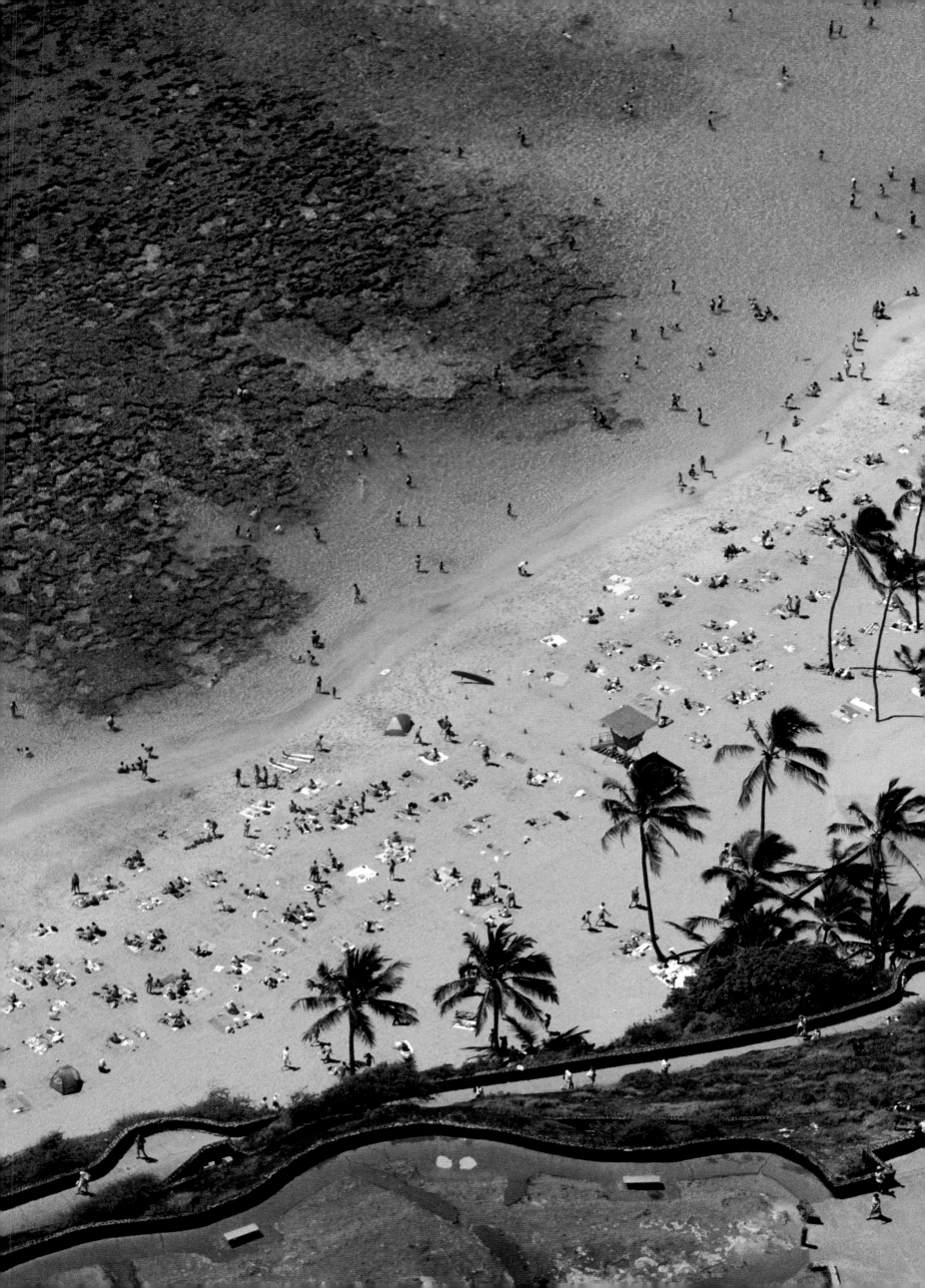

Previous pages: Once a remote, pristine spot frequented only by fishermen, Hanauma Bay has become too popular. As many as 13,000 people have crossed its beach in a single day. Every year 2.5 million visitors come, most shuttled in by tour companies operating out of Waikīkī, ten miles away. In 1967 the bay became an underwater park, and fishing was banned. By 1990 so many people had come to see and feed the tame fish and had so fouled the place with trash and stirred-up silt that the City and County of Honolulu began to implement access restrictions.

Above: A group of Japanese tourists waits on a raft in Maunalua Bay, south Oʻahu, for a turn at parasailing. More "shaka" signs from the locals. This unique Hawaiʻi-style greeting was begun in the 1950s in imitation of a Lāʻie man who had three fingers missing on one hand (he lost them fishing with dynamite). The only way he could wave was with the thumb and little finger sticking out, and when he waved he said, "Shaka, brah!"

Right: Are there only women aboard this launch off Waikīkī? Maybe they should sail over and rendezvous with that other ship of merry mariners, the all-male crew having lunch on page 190.

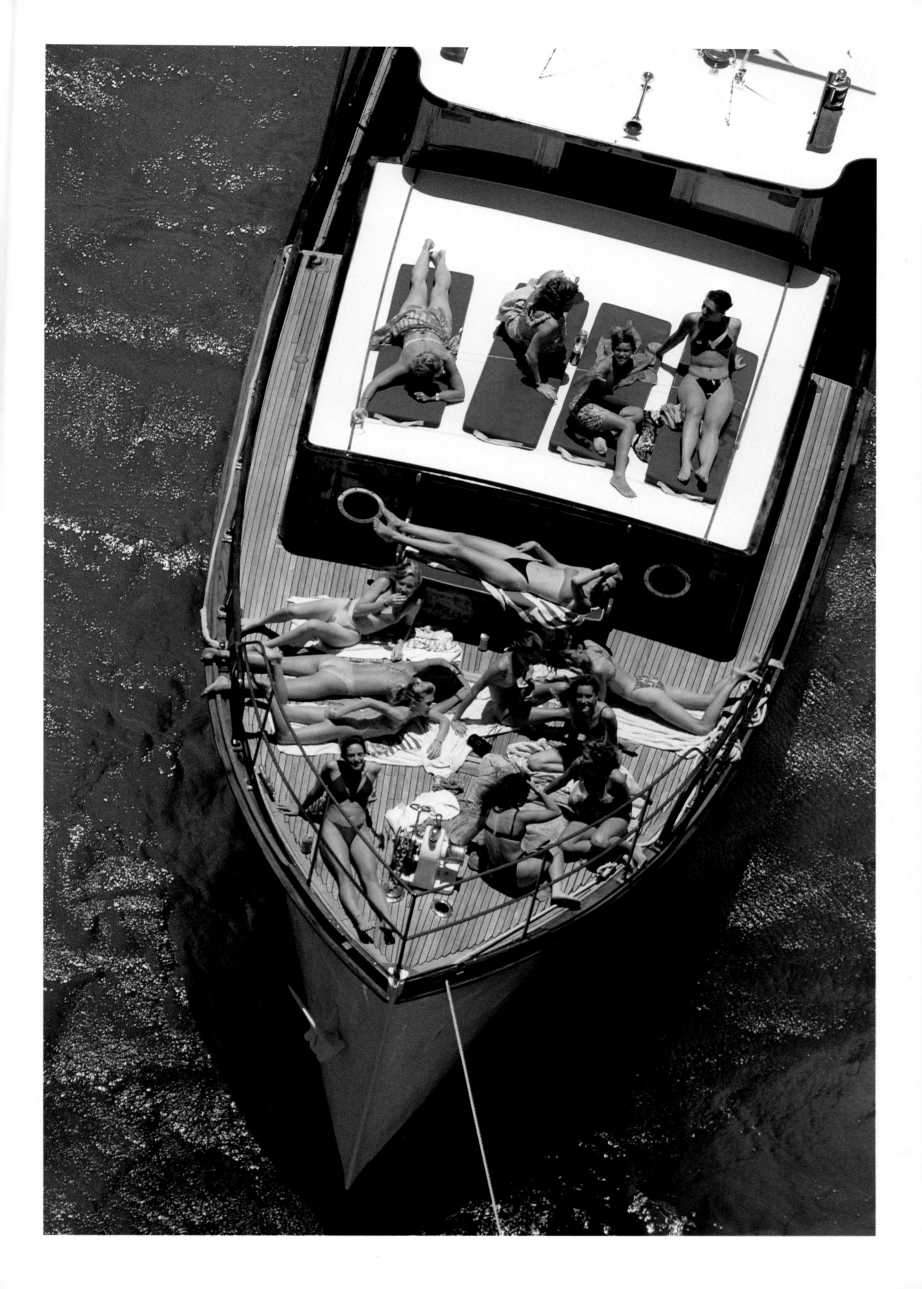

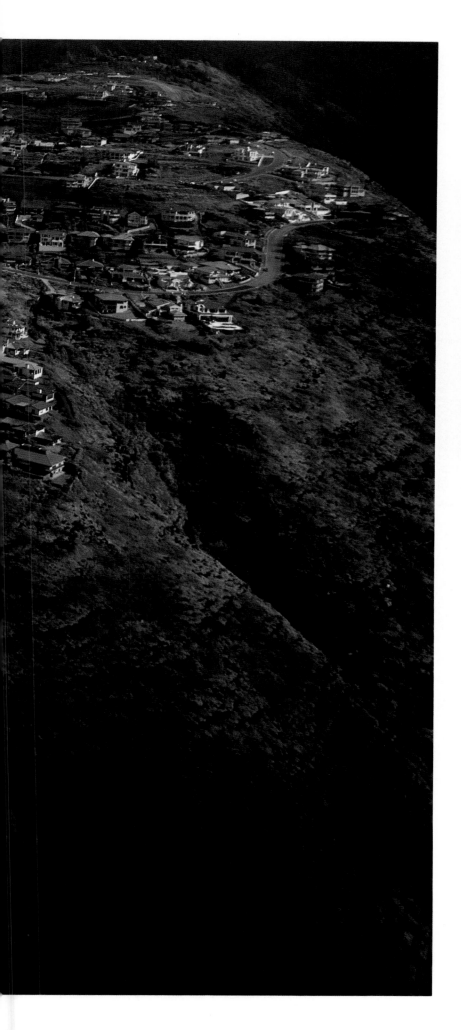

Left: Like a collective statement of postmodern opulence, a community of mansions is rapidly covering Hawai'iloa Ridge, above 'Āina Haina on south O'ahu.
Above: Meanwhile, a basic, three-model, low-income tract has gone up on a Kaua'i flatland. The red dirt of the region has tinted the roads and driveways.

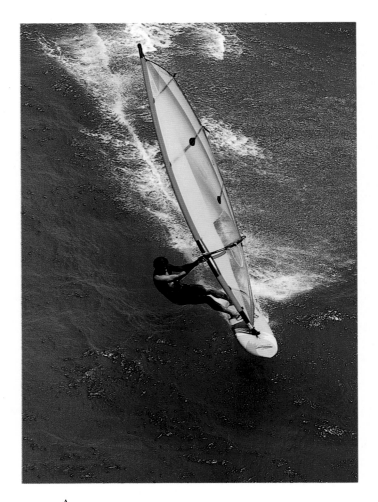

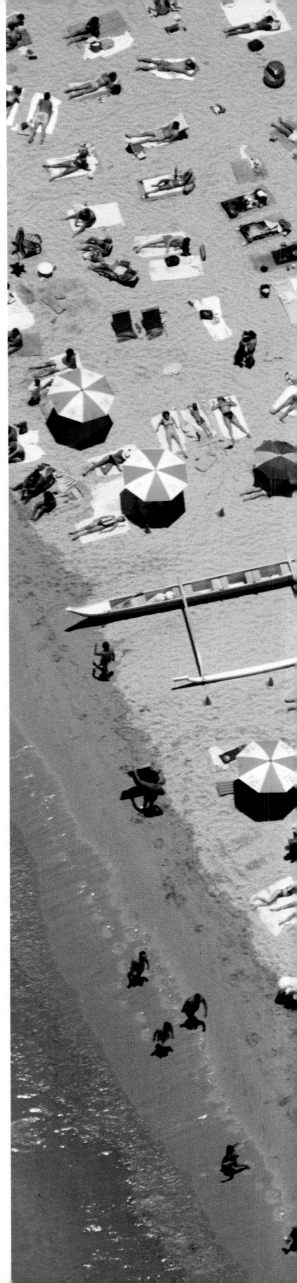

Above: A windsurfer on a beam reach in 20-knot winds heading toward Diamond Head. With their bright sails and boards and acrobatic jumps over waves, windsurfers are quickly becoming the most watchable athletes in sport.

Right: The crown jewel of Hawai'i's resort market, the strand most trod upon by movie stars and world leaders, the fundamental Hawaiian vacation experience, the most famous beach in the world.

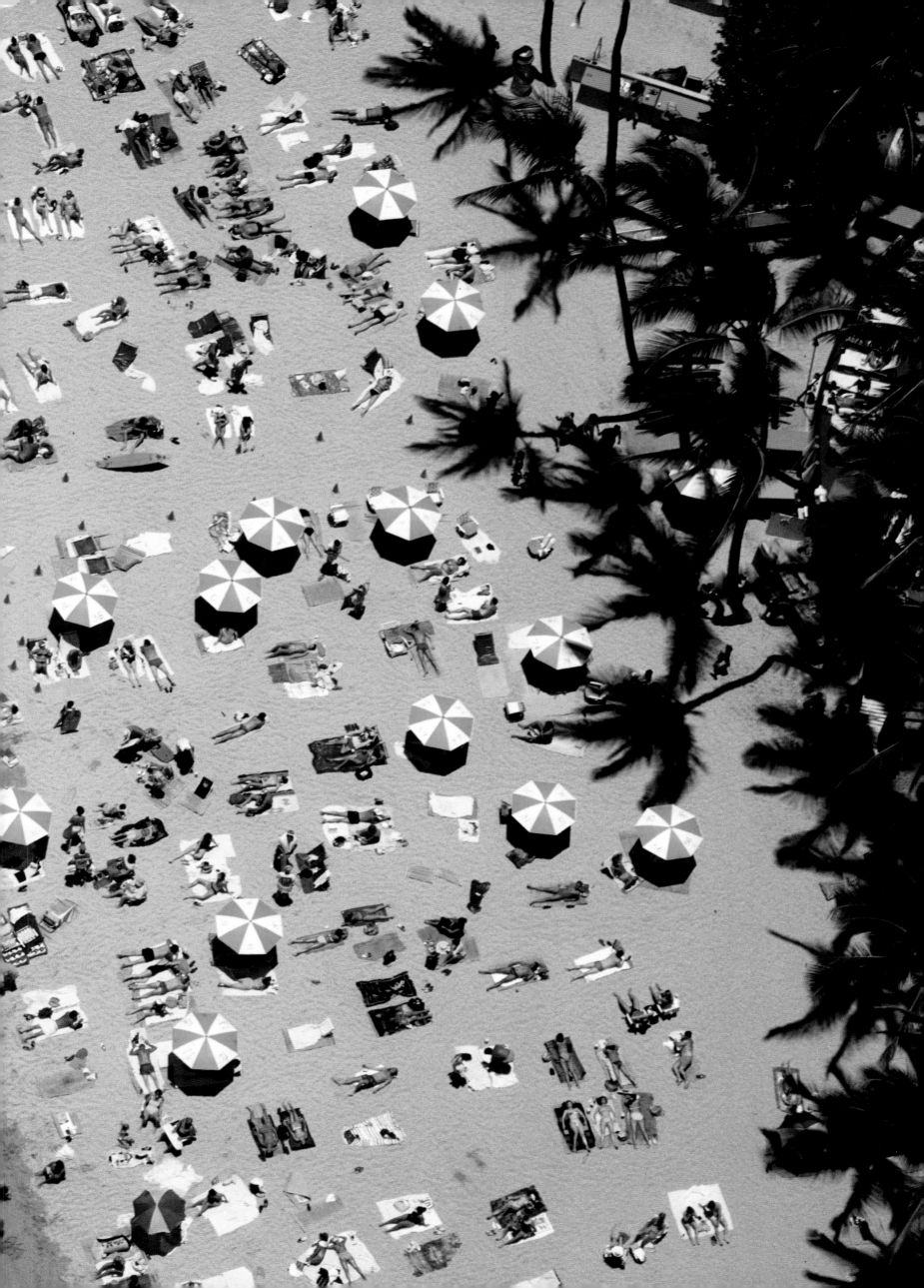

Left: A home in Kāhala, a Honolulu suburb. Although oceanside pools are today a fairly common feature of such ritzy estates, they were once pooh-poohed by the have-nots as needlessly extravagant.

Above: Part of the resplendent estate of the tobacco heiress Doris Duke at Black Point, just east of Diamond Head. Hers was the first swimming pool built so close to O'ahu's shoreline, but "the world's richest girl" endured the criticism.

Right: Following the example of Charles Lindbergh, who lived a few miles down the Hāna coast, former Beatle George Harrison built himself this Hawaiian hideaway on Maui.

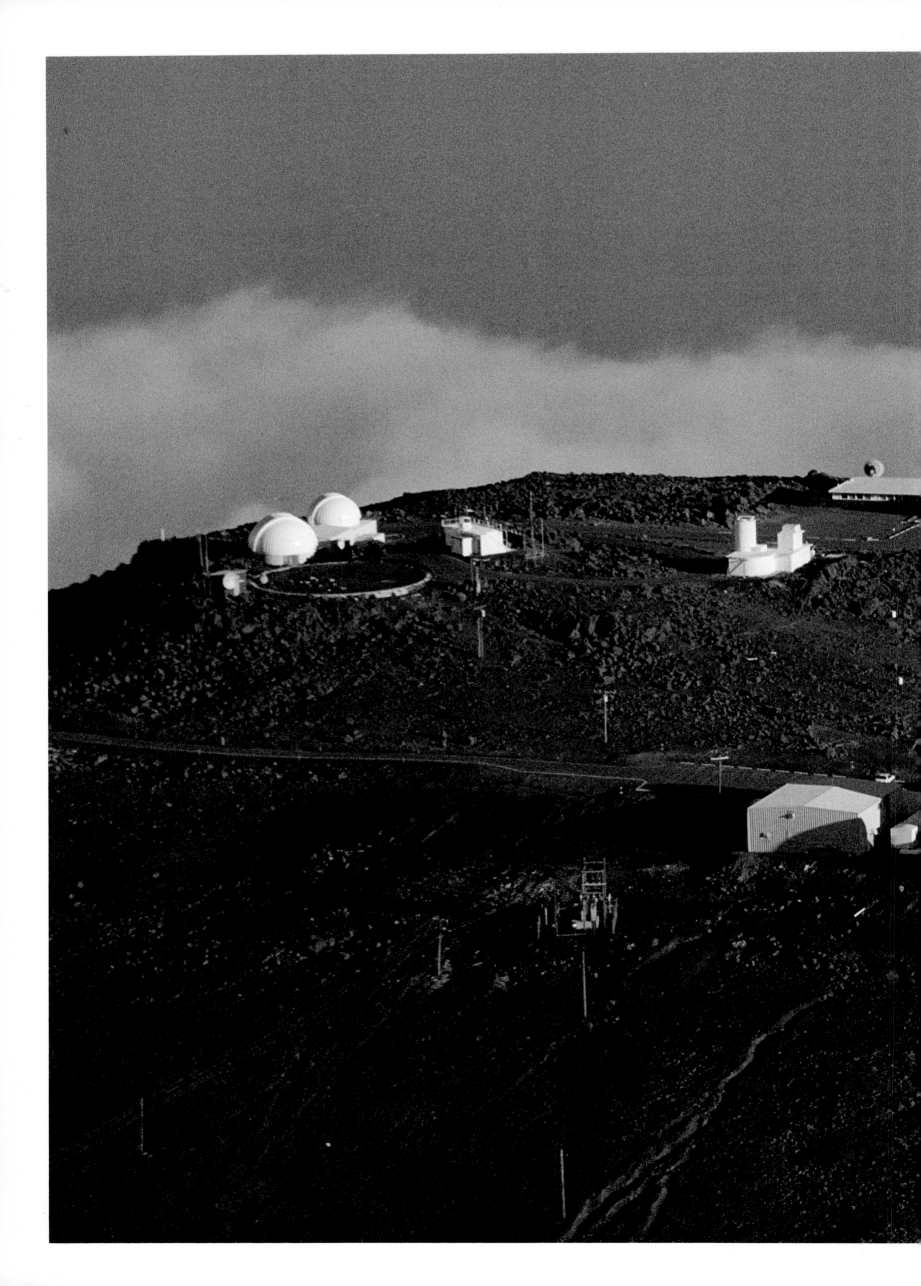

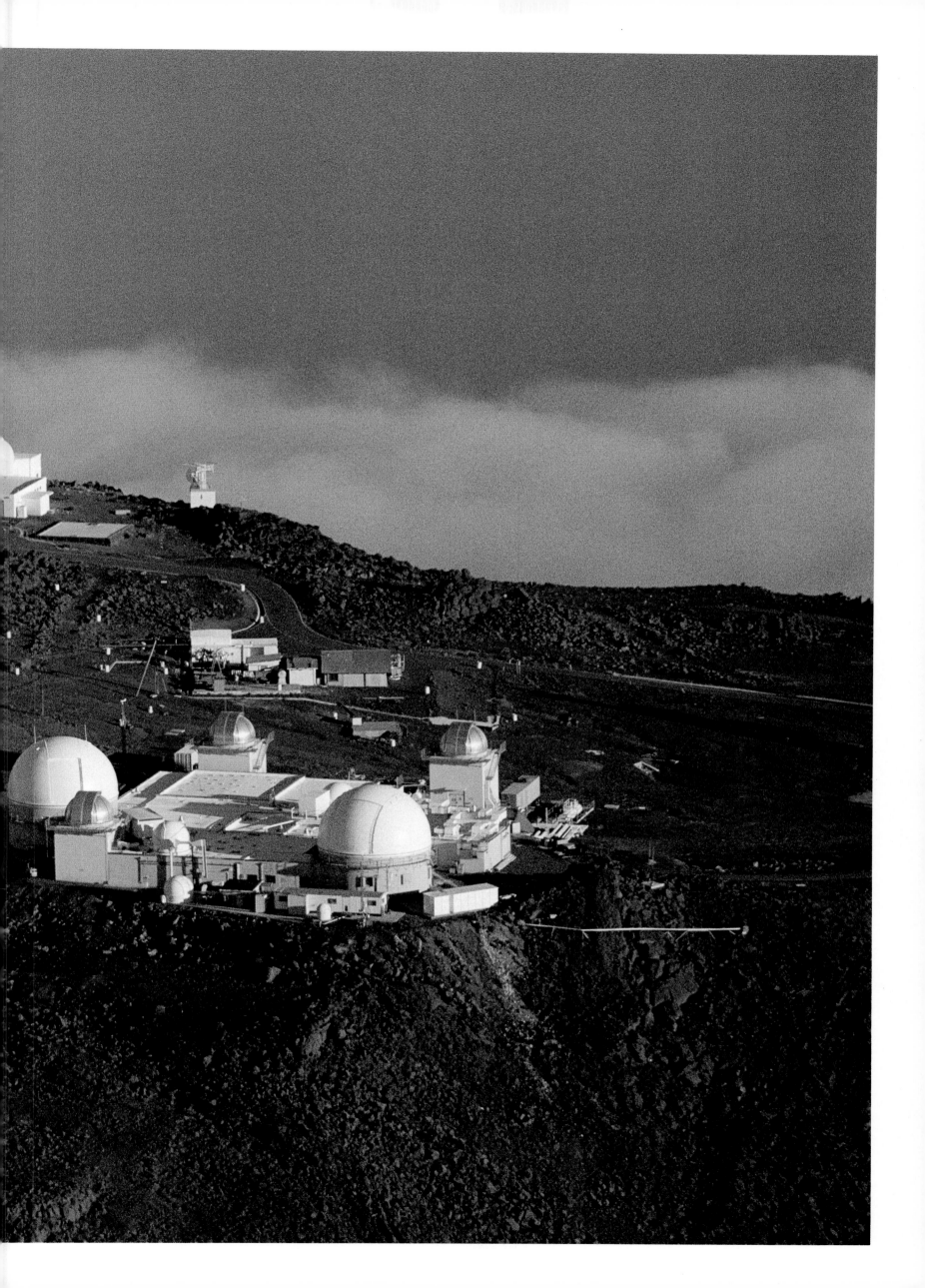

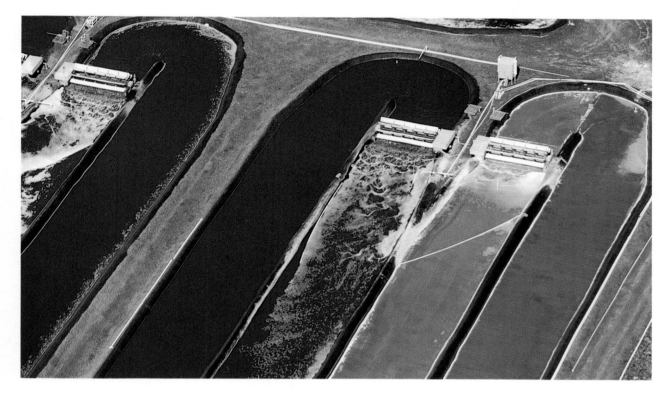

Previous pages: Science City on the summit of Haleakalā. Lasers fired from these domes at the eclipsing moon and other objects in near space have measured distances and provided scientists with information useful in developing the U.S. government's "Star Wars" defense system.

Above: Aeration machines churn the water in the OTEC aquaculture ponds in Kona, Hawai'i. Algae of deep green spirulina and orange beta carotene are being developed as food supplements for people who want nutrient-rich diets. Other aquaculture ventures in the islands include shrimp, prawns, oysters and several varieties of fish.

Left: Mitsubishi wind generators at the South Point Windmill Farm, Big Island. As a power source, Hawai'i's prevailing trade winds (which blow almost year-round) excite every environmentalist.

227

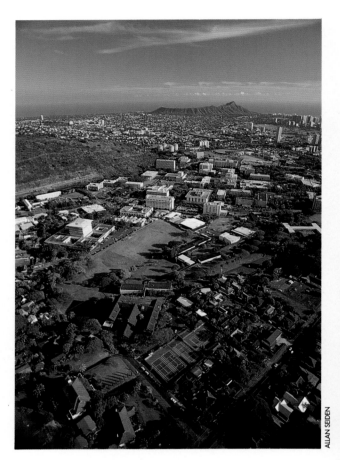

ALLAN SEDEN

Above: Looking seaward from the mouth of Mānoa Valley: Mid-Pacific Institute (a private high school), the main campus of the University of Hawai'i, the suburbs of Kapahula and Kaimuki on the left, Waikīkī on the right, and Diamond Head wearing its rainy season green.

Below Right: There is a baseball game in progress at Kamehameha Schools in Kapālama Heights, above Honolulu. Grades run K-12, and enrollment is limited to students of Hawaiian and part-Hawaiian ancestry as a condition of the will of the school's founder, Princess Bernice Pauahi Bishop, "the last of the Kamehamehas."

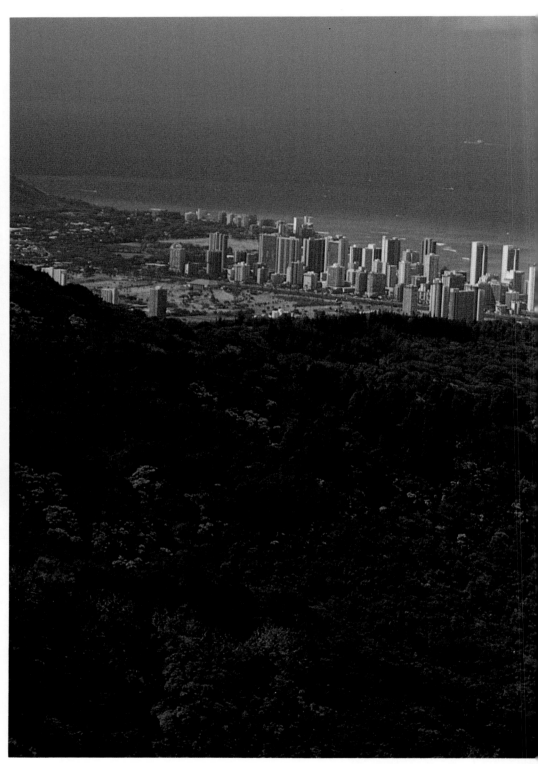

DANA EDMUNDS/PACIFIC STOCK

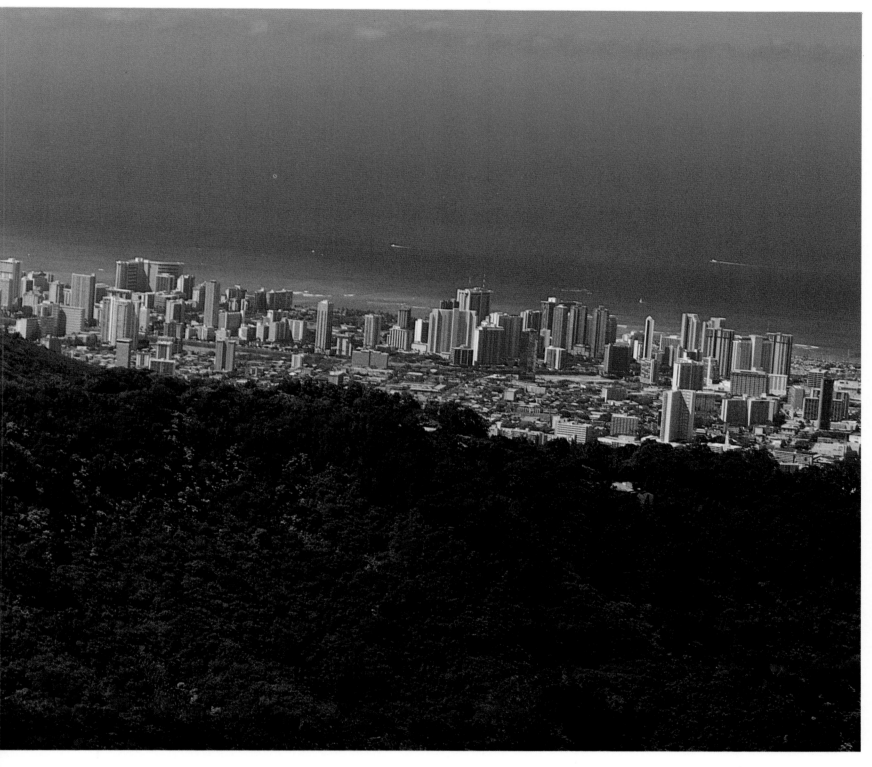

Above: From the time it started to grow in the early nineteenth century, Honolulu was known as a "white city" because its buildings were made of coral block. This view is from above Tantalus and Makiki Heights.

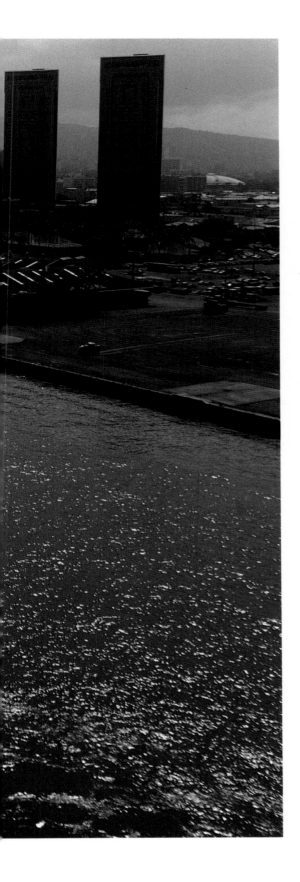

Above: Colossal junkyard on the Wailuku plain, Maui. Traffic woes and abandoned vehicles have spurred the organization of a movement called ZAG, Zero Automobile Growth, whose proposal for car recycling is simple: "For every car imported to Hawaiʻi, one must be deported."

Left: Loaded with Matson shipping containers and new cars, a Young Brothers interisland barge heads out of Honolulu Harbor. The harbor itself has a reputation for being remarkably clean. Live corals and reef fish can be seen through the clear water near the piers.

Left: All these people had the same idea: rent a red car and ride the famous Hāna Highway on Maui. The journey itself is the destination on this "Highway to Heaven." With more curves per mile than any other roadway on earth, the drive from Kahului to Hāna is a mind-boggling challenge with 617 curves (the ones here are too gradual to count) and 56 bridges.

Right: A pack of cyclists pedaling up Diamond Head Road train for an upcoming round-the-island race. Dry roads and generally flat terrain have made bicycling a major sport in Hawai'i. More bike lanes are being added to the state's highways, and lawmakers are considering incentives to encourage commuters to opt for pedal power.

Following pages: Trucked-in dirt and a sprinkler system support the new Kings' Course at Waikōloa, Hawai'i. Several golf courses have been built like this over barren lava flows.

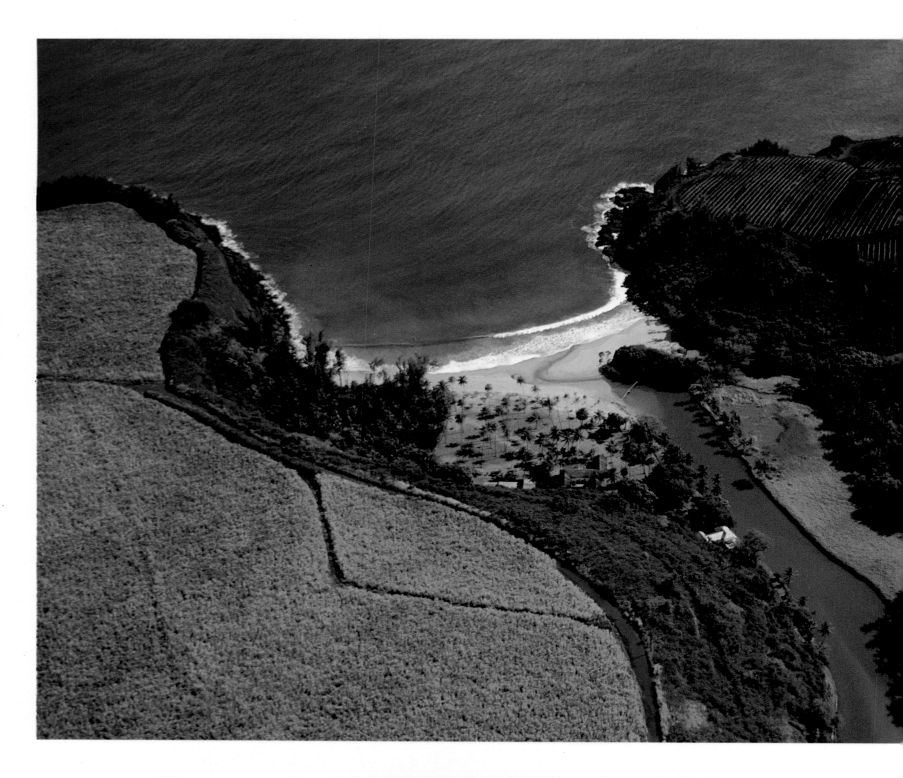

Right: Waiting for the morning's first show, dolphins swim in the pools at Sea Life Park's Whaler's Cove on windward O'ahu. The ship is a scale model of the *Essex*, a whaling ship sunk by a whale. In addition to its tourist attractions, the park maintains several marine support programs.

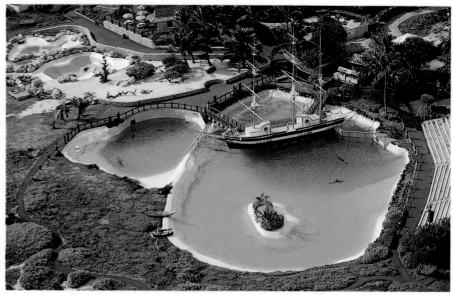

236

Above: The tourist submarine *Nautilus* under tow off Kailua-Kona on the Big Island. The sub takes its passengers down along Kona's reefs to view fish through aquarium-like windows.

Above left: Kalihi Wai River settles into Kalihi Wai Bay on the north shore of Kaua'i. Looking like a small version of Waimea on O'ahu, the river here will swell during the rainy season and cut a gully through the beach sand.

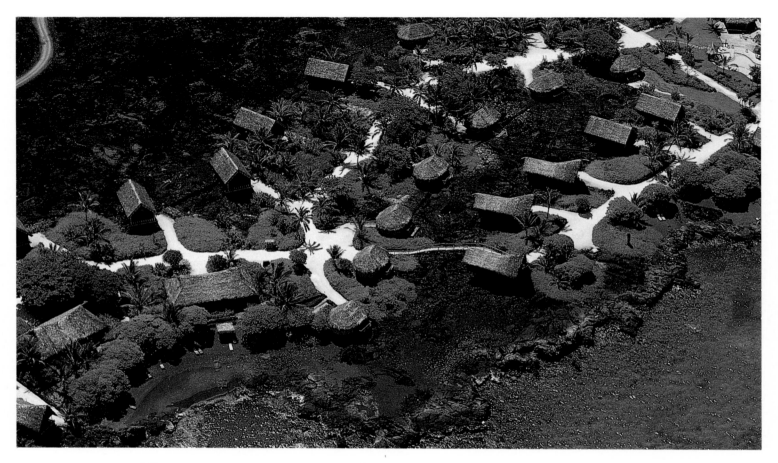

Above: For travelers seeking seclusion and simplicity, the Kona Village Resort on the Big Island offers "plush primitive" thatched bungalows that look weathered and rustic outside but inside feature typical hotel amenities: carpeting, tubs and showers, and ceiling fans. In the bay, tame fish and manta rays swim right up to snorkelers' masks.

Right: A beachfront church in the Honolulu suburb of ʻĀina Haina has become a popular spot for Japanese weddings. Tour companies in Japan offer engaged couples travel packages that include a videotaped exchange of vows in Paradise.

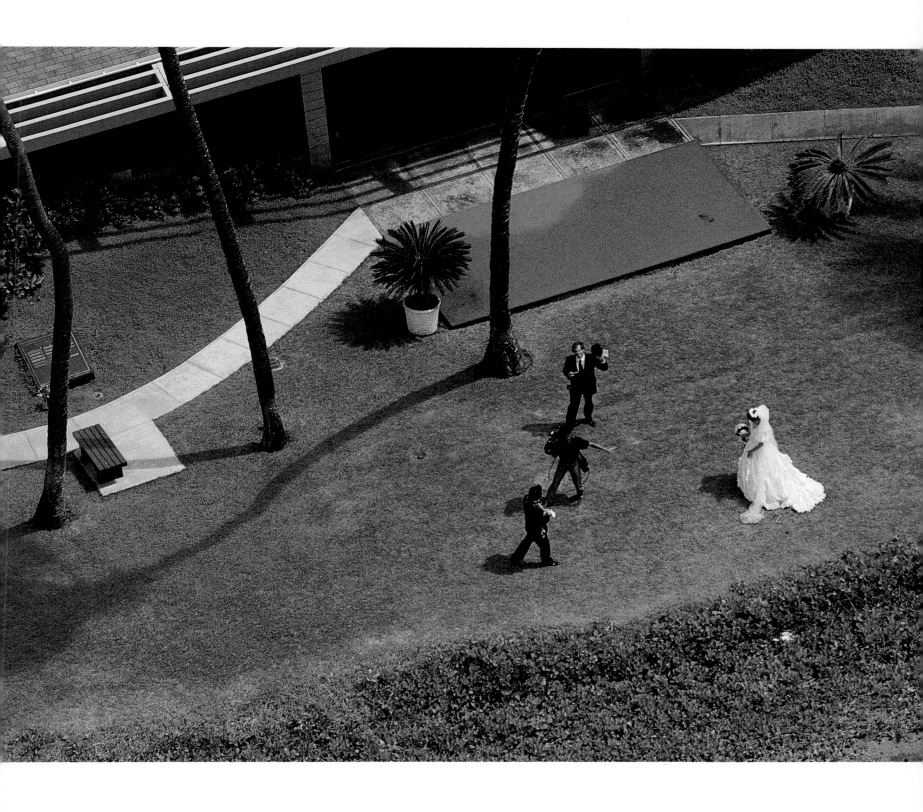

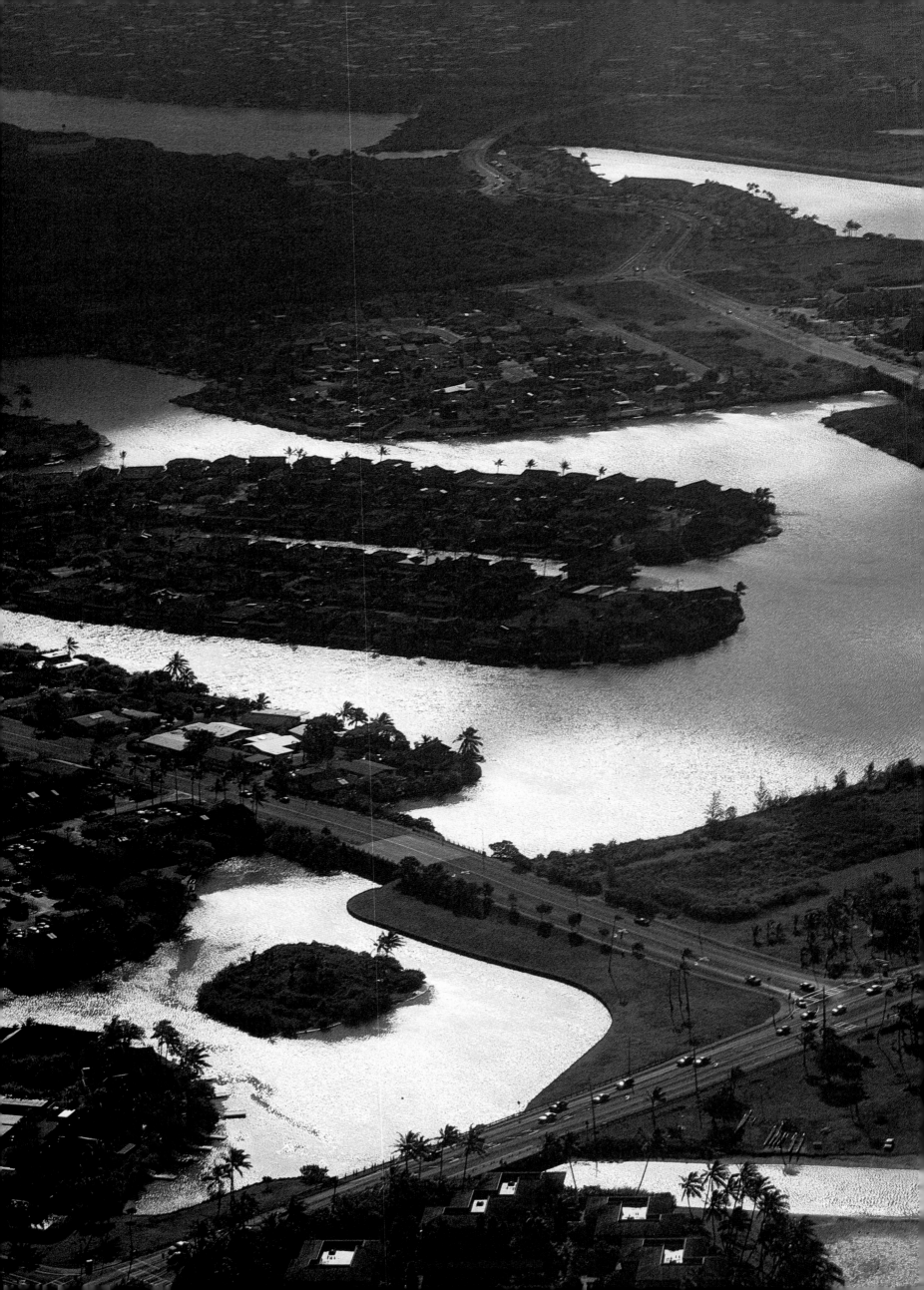

Left: Billionaire industrialist Henry J. Kaiser transmuted Kuapā, Hawai'i's largest ancient fish pond, into this upscale subdivision east of Honolulu. Called Hawai'i Kai (a punning reminder of the developer's name), the community of 25,000 is projected to more than double its size in the next few years.

Right: Flamingos, a shuttle boat and tram tracks highlight the immaculate grounds and waterways of the Hyatt Regency Waikōloa on the Big Island.

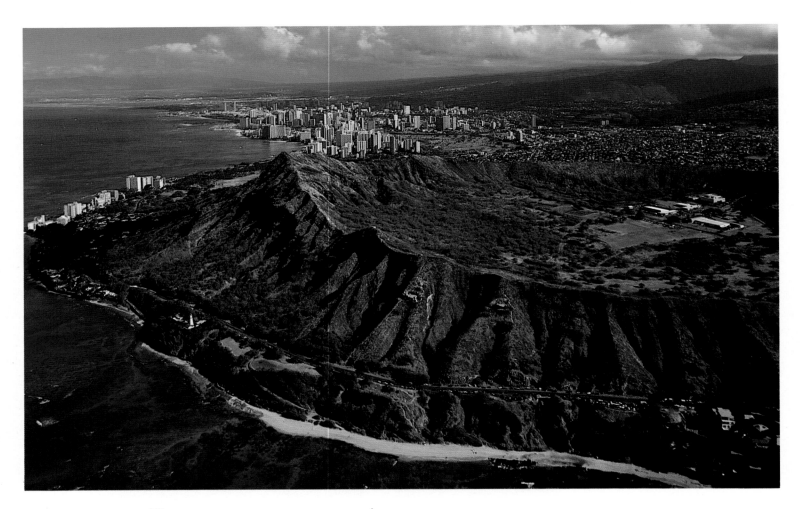

Above: Diamond Head got its modern name in 1825 when British sailors hiking the slopes found some worthless calcite crystals and thought they were diamonds. Points of interest here (clockwise): Hawaiʻi National Guard buildings (inside the crater), Diamond Head Road, Diamond Head Lighthouse, the Gold Coast, Kapiʻolani Park, Waikīkī, the Ala Wai Golf Course and lower Kaimukī, a suburb.

Right: A wall of Pacific power chases windsurfer Luke Hargraves at Hoʻokipa, Maui. For years Hoʻokipa was regarded by surfers as merely an OK spot; the waves break in sections and the wind is side-shore. But these features make it perfect for the newly evolved sport of windsurfing, and now Hoʻokipa is regarded by "board heads" as the world's premier venue for their wild aerials and jump jibes.

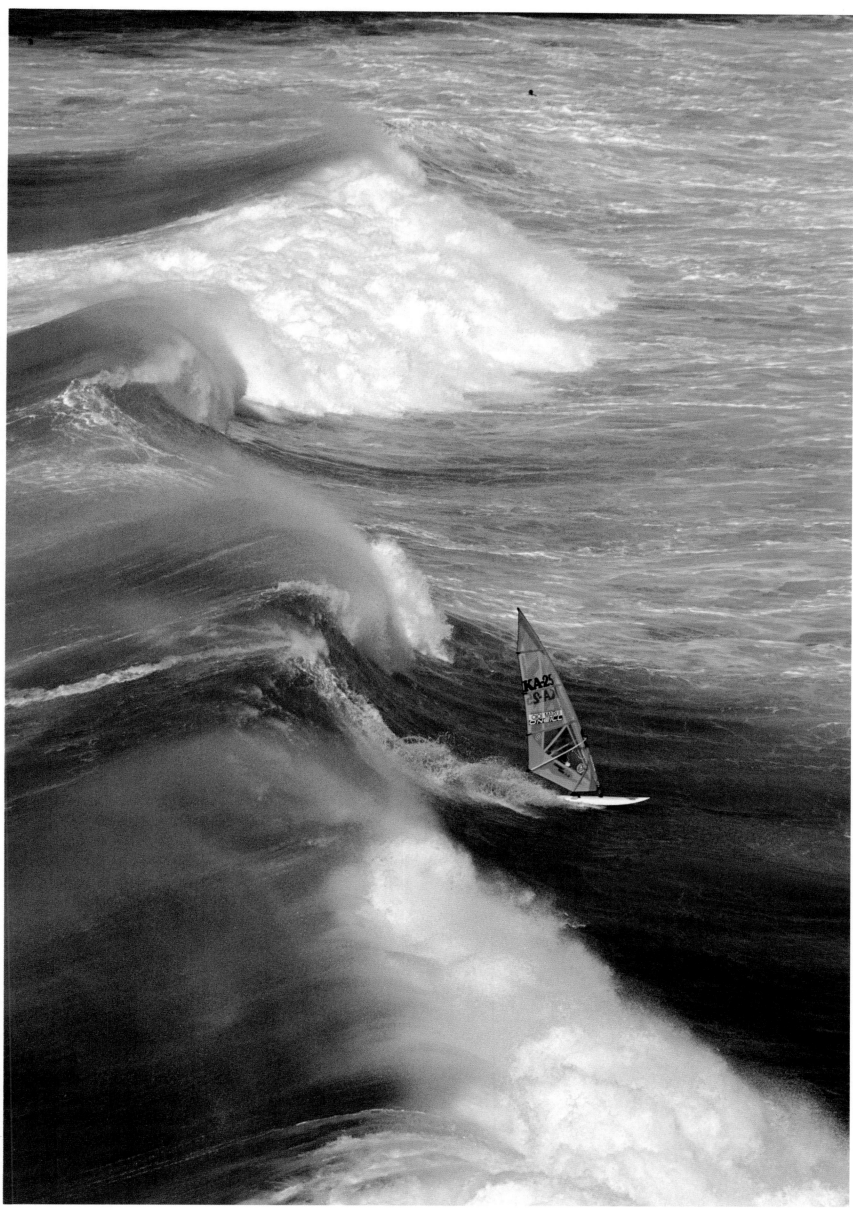

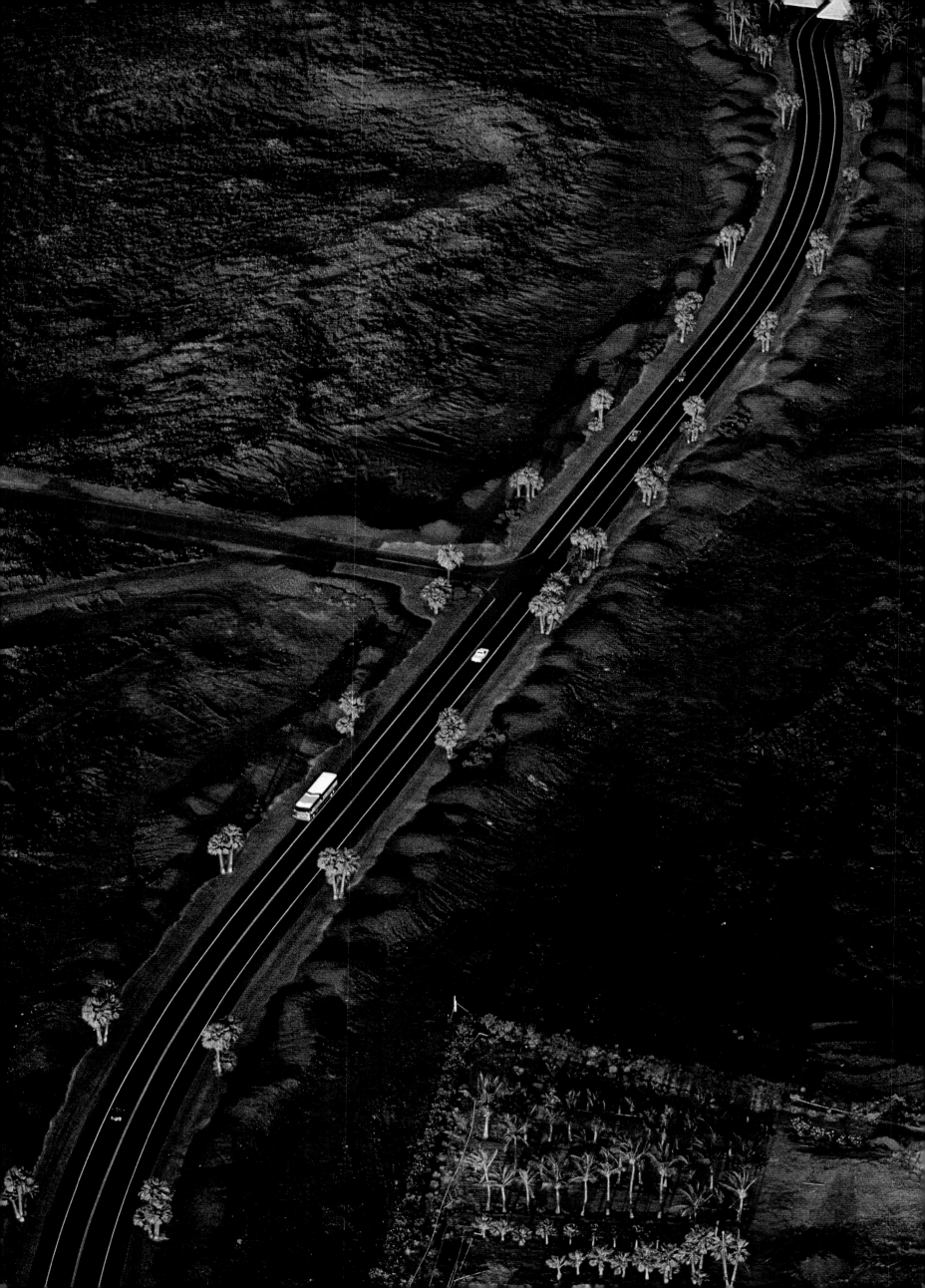

Left: A band of asphalt and manicured landscaping slashes through sunset-reddened lava in South Kohala, Hawai'i. The offset white pyramids signal the entrance from Queen Ka'ahumanu Highway to 'Anaeho'omalu Bay and the Sheraton and Hyatt resorts.
Right: This Coast Guard "skeletal tower" lighthouse sits a quarter of a mile inland on Cape Kumukahi, the easternmost point of the Big Island. In 1960 a flank eruption of Kīlauea volcano sent a slow-moving flow of 'a'ā (clinker) lava rumbling toward the lighthouse and several nearby houses. University of Hawai'i geologists directed bulldozers to throw up rock walls, which held back the flow. The paint on the lighthouse blistered in the heat and fell on the lava, leaving white specks that remain to this day.

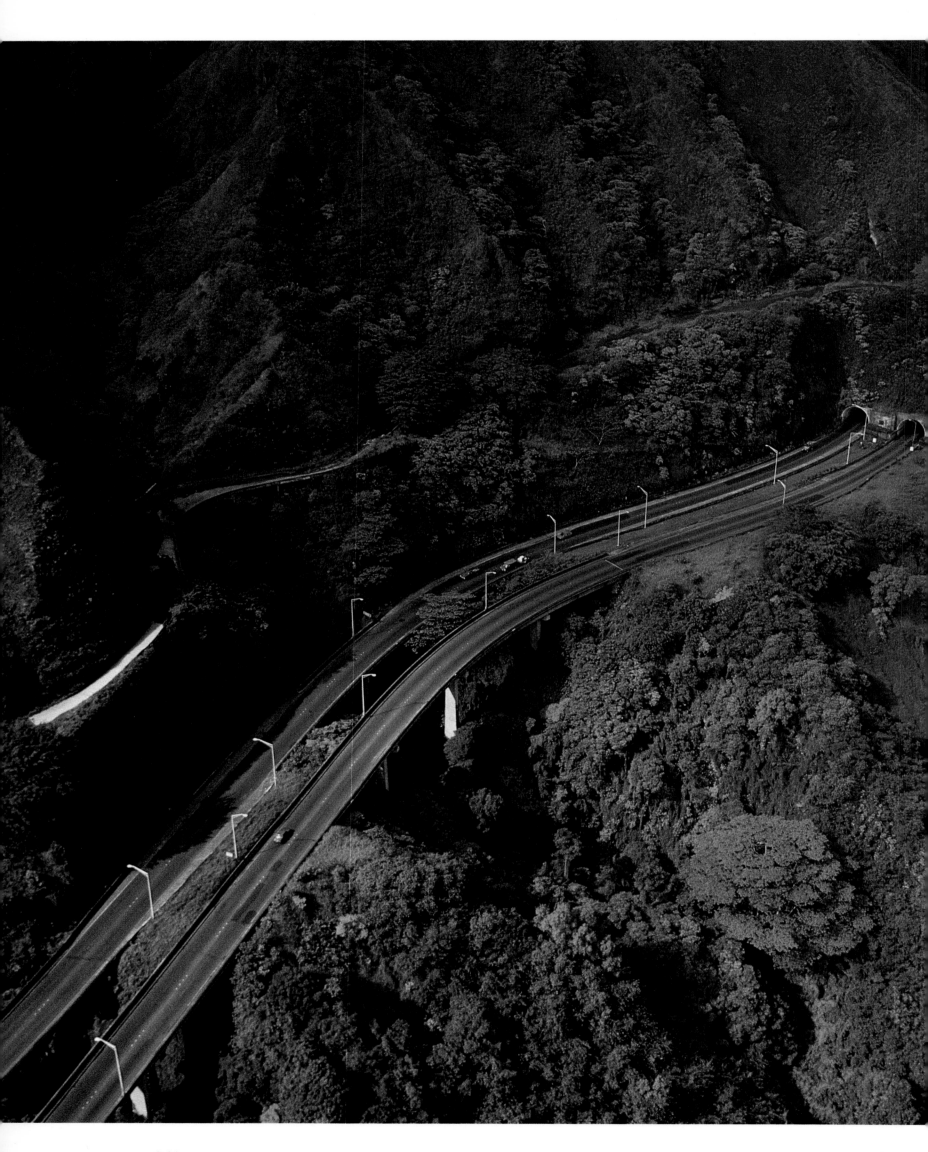

The old Pali Highway and the new. Windward drivers got a much appreciated shortcut into Honolulu when the first highway was completely paved in 1898. Now abandoned, its concrete is cracking under roots and rain. The second highway, double-laned and quadruple-tunneled, was built just below the first and replaced it in 1957. As far back as 1852, an editorial in *The Polynesian* predicted that the residents of Oʻahu would "never be satisfied 'til a tunnel is dug through the *pali*, suitable for the passage of carts and wagons."

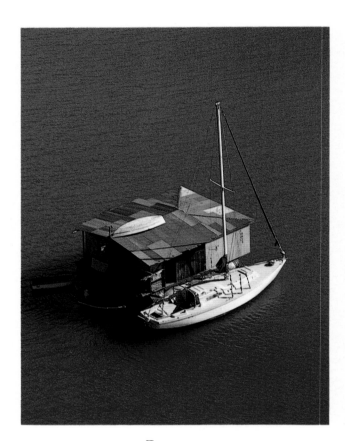

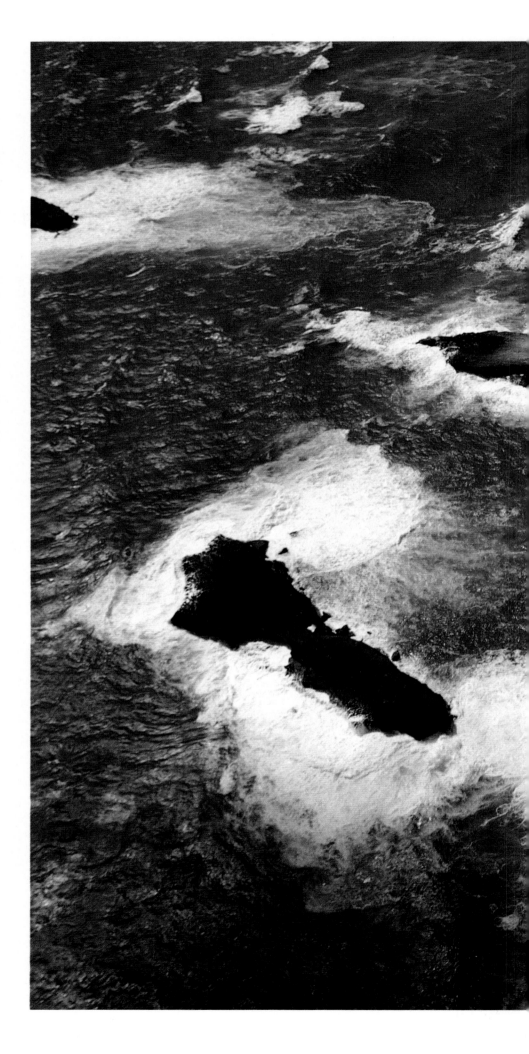

Above: Life couldn't be simpler for the nautical resident of this Keʻehi Lagoon shack made of old shipping crates and corrugated tin. The serenity of the place is periodically broken, however. It sits beneath the jetway of Honolulu International Airport.

Right: Windward Oʻahu's Lāʻie Point, a favorite spot for local anglers, used to be a giant moʻo (dragon-lizard) that the legendary demigods Kana and Nīheu killed and chopped up. The rock islands to the left are two of the five nearby islands that are the moʻo chunks thrown into the sea.

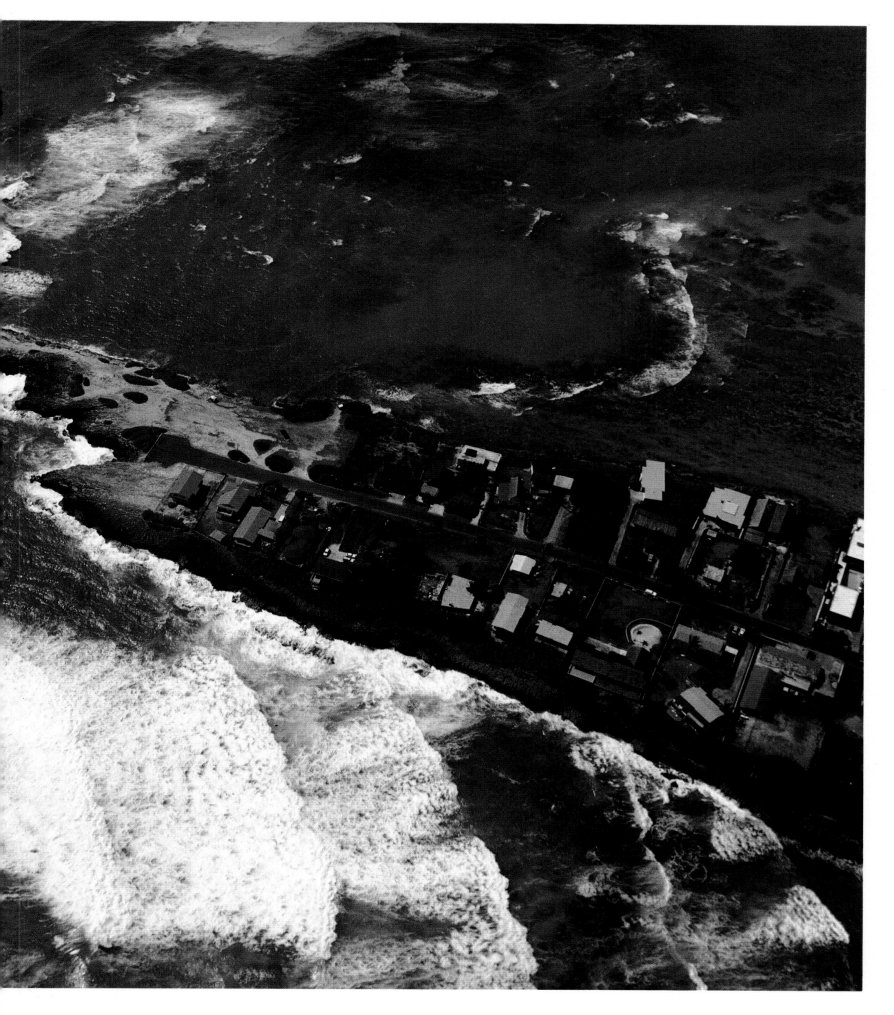

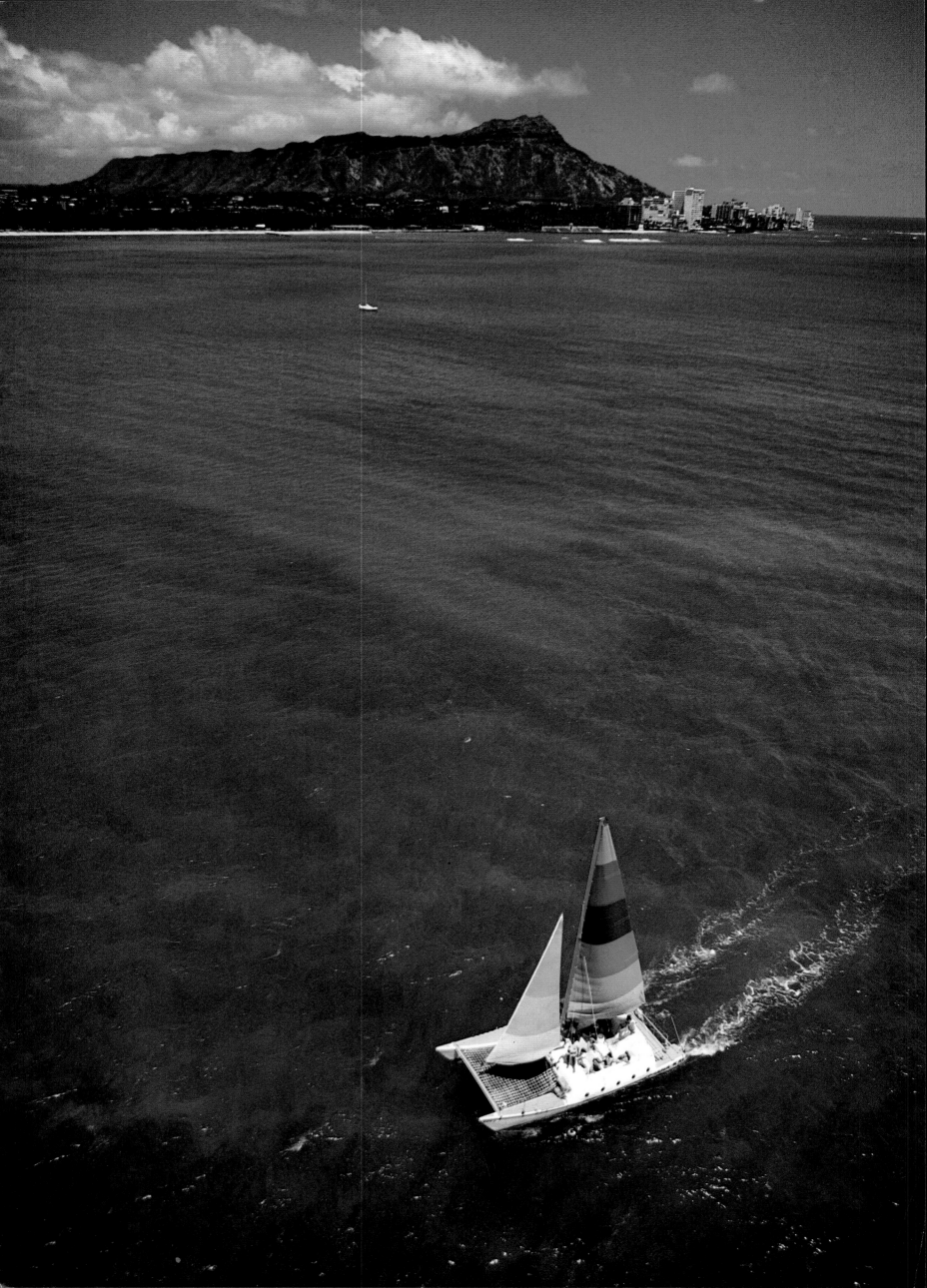

Left: A hotel catamaran circles the reefs off Waikīkī. The white buildings are the hotels, condos and private clubs of the Gold Coast in the quieter, more aristocratic corner of Waikīkī.
Above: Kāne'ohe Bay sandbar, a favorite landing for boaters and windsurfers off O'ahu. Dry only at the lowest tides, the sands shift with the seasons.

Following pages: In up-country Maui, on the western slopes of Haleakalā, is a town called Pukalani. Locals say the name Pukalani means "hole in Heaven." There's usually a hole in the clouds above the town. At sunset, from the 10,000-foot summit of Haleakalā, hikers looking northwest through the Pukalani hole can sometimes see the city lights of Wailuku.

ACKNOWLEDGMENTS

The producers of Over Hawai'i *would like to thank the following people and organizations for their assistance:*

Mitzie Abbott, Neil Abercrombie, Charlie Anderson, Lisa Anderson, Paul Andrade, Paige Aranda, Billie Beamer, Patricia Beggerly, Howard Benham, R. H. Brady, Hillary Brown, Joe Bruey, Barbara Brundage (Pacific Stock), Lance Chase, Susannah Clark, Len Cowper (American Flyers), Dan Cunningham, Norma Cunningham, Linda Delaney, Catherine Domingo, Frank Fasi, Kent Fonoimoana, Galen Fox, Chuck Freedman, Peter French, Joe Germaine, Sally Gribbin, Carol Halemanu, Chief Warrant Officer John Haley, Scott Hare, Kim Harris, Susan Heberling (Qualex), John Heckathorn, Don Hibbard, John Hirota, Brian Hood, Ruth Jacobson, Leslie Jonath, Bart Jones, Minerva Ka'awa, Steve Kaiser, Joe Kau, John Kings (Texas Center for Writers), Jesse Kline, Richard Klemm, Ray Kuruhara, Heather Leitch, Bunny Look, Liane Lum, Roger McClusky, Stan Melman, Vida Merwin, Riley M. Moffat, Marilyn Moore, Alan Murakami, Virginia Murison, Brian Nicol, Merrill Oka, Dr. Kost. Pankiwskyj, Lisa Petersen, Rapidlaser Graphics (San Francisco), Billy Richards, Ronn Ronck, Moana Rowland, Elaine Scott Seacord, Allan Seiden, Richard Seymour, Carl Shaneff, Phil Spalding III, Katherine Stimson, Carolyn Tanaka, David Tarleton, Cheryl Chee Tsutsumi, Richard Van Oosterhout, Dietrich Varez, Greg Vaughn, John Waihe'e, Leighton Wong, Timothy J. Wrath (Papillon Hawaiian Helicopters), Sue Yoshishige

Special thanks to:

Francis Akana, Kainoa Aviation Inc.; Mary Bitterman; Dale Bringelson, American Flyers Inc.; Kevin V. Britt, Fly Kauai; O. A. Bushnell; John Dominis Holt; U'ilani Goldsberry; Emily Hawkins; Rubellite Kawena Johnson; Herb Kawainui Kane; E. Alison Kay; Robert A. Kinzie III; Irwin C. Malzman, Helicopters Hawaii; James A. Michener; Robert J. Morris; Bobby L. Norris; Lilian Ong, Hawai'i Visitors Bureau; Jennifer Overbeck; Frank Peterson; Joseph H. Spurrier

Above: Not far from some of the most remarkable petroglyph fields in Hawai'i, these greetings in Kailua-Kona offer their own kind of expression. Aloha means "hello," "goodbye" and "love."

INDEX